COLONIZED THROUGH ART

Colonized through Art

American Indian Schools and Art Education, 1889–1915

MARINELLA LENTIS

UNIVERSITY OF NEBRASKA PRESS | LINCOLN AND LONDON

Portions of chapter 2 previously appeared as "Art
for Assimilation's Sake: Indian-School Drawings
in the Estelle Reel Papers," *American Indian Art
Magazine* 38, no. 5 (Winter 2013): 44–51.

Library of Congress Cataloging-in-Publication Data
Names: Lentis, Marinella, author.
Title: Colonized through art: American Indian schools
and art education, 1889–1915 / Marinella Lentis.
Other titles: American Indian schools
and art education, 1889–1915
Description: Lincoln: University of Nebraska Press,
[2017] | Includes bibliographical references and index.
Identifiers: LCCN 2016034818 (print)
LCCN 2016049456 (ebook)
ISBN 9780803255449 (cloth: alk. paper)
ISBN 9781496200686 (epub)
ISBN 9781496200693 (mobi)
ISBN 9781496200709 (pdf)
Subjects: LCSH: Indians of North America—
Education—History. | Art—Study and teaching—
United States—History. | Indians of North America—
Vocational education—United States—History. |
Indians of North America—Cultural assimilation—
United States. | Off-reservation boarding
schools—United States.
Classification: LCC E97 .L48 2017 (print) |
LCC E97 (ebook) | DDC 371.8297—dc23
LC record available at https://lccn.loc.gov/2016034818

Set in Scala by Rachel Gould.
Designed by N. Putens.

To Doug, Elizabeth, Christopher, and Rikardo

My people are a race of designers.

I look for the day when the Indian

shall make beautiful things for all the world.

—Angel DeCora

CONTENTS

ILLUSTRATIONS

TABLES

ACKNOWLEDGMENTS

The idea for this project started many years ago in a graduate class on the history of American Indian education at the University of Arizona. I am thankful to all who have helped me and supported me along the way since that spring semester and who have witnessed the transformation of that original paper into my doctoral dissertation and, finally, into this book. First among them is my husband, Doug. I would not be the person I am today if it weren't for him, and this work would have certainly not seen the light of day without his constant love and encouragement. My infinite thanks to you.

I want to thank Tsianina Lomawaima, Nancy Parezo, and Robert Williams for their patient guidance and advice, and for showing me what it means to be a scholar. I appreciate all they have done for me throughout the years, in and out of the classroom, in times of confidence and in times of need. I also want to express my gratitude to Matthew Bokovoy and the manuscript reviewers, especially Linda Waggoner, for believing in this project and encouraging me throughout, and to everyone at the University of Nebraska Press who has made this book possible.

Research for this book could have not been completed without the invaluable knowledge and assistance of many archivists in private and public repositories across the country. I want to thank in particular Randy Thompson and Debra Schultz at the National Archives and Records Administration, Riverside, California; Lorene Sisquoc at the Sherman Indian Museum and Archives; the entire staff of the New Mexico State Records

Center and Archives; the archivists at the Center for Southwest Research at the University of New Mexico; Diane Bird at the Laboratory of Anthropology; Dave Miller at the National Archives and Records Administration, Denver, Colorado; Ken House at the National Archives and Records Administration, Seattle, Washington; Jane Davey at the Northwest Museum of Arts and Culture; Leanda Gahegan at the National Anthropological Archives; Jim Gerencser at Dickinson College; and everyone at the Still Pictures Division at the National Archives and Records Administration, College Park, Maryland. I am particularly grateful to Leigh Kuwanwisiwma of the Hopi Cultural Preservation Office for allowing me to publish the kachina drawings included in this volume and to Anna Harbine (Northwest Museum of Arts and Culture), Daisy Njoku (National Anthropological Archives), and Claire-Lise Benaud (Center for Southwest Research) for promptly answering my requests and granting permissions.

I am indebted to those organizations that provided me with financial support so that I could travel to conduct the necessary archival research: the New Mexico Office of the State Historian, the Arizona Archaeological and Historical Society, the Historical Society of Southern California, the Association of Women Faculty at the University of Arizona, the Charles Redd Center for Western Studies, and the Graduate Interdisciplinary Programs at the University of Arizona. My appreciation also goes to Michael Spinella and the Text and Academic Authors Association for their assistance with publication costs.

Last, but not least, I want to thank my family and friends: those who are abroad in my homeland, those who are physically far from me but close to my heart, those who have made us feel at home in the South, and those who have always had confidence in me and my ideas.

INTRODUCTION

Every child enjoys drawing with colored pencils, crayons, and markers and putting on paper his ideas about the world around him. Similarly, children love to touch and feel things with their own hands, give shape to something out of nothing, to build, to invent. Her mind directs her hand into spontaneous compositions that sooner or later are going to reflect the environment in which she grows and through which she learns about reality. But when such natural and imaginative instincts are forcibly rectified and redirected toward what someone outside of the child's circle deems more correct—the right imageries, the right shapes, the more appropriate color and usage—something is inevitably lost. In the child's mind, a door that was once open to uncountable possibilities of exploration, experience, and knowledge is now all of a sudden closed, although not permanently locked. This unnatural imposition no longer allows the young person to grow and develop to his or her full potential, because the pleasurable creative act has now become an oppressive instrument for reshaping the world according to a different set of foreign and unfamiliar standards that do not value the individual's own imagination, background, and heritage. This is the art training American Indian children received in government schools at the turn of the twentieth century. The purpose and content of that kind of training are the subjects of this book.

The establishment of boarding schools for American Indian children at the end of the nineteenth century marked the beginning of a systematized, government-sanctioned process of assimilation of the Indigenous

population through education. Peopled with children often forcibly removed from their homes, extended families, and communities in order to eradicate "savage" influences, boarding schools suppressed every aspect of Indian cultures, traditions, and languages. In the process, they acted as factories to produce a proletariat of industrious Christian citizens. As Richard Henry Pratt declared at the beginning of his experience at the Carlisle Indian Industrial School, there was "no holding onto Indianism in this transformation"; Indianism meant extinction and death; education opened the doors to a future as members of American society.[1] With the proper kind of education, Indian boys and girls could learn to live and work like Anglo-Americans and thus advance from their primitive state to a civilized one.

Thomas J. Morgan, commissioner of Indian Affairs (1889–93), and Estelle Reel, superintendent of Indian schools (1898–1910), were key players in the education of American Indian children as they brought significant changes to the curriculum of federal institutions by introducing art instruction. In 1890, Morgan proposed the teaching of elementary art while, a decade later, Reel called for the inclusion of "Native industries" such as weaving, pottery, and basketry, recommending Native artists as instructors. Why were American Indian children trained in basic principles of art such as colors and shapes? Why did they have to learn how to draw according to Anglo cultural standards and why were their Indigenous norms inadequate? Why, in a political climate of forced assimilation and Americanization, were they allowed and even encouraged to make their own crafts? How was art education used to help the Indian Service achieve its goals?

This book attempts to answer these questions by examining the process of domestication of Indian children through art education. I propose that instruction in art was included in the curriculum of government-controlled schools as an instrument for the "colonization of consciousness," that is, for the redefinition of Indigenous peoples' minds through the instilment of values and ideals of mainstream society. As nineteenth-century theories of education saw art as the foundation of morality, a means for the promotion of virtues and of personal and social improvement, Indian policymakers and educators embraced it as one of the instruments through which they could reach the assimilationist goals of their time. Boarding

schools aimed at the transformation of little "savages" into civilized men and women; art fit well into their curriculum because it contributed to this evolution. Using educational approaches already tested in public schools with working-class students and immigrant children, and taking advantage of the renewed interest in Native arts and crafts, Morgan and Reel introduced their respective art curricula.

Colonized through Art considers Morgan's and Reel's national mandates at the turn of the twentieth century and explores their rationales for including drawing and Native crafts in Indian schools. It then compares the course of study envisioned by these two bureaucrats to the art instruction that was actually "offered" at two institutions, the Albuquerque Indian School in New Mexico (Territory of New Mexico, at the time of the school's founding) and the Sherman Institute in Riverside, California, from 1889 to 1915. Local implementation of government directives sheds light on the daily practices of Indian education at the micro level and provides specific information as to the organization, pedagogy, and goals of art instruction in these particular localities. The newly penned educational programs, crafted at an administrative level that was disconnected from the everyday reality of Indian schools, were not equally implemented in all government institutions. The two schools under examination clearly demonstrate this diversity of approaches in complying with Washington directives and show not only heterogeneous local responses to national policies, but also different educational praxes. Finally, this work discusses how students' works of art were exhibited in the context of international expositions and national educational conventions as exemplary evidence of the children's progress toward civilization and the instrumentality of an Anglo education in reaching this goal. As Indian policy changed, so did the art curriculum of Indian schools from the early 1890s, when it was first introduced, to the mid-1910s, when it lost its significance; this book attempts to retrace the major phases, objectives, and key players of this story.

Drawing and Native industries such as weaving, pottery, and basketry, as proposed by Commissioner Morgan and Superintendent Reel, did not appear arbitrarily and unexpectedly in the curriculum of Indian schools; rather, they were prompted by changing ideas about art and handicrafts stirring in mainstream institutions. The educational philosophies and

the methodological approaches used in the nation's public schools served as the inspirational basis for the development of art curricula in Indian schools. Art education in Indian boarding schools cannot be considered in isolation from the philosophical currents that shaped American public education starting from the mid-nineteenth century, as the policies actuated in the former had already been "tested" in the latter as part of manual or industrial training, particularly for immigrant or lower-class children. For this reason, an analysis of the art curriculum of public schools and its evolution over the course of the century precedes my discussion of art in Indian schools.

This facet of American Indian history might seem minor and insignificant, yet it unveils the totalitarian nature of government-funded education, whether for American Indians, immigrants, lower-class, or African American citizens: the erasure of heterogeneity for the sake of a homogeneous, uniform "American" cultural cohort that served the needs of a white, Protestant, and prosperous minority who supported capitalistic expansion and the development of wealth for wealth's sake. American Indian schools, like public institutions, sought to destroy everything that did not immediately contribute to the nation's economy. Art education was one way in which the dominance of this economic rationale was asserted: through innocent and enjoyable activities such as drawing and the production of Native crafts, students were intentionally taught to abandon their cultural heritage, including how Native arts were conceived and adorned, as well as to absorb the values of mainstream society and to adopt its working habits in order to better serve it.

Early and mid-nineteenth-century educators distinguished between high arts (drawing, painting, sculpture, and architecture)—which were a prerogative of the cultured and the professional artists, normally males—and low or amateur arts (decorative painting, embroidery, needlework), which belonged to the domestic realm and were thus female accomplishments. As public schools were established for the education of lower- and middle-class children, the arts were incorporated in the form of drawing (industrial and later creative) and handicrafts (fancy needlework, basketry, pottery, and weaving); starting from 1914, they have been collectively referred to as "art education."[2] Because of this historical categorization, which I will explain

more thoroughly in chapter 1, I use the term *art education* in its broadest sense, that is, to refer to any kind of artistic endeavor that was undertaken in school settings; entailed the use of diverse tools such as shapes, blocks, paper, clay, needle and thread, pencil, brushes, crayons, paint, raffia, natural plants, cotton, wool, or wood; and whose goal was the making of shapes, pictures, and objects, or their decoration. As this book shows, drawing and Native arts and crafts were the main activities included in the curriculum of Indian schools and, therefore, the ones that receive the most attention in this study. However, they were not alone, as they were combined with other creative and sensory exercises, particularly in the lower grades.

This book is grounded in theoretical approaches proposed by scholars of colonialism, American Indian education, critical theory, and market capitalism. I borrow the concept of colonization of consciousness from anthropologists Jean and John Comaroff to frame my argument that art education was an instrument for training students' minds and hands in the values and customs of American society. The Comaroffs define colonization of consciousness as the colonizers' efforts to impose on their subjects "a particular way of seeing and being, to colonize their consciousness with the signs and practices, the axioms and aesthetics, of an alien culture." This was a "total *reformation* of the heathen world" through "the inculcation of the hegemonic forms, the taken-for-granted signs and practices, of the colonizing culture."[3] These ideas—originally formulated in reference to the nineteenth-century colonization of the Tswana people of South Africa by British Protestant missionaries—constitute a framework for reading the history of American Indian education, particularly education *for* Indians, as this has historically meant the acquisition (or better, imposition) of certain types of knowledge, skills, exogenous worldviews, and ideas in formal school settings for the purposes of reshaping the culture of Indigenous Americans.[4] Art education was approached in a manner that stressed this basic idea of mind-training: teaching in colors and forms developed the proper power of observation and preferred way of seeing, while training in accuracy and precision eliminated elements of savagery, impulsiveness, and irresponsibility.

I also use Antonio Gramsci's concept of "cultural hegemony" to better illustrate how the instruction of elementary art and Native industries

served the submission, domestication, and assimilation of Indian children, and I complement it with the theoretical framework of the "safety zone" proposed by K. Tsianina Lomawaima and Teresa L. McCarty in their work *"To Remain an Indian"*(2006) to explain the "sudden" appearance and disappearance of arts and crafts.[5] The concept of cultural hegemony advanced by Gramsci is based on the assumption that a group's power over subordinate populations is asserted through control of social institutions, rather than by coercion and physical force; it is a process of "moral and intellectual leadership" that ruling classes covertly impose on subordinate groups in order to gain their consent and make them accept their inferior position, thus preventing disruptions of a desired political, social, and economic order.[6] While not covert, I propose that art education was an act of cultural hegemony because it intended to "conquer" the masses of American Indian students and subordinate them in order to achieve the government's ultimate goals of obedience and adaptation. Instruction in drawing and the institutionalization of Native industries were the preferred means through which the government tried to maintain a political, social, economic, and racial hierarchy.

Lomawaima and McCarty propose a theory that explains the inconsistencies of Indian policy and the greater societal web at work around it, suggesting that Native cultural activities such as the production of arts and crafts were tolerated because through domestication and neutralization they were rendered safe. This theoretical reasoning is the framework for my argument that arts and crafts in Indian schools were considered innocuous activities that could teach a disposition of mind, the appropriate Anglo-American work ethic, the ideal of self-sufficiency, and the value of time, money, and material goods. Voided of their intrinsic epistemologies and cultural baggage, Native arts and crafts were reconceptualized as one of the tools to prepare students to fit into the white dominant society. All three theoretical frameworks help me interpret and assess my contention that art education in American Indian schools was inextricably embedded in the political, cultural, social, and economic needs of the time. Pedagogy reflects the context in which it is proposed.

The laws of supply and demand typical of market economies help explain the dynamics of craft production in selected schools located in

areas where requests for Indian handmade objects were high.[7] As Indian rights advocates and policymakers realized the profitability potential of "authentically Indian" goods for consumer markets, educators did the same; training in Native industries was thus an instrument to provide students with sufficient skills to enter this consumerist circle and counter mass-produced artifacts upon graduation. This theoretical foundation justifies the localization of arts and crafts instruction, that is, the adjustment to local needs and the increasing market requests for particular goods. As a consequence, it is only logical that a school like Albuquerque, located near the center of Southwestern arts markets, would highlight instruction in pottery and weaving. Similarly, Sherman Institute, located in basket-famed California, would place more importance on basket making. Unfortunately, students learned techniques for making "Indian-looking" objects and not tribal-specific or authentic traditional crafts.

Between 1879 and 1902, the federal government ran 307 Indian institutions: 153 boarding schools and 154 day schools. For the purposes of this book, I use a case-study approach with a limited time frame, 1889–1915, and focus on two institutions. The time period corresponds to the years during the assimilation era in which art education as an instrument of colonization was part of the Indian Service curriculum. The Albuquerque Indian School and Sherman Institute were selected on the basis of their geographic locations—near tribes renowned for their artistic skills as well as in proximity to centers of arts and crafts revival and commercialization—and the multitribal affiliations of the student populations.[8] These are two factors of utmost importance in understanding how any particular boarding school complied with Reel's *Course of Study*, which Native industries were taught, and how.

The main focus of this work is an art curriculum imposed "from above" and an objective reality previously unaddressed: that drawing and Native industries *were intended* for the colonization of consciousness. As a consequence, Native perspectives do not take center stage. I do not assume or logically imply that Native students passively accepted government policies that aimed at the destruction of their own cultures; human nature simply does not work this way. In fact, any member of any human society, whether Native American, Irish, Chinese, Italian, or Lugandan, who feels

that his or her core beliefs and ways of life are being threatened, will react in more or less overt ways toward the oppressor. Children are not exempt from this reality; even at a young age, they can understand the difference between right and wrong, just and unjust, good and evil. Native pupils in boarding schools might have been unable to label what was happening to them as assimilation and cultural genocide, but they clearly perceived that not all of it was good. I have paid particular attention to highlighting Native voices and agency whenever possible; however, this has proven to be a difficult task, as they are not always present in the historical records.[9] Yet students' personal experiences sporadically emerge from the written records or can be "read" in some of the surviving photographs or original artworks. While authored by others (with the exception of the drawings), these sources are nonetheless invaluable for a more complete understanding of art education and its impact on students' lives in Indian schools at the turn of the twentieth century. Responses to the art curriculum are scarce, but not entirely absent.

Thus, despite minimal evidence, this work shows that students sought or employed any occasion the art curriculum provided to revive and perpetuate their own cultural practices. It was precisely the pupils' ever-present agency that led government officials to reconsider art education policies. I do not want to dispute or deny this objective reality; on the contrary, the glimpses included in my narrative whenever records are available attest exactly to this. I simply cannot provide abundant evidence of the acts of subversion and resistance that were without doubt occurring at Sherman Institute and the Albuquerque Indian School, in the same way that they occurred at every government-run institution, because the data are insufficient or nonexistent. This study, therefore, is inevitably incomplete and can illustrate neither the personal experiences of all Albuquerque and Sherman students nor the larger panorama of all government schools.

However, it is precisely because of the groundbreaking work of previous scholars such as Robert A. Trennert, K. Tsianina Lomawaima, Brenda J. Child, Devon A. Mihesuah, Jacqueline Fear-Segal, Matthew Sakiestewa Gilbert, and many others, that I can confidently and reasonably advance certain assumptions about students' agency, even when the evidence at my disposal is minimal.[10] Similarly, the concept of agency has been amply

examined by numerous anthropologists and historians of colonization in studies on the relationship between oppressors and oppressed, between institutional authorities and Indigenous societies. Scholars such as Pierre Clastres, Henri Lefevre, Franz Fanon, and Albert Memmi, among others, have shown us complex panoramas in which colonial regimes were regularly confronted with acts of resistance, adaptation, and cultural exchange, as well as of invention, appropriation, and self-determination, thus demonstrating that their "subjects" did more than unresponsively acquiesce to the newly imposed order.[11] By showing how something generally perceived as good—art—was used in an unjust way—for social and economic control—this work hopes to add another tile to the broader story of American Indian educational policies and, albeit in a minimal way, to the students' power of adaptation and resilience.

Art education in American Indian boarding schools did not originate in a vacuum but closely reflected the course of study of public institutions. This book therefore starts with a discussion of the art curriculum of public schools. Chapter 1 examines the development of nineteenth-century theories of art and education and their convergence into a common program of study that continuously redefined its goals, scope, and pedagogies in order to adapt to the political, social, and economic needs of the time. I explain first why art was considered the moral foundation for responsible and productive citizenship, the means to improve society through the development of each individual, and how these views turned it from a privileged activity for the few into essential training for the masses. Second, I explore the changing conceptions of drawing instruction: from an industrial art that connected the brain and the hand and taught accuracy, precision, and discipline to a freehand activity that cultivated taste and appreciation of beauty, and stimulated creativity and learning. Third, I discuss the introduction of handicrafts in public schools, the influence of the Arts and Crafts Movement on art education, and the role of practical activities in the development of manual skills and individual character.

Chapters 2 and 3 focus on art in Indian schools, drawing and Native arts and crafts, respectively. Chapter 2 examines the introduction of elementary drawing under Commissioner of Indian Affairs Thomas Morgan in 1890 and continues by analyzing the changes adopted by his successors,

ending with the 1915 course of study crafted by Cato Sells. Throughout, I consider how the transformations of the public schools' course of study and the changing views on Indian education affected the art curriculum of Indian schools. Chapter 3 makes similar claims by focusing on Native arts and crafts as they officially entered the curriculum through the 1901 *Course of Study* devised by Estelle Reel. The superintendent of Indian schools encouraged instruction in selected traditional art forms, purposely the ones most in demand at the time, to stimulate Indian economic self-sufficiency, but her goals also included satisfying market demands and imparting work habits. Reel's original manuscripts, her official reports to the commissioner of Indian Affairs, and other primary sources are analyzed to broadly illustrate how schools complied with her directives and included Native industries in their curricula.

Chapters 4 and 5 present case studies of the Albuquerque Indian School and Sherman Institute and are designed to illustrate how governmental policies of art education were implemented at the local level. I pay particular attention to how instruction was carried on and whether it was adapted to the local needs of the school and its student population. A discussion of the practice of exhibiting and selling students' works is also part of these sections. Chapter 6 focuses on the exhibition and sale of Indian students' artworks at national and international fairs. I consider major and minor events such as the Chicago World's Fair, the Louisiana Purchase Exposition, and the Pan-American Exposition, among many others. Indian schools contributed to the exhibits organized by the Office of Indian Affairs within the Department of the Interior and located in the Government Buildings, displaying samples of classroom and industrial work to demonstrate the progress of Indian children in their advancement toward civilization. The Indian school exhibits organized for the National Education Association meetings from 1901 to 1909 are examined in chapter 7 to illustrate the "products" of the art curriculum. The chapter concludes with a section on the sale of students' artworks at these expositions and within the perimeters of their respective campuses.

ABBREVIATIONS

AIS Albuquerque Indian School

AYPE Alaska-Yukon-Pacific Exposition

BIA Bureau of Indian Affairs

CSWR Center for Southwest Research, University of New Mexico, Albuquerque

LPE Louisiana Purchase Exposition

NAA National Anthropological Archives, Smithsonian Institution

NARA National Archives and Records Administration

NEA National Education Association

NIA National Indian Association, New Mexico

NWMAC Northwest Museum of Arts and Culture / Eastern Washington State Historical Society, Spokane, Washington

Art "Lifts Them to Her Own High Level"

Nineteenth-Century Art Education

> True democracy seeks not to drag down the highest, but only
> to lift up the lowest. So Art, entering the world of work is not
> thereby degraded but, stooping to the lowly, lifts them to her
> own high level; giving to homely uses divine significance.
> —Isaac Edwards Clarke, *Art and Industry*

> The commerce of any country depends on the style of its goods.
> When a nation falls behind in design, it falls in its commercial
> reputation. Hence it is more important to train its workmen
> than to drill its army.
> —Emma Woodman, "The Value of Manual Arts"

Education in the arts has been a component of American public schooling
since the 1850s, but the term "art education" was used for the first time to
refer to this branch of the curriculum in 1914 by Massachusetts educator
Royal Bailey Farnum; prior to this date, the expression existed, but it was
rarely employed by professionals and was only sporadically present in
the literature of the time.[1] The precedents for art education were clearly
distinguished as fine art and industrial or manual training, two activities
that targeted children of different social classes for opposite reasons. Fine
art was associated with picture making or fancy drawing and was a creative

exercise that upper-class children learned in private schools or from personal tutors as part of a liberal arts education. Its subject matter included still life, flowers, plants, and landscapes that were reproduced from drawing books, prints, or on rare occasions from real objects. Young men often practiced drawing in preparation for college admission or a professional career, while for women it was an essential leisure-time activity, an indispensable accomplishment to a proper upbringing in preparation for a good marriage. As middle-class women began to enter the teaching profession, starting in the 1860s, knowledge of drawing became a sign of culture and refinement and thus a valuable addition to one's personal credentials.

Industrial and manual training, on the other hand, initially included geometrical or mechanical drawing, which was officially introduced in the 1870s at the incentive of industrialists and manufacturers who needed better-prepared workers. About a decade later, more practical activities such as freehand drawing and the production of handicrafts entered the curriculum of American public schools through the kindergarten theories of German pedagogue Friedrich Froebel (1782–1852).[2] These "applied arts" were taught to children coming into the common schools from lower-class, rural, or immigrant families with the goal of preparing them for work in the home, the farm, shops, and the factory. Both geometrical or mechanical drawing and applied arts were considered activities that could develop manual skills and ultimately enhance the quality of labor. Nineteenth-century art education, therefore, consisted of two types of instruction that satisfied diverse societal and economic needs: personal refinement and leisure activity for the upper classes, and skills improvement for the working classes and for immigrants.[3]

The necessity for arts instruction, whether for picture making or industrial training, was grounded in nineteenth-century philosophies of art and education that saw drawing, and thus art, as the foundation of morality. Since Plato, art had always been considered the work of virtuous individuals because of its intrinsic ability to engender a good disposition as well as sentiments of awe, wonder, and appreciation of beauty as a manifestation of the divine; for this reason, it was regarded as an ennobling and uplifting activity that inspired virtuous principles, thoughts, and ultimately conduct. James Jarves, an American disciple of John Ruskin, the English philosopher

and proponent of the Arts and Crafts Movement, wrote that "art was the spiritual side of civilization" and was "necessary to meet spiritual hunger for beauty, to influence the religious faculty, to refine the people, to expand and exalt intellect, and to correct manners and morals."[4] According to another mid-century American art educator, James Mason Hoppin, art would "promote intellectual development" and "foster kind feelings and good manners," while Charles C. Perkins, a Boston art critic and a committee member of the Massachusetts Normal Art School, maintained that in learning art we "widen the circle of our intellectual pleasures, quicken the better part of our being, and, through the contemplation of noble objects fill our minds with elevated thoughts."[5] It was a common belief throughout the nineteenth century that art had the potential for moral uplifting, for improving a person as a single individual and, consequently, as a member of society. From midcentury, however, the role of art in the education of the American people changed as new rationales closely tied to the social and economic climate of the time emerged.

Art Education for All: The "Art Crusaders" and Horace Mann

Art was taught in private academies for elite and middle-class children as early as the 1820s; lower-class citizens and immigrants, however, did not have access to this training until midcentury, when artists and educators advanced two new theories about the importance of art in the education of all citizens. The first idea was promoted by the so-called art crusaders, a group of artists that included John Gadsby Chapman, Rembrandt Peale, and Benjamin Coe, and centered on the concept of a democratic art, that is, an art that could be enjoyed and learned by all individuals, independently of their social and economic status. The second theory, advanced by Massachusetts educator Horace Mann, emphasized the influence of drawing on the improvement of other abilities, particularly industrial skills. Both conceptions saw instruction in art, specifically drawing, as a valuable talent that could develop not only personal character but also the power of seeing and doing.[6]

The "art crusaders" believed that in a modern and advanced country like the United States, art needed to be made available to everyone and its benefits extended to all, both men and women, rather than be treated as an

enjoyment reserved solely for and appreciated only by elites. Their fear was that if art remained a prerogative of rich young women trained in affluent finishing schools, they would become the trendsetters dictating style and taste in American society; this was antithetical to the country's democratic ideals of liberty and equality. The common people, especially members of the lower classes, could obtain the greatest advantages from learning art because its production and appreciation could lead to an amelioration of character and senses: men could be transformed "from insensitive workaday creatures into positive receptors (if not creators) of the beautiful," while women could "have a healthy influence on [their] children."[7]

Additionally, the crusaders thought that knowledge of drawing was the means for refining not only the people but also the quality of their work; women could beautify their homes by making articles "of taste and fancy," factory workers could more efficiently operate machines, and artisans could make better and more valuable handcrafted products.[8] This acquired ability to discern and appreciate beauty was fundamental to America's attempts at asserting her material progress and establishing herself as an international cultural, economic, and political power. Art, therefore, could improve individual character, bring forth a more refined generation of citizens, provide a better livelihood for skilled workers, and contribute to the economic well-being of the country.

According to the crusaders, the most democratic way to teach art to the masses was through drawing manuals that could be used for independent learning, thus eliminating the need for attending classes at expensive private institutions or hiring tutors; education was to occur at one's own pace and leisure. The problem was the lack, or the inadequacy, of publications suitable for teaching, and while Chapman, Peale, and Coe had firsthand knowledge of art, they had neither familiarity with nor background in art educational practices. This, however, did not deter them from their goal. As they discussed the best practical approaches to art instruction, their ideas were soon fashioned around two well-established and complementary art theories. The first stated that knowledge of drawing helped develop an appreciation for old masters and, ultimately, for beauty and truth. Great artwork from the past was the first step toward seeing the splendor of nature, which, as the eminent manifestation of the divine origin of things, was the

source of truth. The second theory affirmed that the act of observation was closely tied to moral education. The accurate vision acquired through a sensible perception of beauty was the foundation of rectitude and morality and was indispensable for leading a principled and prosperous life. The method proposed by the crusaders thus emphasized the importance of drawing as the foundation of seeing, and seeing as the basis of morality; they saw art education as the way in which less-cultured Americans could develop this power of observation in order to attain "clarity" of sight and learn the proper ethics of the dominant society.

The crusaders' ideas were also largely influenced by the writings of Swiss educational philosopher Johann Heinrich Pestalozzi (1746–1827). An educational reformer working in Switzerland, Pestalozzi was a fervent critic of the educational methods of his time; he disapproved of mechanical learning through drills, repetitions, and harsh discipline because they impeded the child's natural abilities and mental development. Instead, he advocated a philosophy that centered on three main tenets: the power of women educators, the fundamental role of nature, and the connection between training and life after school. He firmly believed that because of their natural disposition to love and nurture, women were the best educators, particularly a child's own mother, and that children learned best through personally observing, experiencing, and sensing their surrounding reality. He was also convinced that education should prepare pupils for the lives they would lead after school and thus be relevant and connected to an occupation or profession. This pedagogical approach was recognizably captured in his motto—to educate the head, the heart, and the hand—a dictum that was to be adopted by late nineteenth-century American educators.[9]

Pestalozzi dedicated only one book to the subject of drawing, but it is from this volume, ABC der Anschauung, written with a teacher colleague and published in 1803, that the crusaders derived most of their pedagogical notions. For Pestalozzi, drawing was "a means of leading the child from vague perceptions to clear ideas" in that it allowed him to more clearly see each form present in nature as part of a greater whole, rather than as isolated elements.[10] As a result, he suggested teaching drawing in a very structured and sequential manner that started with basic principles

of straight lines, progressed to vertical and oblique lines, and ended with curves. He advised teachers to draw on the board and let children copy and practice until they learned how to correctly sketch the sequences presented. After these steps had been grasped, students could draw objects by using a combination of these lines and basic forms.

The crusaders' theoretical ideas about art and Pestalozzi's blueprint of fundamental drawing principles were combined into drawing manuals such as *Easy Lessons in Landscape Drawing* by Coe (1840) or *The American Drawing Book* by Chapman (1847). These books proposed a methodology that moved progressively from simple exercises with lines (straight, curved, angled) and geometrical figures to more complex pictures in perspective, landscape, and finally the human body. This step-by-step teaching approach ensured that all learners mastered the primary elements of drawing before venturing into depictions of more elaborate natural forms; and in order to do so, it included systematic instructions that guided the novices through every step of the process. For example, when it came to drawing straight lines, all manuals directed the student to start by fixing random points along a ruled faint line and then connecting them together from left to right and vice versa. Similarly, curved lines had to be drawn by sweepingly linking points marked along two parallel ruled lines. These marks exemplified the educative power of drawing for they were the "products of a disciplined mind directing a trained hand, not a spontaneous expression of uncontrolled inspiration"; consequently, manuals contained numerous and tedious exercises on these important steps.[11] The order of learning was essential, because if a foundational element was missing, the others could not be studied and practiced. Also, according to crusader Rembrandt Peale, correct and sequential learning allowed one "to obtain and cultivate a *correct vision*," which was imperative. Students were taught "*how* to see and *what* to see" through basic compositional principles to be applied to the drawn objects, whether persons, a landscape, or still life.[12] This insistent emphasis on order, rationality, and adherence to geometric style rules further testifies to the perceived role of drawing as a democratic art—something that anyone could do by simply following directions—and an instrument for teaching discipline and thus morality, as it could improve any person and character.

Drawing manuals marked the first step toward a democratization of art, soon becoming very popular and being published in high numbers; by 1860, more than 145 manuals penned by different authors were in print. Confident that this popularity would open the doors to the teaching of art in common schools across the country, the crusaders made several attempts to officially introduce drawing in Massachusetts and in the cities of Philadelphia, Baltimore, and Cleveland, but their pleas fell on deaf ears. Despite their concerted efforts, drawing manuals were never adopted as textbooks during their lifetime. Many school administrators, in fact, were reluctant to make drawing a part of their school curricula because they did not see the usefulness of this instruction for a lower-class student population; in their eyes, drawing was still a fine art and, as such, it had no relevance in the lives of future workers and manual laborers. An official rejection of drawing at the higher levels of the educational bureaucratic machine did not mean, however, that this subject was completely absent from public education; more and more teachers, in fact, began to propose it in their own classrooms and follow the steps outlined by the crusaders.

Similar attempts at introducing formal education in drawing were made by Massachusetts educator and advocate Horace Mann, one of the leading figures in the establishment of the Boston common schools. Mann's favorable attitude toward drawing was based on three main arguments: first, drawing could improve children's handwriting; second, it was an essential industrial skill; and third, it was a moral force. These ideas mostly matured during an 1843 trip to Europe and after an observation of schools, hospitals, and other public institutions in England, France, Belgium, Switzerland, and the German states. Mann was particularly struck by the Prussian educational system and by the close connection between penmanship and drawing that was emphasized in its institutions; he attributed the excellence of the students' handwriting "in a great degree to the universal practice of learning to draw, contemporaneously with learning to write."[13] He concluded that children learned to write sooner and more easily if they already possessed knowledge of drawing because their eyes had already received training in observation, recognition, and imitation, that is, in skills that could later be applied to writing.

In addition to facilitating writing and penmanship, Mann conceived of

drawing as an "essential and indispensable" art for any workingman or -woman; in his view, in fact, it could be applied to any kind of work, for example plotting a field, sketching a road, outlining a machine, building a piece of furniture, or even designing the structure of a house. As a result, drawing was a skill that every worker had to know: it developed the "talent of observing" and was useful to any condition in life.[14] Lastly, Mann believed drawing to be a moral force in that it conferred on the person a new sense of reality by which he was enabled to better perform his duties in life, be more serviceable to others and thus society, and finally be more appreciative of the beauty of God's creation. Such development of the senses, complemented by proper moral and religious education, made art instruction "a quickener of devotion," a powerful instrument for the instilment of piety and zeal.[15] One could see how the faculties acquired through training in drawing would contribute to an overall enrichment of the individual and, consequently, to his or her adult participation in society as an intelligent and productive citizen.

Unfortunately, antebellum American society was not willing to accept that schools should provide such enrichment for all citizens, or that the poor could or should be enabled to acquire "the culture of their 'betters.'"[16] Drawing belonged to the realm of the upper and privileged classes and was a distinctive mark, among others, of refinement, high culture, and wealth. Members of the elite society favored and supported the education of the lower classes as an instrument for moral indoctrination and for the inculcation of values and beliefs that would guarantee the maintenance of social order and privileges; instruction in drawing, however, was strongly opposed because it could lead the poor to advance their status and thus challenge the existing hierarchy and social establishment. Because of these views, held by the ruling minority, drawing was not allowed into the curriculum of public schools and Mann's efforts were soon dismissed. It was not until the Reconstruction years that the debate on the role of art in education reopened as industrialists and business people realized that drawing, particularly geometric or mechanical drawing, could in fact serve the economic needs of the country by providing the skilled hand-training necessary to ameliorate the quality of manufactured goods. Drawing then came to be seen as a necessary talent for the future well-being of the nation.

The Industrial Drawing Movement and Public Education

In the fast-growing industrial expansion that characterized the post–Civil War years, the main reasons behind this new openness to art instruction were economic, driven by the realization of the inferior quality of American-made goods—and thus the competitive advantage of foreign-made products in international markets—and the necessity of raising new, efficient generations of trained workers. As the United States was establishing itself as a great economic power, the quality of its manufactured goods had to surpass Europe's, which meant that laborers had to be better trained in the particular skills required by their profession. Public education was one solution to this problem and mechanical drawing one of the means through which its goal of preparing youth for the workforce could be accomplished.[17]

The first state to require the teaching of drawing in public schools was Massachusetts, which led the way by passing "An Act Relating to Free Instruction in Drawing," also known as the Drawing Act of 1870. This legislation assured the right of "training in art" to every school child and established evening schools in drawing for adults.[18] Maine, New York, and Vermont soon followed by enacting their own drawing legislation, respectively in 1871, 1875, and 1876, while Pennsylvania redesigned its existing school curricula. These laws and educational reforms stemmed from increased pressure by factory and business owners who realized that "in all industrial arts this nation was in danger of relative inferiority" and thus deemed drawing a necessity in the "training of the hand and the eye" that was indispensable for the manufacture of competitive products on international markets.[19] According to William Bartholomew, a teacher in the Boston public schools and supporter of the Massachusetts Drawing Act, drawing was also important in that it "cultivated the habits of neatness and accuracy," which were necessary in the disciplined execution of any type of manual job.[20] Students trained in the use of the pencil and the slate learned to be observant, organized, and precise, and this would eventually allow them to better perform the menial, semiskilled, and skilled tasks required in the work environment they would later encounter.

These sentiments, shared by many other concerned citizens, particularly

in the industrialized northeast regions of the country, arose in the aftermath of the Paris Exhibition of 1861 and became more pressing after the Philadelphia Centennial Exposition of 1876 where, for the first time, the American people observed firsthand the superior quality of foreign-made wares, goods, and textiles. Symbols of cultural and national development, these manufactures were a source of pride for their citizens. If the United States was going to live up to its image as a leading nation in innovation and opportunity, Americans had to be better prepared and more competent in their fields. Writing about a decade later, Isaac Edwards Clarke of the Bureau of Education vividly remembered this national "awakening":

> The citizens of this model republic, with all their boasts and all their free education of the people, were far inferior to the leading nations of the world, European and Asiatic, in all those industries into which the art element enters; and for the first time in their history, the American public had an opportunity to see into how vast a portion of the production of man this element does enter. . . . What England has done, we can do, and it shall go hard with us if we do not better the instruction.[21]

Late nineteenth-century supporters of drawing clearly pushed for a utilitarian and industrial form of art education that was justifiable only in as much as it served the needs of the American economy in the refinement of its workers' skills. The overall concern was practical use, not style or beauty of design. As a result, schoolchildren simply needed to learn basic techniques and their precise and accurate application.

One of the most important outcomes of the 1870s Industrial Drawing Movement was that on a theoretical and philosophical level it cemented the separation between fine and industrial or applied arts.[22] The first undoubtedly belonged in academies and art schools where artists such as painters, sculptors, engravers, and architects were, according to Clarke, prepared for "the actual production of works of high art" and their promotion to the public. This type of art—a product of the intellectual and emotional nature of man—was not for the average American, but for the few gifted individuals whose innate abilities were the sign of artistic genius. Industrial or applied arts, on the other hand, were more fitting to public education, for they encompassed "all matters relating to the technical

Art "Lifts Them to Her Own High Level"

industrial producing arts and artistic industries."[23] Industrial arts, which accompanied men and women in their everyday lives and pursuits, were thus deemed more appropriate for the masses because they entailed the acquisition of rudimentary techniques and skills that could be obtained through a suitable education in the classroom or through apprenticeships. Thanks to this new conceptualization of art, drawing now came to be seen as an activity that had nothing to do with self-expression, individual creativity, or personal refinement, as the art crusaders had proposed; it was a necessity for life and thus it had to be taught to every child.

Educators soon understood the potential of drawing for positively influencing the learning of other skills such as reading, writing, geography, arithmetic, geometry, natural sciences, and languages, something Horace Mann had already highlighted a few decades earlier. Professor Langdon S. Thompson of Sandusky, Ohio, powerfully explained the connection between drawing and other school disciplines in his speech "Some Reasons Why Drawing Should Be Taught in Our Public Schools," delivered at the 1877 meeting of the National Education Association (NEA), in which he defined the development of artistic skills as "the handmaid" to all others subjects. After minutely enumerating the specific advantages drawing could bring to the study of academic subjects, as well as to the performance of manual works, Thompson concluded that these "are much more readily learned by those who have had the eye and attention cultivated by a systematic course in drawing." Drawing, therefore, was recognized as an indispensable foundation for the intellectual growth of the individual because it cultivated attention, close and continued observation, reason, and perception. Once the exercise of these faculties had become "a fixed habit of the mind," they would be automatically used in every circumstance of man's daily life to his great advantage.[24]

The economic necessity of industrial drawing, in its power to develop the hand and the eye and its benefit to overall learning, was what prompted the artistic and educational reform movement of the time. In order to add drawing to the curriculum of public schools, a revision of their course of study and the textbooks adopted was crucial. The existing drawing manuals, designed by the art crusaders, were not suitable for this new concept of art education, because they promoted art as picture making and thus as

an accomplishment. What was needed now was, instead, the application of artistic principles to industry so that students could be prepared for any form of manual labor. The solution to this problem was found in the drawing books authored by Walter Smith (1836–86), a British art educator trained at the National Art Training School of South Kensington, the first nonartist to pen this kind of manual and the first one to write with the goal of transforming drawing from a democratic art to industrial instruction.[25]

Smith's program of study, outlined in the volume *American Text Books of Art Education* (1873), was based on the South Kensington system and consisted of progressive stages of learning that moved from the foundational level of drawing to pre-professional training. This methodology, however, was not completely new because, like that of the crusaders, it deemed geometry as the basic, original tenet. According to art and education scholar Harry Green, students "followed a sequence that aimed at developing muscular control and accuracy of delineation before attempting originality, a quality Smith valued but felt should be an end result, not a concomitant."[26] Instruction began in the lower grades with simple lines (straight, curved, broken, continuous, parallel, etc.) and continued, as the students advanced, with more difficult exercises that entailed geometrical drawing, solids and constructional figures, map drawing, freehand copying, freehand drawing of models and objects, memory drawing, and ornamental design (adaptation of natural forms or historical ornaments), all of which could offer pre-professional training. These studies were based on principles of repetition and symmetry that did not allow for personal creativity and inventiveness. Lessons in color and perspective were given exclusively in the higher school when the mind had already been trained in discipline and accuracy of execution. Overall, Smith's pedagogy was built on the conviction that art education needed to mirror science, that is, it had to employ a sequential methodology through which a uniform competence could be taught to and achieved by all. It was not long before geometric drawing formally entered the public school classroom and was taught to all children of the middle and lower classes as they prepared for a future in the workforce.

Yet despite its emphasis on industrial training, Smith's approach did not last, as it was considered too rigid and lacking in individual freedom of expression. Hence, while laying the foundations for art education in

Art "Lifts Them to Her Own High Level"

American public schools, his ideas were soon discarded for more progressive ones.[27] According to historian of art education Mary Ann Stankiewicz, aesthetic factors were now in conflict with the practical values advocated by industrialists through their proposal of a merely industrial art education. As the social, intellectual, and economic conditions of the country changed, children needed to be instructed in a type of art that not only perfected their hand skills, but also cultivated their creativity, sense of taste, and appreciation of the beautiful, and allowed them to develop their mental faculties in order to become not simply industrial producers but good artisans and consumers. This is why, by the mid-1880s, the importance of mechanical drawing started to wane and new, creative art activities began to appear; these undertakings soon became indispensable for success in an industrial and increasingly consumption-based economy.[28]

If Smith's rigorous approach to drawing instruction was deemed insufficient in preparing America's future labor force, its simplicity, rationality, and sequential nature were considered particularly appropriate for the education of immigrants and eventually American Indian children; these types of learners especially needed to cultivate their undeveloped and "poor" power of seeing if they were to become productive citizens, and the drawing methodology Smith proposed could improve uncultured habits into more skilled and efficient ones. It is this reasoning about the role and value of drawing that would be used by Thomas Morgan in his *Rules for Indian Schools*.

The 1880s and '90s: Changing Views on Art Education

The addition of industrial drawing to the curriculum of public institutions was the first step toward a more practical education, but it was insufficient to change the nature of schooling. As a matter of fact, while schools tried to respond to manufacturers' demands for better practical skills, the overall nature of public education was still too literary and book centered; drills, memorization, and recitation continued to be the centerpieces of teaching methodology and classroom practice. Calvin M. Woodward, a professor at Washington University in St. Louis and one of the most outspoken critics of the contemporary curriculum, accused schools of teaching only "extravagant notions" and useless cultural studies that had no practical

utility in the life of the masses and claimed that "hands without brains are as worthless as brains without hands."[29] The introduction of manual training in the 1880s marked the beginning of a radical change in the purpose of all public education, while the new ideas brought forth by progressive educators transformed classroom pedagogy.[30] Teachers now placed emphasis on the connection between mental and manual development, work and play, education and life in the real world of the shop, the home, or the factory. As a consequence, important changes also occurred in the context of art education.

By 1885, educators were distancing themselves from industrial drawing as national interests shifted from the purely industrial to an aesthetic value of art applied to industries and from a purely mechanical type of drawing to a form of art that allowed more personal creativity and expressive freedom. Three main factors influenced this new approach to art education: the destabilization of societal moral order due to increased urbanization and the need to develop the masses' sense of taste; the influence of the Arts and Crafts Movement; and the discipline of developmental psychology. The newly established Art and Industrial Art Department (1884) at the NEA annual meeting became the main venue for the exchange of ideas on current pedagogical trends.

Destabilization of the moral order and overall decay of society were brought about by the rapid industrial growth that characterized the Gilded Age. As urban centers increased in size and industrial power, they attracted masses of new factory workers, including women, children, and immigrants, who, for the most part, lived in poor, cramped, and often unsanitary conditions at home while facing alienation and fragmentation at work. Social reformers and educators sought to address these problems by calling for a social uplift through training in art as a means to bring beauty into the lives of the masses. On the one hand, art could kindle a desire for the beautiful, thus influencing not only one's work but also the longing for pleasures and enjoyments; on the other hand, it could strengthen moral character and make citizens aspire for better living circumstances. As the art crusaders had stated decades earlier, the proper way of seeing came from a proper art training.

Another important social justification for art education that was tied to

this idea of the uplifting of the masses was its power to alleviate the harsh conditions of factory work. By promoting art as "an idealization of industrial labor," educators and reformers tried to increase the dignity of work by elevating its status.[31] This new conception of art resulted from the influence of the Arts and Crafts Movement, an aesthetic response to the social changes brought about by industrialization and the mechanization of labor. According to John Ruskin (1819–1900) and William Morris (1834–96), industrial labor had become so fragmented that workers did not create a whole product but only a part of one; this labor specialization generated a division between the designer and the maker of goods and devalued the quality of a product, which could no longer be considered handcrafted. An artisan, on the other hand, conceptualized the finished piece as well as controlled the entire production process. The individuality and quality of a manufactured article could be restored only by returning to the handmade process.

Moreover, while the mechanization of labor caused a sectionalized creation of goods, it also separated the hand and the head in that workers no longer had to think about the finished product. According to art historian Wendy Kaplan, Ruskin believed that factory work had "disturbed the natural rhythm of life, that it turned once creative craftsmen into mere cogs in the wheel of machinery so that like their products, they lost uniqueness," thus becoming "anonymous laborers."[32] The repetitive routine of their detail-oriented and now unskilled tasks did not engage their person and thus did not facilitate the development of moral character or creativity. In Ruskin's view, only a reintegration of art and labor could engender a moral reawakening. The Arts and Crafts Movement aimed at restoring the worker to the status of skilled artisan and his or her product as handcrafted by introducing art into everyday life and activities. This would ultimately lead to a reform of society because lower-class people would be brought to desire a betterment of their own living and working conditions.

Development of taste and appreciation of the beautiful through art education would thus bring another essential contribution to the American economy: the ability to make better and aesthetically pleasing goods and products. This function of art had already been considered in the world of education; in 1880, for example, Commissioner of Education John Eaton wrote of a "great awakening of the people to the value of taste

as an element of manufactures and to a knowledge of the many possible applications of art to industrial products."[33] However, the acceptance of art in its practical application to industries had been slow. Now, thanks to the social reformers' plea against the dehumanizing conditions of factory work and the influence of the Arts and Crafts Movement, who called for "art for life's sake," the worker began to be seen as an artisan and art as more than technical drawing. Isaac Edwards Clarke, author of the 1885 government report *Art and Industries*, wrote that art applied to industries—industrial art—was "the wedding of Use to Beauty," the "application of the principles and methods of art to objects of practical utility," that is, the production of functional yet attractive and well-crafted items that satisfied consumers' needs and demands for material culture.[34] Industrial art was a very broad category that included textiles, needlework, ornamental painting, furniture and wood carvings, jewelry, glass, and pottery, but also carpentry, masonry, blacksmithing, and dressmaking.

Drawing was considered the basis of any industrial art, the fundamental skill that needed to be mastered in order to become a good artisan, mechanic, carpenter, engineer, or simply a homemaker, because it could improve the power of perception, careful observation, and thus appreciation for the beautiful. According to James Macalister, president of the Drexel Institute of Art, Science, and Industry, true art education should recognize the mental powers of creativity and observation as its starting point and should seek to "stimulate and direct them so that they shall act and react on each other, and result in the creation of beautiful things, not so much for the gratification of selfish or individual desires as for giving joy to others."[35] Without the development of mental faculties that drawing could afford, any artisan would be but "a superior kind of photographic machine" and his or her work not any different than mass-produced goods.[36] The argument previously postulated by art crusaders and proponents of the Industrial Drawing Movement—that drawing was a necessary means for training the eye and acquiring the proper sense of vision—was now renewed and adapted to embrace the current views of industrial art.[37]

Taste acquired through training in art was therefore indispensable from an economic perspective when directed to manmade objects. For the lower and middle classes, this did not imply the ability to appreciate

the old masters, like the art crusaders had wanted, but simply to recognize quality in order to become better makers and consumers of manufactured goods. As the country produced more, in fact, it was also compelled to sell more, in overseas markets as well as at home. People had to be educated not only in creating, recognizing, and appreciating handcrafted, quality products; they also had to be enticed and encouraged to purchase them. Charles C. Perkins, a Boston art critic and a committee member of the Massachusetts Normal Art School, had said years earlier at the annual gathering of the American Social Science Association:

> It is with taste as with morals: if we live carelessly in the midst of a corrupt society, we little by little lower our standards, and come to look with complacency upon things which formerly shocked us inexpressibly; so if we live with bad pictures and statues and ugly furniture around us and neglect to remind ourselves daily how defective they are, we run great risk of growing content with them.[38]

Members of the less-advantaged classes had to be shown the defective nature of their living conditions and encouraged to aspire to and enjoy the beautiful so that they could imitate the upper classes "in purchasing goods with the correct look and style."[39] The educational transformation in recognizing and economically supporting quality, and the acquisition of a sense of taste through instruction in drawing, would further serve the needs of the emerging industrial and capitalistic society. Despite the intent to improve the workers' taste so that they could ameliorate their living conditions, art *was* still an instrument of social control. Lower- and middle-class citizens were encouraged to emulate the wealthy, but were not educated to become their equals. Art for the masses, in fact, was not envisioned to make people think about "what was right or wrong, good or bad, just or unjust"; it was simply to help them become better consumers and recognize "what was right and good *in present society* [emphasis added]."[40] This was particularly true for minorities such as African Americans, Native Americans, and immigrants.

The fourth major factor that changed the purpose and practice of art education at the end of the nineteenth century was the new field of developmental psychology, a growing, academic discipline that afforded additional

knowledge of the phases of human development and thus learning.[41] According to psychologists of the time, the child was a natural artist whose evolution and self-expression progressed from a primitive to an advanced stage; as he matured physically and mentally, so naturally did his artistic abilities. The child was also an active, inherently good learner who could be best taught when all his faculties and senses were stimulated through personal experiences with reality and, consequently, when schooling was connected to life. The progressive education movement was grounded in these new understandings of the child. Its main pedagogical tenets centered on the idea of less-rigid, child-centered learning experiences that could kindle the child's natural impulses to investigation, expression, and creation; its curriculum included nature study, object teaching, and practical manual training, all of which used art as an invaluable learning tool. The greatest influence on the methodologies used in art education during the last decades of the century came from the Child Study Movement, started in 1880 by G. Stanley Hall and his investigation of children's minds through drawings. Because of this and psychologists' fascination with, and interest in, children's drawings, educators began to believe that the best way to "teach" art was by not interfering with individual creativity and by simply encouraging children's natural inclination to self-expression.

The new ideas that arose in the field of art education, particularly in the aftermath of the Arts and Crafts Movement and the Child Study Movement, had two major consequences: first, recognition of the need for new methodological approaches to teaching drawing; second, the introduction of arts and crafts in schools. As the schematic methods of industrial drawing instruction suggested by Walter Smith now appeared to be obsolete and inadequate, real innovations came from the series of volumes published by Boston lithographer Louis Prang and authored by educators John B. Clark, Walter Perry, and Mary Dana Hicks. These books, commonly referred to as the Prang course or the Prang series, included *The Use of Models* (1887), *Shorter Course in Form Study, Drawing* (1888), and *The Prang Elementary Course in Art Instruction, Books 1–12* (1898). Largely influenced by the kindergarten theories of Friedrich Froebel, they emphasized, for the first time, a pedagogy that centered neither on fine nor industrial art but on the child and her natural development of senses and perception of forms. The

Prang publications were based on the principles that training in drawing could happen if all senses were cultivated and perception of form came from real life rather than models. As Mary Dana Hicks wrote, the goal of the books she coauthored was "cultivating the power to think clearly from both observation and imagination, training students in the decorative arts for both spiritual and practical service in daily life, and 'educating the taste of a whole generation of children.'"[42]

In the classroom, this meant that students were not forced to follow a rigid and sequential curriculum of straight lines, curves, and angles, but were allowed more individual freedom and personal creativity; they were encouraged to play with blocks, make shapes with clay, experiment with paper cutting and folding, and draw freehand, so that they could develop all their senses while learning through trial and error. The basic skills learned through play with forms and shapes, drawing, and freehand sketching were later applied to the next level of craftsmanship—manual training—with the ultimate goal of mastering them for use in a professional or vocational life outside of the school. While these activities trained manual dexterity, they also meant to strengthen the coordination between head and eye, thereby ensuring attention, precision, and neatness, faculties that were extremely valuable in the practical training of future industrial workers as well as in the overall education of children.

The Prang books were the ideal instrument for teachers because, as Stankiewicz points out, they moved beyond mere industrial drawing to embrace "representation, decoration, construction, form study, and color, all based on contemporary psychological theory about sensory learning and the value of self-activity."[43] While construction mostly included those advanced skills in mechanical drawing needed in male professions such as carpentry, masonry, architecture, city planning, and engineering, representational and decorative skills were needed for female occupations in the realms of arts and crafts, that is, activities like needlework, making and decorating household objects, book illustrating, and dressmaking.

Arts and Crafts in the Curriculum of Public Schools

Instruction in arts and crafts presupposed knowledge of basic drawing skills applied to material objects and refined through taste for purposes of

construction, ornamentation, and decoration. Because crafts were associated with the more primitive stages of human development—as part of the natural progression from uncultured to more advanced and refined ones—young learners were thought to be particularly predisposed to them. Thus, as children learned through creative exercises that progressively increased in complexity, they also advanced along a social developmental path that would ultimately lead them to improve their living conditions as adults. According to Lillian Cushman, a late nineteenth-century art teacher from Chicago, crafts had always proceeded from the utilitarian to the aesthetic and, if properly developed, they had the power to "help the individual to eliminate the worthless trash, and enable him to simplify and elevate the standards of his life."[44] Because they facilitated a natural advancement of the individual, crafts were a desirable part of the school curriculum; whether it was "pottery, textile, wood, or metal work," their instruction had a value in the "development from primitive conditions through its various evolutionary stages *ending in the factory* [emphasis added]."[45] For Cushman and many of her contemporaries, the evolutionary social ladder for lower- and middle-class citizens unfortunately ended on the floor of an industrial plant; men and women's natural progression toward a more refined taste, in fact, had to serve the needs of a capitalistic society, not of the individual person. It is not a coincident that this same belief was one of the rationales behind Estelle Reel's inclusion of arts and crafts in the curriculum of Indian schools.

Like Cushman, many educators, arts and crafts promoters, social reformers, and philanthropists of the time identified these "primitive conditions" in past civilizations, such as the Egyptians, but also in the crafts of the Appalachians and of American Indian people. These handiworks were seen as "a source of authentic experience," because they could bring their makers closer to the natural world and thus more in touch with a simple, real life.[46] American Indians embodied the primal experiences working people were craving, and their basketry, pottery, and weaving were conceived as "natural activities" through which this primitivism could be lived. Native communities exemplified the Arts and Crafts ideal of "art that is life" because their works were not separated from life but rather permeated every aspect of it; it was this interconnectedness that non-Natives hoped

to experience. According to Kaplan, this "nostalgia for the handicrafts of a preindustrial period," the possibility of both helping the underprivileged and living a simple life, drew many upper- and middle-class women to become advocates for the preservation and salvage of these arts.[47]

Notwithstanding the goodhearted concern for the developmental well-being of children, one of the main reasons for the promotion of arts and crafts in public schools, and later also in Indian schools, remained social improvement and control, now veiled as therapeutic benefit. If the production of handicrafts had been recommended for adults because it could offer relief from the pressures of modern life and an industrialized society and would bring creativity and originality to the repetitive tasks of manual work in the home, factory, or shop, it was even more efficacious when encouraged at a younger age. Arts and crafts, in fact, not only would add pleasure and play to children's learning experiences during their school years, but would also acquaint them with the benefits these activities could bring to their personal lives. Consequently, if arts and crafts provided "personal rejuvenation" for the maker, they were an ideal activity for the leisure time, particularly for young girls who could learn to make effective use of their idle moments. Sensible employment in arts and crafts ultimately encouraged character building and feminine identification with ideals and principles such as order, cleanliness, docility, dependence, industriousness, and "love of home and family," virtues that were associated with social improvement and the cult of domesticity.[48] By refining young women's characters and work ethics, arts and crafts worked "from below" to ameliorate the quality of the lower strata of society.

Arts and crafts, or applied arts, entered the curriculum of American public schools through kindergarten projects extended to the higher grades; progressive educators greatly valued Froebel's methods as they facilitated a correlation of school and everyday life. According to Froebel, in fact, learning could not happen without personal experience and self-discovery, that is, through doing—an educational motto that was later adopted by John Dewey and repurposed as "learning by doing." Children needed to be personally involved in the learning process, and thus experimenting, seeing, and touching with their own hands had to be an essential part of the method. Froebel had designed a series of "gifts" or "occupations" through

which a more comprehensive sensory training could be imparted and it was these gifts that progressive educators now introduced. They included a box with six colored woolen balls; a wooden sphere, cube, and cylinder; cubes divided into smaller cubes or other geometrical shapes such as the parallelepiped; geometrical shapes of contrasting colors and materials; sticks and rings; drawing on slate and paper; sewing with colored threads; paper activities such as cutting, folding, perforating, and braiding; clay modeling. These basic pursuits could train the head and the hand and thus prepare children for gendered professions in manual trades.

Additionally, these classroom activities matched a child's psychological, physical, and sensory development, beginning with more elementary exercises and ending with "present methods of manufacturing" as proposed first by Froebel and later by progressive educators.[49] Thus, all children were employed in paper crafts, play with blocks and clay, design from real models in nature, and basic sewing; eventually, they moved on to gendered crafts such as needlework, basketry, and weaving for girls, and furniture making and decorating, jewelry, bookbinding, and glassmaking for boys. Even the "advanced" crafts were learned in stages, going from simple activities to more complex ones in order to follow the natural progression of the children's skills. For example, in weaving, one of the primal race occupations, according to Froebel, and, consequently, a necessary training, girls were taught to make the following: pot holders and mats in the first grade; pot holders and mats with more complex designs and small bags in the second grade; silk mats and scarves or wool rugs in the third and fourth grades; small rugs, pillow covers, and rag rugs in the fifth and sixth grades; pillow covers for couches, strips for bags, and purses in the seventh and eighth grades. These articles, suggestions for Christmas work by an elementary-school teacher to the readers of the homonymous journal, took into account the developmental theories of the time and the need to connect school and life.[50]

Similarly, boys were initially trained in knife work in wood and little by little moved on to make "simple equipment such as benches, cabinets, etc." in the fifth grade, iron work in the sixth, and carving in low relief in the seventh, in preparation for detailed work on both furniture and iron ornaments.[51] Starting in the fourth grade, boys were also taught sheet

construction and design, which consisted of applying their knowledge of design to the making of items of increasing difficulty such as pencil cases, match cases, pen wipers, candy and ice cream boxes, rails, and fences. The precision acquired through these practical activities could have also been applied to jewelry and other kinds of metal work such as enameling and inlaid. The progression of this manual training aimed to turn the skills from craft into artisanship.

There were no arts-and-crafts school textbooks for teachers to use, but they could refer to popular magazines such as *Studio, Brush and Pencil*, and *Handicrafts*, which began to be published in the early twentieth century for amateur craftspeople. There were also journals such as *Common School Journal, Elementary School Teacher, The Course of Study*, and *School Arts*, which were specifically targeted to a school audience and had, for the most part, contributions by teachers. Here, novice as well as expert educators could find ideas, suggestions, and descriptions of crafts' practical applications to the curriculum from the lower to the higher grades. Articles would recommend the appropriate student age for the proposed craft, describe the benefit of this activity, list the materials needed, and provide step-by-step practical guides to aid the teacher in the classroom. Titles such as Basketry, Primitive Textile Work, Textile Fabrics, seem to have been prevalent, thus indicating that arts and crafts were deemed important, particularly for young women, future keepers of their home, educators of their families, and all the while productive members of society. As the president of the Chicago Women's Club put it, if women could take "art into the home and then through the homes into the neighborhood, and then from one neighborhood into another, we shall soon make our whole city beautiful."[52] The message was clear: by improving one woman and home at a time, art could become a means of civilization.

The 1900s: Cementing Art Education Theories and Practices

New changes marked the beginning of the twentieth century as educators continued to assess the significance of art in its power to reveal beauty and stimulate individual creativity as well as serve utilitarian and social purposes. Adjustments in the art curriculum of public schools, however, did not happen overnight; while scholars identify the beginning of the

twentieth century with a new epoch of art education, the ideas behind it were shaped by the social, political, economic, intellectual, and artistic climate that characterized the last two decades of the nineteenth century.[53] The methodologies introduced in the early 1900s were not complete novelties but simply the continuation, "perfection," and at times combination of previous ones, presented now with "fancy" names. Between 1900 and 1912, years during which the Arts and Crafts Movement reached its highest popularity in the United States, art education focused on the teaching of five main subjects divided into two distinct categories: (1) color and design, appreciation of beauty (also known as picture study), nature study, and model and object drawing were part of the fine arts; (2) arts and crafts, on the other hand, belonged to the realm of industrial or decorative arts.

One of the most influential art educators of this time was Arthur Dow, director of fine arts at Columbia University Teachers College and author of the book *Composition*. Dow's aesthetic and educational philosophy was largely shaped by the Arts and Crafts Movement and its concept of simplification and stylization of forms, but contrary to Ruskin and Morris, he believed that abstraction had a central place in the decorative as well as the fine arts. He identified color, line, and *notan*, the arrangement of light and dark, as the main elements of design, which were organized according to principles of opposition, transition, subordination, repetition, and symmetry. "The main idea of the system," Dow wrote, "is to help the pupil at the very outset to originate a beautiful arrangement, say a few lines harmoniously grouped together, and then proceed onward step by step to greater appreciation and fuller power of expression."[54] This system of art making allowed "young minds to appreciate and grasp the essentials of all true work, at the same time giving the inventive faculties freedom and practical purpose" and could thus be applied to all kinds of creative endeavors, whether drawing, painting, design, or crafts.[55] In fact, once the fundamental principles of composition in the juxtaposition of light and shadows and the conveyance of color degrees through the simple use of a lead pencil in five degrees were mastered, students were ready to undertake any artistic arrangement with endless possibilities for ornamentation and creative variations.

This method was not essentially new in itself, because once again it claimed a thorough understanding of form and color as the precedent of

any attempts at more complex drawings. However, it soon came to be preferred over the approaches proposed by educators just over a decade before because the "study of pattern and picture, form, composition and colors" that it suggested was more related to "the constructive surroundings of the child" and thus more effective in narrowing the gap between learning and doing.[56] The drawing methodology of the new century, therefore, embraced some of the drawing traditions of the previous fifty years and enriched them with the pedagogical theories of the time that nurtured children's physical, mental, and intellectual development through experiential and sensorial learning. Picture study, nature study, and lessons in model and object drawing (still life) were all based on Dow's compositional principles.

Picture study, previously called school decoration, was a curriculum movement that, starting around 1895 and lasting approximately through the 1920s, aimed to introduce art history and appreciation in the education of public school children so that "our young men may see visions, and our young women may dream dreams" and may acquire "a sensitiveness to beauty, an intelligent appreciation of beautiful things, the power to make things beautiful and to reveal beauty to others."[57] Its rise and entrance in the classroom coincided with the widespread interest in history and the fine arts at the turn of the century as well as with the growth of public and private institutions for the promotion of culture, including museums, galleries, and universities.[58] Casts and reproductions of great works of art displayed in classrooms and halls (fig. 1) were the main teaching tools; they conferred the idea of a "museum of virtue" and were meant to inspire "manners and morals" in children, particularly those coming from lower-class and immigrant families.[59]

In the book *School Sanitation and Decoration* (1899), Henry Turner Bailey, Massachusetts supervisor of industrial drawing and one of the main proponents of picture study, thoroughly discussed the proper decoration of school buildings and particularly emphasized how art works should be displayed in order to best facilitate pupils' moral and aesthetic development. Bailey also described in detail how reproductions and casts should be selected in each grade so that "one may contemplate with pleasure." For example, in discussing pictures, he wrote that "little children care nothing for Roman ruins and Greek fragments; the pictures they love are those which tell the

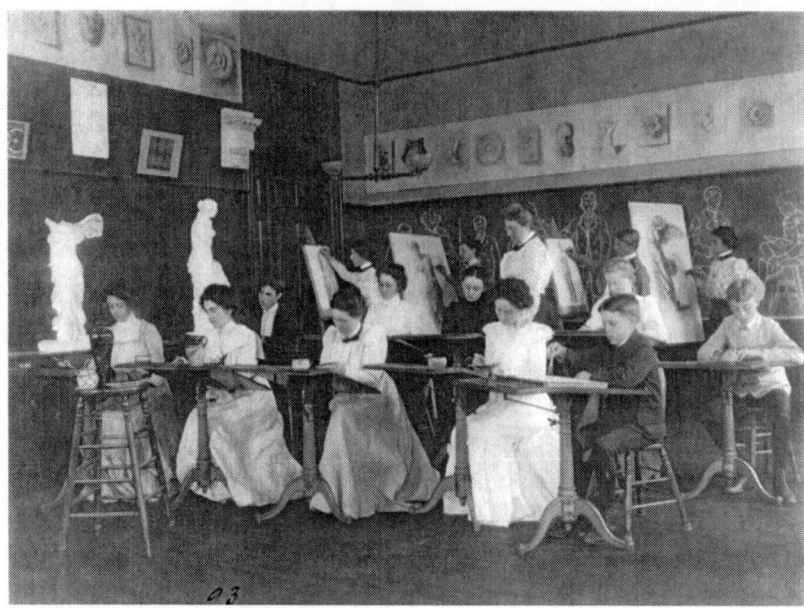

Fig. 1. Washington DC public schools, Eastern High students in art class, ca. 1899. Frances Benjamin Johnston Collection, Library of Congress, Prints and Photographs Division, LC-USZ62–68189.

story of happy animal and child life, of vigorous action and of mother love." So for students in the lower grades, he recommended art works representing birds, sheep, the Holy Family, or the Madonna and Child; in grammar school and higher grades, on the other hand, teachers needed to use images of cathedrals, historical monuments, saints, and biblical figures.[60]

Teachers mostly used methodologies suggested by *Schools Arts*, a magazine edited by Bailey and firstly published in 1901. Stankiewicz writes that some of the methods proposed included "telling the story of the painting and its artist, asking the children questions about subject matter or story, setting up tableaux, writing stories, or making booklets of reproductions with essays." With an eye to the developmental theories of the Child Study Movement, picture study also proposed instructions based on the children's progressive acquisition of skills and abilities and so art appreciation went from mere "identification of subject matter and moral lessons" for the younger learners to "knowledge of artistic composition, its elements and

Art "Lifts Them to Her Own High Level"

principles" for the older ones.[61] This meant that children in the lower grades began with simple drawing exercises to eventually reproduce parts of the work under examination, while upper-level pupils analyzed and copied the entire images. Discussions of the artists' lives and their rationales for creating their works always accompanied the practical study of their art.

Photographs of picture-study classes, whether in Boston, Philadelphia, or Chicago, for the upper or lower classes, for Anglo or American Indian children (figs. 1 and 2), always show students composedly sitting or standing at their easels in front of the works of art to be reproduced. Classrooms, resembling museum hallways and corridors, appear pleasantly ordered and immaculately clean; nothing is out of place. In these unnatural classroom views, very likely staged for the purposes of the photograph, the learning of art seems ordinary, yet virtuous and ennobling, as students maintain proper and erect body postures, correctly hold their drawing instruments, and focus attentively on their work. Schools appear as comforting places in which pupils, guided by their teachers, can channel their creative energies into something beautiful and uplifting. Sociologist Eric Margolis maintains that historic school photographs were created to represent social relations and certain aspects of the schools' "hidden curriculum," such as "assimilation, order, discipline, purity, equality, patriotism, community pride and stability."[62] Snapshots of art classes such as these convey the message that instruction in art was democratic (for all citizens), beneficial (inspirational), and constructive.

Nature study and model and object drawing, already accepted by educators in the late nineteenth century as good instruments for training the students' powers of observation, the coordination between head and hand, and the correlation of school and life, were still retained in the twentieth-century classroom. Representation of nature, whether flower, fruit, plant or landscape, had always been a favorite subject for drawing and painting and was one of the themes promoted by the art crusaders as well as by other authors of drawing manuals. In decorative arts, on the other hand, a peculiar interest in flora bloomed thanks to the influence of the Arts and Crafts Movement, its emphasis on the simple life, and the appreciation of the natural forms that are found in the surrounding environment. The prominent role of nature study in the early years of the new century,

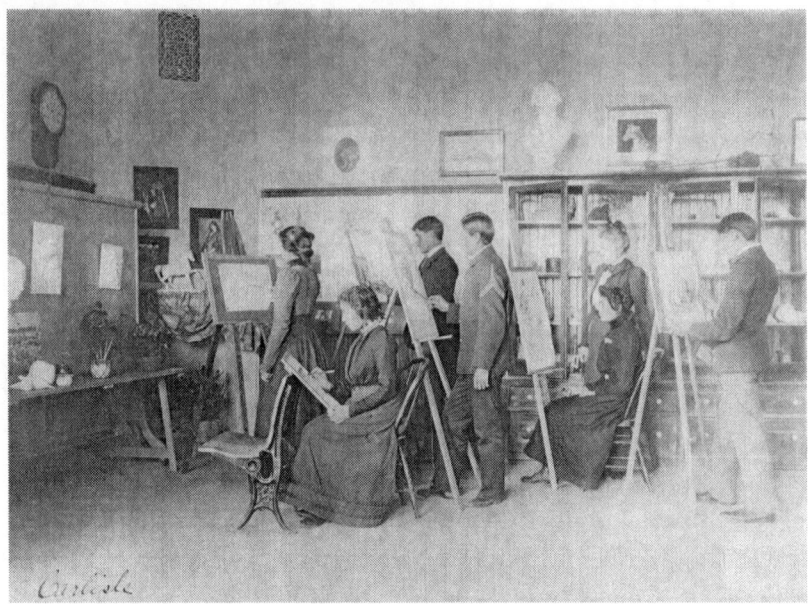

Fig. 2. Classroom instruction in art, U.S. Indian School, Carlisle, Pennsylvania, ca. 1901–3. Frances Benjamin Johnston Collection, Library of Congress, Prints and Photographs Division, LC-USZ62–115831.

however, resulted more from the School Gardening Movement than from previous influences. The establishment of school gardens in city, country, and even Indian schools stemmed from John Dewey's progressive urge to integrate school and life and thus connect academic with practical training; gardens meant to introduce science by stimulating children's curiosity through concrete and individual hands-on activities. Colorful and detailed drawings of fruits, plants, trees, crops, and animals were a first step in the child's process of familiarization with these products of nature.

Despite a clearer delineation between fine and industrial arts in the first decade of the twentieth century, drawing remained the foundational skill to be mastered in order to venture into many art-based activities. Handicrafts such as weaving, basketry, woodwork, or metal work presupposed good mastery of the basic principles of form, color, and ornamentation applied to functional objects. Similarly, domestic arts such as sewing, embroidery, lacework, and other kinds of fancy needlework that were seen as part of a

Art "Lifts Them to Her Own High Level"

woman's work—and were also considered industrial arts—presupposed an elementary knowledge of the tenets of drawing. One again, even in the face of new theories on the role of art in education and new methodological approaches to the practical teaching of art, the underlying motif persisted: a hand trained through drawing could contribute to the beautification of the home, and thus of society, and to making well-designed objects of practical utility for all.

Art Education after 1915

Developments in the field of art education during the first years of the twentieth century cemented theories and practices in drawing and arts and crafts until the 1920s. Public schools, however, did not offer separate classes in drawing or crafts but rather incorporated both under the encompassing name of manual training, applied arts, or industrial arts. The advent of World War I saw a renewed attention to the role of industrial drawing and design as tools that could have, once more, helped the American economy through tough times. Crafts, on the other hand, began to be used more and more as therapeutic activities; they could benefit underprivileged, orphaned, or troubled children by promoting their emotional and social welfare and could help wounded soldiers in their process of physical and psychological rehabilitation. As the country fought through and recovered from the war, art brought comfort and beauty to the lives of many by unifying people and communities.

2

"An Indispensable Adjunct to All Training of This Kind"

The Place of Art in Indian Schools

> There is no limit to the subject of drawing. It touches every sub-
> ject we teach: geography, science, physiology, number work, etc.
> Every new way of expressing thought strengthens mental power.
> —Estelle Reel, *Annual Report to the Commissioner of Indian Affairs*

Educators at the turn of the twentieth century argued that as Indian stu-
dents became "civilized," the development of their mental and manual
skills through art classes would facilitate their assimilation into main-
stream society, thus allowing them to embrace American values, secure
an income through the work of their trained hands, and live dignified lives
in ordinary homes. The curricula introduced by Commissioner Thomas
Morgan and Superintendent Estelle Reel, in 1890 and 1901 respectively,
were clearly designed to meet these expectations and enable students to
be equipped for a life as semiskilled or skilled laborers.

Federal Indian Policy and American Indian Education

The education of the Indigenous population of America was one of the main
goals of the colonizers since their arrival on the continent; missionaries of
different religious denominations were responsible for the founding and
operation of numerous schools where the colonists' language, religion

(Christianity), and mode of living (agriculture) were the core areas of instruction. Despite their longstanding efforts, which were often very successful from the educators' standpoint, by the early 1870s many American Indians had not been "civilized" and were thus considered to be a major problem, particularly in the West. Here, wars in the Plains had engaged the U.S. Army for over a decade and drained government finances; conflicts with white pioneers continued as their settlements expanded to "unoccupied" lands claimed by Indian people who did not productively make use of their resources according to Euro-American standards; and, finally, the establishment of a reservation system to confine tribes to limited geographic areas increased Indians' dependency on government aid and thus retarding their adoption of farming and the abandonment of old lifestyles.

As the advancement of the self-conceived "great" American nation—foretold in ideas of manifest destiny that equated civilization with white, Protestant society—was slowed down by a nonassimilated Indian presence, policymakers and self-appointed reformers, such as members of the Lake Mohonk Conference of the Friends of the Indians, envisioned a solution to the so-called Indian problem: it consisted of the total assimilation of the Indigenous population into American society through the adoption of mainstream behavior, values, language, and work habits. This was to be achieved through a breakup of the reservation system and the tribal customs of holding land in common, an eradication of tribal cultures and identities through education, and a transformation of men and women into self-sufficient and law-abiding citizens through manual labor.[1] By the late 1870s, total assimilation became the goal of the federal government for its wards.

The Dawes Act of 1887 was responsible for the division of reservation lands into individual allotments assigned to each male head of a family, but also, in smaller sizes, to women and children; it conferred citizenship and made Indians subject to the laws of their state of residency. Most importantly, it attacked tribal institutions, forms of government, and kinship systems by imposing Euro-American concepts of individualism and personal responsibility, nuclear family, and a political and societal structure based on private landownership. This legislation was considered a major step toward Indian assimilation because it "freed" individuals from the corrupting influences and bonds of tribalism and from reliance

"An Indispensable Adjunct to All Training"

on government support and paternalism, thus giving Indian people the opportunity to live as independent, civilized Americans citizens.

The second powerful instrument for the eradication of tribal cultures and identities was education. The establishment of the first off-reservation boarding school by Capt. Richard Henry Pratt, in 1879 in Carlisle, Pennsylvania, marked the beginning of similar government-controlled educational institutions that strove to eliminate the Indian from the man in order to completely assimilate him. At their start, these schools intended to eradicate the "savage traits" of younger generations of Indians and totally transform their lives and habits so that they could enter into American society on an equal footing.[2] However, as integration did not happen as quickly as envisioned, educators and policymakers began to contemplate an inherent inability of Indian people to advance in society because of their racial inferiority. The appointment of Thomas J. Morgan as commissioner of Indian Affairs in 1889 denoted a significant shift in attitude toward the wards of the government, and consequently, in the policies and practices employed to civilize them: education now meant manual and industrial training in order to prepare students for a life as farmers or laborers in the lower levels of society. Contrary to what Captain Pratt had envisioned for his Carlisle pupils, Indian schools no longer intended to equate American Indians with Anglo children and train them to become professors, businessmen, doctors, or civic and political authorities; rather, they aimed to teach a trade and instill habits of work and industry, thus compelling boys and girls to become subservient to the needs of white capitalism. Consequently, the curriculum was changed to emphasize learning to "work for others" rather than self-sufficiency.[3]

Thomas Morgan and the Standardization of Indian Schools

The education of American Indian children started with a physical transformation and expanded to a linguistic, moral, religious, social, and ultimately cultural "renovation" at an individual as well as a group level. The curriculum of boarding schools was designed to accomplish this goal and, consequently, all Indian cultural and social elements were forced out of the students through harsh discipline, punishment, and even ridicule.[4] The moment of arrival at the school marked the beginning of a child's

"makeover"; each was separated from siblings and tribal friends and segregated according to sex and age, given new clothes, look, and name to symbolize his or her new identity. Additionally, as children were introduced into a world of rigid schedules, restraints, and military-style drills, they were forbidden to speak their native language or display any cultural trait; every manifestation of Indianness, including the production of traditional arts and crafts was denied and censored. Children had to forget they were Indians in order to become white men and women. They had to learn to walk on the paved road of civilization.

By the late 1890s, twenty-five off-reservation schools had been established and over one hundred existed on or near reservations. Following the model of Carlisle and of Hampton Normal and Agricultural Institute—the first off-reservation boarding schools—they divided the school day between academic and gendered industrial work: boys learned farming, stock raising, blacksmithing, carpentry, and shoe and harness making, while girls were instructed in all the branches of domestic work, which included laundering, cooking, sewing, dairying, and care of animals. While teachers in each school actively worked to turn young "savages" into responsible civilized citizens, they did not have a common course of study to follow. Commissioner of Indian Affairs John D. Atkins (1885–88) maintained that teaching the English language had to be a priority of Indian education and wrote in his first report that "a common English education is about all that these people ought to receive."[5] He also issued a series of directives for government and missionary schools to ensure that each institution adopted an English-only policy. Aside from this, however, no further indication was given as to what exactly to teach or how.

At Carlisle and Hampton, the subjects of instruction included reading and writing, arithmetic, U.S. history, geography, and Christian religion. The Indian Office endorsed these models of instruction as the examples new schools had to emulate. For instance, teachers were encouraged to use the methodology of teaching from objects employed at these pioneering institutions so that children could learn to connect English words with their corresponding articles and, little by little, expand their vocabulary. At Carlisle, younger students improved their English through oral descriptions of pictures, while advanced students kept daily diaries of school events

as composition exercises. Pupils at Hampton, on the other hand, played talking games, memorized short dialogues and sentences, and were taken on nature walks so that they could learn the English names of the natural features around them; they also learned history and geography through the aid of pictures, maps, and the sand table.[6]

Aside from warm recommendations, however, specific government regulations were lacking, prompting many schools to devise their own curricula either on the common branches of English education (spelling, reading, and writing), on the examples set by Carlisle and Hampton, or on the curricula of public schools in the surrounding areas. At the Albuquerque Indian School, for example, children learned spelling, reading, writing, arithmetic, and geography, all taught through object lessons; this curriculum was introduced by the Board of Home Missions of the Presbyterian Church at the founding of the school in 1881 and continued to be implemented after the government took control in 1886. Similarly, the Forest Grove Training School in Oregon (1881) offered an academic training that included religion, reading and writing, public speaking, recitation, oral arithmetic, and some lessons in geography; teaching was mainly through objects but also through the use of the textbooks adopted in the common schools of the area.[7] Indian schools also lacked teaching materials and supplies and this proved to be an additional difficulty for teachers who oftentimes had to use their own wages to remedy these precarious conditions.[8]

When Thomas J. Morgan became commissioner of Indian Affairs, he soon realized the shortcomings of the laissez-faire approach of his predecessors and began to develop a national compulsory system of education that would resemble that of public institutions. Morgan, an ordained Baptist minister and educator, became a recognized figure in the world of education after the publication of *Studies in Pedagogy* (1889), a textbook for public schools, and because of his involvement with the National Education Association in the roles of speaker and vice president.[9] According to historian Francis Paul Prucha, Morgan embodied some of the most prevalent ideas of his time: he was an ardent Protestant who believed in Americanism, in the elevation of "inferior" races, and in the effectiveness and necessity of a public school system. In his view, education was the instrument through

which American citizenship had to be promoted among the many diverse people that made up contemporary society; individual differences due to race, nationality, culture, and religion had to be supplanted by "national characteristics" such as a common language, love of the same institutions, loyalty to the American flag, and faith in God.

Morgan envisioned an Indian education system divided into primary, grammar, and high schools, modeled after American public schools, and unified by a common course of study with standard textbooks and teaching methods. Thus, in addition to English, instruction had to include arithmetic, geography, nature study, physiology and hygiene, U.S. history, and music. Morgan also stressed the importance of promoting patriotism in order to successfully assimilate Indian children and hence recommended training in the duties of American citizenship (civil government) and the significance of all national holidays, which were to be properly commemorated.[10] Finally, he proposed coeducation, which he deemed the best way to "lift the Indian women out of their position of servility and degradation which most of them now occupy"; intertribalism, to "destroy the tribal antagonism and to generate in them a feeling of common brotherhood and mutual respect"; and the expansion of the Carlisle outing system for boys and girls.[11]

In 1890 Morgan outlined his new curriculum in the pamphlet *Rules for Indian Schools*, included as an appendix to the *Annual Report of the Commissioner of Indian Affairs*. In 1892 he published it as a separate pamphlet with the title *Rules for Indian Schools with Course of Study, List of Text Books, and Civil Service Rules*. The two documents were based on the same principles and ideas but presented some differences. The 1892 version was much more thorough than the earlier one and included some modifications in the section on the supervisor of education and the classification of schools, as well as a few additions like the civic service rules. On the other hand, it omitted questionnaires to perspective applicants and a series of instruction for Indian agents. There were no substantial changes to the course of study between the first and the second manuscript, but the most recent version included a revised and more comprehensive list of textbooks, so for the purposes of this discussion, I refer to this more recent one. The *Rules* clarified the educational agenda of the government and explained in detail the content of the new curriculum:

"An Indispensable Adjunct to All Training"

[T]he general purpose of the government is the preparation of Indian youth for assimilation into the national life by such a course of training as will prepare them for the duties and privileges of American citizenship. This involves the training of the hand in useful industries; the development of the mind in independent and self-directing power of thought; the impartation of useful practical knowledge; the culture of the moral nature, and the formation of the character. Skill, intelligence, industry, morality, manhood and womanhood are the ends aimed at.[12]

As evidenced by this passage, Indian schools served to absorb generations of Indian children into mainstream American society by teaching them how to become good and loyal citizens, industrious and effective workers, and autonomous and mature thinkers. Lessons in elementary art were part of Morgan's assimilationist plan and served in reaching these objectives.

The Art Curriculum

The commissioner argued that because of the students' uncivilized and uncultivated state, training in art needed to start in the second year of primary school with basic concepts such as form and color. He directed teachers to give "systematic instruction . . . in form by the use of blocks, clay modeling, paper folding, etc.; also in color" and added the study of "penmanship and drawing" through simple lessons that would "interest the pupil, cultivate the eye and hand, and give opportunity also for teaching English." In the third year of school (the second year of art instruction), pupils continued lessons in form and color and learned to draw "straight and curved lines and [make] geometrical figures." In the fourth, fifth, sixth, and seventh years, students continued these activities in order to make "fairly creditable work" and eventually "practice drawing from copies and objects" and make "freehand drawing" with "colored crayons." The textbooks "for use throughout the course" included the Prang series, specifically the *Complete Course in Form-Study and Drawing* (one to six) and *Use of Models* (models twenty and twenty-one for each child; models twenty-five and twenty-six for every two scholars over twelve years of age), accompanied by the *Teacher's Manual*.[13]

The activities proposed by the commissioner for students in the lower grades mirrored Froebel's occupations used in public schools at the kindergarten level. The use of blocks, clay, paper, and even color, had already been encouraged by educators since the beginning of the 1880s because these instruments could improve the connection between the head and the hand by developing children's sensory faculties, thus better preparing them for manual training. Morgan's inclusion of this kind of art training is indicative of two things. First, it shows the close connection between the methodological approaches envisioned for Indian schools and the ones used in the public school system at the time, thus demonstrating that Morgan's ideas were neither arbitrary nor unique, but solidly grounded in the national debate on the role and value of art in education. Second, it suggests that independently of the pupils' ages when they entered a boarding school— and in many instances pupils had passed the kindergarten age as they were eight, nine, or older—they needed to develop the most elementary skills through exercises in manual dexterity and connection between the head and the hand. Morgan and other Indian Service pedagogues assumed that because of their "savage" backgrounds, Native students had never received any such disciplined training and were thus particularly in need of it, especially at an older age. Thus, no matter what kind of education children had already received in their home communities, teachers in Indian schools had to start anew.

A photograph from around 1898 of a kindergarten class at Haskell Institute working with blocks is indicative of the adoption of Froebelian occupations (fig. 3).[14] On the right, about a dozen children are seated at a long table orderly crowded with wooden blocks of different sizes. In front of each pupil are about twenty small blocks, perfectly arranged in identical manner in a diamond shape. Three teachers are standing at the end of the table, towering over the students, ensuring that the composition has been correctly executed and the shapes properly arranged. This exercise was aimed at developing the students' attention (they had to understand directions), powers of observation (they had to visualize the shape and be able to reproduce it), discipline (they had to work in a methodical manner), and precision (their blocks had to be neatly placed to form the diamond figure), all "civilized" traits that Indian students needed to acquire.

"An Indispensable Adjunct to All Training"

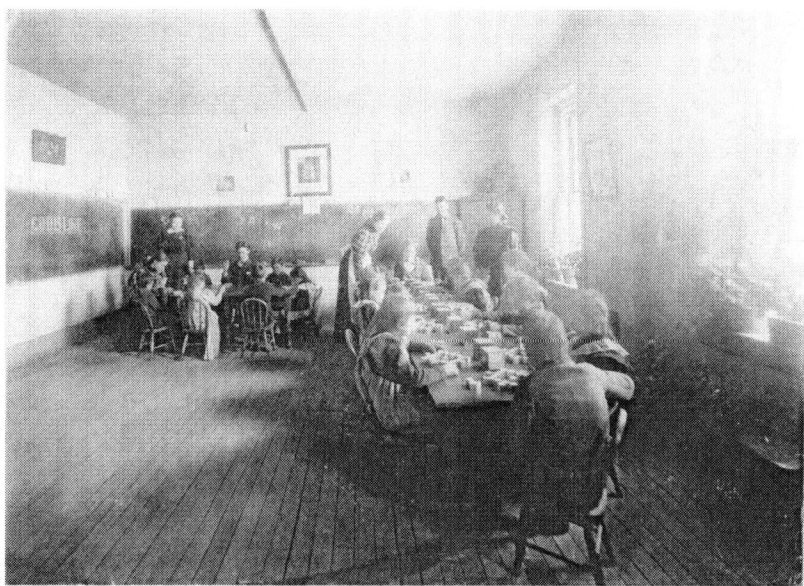

Fig. 3. Kindergarten class working with blocks, Haskell Institute, Kansas. Photographer unknown. Estelle Reel Collection, Northwest Museum of Arts and Culture / Eastern Washington State Historical Society, Spokane, Washington, MONAC no. 45.

On the left in the photograph is a table for the younger children, who seem to be similarly engaged, though the nature of their activity is difficult to discern; while they are clearly not working with the same objects as their older peers, they still appear to be using some other kinds of blocks. Seated at their table are two adults, likely teachers. The fact that younger students are not employed in the same type of work as the others suggests that the teachers assigned these basic exercises at an age-appropriate level, with older students engaged in more complex tasks. Along the walls of the room, right above the blackboards, are numerous samples of student drawings; different kind of leaves can be recognized, particularly on the left wall, suggesting that these illustrations were likely made as part of nature study classes. Training in hand-eye coordination, as this photograph attests, was an essential prerequisite for the development of those faculties necessary for a civilized life.

Additional visual records of boarding school classrooms reveal the

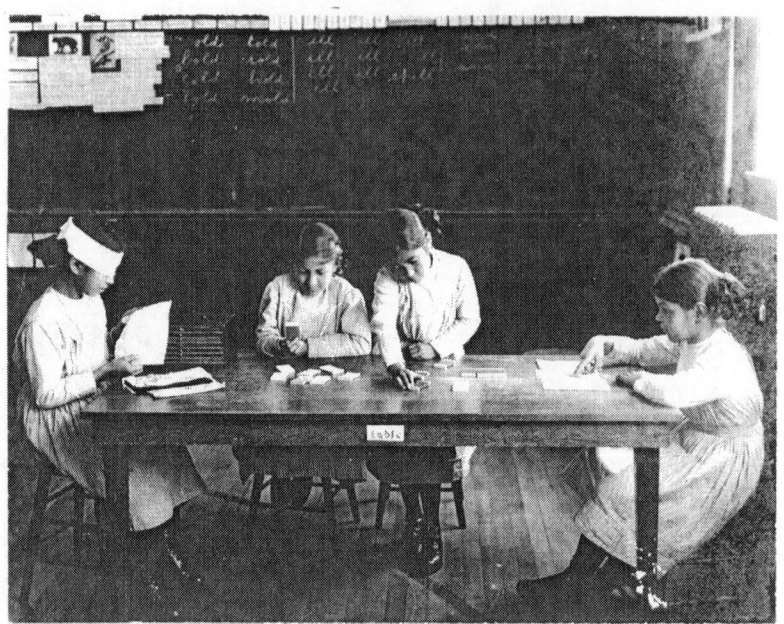

Fig. 4. Life in an Indian school—what the girls and boys learn—Tulalip, Washington. National Archives and Records Administration, College Park, Maryland, 75-L-20-B. Photographer unknown.

nature of art lessons. At the Tulalip School in the state of Washington, girls were trained to develop their senses through play with fabric, colored blocks, and sand paper (fig. 4). A photograph from the early 1900s shows four young pupils seated at a table (note the label "table" attached to the side to help students connect the object to the word), occupied in different activities. The girl on the right end is, according to the caption, "developing muscular direction by tracing sandpaper letters"; her right index finger is following the shape of each printed letter while her gaze is absently fixed beyond the papers in front of her, almost dreamily. The two girls in the center are intent at playing with small blocks, likely made of wood, with two differently colored surfaces, light and dark. Since the caption reads "developing color-sense by classifying shades," we have to presume that these blocks are in a variety of different colors and hues; unfortunately this information is not conveyed by a black-and-white

"An Indispensable Adjunct to All Training"

image. The fourth girl at the left end of the table is blindfolded and is holding a white piece of cloth; in front of her are other scraps of textile materials, which could be cotton, linen, and wool that she is using for "identifying fabrics by touch." While this photograph does not show art instruction per se, it unmistakably illustrates the training that preceded further artistic endeavors.

Examples of paper activities can be found in a display board created by the Indian school on the Wind River reservation, Wyoming, at the turn of the century (fig. 5), which includes samples of kindergarten work by children aged five to twelve. This board clearly shows that the age of the pupils upon entering school was irrelevant as they were all considered tabula rasa and thus in need of the most basic training. The works displayed here are: paper cutting and folding (yellow diamond by Willie Engavo, age five; violet and white diamond by Wyo Hora, age twelve; and yellow star by Bee Wolfrang, age six); perforating (yellow and lilac circle by Gould Quiver, age eight; blue square by Bertha Farness, age eight); and braiding (works by Marshall Friday, age five, top left; Percival Shavehead, age seven, top right; and Willie Hugo, age seven, bottom left). The remaining items were made by sewing paper with colored thread (flowers by Celia Gattoca, age seven, top left, and Sadie Black, age eight, top right; elephant by Pauline Quinn, age six; snowflake by Ajax Trumbull, age six; horse by Edith Tyler, age seven). These activities targeted sensory skills such as appreciation of color and its proper combinations, and also developed finger skills and faculties such as concentration, precision, and care.

Training the "poor Indian" in the use of forms, colors, and shapes was an innocent yet subtle way to put into practice the Indian Service's master plan of assimilation. Morgan's reasoning, in fact, was that the values and skills learned through art instruction would prepare the Indian youth for life as American citizens. Their minds needed to be trained "in independent and self-directing power of thought" and this independence was possible only with the acquisition of "the proper" way of seeing and understanding the world.[15] Indian children had to be educated not only in speaking, living, and working like the white man but also, and most importantly, in thinking, seeing, and reasoning like him. From simple instructions like these in forms and colors, students were taught a disposition of the mind

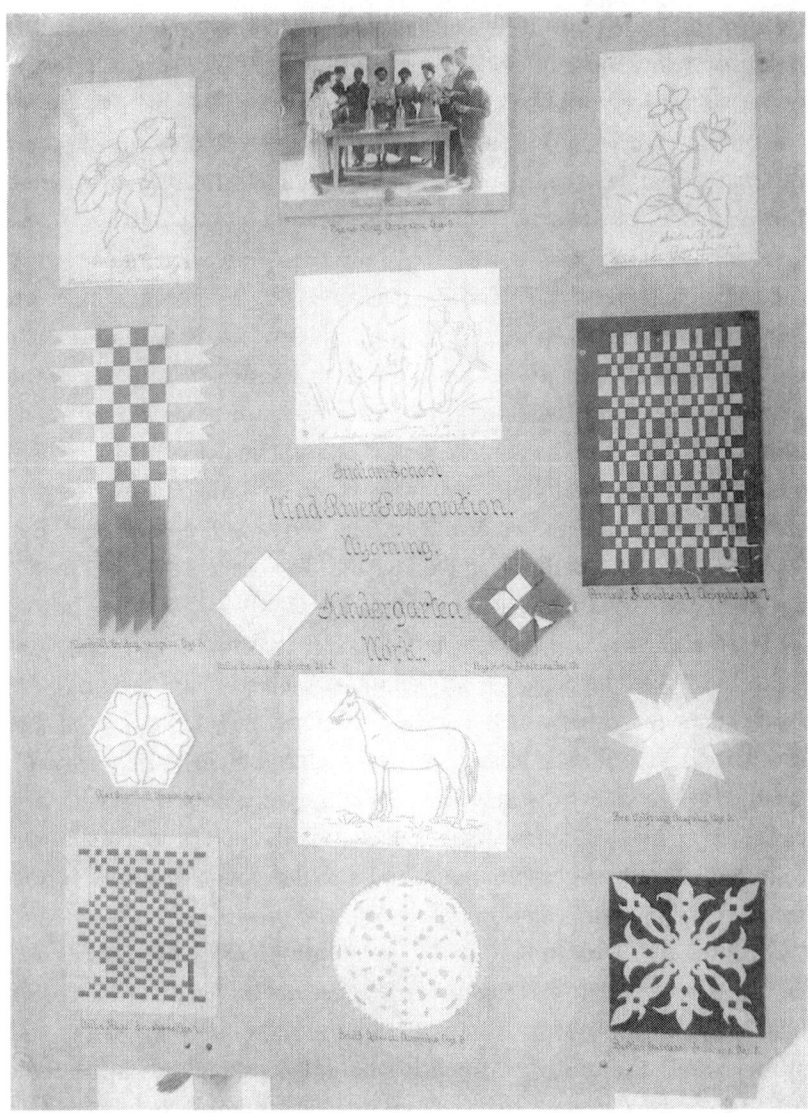

Fig. 5. Thirteen examples of kindergarten students' work, Indian School, Wind River Reservation, Wyoming. Among these examples of Froebelian activities are sewing with colored thread (flowers and animals) and paper braiding (the two works below the flowers and the one on the bottom left corner).Estelle Reel Collection, Northwest Museum of Arts and Culture/Eastern Washington State Historical Society, Spokane, Washington, MONAC no. 51.

that was necessary in order to obtain the eradication of the savage culture and facilitate total assimilation and acceptance of American values.

The introduction of art education in Indian schools was not the result of Morgan's own pedagogical farsightedness; rather, his ideas were shaped by the larger, ongoing debate on the role of art in education and were thus solidly grounded in the theories developed and put into practice in American schools. As in public institutions across the country, art in Indian schools was an instrument to improve and uplift the students' minds, facilitate their development from a primitive to a more cultured stage, train manual dexterity and mental skills, and build coordination between the eye and hand. Similarly, following the blueprint used in public education, the art curriculum for Indian children outlined in the *Rules* progressed from activities with paper and blocks to develop an understanding of basic forms and colors to the foundational skills of drawing in the lower grades, and finally to picture study (drawing from models or real objects) in the final years of schooling.

The progression in learning art from its basic principles to representations of the human form shows that Morgan understood the importance of drawing as a foundation for any other hand-related activity. It is no coincidence that students in Indian schools, who were also instructed in manual trades such as shoemaking, tailoring, carpentry, and sewing, received basic instruction in drawing before learning one of these occupations. Drawing, therefore, was deemed not only essential for the development of a particular way of seeing, but also a preliminary instruction required for subsequent manual training. Morgan personally knew many members of the NEA, having served as vice president of the association for two years, and was well aware of the debate over the role of art and its relation to industrial education in public schools. His inclusion of art education in Indian schools mirrored the prevalent belief of his time that drawing was "the chief means of manual training in the lower grades and the foundation of its best advanced work" and "an excellent preparation for the handling of the various tools used in these vocations."[16]

The insistence on drawing as the necessary foundational skill for manual trades also denoted the government's future expectations for American Indians; art, in fact, was not taught so that children could become artists,

but so that they could be producers of manufactured goods needed by the American people. Drawing, therefore, was a tool for improving industrial skills, not for developing the ability to make fancy pictures or express one's own creativity. As Alice Littlefield has pointed out, boarding schools did not intend to create students or workers able to compete, but rather obedient citizens. She writes that federal institutions "did not succeed . . . in incorporating Native Americans into the larger society on a basis of equality with Euro-Americans" but were "quite successful in facilitating the entry of previously independent farmers, hunters and gatherers into the wage labor force."[17] Native children needed to learn to become subservient to the needs of American society and this meant becoming third-class citizens, or simple semiskilled or skilled laborers. Art education facilitated these aptitudes as it laid the foundation for the exercise of the mind and the body, and thus the development between the eye and the hand, and had "intellectual, aesthetic, and moral results in accuracy, patience, perseverance, self-control, taste, and appreciation of beauty," qualities that Indian students needed to acquire.[18]

Another element that emerges from an analysis of Morgan's art curriculum is that, despite the use of books such as the Prang system, it followed the highly structured approaches of the early art crusaders and supporters of industrial drawing, which moved from basic principles to representations of the human form. However, while in U.S. schools these teaching methods were discarded after the early 1880s in favor of more progressive models that valued new pedagogies based on child development theories, Indian schools continued to follow the old-fashioned system that uniformly saw all children as being at the same primitive level regardless of their individual growth, skill proficiency, and intellectual progress. For this reason, American Indian pupils were allowed neither individual freedom nor flexibility; rather, they had to follow a rigidly established curriculum that was monotonous and uninspiring. Furthermore, because students needed not only formation, but a deprogramming of the Indigenous knowledge they still retained, teaching approaches and methods had to be somewhat different from public schools and adapted to the needs of the Indian Service. For example, in public schools knowledge and appreciation of beauty through "study of pattern and picture, form, composition

and colors" was "related to the constructive surroundings of the child."[19] In Indian schools, this kind of teaching was completely absent because it would have contradicted the educational agenda.

Native children had to learn how to draw and see things from a Western perspective that did not take into account their Indigenous knowledge or social and natural environments. This is illustrated by the following examples. The triangle, one of the simplest forms for an Anglo child to master, would have been very difficult for a Navajo pupil to draw or imagine because there is no word for it in the Navajo language. On the other hand, Navajo children would have been surprisingly (for the Anglo teacher) familiar with the hexagon—the shape of the hogan, the traditional Navajo dwelling—the Navajo word for which is mastered at a very young age. Another conceptual difference can be found in the perception of the color spectrum. According to scholar of art education Muriel Saville-Troike, in Navajo, the colors blue and green are "placed in a single category (*dotł'izh*), whereas the English black corresponds to two distinct Navajo colors." Similarly, in Choctaw there is no distinction between yellow and brown because "these hues are categorized together under a single term signifying 'earth color.'"[20] Although this kind of information was unknown to Anglo educators during the boarding-school era—because no one troubled themselves to understand it—it demonstrates how Indigenous ways of perceiving reality, which stem from different sets of values, beliefs, and epistemologies, were utterly disregarded. To educators and policymakers at the turn of the twentieth century, there was only one way of seeing the world and, clearly, it was not the Indigenous way.

Indigenous knowledge in art education might have been disregarded "from above," but it certainly was maintained and promoted "from below," including by the few known Indian art educators who taught in boarding schools. Arizona Swayney, a Cherokee from North Carolina who worked at Hampton (1902–6), and Angel DeCora, a Winnebago from Nebraska who taught at Carlisle (1906–15), were two educators who approached art from an Indigenous perspective, thus passing on to the next generations of Indian men and women imageries, techniques, stories, values, and beliefs that were quintessentially Indigenous.[21] Swayney, prompted by Hampton's official acceptance and encouragement of Native art, returned

to her reservation after graduation and learned Cherokee basketry from the older women of the tribe, so that she could teach the art to Hampton students and contribute to the revitalization and perpetuation of Cherokee culture. DeCora, hired by Commissioner Francis Leupp after Richard Pratt resigned from Carlisle, accepted the position of art teacher only on the condition that she "shall not be expected to teach in the white man's way, but shall be given complete liberty to develop the art of my own race."[22] These two examples show how Native people ingeniously took advantage of the windows of opportunities that opened at particular times in history and were able to carve for themselves and for others spaces through which they could continue the transmission of Indigenous knowledge through art.[23]

Changes in the Art Curriculum

With the appointment of William N. Hailmann, a well-known progressive educator, as superintendent of Indian schools in 1894, views on art instruction, particularly drawing, slowly began to change and follow the progressive turn that was already prevailing in public institutions.[24] From an activity that served solely to train perception of forms, coordination, and manual dexterity, drawing came to be seen by Indian educators also as a tool that could facilitate the students' overall learning and the expression of their individual creative powers. Hailmann's philosophy was extensively outlined in his first annual report to the commissioner of Indian Affairs. According to him, pupils were not only learners but also doers, so every kind of knowledge gained, including drawing, had to be put to practical use. He stated, for example, that "strenuous efforts will be made to introduce into the schools elementary drawing, more particularly in connection with language work, and written nature study, under the direction of the regular teachers." Drawing also figured in connection with arithmetic, which was to be done "wholly with things and with simple pictures of things" and only later with concrete applications in agricultural, industrial, and economic pursuits. Thus, in the core subjects of language study, math, and science, drawing was to be the means through which children learned about things.[25]

Hailmann also voiced the "great desirability of systematic instruction" in drawing and music because Indian children had "a decided talent for these arts and find in them much joy and inspiration, much that makes

the school attractive and dear to them." If properly taught, these subjects would allow children to express and communicate their ideas and emotions, would be of value in the instruction of manual trades, and in the overall moral development of Indian youth. These reasons were sufficient to give drawing a prominent role in the curriculum.

In his second annual report, Hailmann wrote that "increased attention is being paid to drawing and music, with encouraging results," and while he had hoped "to furnish the teachers with a syllabus to guide them in the work, other duties, possibly of minor importance but requiring immediate attention, have so far kept me from completing this work."[26] Although unable to "officialize" his take on drawing and to provide teachers with a set of guidelines to follow, Hailmann instructed them to include drawing at both reservation and non-reservation schools and gave a few practical recommendations in the pamphlet *General Course of Work and Textbooks Adopted for Indian Schools*, which was appended to his report. He provided the title of the textbook to be adopted, Augsburg's *Elementary Drawing* (1891), and a list of materials needed for drawing classes: drawing paper, black pencils, colored pencils (six colors), colored slate pencils (three colors), camel's hair brushes, and practice drawing paper.

Hailmann's intention to write a drawing syllabus is indicative of two things: first, his *General Course of Work* was deliberately generic and did not thoroughly outline how drawing was to be taught year by year; second, he was not satisfied with Morgan's art curriculum and wanted to ameliorate it in order to reflect current mainstream pedagogies. There is no evidence that a syllabus for Indian-school teachers was ever written, but the 1896 report informs us that "commendable progress" was being made:

Quite a number of the teachers have learned the art of using drawing in their work, not as a mere accomplishment in the more or less bungling imitation or copying of "pictures," but as a means of thought expression, quite helpful in the acquisition of spoken language and as a means of developing the child's aesthetic sense. Children are taught to tell simple stories, make sentences, and to prepare lists of things with the help of simple outline sketches. With the help of kindergarten material, which a number of teachers have learned to use intelligently, children

are taught to use simple form elements in symmetrical and decorative arrangements. Mechanical and industrial drawing in connection with the teaching of industries has entered a number of schoolrooms. At the same time special talent is not neglected and is given free scope and ample assistance. In some schools the use of water colors has been introduced, and with their help drawing is being made as effective in developing the child's love of the beautiful through the eye as is music stimulating the same love through the ear.[27]

Instruction in drawing had shifted beyond the structured sequential learning of the previous curriculum and was now supposedly used as an instrument for self-expression and for the development of children's sense of beauty. Students were given more individual freedom and encouraged in their creative endeavors. This focus on the student as a person and on his or her aesthetic faculties mirrored the ideas brought forth in mainstream society by supporters of the Arts and Crafts Movement, who tried to introduce beauty into the lives of laborers so that they could produce beautiful objects of practical utility, and adherents of the Child Study Movement, who promoted unstructured and spontaneous imaginative works. At the same time, however, the industrial nature of Indian education was not forgotten and so, along with freehand drawing, mechanical drawing was introduced for continuing the training of skills in preparation for life in the shops. The central section of the above passage provides a brief description of the methodologies used by teachers, thus offering us a little glimpse into what was going on in the classroom. For example, we learn that children used drawing in connection with language and made sketches to express themselves and tell stories (freehand drawing), thus making the first steps in the acquisition of English vocabulary. We can also see that teachers used kindergarten materials, likely Froebel's toys (blocks, paper, clay, etc.) to teach concepts of forms, compositions, and decoration.

While Hailmann tried to put into practice the progressive theories of his time, his vision for art education did not completely reject the work Morgan had done; on the contrary, he expanded his predecessor's curriculum in order to incorporate the current approaches. The basic drawing principles and steps exposed in Morgan's *Rules*, in fact, were not eliminated, as they

"An Indispensable Adjunct to All Training"

were still found in the drawing manuals published in the 1880s; students still learned from simple lines and angles, moved on to more complex geometrical compositions, and eventually to object drawing, landscape, and the human form. What changed was the acknowledgment that the development of artistic talents mirrored growth and that in order to educate the Indian child as a whole, instruction in drawing had to be less schematic and more connected with the child's life as well as other areas of study, particularly manual training. Again, this was nothing new because drawing as the foundation of manual training had already been recognized by the commissioner. The difference between Morgan and Hailmann was that for the former, art instruction aimed at enhancing the students' power of seeing and the coordination between mental and motor faculties so that they could be better workers in whichever menial field they chose; for the latter, art meant connecting classroom and shop a step further by unleashing students' creativity and sense of the beautiful in the making of useful *and* aesthetically pleasing commodities.

The frequent discussions at the annual meetings of Indian Service employees testify to this new understanding of the role of art. At the 1897 Indian Institute held at Odgen, Utah, for example, Hailmann participated in a roundtable discussion in which he argued that drawing and other art work "should be organically connected with the school work. Not added as a new phase—as a new species of instruction—but as a fresh means for making the already existing steps of instruction more vital."[28] In his view, intellectual development and work reciprocally influenced one another; teaching the principles of art would enable students to employ all their mental powers and become creators of things. Similar views were expressed by F. A. Thackrey of Crow Creek, South Dakota, at the Omaha institute held the same year. He stated that "the relation of shopwork and drawing is such an intimate one that it is impossible to disconnect the two. Both work toward the same end. . . . The one is connected with conception; the other with creation. They are not substitutes for each other, but supplements, and should be taught in parallel courses supporting each other."[29] Two years later, Frances E. Ransom insisted that "there is no limit to the subject of drawing" because "it touches every subject we teach: geography, science, physiology, number work, etc."[30] These examples, and many others

that could be cited, illustrate the renewed emphasis on drawing and the understanding that it would best serve the students' interests if connected to every other aspect of their education, academic and industrial.

The most interesting presentation on the subject of art education was without doubt offered by Professor Frederick Simons of LaPoint, Indiana, titled "Art and Art Education in Their Relation to the Social Welfare of the People," at the 1898 summer institute in Colorado Springs. Estelle Reel, who had been appointed earlier that year to succeed Hailmann, described it as "a course of daily lectures on pictorial, decorative, and constructive art, such as it is rarely the good fortune of teachers to receive in summer schools."[31] The class opened with a discussion of the rationale for art instruction, followed by curriculum suggestions from the first year of primary school to the higher grades, and concluded with practical illustrations of the methodologies to be used and a list of books to assist the teachers. Among the reasons for art education, Simons mentioned its ability to develop "the mind in the right direction," "close and strict observation," "the power of seeing," but also the fact that art "trains the judgment" and "generates wealth." Overall, he maintained that art was a "civilizer, a promoter of intellectual self-activity and creative inventiveness, hence of progressive evolution" and was thus a necessary component in the education of any child.

His curriculum suggestions included a subdivision of instruction into three categories, pictorial work, decorative work, and constructive work, for each of the school levels (primary, grammar, and high school); each category involved age-appropriate activities that increased in difficulty as children progressed in their schooling. Table 1 illustrates these distributions of activities per grade and category.

Thanks to Morgan's *Rules*, the work done in Indian schools already included some of the activities outlined here; for example, paper folding and cutting, object and nature drawing, and the human figure, but it was lacking in many other aspects, particularly the creative and self-expressive, which Hailmann had tried to introduce. Because a new set of official guidelines and regulations on the teaching of art was never issued during Hailmann's tenure, it is very likely that Indian teachers drew from this curriculum outline.

"An Indispensable Adjunct to All Training"

Table 1. Condensed Outline of Work by Grade Level

	Pictorial work	Decorative work	Constructive work
School Years 1–4	Color the outline of pictures Draw season-appropriate natural objects Draw objects used in trades Illustrate stories Blackboard sketching	Learn colors Arrangement of patterns Ornamental paper forms Decorative painting of paper or clay objects	Clay modeling Paper folding and cutting
School Years 5–6	Object drawing and painting (sketching easel) Silhouette painting Creative sketching in pencil, ink, watercolors Human figure	Drawing and painting of original designs, geometrical and vegetable Decoration of cardboard forms	Making cardboard forms Making working drawings
School Years 7–8½	Object drawing (easel) and creative sketches in pencil, ink, watercolors Outdoor sketching Human figure Perspective Light and shade	Drawing and painting of original designs Plant analysis and studies Historical forms of ornaments	Industrial drawing Geometrical drawing Working drawings from models Lettering

Adapted from *Report of the Superintendent of Indian Schools*, 1898, 52–53.

A series of historical prints from the turn of the century provides evidence that drawing instruction not only continued to progress from simple to more complex representations, but also included some of the ideas proposed by Frederick Simons, particularly in advanced pictorial work. A photograph from the Phoenix Indian School, dated June 1900 (fig. 6), shows students engaged in freehand drawing exercises that likely preceded the more advanced ones of picture study; it portrays a small class of a dozen pupils, sitting at their desks, each looking down at his or her work. On the right side of each student are a glass of water and a paint box, indicating that they are using watercolors; also visible on the desks closer to the camera are sets of paints confirming that they are working with this technique. A teacher stands in between the rows of desks checking on the students' progress. Possible examples of nature study are hanging on the wall behind the students, while on the left back corner a door opens to another art classroom where portraits from a previous drawing session from live models are left standing on easels. On each desk are two sheets of paper, one on which the students are drawing and a blank one holding the object they are reproducing. A close examination of the desks in the forefront reveals that the object being copied was organic material, either a flower or a small branch with a bud, suggesting that this exercise in freehand drawing was part of a nature study class on local flora.

Some elements of this photograph clearly indicate that the students were posing for the photographer and that this classroom outlook was actually staged. For example, all pupils but the boy at the end of the last row are intent upon their work and are looking at their drawing exclusively, not at the model; both arms and elbows are on the desk, the left hand holding the paper down (the girl in the second row is the exception, her right elbow is off the desk); and boys (and likely girls too, we just cannot see them) are properly sitting with legs at ninety degrees under their desks and feet on the floor, a position no one can easily hold for too long, let alone while painting. Despite these aspects of posing, the students' upper bodies, particularly those of the students in the front row, bent at different degrees over their papers and signifying individual preference in the way of working, as well as the dirty water in many of the glasses, suggest that we are glimpsing an actual drawing exercise, albeit an unnaturally polished one.[32]

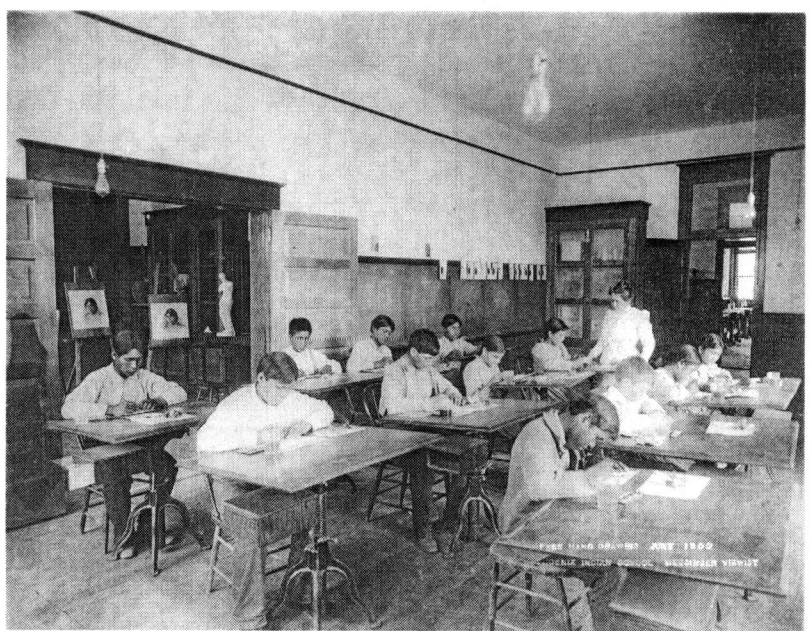

Fig. 6. Freehand drawing, Phoenix Indian School, June 1900. National Archives and Records Administration, College Park, Maryland, 75-EXP-1-B. Photograph by Messinger Viewist.

An almost identical photograph shows a class of students from Hampton Institute doing watercolor drawings of butterflies (fig. 7), as the title given by photographer Frances Benjamin Johnston, "Group portrait of teacher and students at Hampton Institute painting watercolor pictures of butterflies," also indicates. About twelve young men and women are in the classroom, their teacher in the background looking over as they work, just like at Phoenix. They are drawing from an object—a dried butterfly possibly caught on school grounds—pinned to the paper on the incline of their desks. Like their peers at Phoenix, pupils here are focused on their work, not the model, each holding a brush and immortalized in the act of drawing. However, contrary to the previous image, this one does not depict pupils actually engaged in a drawing exercise, it only pretends to; there are no water jars to indicate that watercolors of butterflies are being made. Additionally, the students' upper bodies are postured at too much

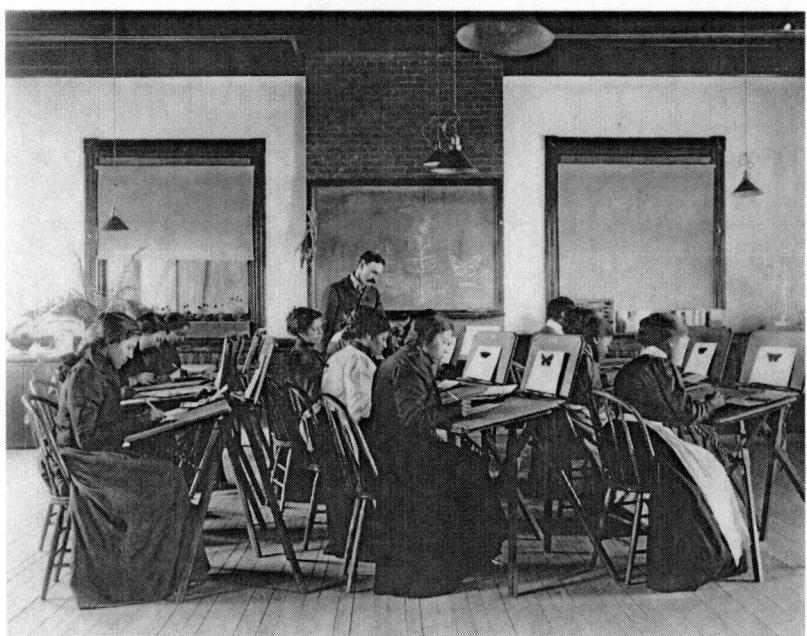

Fig. 7. Group portrait of teacher and students at Hampton Institute painting water-color pictures of butterflies, 1899 or 1900. Frances Benjamin Johnston Collection, Library of Congress, Prints and Photographs Division, LC-USZ62–127364.

of a distance from the desks to allow the faithful execution of the details a nature study class would require.

Both images tell us that students involved in these drawing exercises were in the early stages of their pictorial work training—as they depicted natural objects for nature study classes—and that their work was constantly monitored by a teacher to ensure mastery of the subject matter (structure of a specific plant or insect) and correction of execution. The similarities between these two classrooms are remarkable but not unexpected, as photographs of this kind were created for propaganda purposes and were used to demonstrate the progress of Indian education to local citizens, patrons, and the American public at large. They were part of a larger corpus of photographs "by Anglo photographers for Anglo viewers" taken, as sociologists Margolis and Rowe sustain, for the purposes of "manufacturing assimilation."[33] Individual improvement in the art of drawing also

"An Indispensable Adjunct to All Training"

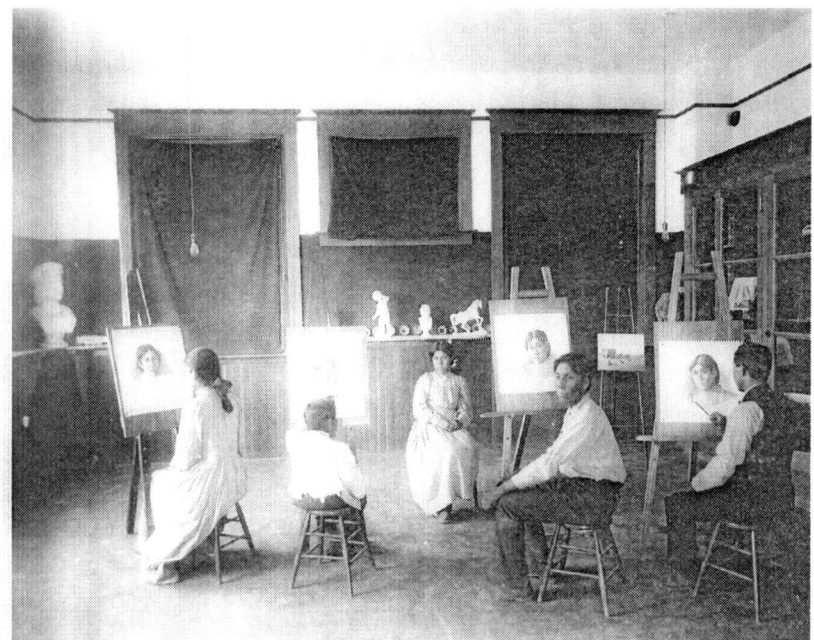

Fig. 8. Art Department, June 1900, Phoenix Indian School. National Archives and Records Administration, College Park, Maryland, 75-EXP-ID. Photograph by Messinger Viewist.

meant that students were making steps forward in the acquisition of the proper power of seeing.

Additional photographic records of Indian school art classes attest to the advancement from more simple activities to picture study and drawing from models that involved older students. A print of the art department at the Phoenix Indian School, for example, shows three boys and one girl working at portraiture while one of their peers sits as a model (fig. 8). Their age or year in school is not indicated, but these pupils are older than the ones in the Haskell or Tulalip kindergarten classes discussed earlier. Similarly, more mature students are captured in the art classes at the Carlisle Indian School (fig. 2). In all of these images, drawing is done from models, either "live," as in the case of Phoenix, or from small cast reproductions of classical sculptures, which can be seen in all classrooms. Numerous drawings previously made by the students are also visible in

these studios; these reflect a variety of subject matter, including nature study and landscape, which were taught before any study of the human form, thus suggesting that a sequential training in art was still the norm in Indian schools.

Estelle Reel and Art

When Estelle Reel replaced Hailmann in 1898 and began to work on a new course of study for all Indian schools, art education was not one of her most pressing concerns; it still maintained a place in the curriculum, but it had a different purpose. While Reel valued art's ability to develop the power of observation and attention, and to transmit ideals of the dominant society, she did not place much emphasis on its creative side and its connection with manual training; she promoted it solely as a valuable vehicle for learning other subjects, such as reading, writing, science, and agriculture, a position she had already expounded in the course of study she penned in 1897 for the Wyoming public schools.[34] However, although Reel followed the blueprint of art educators of the time and thoroughly described drawing instruction year by year in a total of four pages, she did not include any information in the 1901 *Course of Study for Indian Schools of the United States Industrial and Literary*. This is indicative of a new, yet limited conception of art education for Indian children.[35]

Drawing was not contemplated by the superintendent as one of the activities best suited to developing students' manual skills. This is not surprising when one considers that Reel had no sympathy for painting, sculpture, and other fine arts in Indian schools. She believed that Indian people were not civilized enough for the white man's arts. In her eyes, racial inferiority was a main obstacle to the Indians' achievement of a higher level of art. Secondly, Reel's hostility toward art was dictated by very practical reasons: it did not prepare students for the job market, as this did not require leisured refinement. The training of the eye and the hand, particularly finger skills—necessary prerequisites for becoming good laborers—was instead better achieved through practical activities such as sewing, raffia and cane work, and eventually basketry. It was this kind of creative training that best suited Indian students because it "concentrate[d] the forces of the brain, hand, and eye to accomplish a set task" and was a

"means of race development."[36] As Professor Woodward of the St. Louis Manual Training School had said in his speech at the 1901 Summer School Department of Indian Education in Detroit, "We must reserve our pearls till a higher plane has been reached. . . . To attempt the refinements of literature and art would be to sow seed on stony ground."[37] Reel fervently shared Woodward's opinion in this regard.

Drawing, therefore, was not to be a subject with its own inherent worth and usefulness, but was rather one of the means through which more beneficial skills, such as reading and writing, could be taught and learned. Teachers could implement it in their lessons as long as it contributed to the main class work. Drawing was thus seen as a practical activity that could become valuable only insofar as it was serviceable to the learning of other skills. There was no explicit intention of promoting it for the development of children's visual acuity or the training of their eyes and hands, as Morgan had recommended years before. For Reel, drawing had to be strictly functional and subordinate to those classroom exercises that would have contributed to the tangible improvement of students' progress. This is why classroom samples were always requested for the public exhibitions of the Indian Office's good work; they were standardized measures of advancement.

Art activities did not disappear from the curriculum but became appendages to other, more important undertakings, whether strictly academic or not. For example, Reel recommended clay modeling and drawing for children in the first year of school; as they learned to speak English by creating a family of dolls to take care of, students used clay, pencils, and crayons to make or draw common objects such as fruit, vegetables, toys, dolls, and household items.[38] The daily repetition of these activities allowed the child to learn the words associated with these objects and thus expand her vocabulary. In the second year, clay and crayons were used to facilitate additional language work, reading, and writing; Reel instructed teachers to "have the children mold an apple from clay, color it green or red, and insert the stem. . . . The objects may be drawn on the board and the name of their colors written within or above them. While working, conversation will make the words familiar."[39] The words were read and erased and children were asked to repeat them from memory and, eventually, to write

them on their own. Similarly, teachers would read stories, tell students to draw pictures on the blackboard representing what they had just heard, and then ask them to retell the story from the drawing. These exercises were constantly repeated, each time with new words and scenarios, for example, in the sewing room, thus allowing pupils progressively to learn speaking, reading, and writing in the English language.

A 1902 photograph, "Blanket Weaving in the Class Room as Suggested by the *Course of Study*, Fort Lewis School, Colorado," included in the *Report of the Superintendent of Indian Schools* to demonstrate the work in Native industries, also reflects the nature of the simple drawing exercises recommended by Reel. It shows a student posing next to a loom displaying her finished blanket and, behind her, a small easel with a chart of geometric figures and a blackboard with two rows of chalk drawings of everyday objects and their corresponding spelling. This image affords additional evidence that drawing and other art occupations did not have a central role in the daily classroom work of Indian students but were employed as aids for other kinds of learning. According to art historian Elizabeth Hutchinson, knowledge of such objects in fact implied the acquisition of Euro-American values and cultural traits, in this case domesticity (represented by the cup and the cat), good manners (the western hat), and government authority (book and flag).[40] The choice of vocabulary, therefore, was not casual but carefully considered to ensure that while students learned the English language, they also assimilated the ideals of mainstream American society.

The 1901 *Course of Study* is filled with evidence that drawing was to be an auxiliary aid for learning and not a main subject of instruction. For example, it was used in the sewing room to understand the tools used in the trade before introducing students to the design of dresses and other garments. According to Reel, teachers had to spend at least five minutes a day showing pupils how to draw a needle, thread, spool, and eventually stitches by sketching them on the blackboard and having students copy them onto their own sheets of paper. In nature study, students were instructed to make "properly colored drawings of all vegetables and fruits raised in the locality" as well as of each part of a plant and "each tree whose fruit is being studied."[41] In fourth-year geography classes, drawing was used to reproduce traditional crafts, such as pottery and basketry, when studying

people who lived on reservations, their work, and their influence, whether Indians and pioneers. Reel wrote:

> Drawings of the principal industries must be made. For example, if pottery or basketry be the work of the tribe, have the pupils make drawings of the different shapes they have seen at home. Stimulate effort in this direction by having pupils try to see who can bring the largest number of shapes. These drawings must be colored in the schoolroom to correspond with the articles seen at home and then carefully preserved, as they will be great helps in the work of teaching the native arts and perpetuating the work of the older members of the tribe.[42]

These directives suggest that Reel was adamant in having children reproduce as closely as possible the crafts made by the adult members of their tribes, and while she claims crafts perpetuation as her guiding principle, I believe she was motivated by the need to imitate what was commercially successful, that is, the crafts of the past. In this light, drawing was not an instrument employed to maintain Native crafts per se, but rather a practical tool with which the objects' aesthetic features were to be forever captured for a later use, first as supplementary classroom materials—likely by Anglo teachers—and eventually, as future economic opportunities for personal extra income.

Finally, drawing was employed in the creation of scrapbooks. In the section on reading and language work for the third year, Reel wrote that each child "is expected to make a book showing everything learned in classroom and in laundry work, also containing drawings of utensils used and of pupils engaged in the occupation, showing the different stages of work."[43] A few original drawings found in the Estelle Reel Papers, and dating to the early 1900s, beautifully illustrate how these directives were implemented in the classroom. Although to my knowledge no scrapbooks have survived, photographic evidence shows that the existing drawings were intended for this use and were publicly displayed in exhibitions organized in connection with the annual NEA meetings to demonstrate the progress made by Indian schools.

A series of crayon and watercolor drawings made by students from the Oneida Indian School in Wisconsin for the 1902 exhibit in Minneapolis illustrate some of the subject matter Reel wanted to see: nature studies,

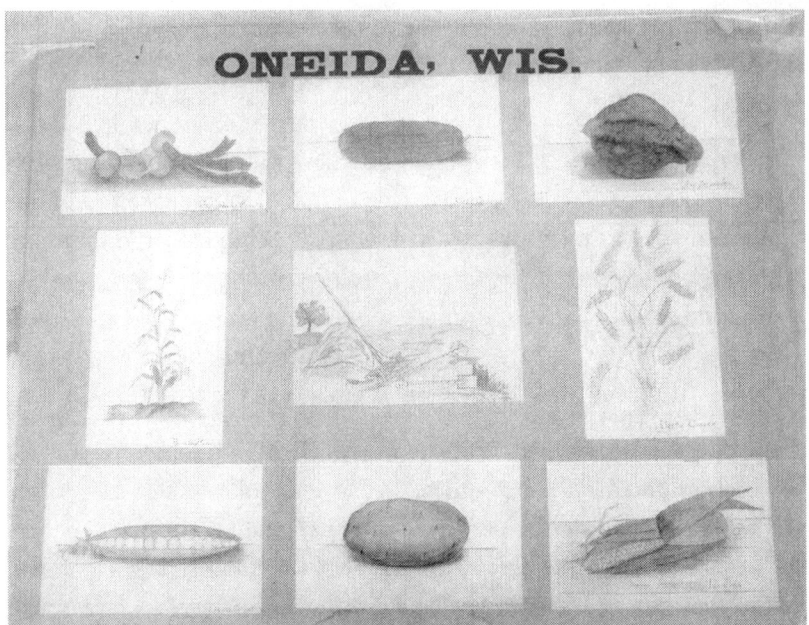

Fig. 9. Display board with nine drawings of agriculture, vegetables, and implements by the students. Estelle Reel Collection, Northwest Museum of Arts and Culture / Eastern Washington State Historical Society, Spokane, Washington, MONAC no. 17.

tools and utensils, and pupils engaged in various activities and occupations. Nine of these drawings are mounted on a large poster board; six of the pieces represent vegetables, two depict plants, and one shows a group of farming tools. The vegetables are a small bunch of radishes, a cucumber, a squash, a pea pod, a potato, and an ear of corn. All are depicted on a plain, two-dimensional background where the perspective is conveyed by a simple diving line and some degree of shading to indicate that the objects are placed on a flat surface. Each drawing is executed with precision and proper use of colors, rendering the vegetable in minute detail. Similarly, the two plants, corn and wheat, are meticulously drawn and reveal a good knowledge of the crops' characteristics (fig. 9). The drawing of farming implements distinguishes itself from the other eight in the set in that it depicts not only the tools but also the landscape. However, despite the presence of a plowed field and a lone tree, the background is mainly left

empty. Likely made under the supervision of a teacher, this work is an example of the "colonization of consciousness" that was being carried out. Three tools—a rake, a hoe, and a spade—have been left unattended on a field where civilization (represented by the farming implements and the stump) has already left its mark, a symbol of progress. Most importantly, there are no farmers on the horizon, suggesting that each person has to learn to work as an independent citizen, not as a member of a community.

This emphasis on individuality and self-sufficiency is evident in three other crayon and watercolor drawings from the Oneida School. The first two drawings, likely made by the same fifth-grade student, show a girl at a laundry tub washing clothes (fig. 10) and another girl holding blue yarn (fig. 11). Both figures, dressed in school uniforms and with their hair pulled back, are standing against an interior, unadorned background and are portrayed from the side so that the viewer, that is, the teacher, Super-intendent Reel and eventually the American public, can better distinguish the activity in which they are engaged. The girls' facial expressions cannot be distinguished. A third drawing (fig. 12), perhaps by the same fifth-grade student, depicts a boy standing at attention and holding an American flag, his body and face turned away from the viewer. The grass on which he stands is the only indication that he is outdoors. This lack of other elements, whether animate or inanimate, was yet another indirect tactic to isolate Indian children from their tribal customs and communal ways of living and instill in them mainstream American values of self-sufficiency, inde-pendence, and hard work. Similarly, the immaculate environment in which the subjects of the drawings were placed also reveals the indoctrination that was underway: students, particularly girls, had to learn the Victorian ideals of domesticity, cleanliness, and propriety in order to become good housekeepers, housewives, and eventually mothers.[44]

A few more examples of students' drawings—likely made before 1910 by students from the Carlisle Indian School, the Pawnee Boarding School, and the Oneida School—were found in the Estelle Reel Papers (figs. 13 and 14); they provide further visual evidence of the work done in Indian schools during her tenure.[45] Mounted on large poster boards, they were also displayed at Indian exhibits organized for the NEA meetings. Their subject matter consists of flowers, nature study in the form of fruits and

Fig. 10. (*above left*) Fifth-grade artwork of girl doing washing, Oneida Indian School, Wisconsin. Estelle Reel Collection, Northwest Museum of Arts and Culture / Eastern Washington State Historical Society, Spokane, Washington, MONAC no. 15.

Fig. 11. (*above right*) Fifth-grade artwork of girl holding yarn, Oneida Indian School, Wisconsin. Estelle Reel Collection, Northwest Museum of Arts and Culture / Eastern Washington State Historical Society, Spokane, Washington, MONAC no. 15.

Fig. 12. (*opposite*) Boy holding flag, Oneida Indian School, Wisconsin. Estelle Reel Collection, Northwest Museum of Arts and Culture / Eastern Washington State Historical Society, Spokane, Washington, MONAC no. 15.

vegetables, simple landscapes, and still lifes. They were made using pencil, ink, crayons, and watercolor. Some drawings are quite simple, such as the small apple and the flower on the first board, or the sails and city landscape on the second. Others display careful attention to detail and the material properties of the object—for example, the radishes, carrots, and apples on the first board, and the white roses and red carnations on the second. Finally, other drawings are more stylistically elaborate, presenting the use of perspective and a more developed sense of shading; among these are the fireplace and the flowers on the second board.

Fig. 13. Display board with seven examples of student drawings. Estelle Reel Collection, Northwest Museum of Arts and Culture / Eastern Washington State Historical Society, Spokane, Washington, MONAC no. 16.

All of the works in figures 13 and 14 reveal a high quality of execution and greater artistic skills, which could mean that the students were more gifted and thus better artists, or it could mean that the drawings, though attributed to students in specific grades, may have been made by older children who had not been placed in their age-appropriate grade. For example, the carrots on the top right of figure 13 were made by a third-grader. Similarly, the roses on the Oneida board were made by a fourth-grader, while the carnations on the bottom right were made by a fifth-grader (fig. 14). As noted earlier, when students entered boarding schools, they were placed in a specific grade according to their overall skills and developmental level, not by age; it was not surprising, therefore, to find a twelve- or thirteen-year-old in one of the lower grades. Unfortunately, I am unable to identify the exact ages of these particular pupils. What is obvious, however, is that these students made superb drawings.

"An Indispensable Adjunct to All Training"

Fig. 14. Display board with nine examples of student drawings. Estelle Reel Collection, Northwest Museum of Arts and Culture / Eastern Washington State Historical Society, Spokane, Washington, MONAC no. 15.

With very few exceptions—such as the sailboats and the fireplace—these works denote that students were directed to depict situations and objects that specifically dealt with school life, including what they were learning. Personal creativity and self-expression, now in vogue in mainstream institutions, were not a major concern here in Indian schools and thus were not encouraged. These drawings distinctly suggest that almost a decade after Morgan's tenure as commissioner of Indian Affairs, and despite the adoption of more progressive ideas linking classroom work to the home, shops, and farms, the nature of the art curriculum of Indian schools remained virtually unchanged. Except for a brief period during Hailmann's superintendency, contemporary theories of art education were largely ignored, at least at the official level. Indian students needed to improve their skills and acquire the working and living ethic of white America, and this is the kind of training they were supposed to receive;

drawing had to serve these goals and nothing else. Although progressive textbooks such as the Prang system were used in many classrooms, practical art instruction never really progressed.[46]

One final element that emerges from examining the nature of art education in the Indian Service is that schools, with the exception of Carlisle, did not have a position of art or drawing teacher. Official records of employees from 1890 to 1910 reveal that Carlisle was the only institution that hired a teacher for the sole purpose of teaching art.[47] According to the *Indian Helper*, the Carlisle student paper, in 1894 Marie Northington had "undertaken a class of Indian students in art" and she was "gaining an enviable reputation for her beautiful paintings and other works of art." The publication also reported that under her direction the Indians' natural talent would "no doubt bud and blossom into a thing of beauty and usefulness."[48] Two years later, on October 23, 1896, Elizabeth Foster was hired to be the school's drawing teacher, a position she held until 1903.[49] According to Pratt's 1897 report, the drawing classes had had "special instruction in charcoal work" and the results showed that "when opportunity is given, the Indian as a class is not inferior in these lines to the more favored Anglo-Saxon."[50]

In all other Indian schools, drawing was taught by regular classroom teachers who, as part of their preparation, should have received some basic art training. When filling out an application for employment in the Indian Service, interested parties were asked to specify whether they had "skill in drawing and painting."[51] However, if hired and lacking adequate training prior to their appointment, teachers were not required to attend summer classes or special art institutes in order to improve their artistic abilities.[52] The lack of an official position for drawing teacher in the Indian Service shows that art education, although considered important, was not prioritized, and that whatever knowledge teachers had at the time of their appointment, it would have sufficed to impart the kind of art instruction Indian students were expected to receive in order to succeed in their academic and industrial training.

Drawing after 1910

Estelle Reel's 1901 *Course of Study* did not place much emphasis on drawing, but the new classroom guidelines that were published by her successor,

"An Indispensable Adjunct to All Training"

Harvey B. Peairs, after she left office did. The *Tentative Course of Study for United States Indian Schools*, published in 1915, and written by a committee of nine school superintendents under Commissioner of Indian Affairs Cato Sells, included an extensive section on this subject, detailing instruction from the first to the sixth grades. Sells and his aides clarified that this outline was not intended "to be followed in detail" but had to be adapted to the local conditions and most of all to the students under the care of each teacher. They stressed the importance of selecting a number of pictures for decorating the schoolroom and of correlating drawing with other academic subjects, particularly English and arithmetic, as well as with shop and farmwork.[53] The most interesting feature of this course outline is the division of the work for each grade by season, following the academic cycle and thus starting with fall and ending with summer. The reasons for this approach were multiple: first, it intended to make students learn about the changing reality of their surrounding environments and thus develop their power of observation and sense of taste; second, it introduced them to the calendar and its important national celebrations, thus instilling a conception of time and a sense of duty and responsible citizenship; third, it made drawing relevant to the students' lives and thus allowed more efficient learning.

Each season included work in four categories: drawing and painting, imaginative drawing, construction, and picture study. The subject matters of drawing and painting were natural elements, such as plants, trees, leaves, fruit, flowers, and landscape, suggested by the season but also by holidays and celebrations such as Halloween, Christmas, Lincoln's and Washington's birthdays, Memorial Day, and Arbor Day. For imaginative drawing, students were asked to creatively sketch objects, animals, or people that reminded them of the particular season they were in at the moment or, in more advanced grades, to illustrate words and phrases from their English lessons. In addition to these, construction activities such as cutout designs and the making of simple objects related to the seasonal festivities, for example jack-o'-lanterns, Pilgrims, and calendars were made. Finally, students dedicated some time to the study of famous pictures, once again in theme with the season. All drawing and painting were done with pencils, watercolors, and crayons.

The nature of this drawing curriculum and the lack of textbook recommendations indicate that teachers no longer had to follow the learning trajectory proposed by drawing manuals. Instruction was not organized according to levels of difficulty and students were not asked to start with the rudiments of lines and angles and proceed to more complicated forms. This approach to drawing was certainly less rigid and allowed more freedom of expression, although students were still asked to use their imaginations within the confines of very specific areas. Another interesting feature of this course of study is that it included an overall outline indicating for each grade the time that teachers were to spend daily on each subject. In the primary division (first through third grade), drawing was to be taught alternatively with writing for twenty minutes, and for twenty-five minutes in the prevocational division (fourth through sixth grade). This subject was not taught to students in the seventh through tenth grades since their time was devoted to subjects with vocational application such as drafting, vocational arithmetic, industrial geography, agricultural botany, farm and household physics, chemistry, rural economics, insects and insecticides.

Overall, the main difference between this new drawing curriculum and those of the past was that the new approach was much more comprehensive, detailed, and varied in the kinds of activities students could engage. Apart from this, the subject matters, the methodological approaches, and the rationales for this type of instruction seemed to have remained unaffected. The superintendents who penned the art program had a more direct knowledge of the Indian classroom than Washington bureaucrats or public-school educators, so they targeted the specific needs of their student population, yet what they attempted to do was in part to bridge the curricular gap between Indian and mainstream institutions while continuing to impart Western values. Despite its shortcomings, however, the *Tentative Course of Study* had a few positive consequences: firstly, by freeing teachers from rigid modules, it allowed more flexibility in the classroom and consequently a little more individual creativity for the students, although not complete freedom of expression; secondly, it was the result of a collaborative effort that for the first time considered the needs of Indian children in a more human, constructive, and relevant way.

Notwithstanding the good intentions of Sell's course of study, art

education slowly declined in Indian as well as in public schools. One of the main reasons for this was the outbreak of war in Europe and the eventual U.S. entrance into the conflict; another one was the rise of social efficiency, an educational doctrine pushing for programs that gave students only those skills necessary for their future roles in society and nothing more. Renewed emphasis was thus placed on industrial or vocational training, while academic subjects that did not meet the demands of labor and the war effort became marginal or completely disappeared.[54] Drawing in Indian schools, while not taught for personal refinement or the expression of individual feeling as in public schools at the time, became even more marginal and inconsequential. American commerce and industry demanded an efficient labor force, and as this need became more pressing because of wartime shortage, Indian schools were called to produce unskilled or semiskilled workers for specific jobs in farm fields, construction, service, and domestic labor. Classroom time needed to be used more effectively, and painting pictures did not meet this requirement.

With the exception of a few years during William Hailmann's tenure (1894–98), when drawing was valued for its potential to develop individual creativity and self-expression, this instruction was considered useful exclusively for its practical and economic benefit, that is, the improvement of mental and manual skills, the instilment of values, discipline, and the development of a sense of taste. While it might seem obvious that Indian children were the main beneficiaries of this training, a closer analysis indicates that these outcomes were instead ultimately desired for the good of American society: the development of skills was intended to make children better workers, Anglo values were imposed to distance students from their tribal heritage, discipline was used to teach them a sense of responsible citizenship, and taste was developed to make them better producers and consumers. These newly acquired features were not designed to ensure that Indian students had competitive skills to find meaningful employment, especially in professions, but rather so that America had a cohort of efficient, productive, and docile workers.

3

"Show Him the Needs of Civilization and How to Adapt His Work to the Needs of the Hour"

Native Arts and Crafts in Indian Schools

> The fact that the Indians naturally possess great finger skills
> should be taken into account whenever we are considering
> means to whereby help them to become self-supporting.
> —Estelle Reel, *Report of the Superintendent of Indian Schools*

Blanket weaving, basket making, pottery, beadwork, and other traditional Indigenous art forms were not contemplated in the curriculum of Indian schools in the early days; government policies, still ringing of Captain Pratt's statement that "there must be no holding onto Indianism in this transformation," called for the complete eradication of every aspect of Indian cultures.[1] As children needed to forget their Native languages, customs, and ways of living, they also had to turn their backs on their expressive visual traditions. Starting from the mid-1890s, however, Native arts and crafts assumed a different meaning and role, first with William Hailmann and then with Estelle Reel. Superintendent Hailmann was the first one to suggest that the teaching of Native crafts in Indian schools was not only appropriate but also necessary for the preservation of these authentically American art forms, and while he opened the doors for change, he did not concretize his ideas into curricular implementation. A few years later, Superintendent Reel took this position to the next level and ensured that

the training in "Native industries" became institutionalized and officially part of the curriculum of Indian schools. Although her rationale was not the same as her predecessor's, she was the real mastermind of this apparently minor yet significant turn in Indian education.

What were the reasons behind this new approach? Why, suddenly, were Indian arts and crafts considered worthy of instruction and thus officially sanctioned? The public endorsement of these intrinsically Indigenous activities in government schools was not an isolated leap of generosity toward the "poor Indian" but was rather part of broader political, social, and cultural changes. Scholars of Indian education have attributed this unexpected mandate to shifts in Indian policy, a new outlook on arts and crafts as "safe" cultural differences, and the economic profitability of these industries.[2] Their appearance in the curricula of Indian schools, however, cannot be divorced from contemporary changes in the educational agenda of public institutions. As discussed in chapter 1, public schools introduced art instruction—both drawing and arts and crafts—as a tool for basic mind-training of the lower classes and immigrant children: lessons in color and form were to enhance the power of observation and the proper way of seeing, while practical exercises in craft making eliminated inaccuracy, impulsiveness, and negligence. These were the same justifications for Native industries in Indian schools, particularly under Reel: children needed to be taught a disposition of mind in order to fit into the white world. Thus, moved by the revived interest in Native American cultures and the surge in demand for their traditional crafts, Reel planned instruction in a carefully selected number of art forms with the conviction that they could impart an appropriate Anglo-American work ethic that valued accuracy and care, a productive use of time, material goods, and economic self-sufficiency.

Paving the Road for the Inclusion of Indian Arts and Crafts

The Carlisle Indian Industrial School opened with the goal of preparing students for a working life in the white world on an equal footing with Anglo youth; the reality was, however, that the majority of pupils returned "to the blanket," back to their homes, and often with a knowledge that could not find practical application in the diverse environments of reservations. What was deemed more appropriate for the living conditions awaiting

"Show Him the Needs of Civilization"

students after school was a less academic and more practical education that placed greater emphasis on industrial and domestic training. For boys this meant learning to farm and work in manual trades such as blacksmithing, carpentry, shoe and harness making, tailoring, farming, gardening, and dairying; for girls it implied a thorough knowledge of the home and tasks such as cooking, baking, butter making, serving meals, sewing, laundering, ironing, and care of farm animals.[3]

Emphasis also shifted from off-reservation schools to schools located on the reservations, which were deemed more appropriate to prepare students for the kind of life they were expected to live after graduation. These changes in attitude mirrored two main ideas of educators and policymakers of the time: first, that Indians' learning abilities were inferior to those of white students; second, that Indian children were no longer expected to compete, but rather to learn their place in society by making a living within certain fields. The first belief resulted from the realization that because of his or her innate primitive and thus second-rate qualities, the Indian could not assimilate as quickly and completely as had been hoped; Indian people possessed the traits of a backward civilization that was still at the lowest stage of social development and these inherited racial characteristics could not be instantaneously eliminated. Somehow they had to be taken into account in a more gradual, civilizing approach. The second viewpoint was a direct consequence of the first: since Indians could not fully assimilate into American society, they could not rival their Anglo brothers and sisters. Education for class subservience better reflected their abilities and society's expectations. When Reel became superintendent, this view was well-established and was once more reiterated in her first official report: "Industrial training should have the foremost place in Indian education, for it is the foundation upon which the government's desire for the improvement of the Indian is built."[4]

Another fundamental factor that brought modifications in Indian policy and education was the belief that with the anticipated disappearance of the Indian and the closing of the frontier, Native cultures and artistic expressions would vanish as well. The Chicago World's Fair of 1893 and other smaller and more regional expositions strongly contributed to impressing the idea of the "vanishing Indian" on the American public; this, in turn,

signified a change in the way Indians were perceived. Historian Frederick Hoxie clearly describes this new general sentiment:

> Like the prairie schooner and the roughhewn cabin, the Indian too would slip into history. The race would become more important for what it represented than for what it might become. As the frontier began to evoke nostalgia rather than dread, Native Americans would cease to be an immediate threat that required bludgeoning or "civilization." The need to eradicate native cultures faded with the memory of the frontier struggle. In the new century, Indians . . . would become a valued part of a fading, rustic landscape.[5]

Arts and crafts were seen as part of this historical past and, therefore, of America's real past, that was fast disappearing. Philanthropic associations, anthropologists, artists, scholars, and reformers all agreed that Anglo intervention was the only way to preserve these crafts. The Indian had, according to Samuel C. Armstrong, principal of Hampton Normal and Agricultural Institute in Virginia, "the only American art"; it was a duty of the American people, therefore, to preserve a patrimony that was valuable to the entire nation.[6] Starting from the 1880s, members of reform groups such as the Women's National Indian Association, the Indian Rights Fund, the Indian Industries League, and the Friends of the Indians annually gathered to advance and recommend policy reforms that took Native culture into greater consideration in and out of the classroom; Native arts and crafts in particular were lobbied as activities that could lead Indian women to economic self-sufficiency.[7]

The influence of the Arts and Crafts Movement and its critique of mechanized labor had also been instrumental in reviving interest in preindustrial societies and old ways of living that were not corrupted and made ugly by the advent of machines and mass-scale production; rather, they coexisted in organic harmony with the natural rural environment. This rejection of industrialization had generated nostalgia for a past agrarian life and a reevaluation of American Indians and their roles in society. They became the prime examples of authentic primitive cultures on the American soil, thus engendering a growth in anthropological tourism and new markets for their traditional crafts. For middle- and upper-class Anglo women, the

"Show Him the Needs of Civilization"

"discovery" of Indigenous art forms had two practical applications: first, they could escape the harsh reality of modernity by learning Native-style handmade crafts for their own personal leisure and home decor. This was most commonly accomplished through books, journals, and women's magazines that were popular at the turn of the twentieth century or through special workshops or summer institutes such as those sponsored by the Chautauqua Institute. Second, they could personally contribute to the philanthropic efforts of preserving, promoting, and marketing Native crafts and thus indirectly help the assimilation of Indian women. In addition to feminine accomplishments such as fancywork and needlework, the Aboriginal crafts of weaving, basketry, and pottery came to be considered dignified occupations that offered an economically viable and domestic alternative to dependent work and that could lead to self-sufficiency. Anglo patrons, therefore, transformed the crafts revival into a "revivifying hobby for the affluent," as anthropologist T. J. Jackson Lears has pointedly stated, for the concomitant purposes of home beautification and amelioration of Indian life.[8]

Thanks to a completed intercontinental railroad system that connected the Atlantic to the Pacific Oceans, the Southwest turned into a magnet for tourism and authentic Native crafts, and California, Arizona, and New Mexico Indians became the epicenter of philanthropic and marketing activities. As associations of wealthy white patrons championed American Indian rights, traders, anthropologists, tourists, and private collectors acquired, sold, and exchanged California baskets, Navajo rugs, and Pueblo pottery, thus contributing to saving and promoting Indigenous crafts through the ethnic art market and the curio trade.[9] Recommended by proponents of the Arts and Crafts Movement, such as furniture designer Gustav Stickley, these items were ideal for decorating tasteful homes that reflected domesticity, womanhood, the connubial values of beauty and utility, and a certain status within society. It is in the midst of this "Indian craze," as scholar of American Indian art Elizabeth Hutchinson has called it, and following the curricular changes in public institutions, that Native arts and crafts found their place in Indian schools, welcomed first by Hailmann as activities that could enhance practical training, and second by Reel as opportunities for developing an American work ethic and progressing toward self-sufficiency.

William N. Hailmann, a noted educator and writer trained in the Froebelian school and one of the main promoters of the kindergarten movement in the United States, strongly favored a progressive education that integrated classroom learning with practical work in the shops, the farm, and the home. He believed that children could learn best when practical knowledge, sensory experience, and creativity were emphasized; consequently, he envisioned Indian education as cultivating the students' needs through enjoyable, interesting, stimulating, and thus rewarding hands-on activities and play. In line with Froebel's ideas, Hailmann regarded arts and crafts as important elements of a school's curriculum and had already suggested their application in *Kindergarten Culture* and *Primary Methods*, two of his publications on education; for Indian children these activities were even more relevant because they could easily connect the work done in the classroom with the students' heritage and personal experiences. The superintendent discussed the introduction of Native industries for the first time in his 1894 annual report, when he wrote that "additional gain might come in the industrial training by taking into account at the different schools the local Indian industries, such as tanning and pottery among the Pueblos, blanket-weaving and silver-work among the Navajoes, boat-building among the Indians of the Puget Sound, etc."[10] Hailmann proposed to include Indian industries as part of the practical training students received in the shops without specifically differentiating between activities for one gender or the other.

It is not a coincidence that this recommendation was formulated the same year that attendees at the Lake Mohonk Conference favorably agreed on the creation of the Indian Industries League, an association to "build up self-supporting industries in Indian communities."[11] Hailmann's educational policies were not estranged from the larger political and social reforms of the time and fit within the debate and resolutions on the overall status of American Indians. Unfortunately, there is no evidence that any school implemented his proposal by offering instruction in one of the industries of the local Indians; neither the superintendent's annual reports nor those of several school principals reveal such information. Similarly,

these documents do not provide any evidence that Hailmann's solicitation was repeated in the following years of his mandate.[12] This may suggest that while the conditions to introduce some changes in the boarding schools curriculum were in place—reform groups supported the initiative, the Indian Office was favorable, elements of Native cultures were reappraised by the American people—administrators at the local level were either unwilling or unable to implement these guidelines, particularly since they were not mandatory and required additional time and expenditures.

When Estelle Reel took office in 1898 and began to work on a new, unified curriculum, the *Course of Study for Indian Schools*, she added instruction in a selected number of gendered crafts such as Native basketry, pottery, weaving, and beadwork, thus embracing philanthropists' concerns for the preservation of traditional art forms and educators' promotion of industrial training that would lead to a good work ethic and self-sufficiency. Reel's decision to include the teaching of what she called "native industries" was undoubtedly influenced by the political, social, cultural, and educational climate of her time. While serving as superintendent of the Wyoming public schools, she was the NEA honorary vice president and state director for Wyoming, which means that she was aware of the nature of discussions at the annual meetings.[13] Furthermore, she attended some of the reform groups' conferences and was personally acquainted with members of the Indian Industrial League, particularly Nellie Blanchan DeGraff Doubleday, who had sought the attention of the superintendent to discuss the development of a basketry industry in Indian schools.

From philanthropic groups, Reel borrowed ideas on the economic profitability of crafts, especially for Indian women. However, while she claimed that Indians' financial well-being and self-sufficiency were the principal motives for teaching arts and crafts and for the new curriculum guidelines overall, a close examination of her *Course of Study* suggests that the real economic rationale for Native industries was the necessity to supply market demands for handmade Indian goods. Clearly the two go hand in hand as Indian people could not derive any economic benefits in the absence of consumers' requests and without their participation in a market economy; however, Reel seemed to be more concerned with a timely fulfillment of

these requests—now that demand was high—rather than providing quality instruction that would benefit students in the long run.

Reel's Economic Rationale: Benefits for Indians versus Benefits for Society

The basketry section of the new course of study opened with the following statement: "It is desired that the tribes that make especially good pottery, weaving, or basketry teach the children of the tribe the art, and equip them with the ability to *put on the market* [emphasis added] as useful, durable, and beautiful articles as could their ancestors."[14] Right from the introductory paragraphs, this new curriculum spoke of Reel's main concern: to satisfy consumers' demands for Native handicrafts. The Indian pupils' welfare, a natural consequence, was secondary. This document and all the annual reports penned by the superintendent during her tenure unmistakably reveal this agenda: through very specific language, they articulate the importance of arts and crafts to provide first and foremost for society's wants. In doing so, they marginally reference the economic benefits students can derive from their work. A thorough textual analysis revealed a strong prevalence of the former over the latter.

Table 2. Language Denoting Benefits for Society versus Benefits for Indians in Reel's *Course of Study*

Benefits for society	page	Benefits for Indians	page
"*Supply the demands of the market* for such baskets"	54	"*A good living* is in the hands of those who will faithfully portray the work of their ancestors"	55
"That the pupils may become skillful in doing the work and thus be able to *place upon the markets* the beautiful blankets"		"Soft, well-made moccasins and other articles of Indian manufacture *will always find sale*"	56
"Indian work is *always in demand*"	55	"And thus take a long step in the direction of *self-support*"	57

"Show Him the Needs of Civilization"

"Equip them with the ability 56
to *put on the market* as useful,
durable, and beautiful articles"

"Basketry must take the lead,
since *the demand* for this arti-
cle is great everywhere"

"All children [of basket-making
tribes] must learn the art, since
many skilled workers *are nec-
essary to supply the demands* of
the time for these baskets"

"Many other baskets made by
Indians . . . if *put into stores,*
would attract and surprise
purchasers by their beauty and
durability"

"The caution against using
aniline dyes is repeated, since
they fade and "run" and *detract
from the value* of the baskets"

"Why should not our Indians 57
do this and *make our greatly
needed articles* in straw?"

"*Needs of the world*"

"The Indians as people must
be led to see the importance of
developing the work they are
so gifted in doing and to *help
supply the market's demands*"

"*Their work is appreciated and
needed*"

"Our own Indians should be
the producers and the benefi-
ciaries *in supplying the demands
for baskets*"

"Our own Indians should be
the producers and *the beneficia-
ries* in supplying the demands
for baskets"

"*The revenue* arising from this
industry *would be important*"

"Can acquire the skill *to make baskets of great value*"	59	
"In the tribes of potters, criticise [*sic*] the work and *see just what it lacks for utilitarian purposes*"	131	
"With the help of improved methods, make his wares *serviceable, stronger, and better, and hence marketable*"	131	
"*Show him the needs of civiliza-tion and how to adapt his work to the needs of the hour*"	131	

Emphasis added. Source: *Course of Study for Indian School Industrial and Literary* (Washington DC: Government Printing Office, 1901).

Table 3. Language Denoting Benefits for Society versus Benefits for Indians in *Reports of the Superintendent of Indian Schools*

Benefits for society	Year and page	Benefits for Indians	Year and page
"Although there is *a large demand for these articles,* solely because of their artistic beauty and symbolic designs, they should be *adapted to modern uses, in order to create a wider market.*"	1902, 20	"One of *the most efficient helps* in the work of making the Indian independent is the encouraging of the useful native arts."	1902, 20
"The making of lace *of modern designs* is another direction in which the great *natural skill of the Indian is being utilized.*"	1902, 20	"The necessity for pre-serving these arts and *simultaneously providing means of livelihood for the Indian* is obvious."	1903, 17

"Show Him the Needs of Civilization"

"Beadwork done by children at Oneida school in Wisconsin has found *ready sale*. In beadwork they have been instructed in making belts and pockets, bags, purses, lamp-shades, watch and fan chains, and collars." 1904, 22

"Even while they are engaged in other productive work . . . they can simultaneously prosecute this industry and *make of it an added source of income*." 1903, 21

"At Bena, Minn., the pupils have made beaded belts and bags and *useful articles* of birch bark." 1904, 22

"The bead fan chains made at Chilocco, Okla., *have netted a nice profit to the Indian girls*." 1904, 22

"The pottery made by the Moquis of Arizona and the Pueblos of New Mexico *finds ready sale and the supply does not meet the demand* for this symbolic and artistic ware." 1904, 22

"The *demand* for native Indian work has *very largely increased* during the past five years" 1904, 23

"A great deal has already been accomplished, but much remains to be done if we would preserve the native industries of the Indian, whose historic associations, no less than *their material value*, appeal to us to save them." 1904, 24

"These blankets [Navajo] have become well known and *the demand for them exceeds the supply*." 1905, 6

"Aside from the economic importance of preserving these native arts . . ." 1905, 17

"This will eventually not 1908, 39
only open up a *larger field*
for the sale of products of
the Indian but will enable
him to make a practical
contribution of the native
art of America to the art of
the world."

Emphasis added. Sources: *Reports of the Superintendent of Indian Schools*, 1902–10 (Washington DC: Government Printing Office).

It appears that Reel's goals were to transform Indian students into laborers and skilled producers of authentic (i.e., Indian-made) crafts wanted by a large consumer society; one might consider the number of times she used the words "demand," "market," "supply," "needs," "sale," and "stores"—a total of sixteen instances in the first three pages of the *Course of Study* basketry section—and compare it to the only four terms indicating Indian economic development ("good living," "self-support," and two others denoting that Indians would be the beneficiaries of revenues). Thus, the *Course of Study* informed teachers and employees in Indian schools that instruction in Native industries was primarily for meeting contemporary demands for very specific types of arts and crafts. That in this process Indians could earn some extra money and contribute to their own economic well-being was a welcomed advantage.

Basketry was the most important example of economically justified artistic exercise. As Reel indicated through the pages of the *Course of Study*, its instruction aimed to provide girls with the necessary skills to supply market requests for Indian-looking objects indispensable in the proper decoration of the home. Young Indian students were thus taught the value of their goods and their role in maintaining the capitalistic growth that was needed for a proper functioning of the overall economy. Furthermore, teaching this industry was relatively safe and was not going to spoil progress toward assimilation for two reasons: first, basketry was turned into a generic type of finger weaving with Indian designs, thus stripped of its Native content and meaning; second, it did not raise their producers to the status of artists or artisans, but simply left them as manual laborers.

Instruction in Indian schools aimed to destroy the cultures that had produced these goods and replace them with a production system that could efficiently create crafts for consumption by racially dominant groups. Training in basketry existed mainly as an economic enterprise that could satisfy the persistent demands of white clients and subordinate Indigenous cultures to the needs of the United States market.

The Cultural Preservation Rationale

A second rationale that Reel gave for the teaching of Native industries in Indian schools was cultural preservation. If Indian people could be brought to produce more crafts and supply the demands of craving Americans, the problem of losing the arts of their ancestors would be solved: an increased production of handmade goods would automatically lead to their survival and continuation. As tables 4 and 5 show, terms like "preservation," "revived," "lost," or "extinct art" appeared quite often in the *Course of Study* (ten times total in the basketry section) and in subsequent annual reports (nine times) as Reel touched upon this issue to discuss the importance of maintaining "all distinctively Indian work."[15] Yet the perpetuation of Native crafts for the sake of their aesthetic and economic value was limited to only a few art forms, namely basketry and weaving, the best examples of Indigenous handiwork and ingenuity, and, not coincidentally, the most prized by consumers.

In contrast, pottery and beadwork were snubbed and relegated to an inferior status that was completely subordinate to a mass-market mentality. In fact, while Reel advocated for a revitalization of traditional methods, the use of Native materials, and original symbols in basketry and weaving, she also suggested the adaptation of the other crafts to the modern needs of the time. For example, in the geography section of the *Course of Study*, she wrote, "In the tribes of potters, criticise [sic] the work and *see just what it lacks for utilitarian purposes,* and seek, not to take the industry from the Indians, but so to improve its lasting qualities that the Indian can continue to pursue the native art, and *with the help of improved methods, make his wares serviceable, stronger, and better, and hence marketable.*"[16] Similarly, in her 1902 report, she stated that "although there is a large demand for these articles [ornamental and useful articles, such as moccasins, purses, belts, etc.], solely because of their artistic beauty and symbolic designs, they

should be adapted to modern uses, in order to create a wider market."[17] Reel is plainly conceding that more traditional items would not have found ready sale. Patrons were interested in "belts and pockets, bags, purses, lampshades, watch and fan chains, and collars," which were successfully made and sold, for example, by the children of the Oneida school in Wisconsin; it was these kinds of ornamental goods that Indian students all over the country needed to produce.[18]

Table 4. Language Referring to the Preservation of Indian Arts and Crafts in Reel's *Course of Study*

Excerpts from the *Course of Study*	Page
"The basketry as woven by Indians for generations past *is fast becoming a lost art and must be revived by the children of the present generation*, that they may take their rightful place among the leading basket makers of the world."	54
"Training given the children that *will enable them to continue the work begun long ago*, and so skillfully executed by their ancestors."	
"The *importance of preserving the Indian designs and shapes can not be underestimated*. The object *must be to weave the history and traditions of the tribe* in all distinctively Indian work, thus *making it historical, typical, and of value*."	55
"Race pride should stimulate them to effort in *preserving* the work of the past."	
"Soft, well-made moccasins and other articles of Indian manufacture will always find sale if there are workers who *will make them of distinctively Indian design*."	56
"Indian basketry *must not become a lost art* and it rests with the children of the present generation to acquire skill in doing the beautiful work accomplished by Indians in the past."	57
"The children must be led to see how important it is for them to learn the arts of making baskets as they were woven by their parents, since but few old Indians are living who can impart this valuable instruction, *and to allow these arts to become extinct is the greatest mistake the Indian of to-day could possibly make*."	

"Originating new shapes and *faithfully reproducing the patterns made by their ancestors* will be an important part of the instruction in basketry."

"At the schools located among the tribes of basket-making Indians, the native basket maker will teach the children basketry, *thus perpetuating the art and endeavoring to show the children of a race whose ancestors have excelled in making baskets that they possess the ability* and can acquire the skill to make baskets of great value." 59

"We do not wish to make the Indian *give up any of the useful and profitable industries* he has been practicing for generations." 131

Emphasis added. Source: *Course of Study for Indian Schools of the United States, Industrial and Literary* (Washington DC: Government Printing Office, 1901).

Table 5. Language Referring to the Preservation of Indian Arts and Crafts in *Reports of the Superintendent of Indian Schools*

Excerpts from *Reports*	Year and page
"During the past year much progress has been made in the native industries. The children from tribes especially skilled in artistic native work have *been encouraged to learn and preserve the arts of their ancestors.*"	1902, 20
"The beadwork of the Indian cannot be equaled, and while the fancy for articles of beadwork may be but a passing one, *rather than let the art be lost it has been thought well to teach it to the children in the schools*, making the work educative, and having the beads and colors take the place of kindergarten material."	1903, 16
"The necessity for *preserving these arts* and simultaneously providing means of livelihood for the Indian is obvious."	1903, 17
"In teaching the Indian children the native industries care is taken to *teach them the industries of their own tribes.*"	1903, 17
"A great deal has already been accomplished, but much remains to be done if we *would preserve the native industries of the Indian*, whose historic associations, no less than their material value, appeal to us to save them."	1904, 24

"With a *view to preserving the native handicrafts of the Indian*, efforts 1905, 15
have been made to have them taught in the schools wherever it was
found that the children took delight in practicing the arts of their
ancestors. It has been deemed especially important to *emphasize
the necessity of maintaining the high artistic standards* which have
made the Indian work famous and have given it its greatest value.
This involves *preserving the symbolic tribal designs and employing only
those dyes and materials which have stood the test of time and use.*"

"Aside from the economic importance of preserving these native 1905, 17
arts, there is a natural feeling among well-wishers of the Indian
which *deprecates depriving his descendants of much that has been a
distinctive feature of his former life.*"

"Each tribe excels in some branch of the numerous Indian arts and 1908, 23
crafts . . . and as you have directed, we have made special efforts
during the past year to have the *teachers revive and perpetuate them
through instruction given to school children.*"

"A concerted effort has been made during the *year to preserve Indian* 1909, 13
*music and songs and to stimulate the practice of Indian arts and crafts
among Indian children.* . . . A number of native experts in various
lines of Indian handicraft are now employed to instruct Indian
children *to produce specimens of the arts and crafts in the same man-
ner as did their forefathers.*"

Emphasis added. Source: *Reports of the Superintendent of Indian Schools*, 1902–10.

Despite Reel's insistence that the teaching of Native industries was for
the purposes of cultural preservation, her stated motives did not seem to
manifest an earnest desire to maintain Native cultures per se; as a matter
of fact, in her eyes, Native arts were nothing more than abstract represen-
tations that did not convey any meaning or philosophical values. They were
"the voluntary expressions of the Indian mind in its native state," that is,
the products of primitive, racially inferior peoples, and as such, they could
not be the carriers of anything but instinctual thoughts and ideas.[19] It is
precisely because Native industries did not contribute to the perpetuation of
tribal values and Indigenous epistemologies that she considered them "safe"
cultural differences that could thus be domesticated in a school setting.[20]
What she intended to preserve, therefore, was not the aesthetically beautiful

artifact that came with cultural baggage, but simply the traditional technique of craft making, the actual process of creating an object with specific Indian imageries from the raw materials found in nature. Additionally, because she regarded the decorative patterns used in Native crafts as purely functional and lacking any inherent meaning, they could have been easily substituted with more contemporary and trendy designs that would have still preserved the overall artistic and aesthetic qualities of the handmade objects.

The Civilizing Rationale

The last, but certainly not least important motive for Reel's endorsement of Native industries was their civilizing power. Reel, in fact, planned instruction in a carefully selected number of art forms also because of their potential to impart values of industriousness, cleanliness, care, and independence. The refining effect of art had been stressed by the superintendent since the beginning of her tenure; as early as 1898, the year Reel took office, she underlined the importance of art, "a delight to mankind," for the uplifting of uncivilized minds.[21] In her first report to the commissioner of Indian Affairs, she praised the Indian's admiration for nature and colors and his imagination in using the natural elements for self-ornamentation, while benevolently and maternally reinforcing the dominant ideas of an innate racial inferiority: "In his rude and uncultured state," she wrote, "the Indian is a novice in works of art. He would exchange a Rembrandt for a highly colored sheet from a yellow journal. Yet, through his native disposition to ornamentation, he can be taught to enjoy higher forms of art than pertain to his primitive state."[22] Reel believed proper art training could advance the Indians' progress toward civilization and the overall quality of their works, but could not turn them into refined individuals; they belonged to a lesser race and because of this they would never possess the ability to discern, appreciate, and consequently create real beauty. This is another reason why she considered Indigenous crafts nonthreatening.

The civilizing effect of crafts was, according to the superintendent, in the act of production: the creation of objects with the work of one's hands, in fact, afforded a manual dexterity that imparted values of precision, care, and industriousness, which in turn could significantly help the transformation of generations of little "savages," particularly women, into productive

workers and homemakers who could contribute to the well-being of their families. Her official reports are interspersed with several references to this potential benefit of Indian crafts. In the *Course of Study*, for example, Reel wrote that "while the child's hand and eye are being trained to accuracy and his observing faculties aroused . . . the finger skill which the child acquires from work of this kind not only lays a valuable foundation for basketry, but trains the faculties in many ways," whereas in a later document she declared that "the making and selling of baskets teaches the Indian the care and value of money and the wisdom of economy and thrift—lessons vitally important to permanent advancement."[23] Arts and crafts perfectly fit within the confines of Indian schools because they could enhance manual skills, improve character, and implant good working habits.

Additional references suggest that Indian girls were taught arts and crafts so that they would learn to keep themselves constantly occupied in useful employments—another proper custom to acquire now in preparation for the future—thus abandoning their instinctive inclination toward idleness and dependency on their tribal communities. Reel suggested, for example, that women could "simultaneously prosecute this industry [basketry] and make of it an added source of income" while engaged in other kinds of work at home or in the farm.[24] Native industries were thus beneficial pastimes through which students could be trained in making valuable use of their hand skills and their unoccupied moments; only by working and appreciating the dignity of hard labor and time they could have become self-sufficient citizens.

The importance of arts and crafts as meaningful occupations to impart diligence and attention was echoed by other Indian Service employees at the yearly summer institutes. Lucy Hart, a teacher at the Oneida School in Wisconsin, for example, spoke at the 1903 summer institute in Albuquerque and said that "Native industries, such as beadwork, basket weaving, and moccasins, have been valuable as a training skill in neatness, as furnishing a pleasant and profitable way of using time," which "might otherwise have been spent in idleness or even less profitably."[25] Similarly, the superintendent of Chilocco, Oklahoma, reported that students made bead fan chains, which not only "have netted a nice profit to the Indian girls," but also "furnished them with profitable work for the idle

hours."[26] These examples show that Native industries were considered civilizing activities because they could be pursued in the spare time for the earning of extra money, thus teaching Indian girls how to properly manage their lives, use their resources and skills, and contribute to their own economic well-being.

The *Course of Study* and the Introduction of Native Industries

Estelle Reel's 1901 *Course of Study* unified the curriculum of government institutions, outlined methods of instruction, and provided a common tool for the evaluation and comparison of students' progress. It covered thirty-one subjects, literally encompassing everything that was needed to train Indian pupils in each aspect of civilized life. As Reel wrote to reservation agents, superintendents, and teachers of government schools, "Aside from the literary branches, the course embraces instruction in agriculture, baking, basketry, blacksmithing, carpentry, cooking, dairying, engineering, gardening, harness making, housekeeping, laundering, printing, painting, sewing, shoemaking, tailoring, and upholstering."[27] The special stress on Native industries was delineated in the basketry section:

> Correspondence is invited with this office from agents and superintendents representing the weaver and potter tribes of Indians, recommending native teachers in these arts. It is desired that the tribes that make especially good pottery, weaving, or basketry, teach the children of the tribe the art, and equip them with the ability to put on the market as useful, durable, and beautiful articles as could their ancestors. . . . Of all Indian work, however, basketry must take the lead, since the demand for this article is great everywhere. In every school where the children are descendants of a basket-making tribe and where suitable materials are obtainable, a good teacher of basketry should be employed, and all the children must learn the art, since very many skilled workers are necessary to supply the demands of the times for these baskets . . . the Indians as people must be led to see the importance of developing the work they are so gifted in doing, and to help supply the market's demands, and thus take a long step in the direction of self-support, which, after all is the end of all Indian education.[28]

Basketry and weaving have been important crafts since the beginning of mankind; their close connection to human survival has made them a vital component of a woman's skills (and oftentimes of a man's) and her domestic responsibilities. In the course of time, these activities came to be seen as indicators of civilization as their mastery marked the upward progress from a primitive to a more advanced stage. Reel believed in the importance of these crafts for the advancement of all human societies: "All civilized nations have obtained their culture through the work of the hand assisting the development of the brain. Basketry, weaving, netting, and coarse sewing were the steps in culture taken by primitive people."[29] It was only logical that these activities were especially emphasized in Indian schools; here, they could contribute to the transformation of hundreds of girls into productive, self-sufficient women able to produce clothing, bring income, and beautify their homes.

In addition to describing basketry and the importance of its instruction, Reel also outlined in minimal detail, as she did for all the other subjects of the *Course of Study*, how it was to be taught, and how its materials were to be procured and used. She recommended starting the instruction in the first year, in order to begin training the students' eyes and hands in accuracy and instill a desire to create beautiful work; schools were to use plant growths nearby their locations and discarded materials. Teachers could refer to books such as *Varied Occupations in Weaving* by Louise Walker, *Cane Basket Work* by Annie Firth, and *How to Make Baskets* by Mary White for suggestions and practical illustration of the elementary steps of basket making. The second year was a continuation and expansion of the first and aimed to teach pupils accuracy of execution; at this time, students were also to start work in cane because it was "excellent in connection with basketry and develop[ed] finger skills."[30] Finally, during the third year, students attending institutions near a tribe of basket-making Indians would learn from Native craftspeople who were expected to impart thorough instruction and give the pupils "every opportunity to learn this important work."[31]

Through very meticulous directives, Reel ensured that teachers learned how to train students in making their tribal crafts. Why such attention to details? Because all barbarous traits needed to be removed in order to transform children into civilized, respectable, and productive men and

"Show Him the Needs of Civilization"

women. Negligence needed to be replaced with carefulness; coarseness and impulsivity with accuracy and thoughtfulness; dirtiness and disorganization with cleanliness and order. No rushed and inattentive work was accepted; children had to learn how to do things properly, that is, according to Anglo-American standards. The making of traditional arts was one of the means through which the complete training of the mind was to be accomplished. Their instruction did not merely aim at satisfying market demands, preserving America's crafts or the valuable skills of the craft makers; it was another way to control the Indians, molding them according to the desires and needs of American society in order to achieve the government's goals of obedience and adaptation. The teaching of Native arts and crafts thus fit well into the framework of the colonization of consciousness and cultural hegemony models because it aimed to impart practical skills that served the needs of the dominant ideology and ensured the government's assertion of its hegemonic power. It was an instrument for the maintenance of a political, social, economic, and racial hierarchy as well as for the erasure of cultural diversity.

In the first three years of her appointment, Reel traveled 65,900 miles and visited forty-nine schools; since the *Course of Study* had yet to be published, the superintendent did not report on the status of Native industries instruction in the facilities inspected. The only exception was a brief account of the Eastern Cherokee School in North Carolina for which Reel wrote to the commissioner of Indian Affairs that "the making of native pottery and the weaving of willow baskets" should receive more encouragement in the curriculum of this institution.[32] Upon visiting the school and the reservation, Reel likely witnessed how Eastern Cherokee women were able to participate in the basketry revival of the southern Appalachian region and adapt their traditional wares to the new needs of tourists and collectors; her suggestion to give more attention to this local craft stemmed from the recognition that, upon completion of their studies, Cherokee students could have also become part of this market economy by satisfying demands and earning revenues through their craft work.

Implementation of the *Course of Study* at the local level did not happen overnight, as schools had to figure out how to comply with the new requirements with the work force at their disposal. Little by little, however,

arts and crafts became an additional feature of the industrial work of various institutions from east to west, although not of all and not in the same manner. The reports each superintendent annually sent to Reel offer evidence as to the amount of attention given to the new industries in each institution. In numerous schools, they were not immediately accepted, while in several others sewing, knitting, embroidery, cutting, and fitting remained the only "arts" taught as part of the "household duties" requirement. For example, according to Reel's reports, arts and crafts were never featured at Haskell in Kansas, the Carson school in Nevada, or the Santa Fe Indian School in New Mexico, places that Reel visited in the first three years of her superintendency and again toward the very end. The absence of any reference to Native industries before the publication of the *Course of Study* is not a surprise, as teachers had not yet been directed toward their implementation; the lack of documentation during Reel's final years, on the other hand, is because her last four reports did not include a narrative description of her school visits, so we cannot know from this data whether arts and crafts existed at the above-mentioned institutions. Sherman Institute is a perfect demonstration of this documentary void: basketry was never mentioned in Reel's official reports and yet, as a later chapter will show, it was encouraged and practiced. Carlisle was the one outstanding exception in the entire Indian Service in that here Native industries eventually became an integral part of the curriculum, had their own department, classroom of instruction—an art studio—and full-time Native teachers.[33]

Numerous schools welcomed the new curriculum and its encouragement of Native industries and made the necessary changes to accommodate them into the students' daily schedules and school life. Milton J. Needham, superintendent and special disbursing agent for the Western Navajo School reported, for example, that the matron

> had arrangements made in the dormitory for the girls to work at blanket weaving. She also taught them the manner of cleaning and dyeing the wool. Under her directions the little girls made some excellent blankets, much to the delight of their parents, who would come and sit by the hour watching their little girls working at coloring and weaving.[34]

"Show Him the Needs of Civilization"

Similarly, at the Indian Training School in Springfield, South Dakota, Superintendent Walter J. Wicks secured "the assistance of an experienced basket maker and began instruction of about a dozen larger girls in the art of making baskets from the native willows." According to him, "The girls showed much interest in the work, and made a number of baskets which are of great usefulness about the school, though not yet sufficiently well made to be salable in the markets."[35] Flandreau Indian School in South Dakota added beadwork and other Native crafts to its curriculum; "interest in native bead and buckskin work and art needlework [was] encouraged and increasing" at the Hayward Training School in Wisconsin; while "creditable beadwork" was done in the sewing room of the Indian school at Morris, Minnesota.[36] Lastly, at Haskell, girls learned basketry from their domestic science teacher, who instructed them to make "not only baskets but pretty napkin rings," too, and "looms were set up . . . for female and male students who chose to work at rug-and blanket-weaving."[37]

In her 1902 report to the commissioner of Indian Affairs, Reel provided a summary of the schools visited and the progress therein made in following the course of study; the teaching of Indian industries was carried out at twenty-seven institutions including off-reservation, reservation, and day schools.

Table 6. Native Industries in Indian Schools, 1902

State	School	Native Industries
Arizona	Truxton Canyon	"The girls have made progress in sewing, cooking, and housekeeping, and *have also done much beadwork.*" (25)
	Western Navajo	"The instruction in *blanket weaving* was especially good." (25)
California	Hoopa Valley	"*Basketry* was also taught." (25)
	Round Valley	"The girls gave special attention to *basketry.*" (25)
Colorado	Fort Lewis	"The girls received instruction in cooking and sewing and *weaving of blankets.*" (25)

	Grand Junction	"Household duties, dairying, and *basket making* were taught to the girls." (25)
Idaho	Fort Hall	"Progress was made in *beadwork*." (25)
Iowa	Sac and Fox	"The girls were instructed in household duties and *beadwork*."(25)
Michigan	Mount Pleasant	"Also *splint baskets* are made." (26)
Minnesota	White Earth	"*Native industries* were taught." (26)
	Wild Rice River	"A fair beginning was made in *native work*." (26)
Montana	Crow	"Instruction in sewing was given and considerable *beadwork* done." (26)
Nebraska	Omaha	"*Beadwork* was done by the girls." (26)
New Mexico	Albuquerque	"*Blanket making* is taught, and the girls have done creditable work. Several handsome *rugs* have also been made." (10)
		"*Blanket weaving* and *beadwork* were done." (26)
	Mescalero	"The manufacture of *baskets, plaques,* and other *native work* was stimulated." (26)
North Carolina	Cherokee	"The girls were trained in household duties and they *make baskets* and *pottery*." (27)
Oklahoma	Arapaho	"Extensive work in the sewing room was given the girls and they are making a beginning in *beadwork*." (27)
	Cantonment	"*Beadwork* was given attention." (27)
	Cheyenne	"The girls are taught *beadwork* to a limited extent in order that they may be kept in touch with the industries which have been practiced by the older women for many generations." (10)
		"Lessons in domestic duties were given the girls, who also did excellent *beadwork*."(27)
	Chilocco	"Some attention has been given to *beadwork*."(27)
	Rainy Mountain	"*Basketry* and *weaving* were taught." (28)

"Show Him the Needs of Civilization"

	Red Moon	"*Moccasins* and other *beadwork* common to the tribe were made by the girls." (28)
	Seger	"*Native work* received attention." (28)
Oregon	Yainax	"Instruction was given in *rug-making*." (28)
South Dakota	Riggs Institute	"In the native industries girls did excellent *beadwork*." (29)
Utah	Shebit	"*Basket weaving*, which is the only native industry for the women of this tribe, was begun." (29)
Virginia	Hampton	"The introduction of a native teacher, whose presence affords the Indian students special opportunities for learning to make *Indian baskets and pottery*" (quoted from the *Southern Workman*, 20)
Washington	Puyallup	"Good *baskets* were made." (29)
	Tulalip	"The Swinomish day school gave instruction in gardening and the *native industries*." (29)
Wisconsin	Oneida	"*Basketry* and *beadwork* have successfully been practiced, producing considerable revenue for the Indians." (29)
	Wittenberg	"*Basketry* and *beadwork* have been encouraged." (29)

Emphasis added. Source: *Report of the Superintendent of Indian School*, 1902.

Table 7. Native Industries in Indian Schools, 1904

State	School	Native Industries
Arizona	Navajo Training	Girls trained in *weaving*.
California	Riverside	"The training of the girls in useful as well ornamental handiwork is also of the best." (52)

Colorado	Grand Junction	"The matron has encouraged *blanket weaving* among the Navaho pupils." (22)
Idaho	Fort Hall	"Many of the children . . . are expert *bead workers.*" (22)
Minnesota	Bena	"The pupils have made *beaded belts and bags* and *useful articles of birch bark.*" (22)
New Mexico	Albuquerque	"The girls whose parents are blanket weavers *are so anxious to carry on this work that they utilize the legs of an ordinary chair for a loom,* and it is no unusual occurrence in passing through the dormitory to find *a number of chairs used as looms on which are unfinished blankets.*" (22) "The Albuquerque school is teaching *blanket weaving and lace making.*" (23)
North Dakota	Fort Berthold	Girls interested in Indian *bead and porcupine work.*
Oklahoma	Cheyenne	"Under the direction of the seamstress, who is an Indian, excellent *beadwork* has been made." (22)
	Chilocco	"The *bead fan chains* . . . have netted a nice profit to the Indian girls." (22)
Oregon	Grande Ronde	*Basket weaving* and *bead work* [are] introduced in the course of study for the first time.
Virginia	Hampton Institute	"There are also special classes in lace making and *pottery* for the Indian girls." (8)
Wisconsin	Oneida	"The children take special delight in *bead* and lace *work*" . . . "In *beadwork* they have been instructed in making belts and pockets, bags, purses, lamp-shades, watch and fan chains, and collars." (22)
	Tomah Industrial School	"Pupils are taught to cut and fir, and many girls learn *beadwork* out of school hours." (47)

Emphasis added. Source: *Report of the Superintendent of Indian School*, 1904.

"Show Him the Needs of Civilization"

Table 8. Native Industries in Indian Schools, 1905

State	School	Native Industries
Arizona	Navajo schools	Girls "are also given instruction by a native teacher in *blanket weaving*." (6)
		"The Navajo School has been very successful in *teaching blanket weaving. A native weaver is employed as teacher*, and she instructs her charges how to string the warp upon the hand-made loom, card and spin the wool, and dye the threads to suit the designs they are to work in fabric." (18)
	Phoenix	"The pupils are taught to make *blankets, baskets and beadwork*." (16)
	Pima Training	The girls "are taught *basketry*." (16)
California	Hoopa Valley	"The girls, many of whom are skilled workers, make *baskets* during their leisure time." (16)
New Mexico	Pueblo Day Schools	"Pupils have been encouraged in *pottery making* and some creditable shapes in cases and jugs have been exhibited." (16)
Oklahoma	Cheyenne	"The pupils are *taught beadwork by a native teacher* and a great many articles made by them have been sold." (16)
	Chilocco	Girls "are taught *bead* and drawn work." (16)
Virginia	Hampton	"There are also special classes for the girls in the *native industries*, where they learn *basketry, pottery, rug and carpet weaving*. They are also taught to *make lace*."(10)
Wisconsin	Hayward	Girls made "*bead* and *buckskin* work" for the St. Louis exposition. (16)

Emphasis added. Source: *Report of the Superintendent of Indian School*, 1905.

As these tables show, after the distribution of Reel's *Course of Study*, many schools complied with the directive and included Native crafts as part of the industrial, namely domestic, training for girls. In many cases, like at Round Valley, Chilocco, Seger, and Wittenberg, just to name a few, crafts were simply encouraged, given attention, or allowed and not necessarily taught by a teacher. This distinction between "encouraged" and "taught" suggests that some crafts were more seriously considered and thus more organically incorporated into the curriculum under adult guidance and instruction; these were, predictably, basketry and weaving. Pottery and beadwork, on the other hand, were almost always done by the girls without the help of a teacher. This does not come as a surprise, because Reel placed more emphasis on the former two industries for which demand was much greater and more urgent.

The reports of some school superintendents also reveal that beadwork, weaving, and even basket making were exercised during the girls' spare time. Although often taught in the sewing departments, which also included domestic arts and fancywork such as sewing, crocheting, knitting, and embroidery, they did not replace any of these industries; girls still needed to learn, first and foremost, how to make and decorate garments and other essential household items (fig. 15). Furthermore, even if in many schools these industries were taught as additional activities, pupils were strongly encouraged to make them on their own, outside of the time prescribed for domestic training. This suggests that the presence of arts and crafts went far beyond the idea of economic profitability or cultural preservation: basketry, weaving, beadwork, and pottery were safe to teach and include in the curriculum of Indian schools because they were activities to relegate to free time and, therefore, beneficial pursuits for idle moments.

The introduction of Native industries had a specific goal that blended into the more general policy of federal education: to inculcate into the Indians' minds the value and importance of labor, the ideal of domesticity, and the concept of proper and profitable use of one's time. By stimulating the production of traditional crafts, and therefore showing that complete eradication of Indian cultures was not necessary, policymakers and educators sent an indirect, yet nonetheless clear message to students, particularly females: first, they needed to attend to their womanly responsibilities and

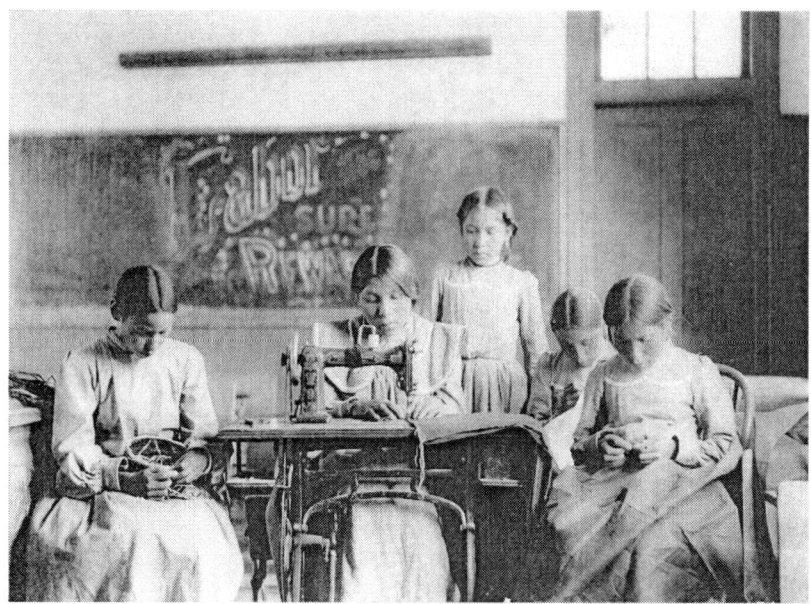

Fig. 15. Class in sewing and basketry, Pine Ridge Day School, no. 25. Estelle Reel Collection, Northwest Museum of Arts and Culture / Eastern Washington State Historical Society, Spokane, Washington, MONAC no. 153.

properly perform their main duties as citizens; then, if sufficient time remained, they could use their spare moments to dedicate themselves to their Indian fancywork. Native industries were recognized as useful occupations, but were not essential for an Indian woman on the road to progress and a civilized life.

A series of photographs from the early 1900s illustrates the different nature of arts and crafts instruction in government schools. Figure 16 captures students of the Crow Boarding School in Montana during Miss Palmer's basketry class; interestingly, this group is composed of boys and girls, a combination that is not documented in other historical visual records, as the pupils involved in Native industries are normally females. Boys are sitting on the left side of the photograph while girls are on the right; their teacher is standing in the back of the room between the two rows of desks, likely moving up and down to monitor the progress of the students' work. The room is immaculate and nothing is out of place, thus

"Show Him the Needs of Civilization"

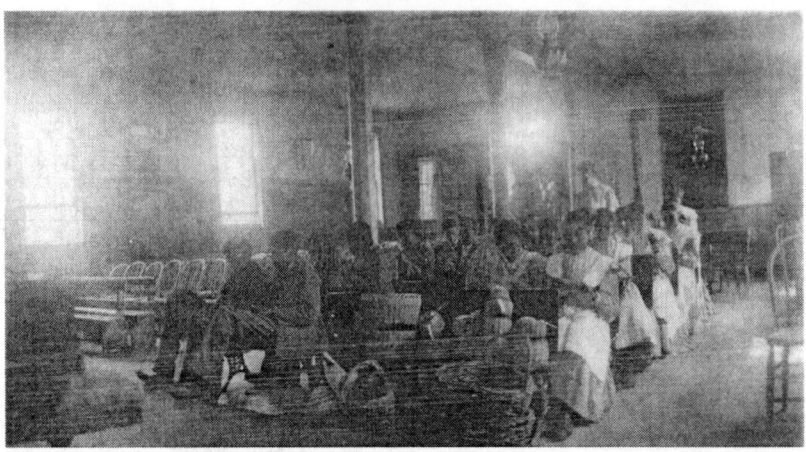

Fig. 16. Miss Palmer's class in basketry, Crow Boarding School. Estelle Reel Collection, Northwest Museum of Arts and Culture / Eastern Washington State Historical Society, Spokane, Washington, MONAC no. 23a.

making cleanliness and order another unusual yet striking element of this photograph. Lomawaima and McCarty describe a similar picture from the Uintah School and write: "Each girl holds a basket, but the untidy bundles of materials necessary to their construction are conspicuously absent. Not a shred of wayward willow, sedge, junco, sumac, or yucca litters the well-swept floor."[38] This description could be easily applied to the present scenario and no one would know the difference were it not for the name of the school; everything else looks exactly the same. As Lomawaima and McCarty argue, this is indicative of the government's efforts to "domesticate and contain Native arts" in all schools in order to render them safe.[39]

Even the nature of the baskets made by the students speaks to this domestication of the craft. The traditional arts of the Crow people, for whom the day school was established in 1881 within the boundaries of the reservation, were closely connected to personal adornment and the decoration of material possessions through paint, quills, hides, and most of all beadwork; basket making was not one of their artistic accomplishments, as it was not for other tribes living in the Great Plains region. The photograph shows about two dozen Crow students making baskets that not only do not belong to their traditional artistic heritage but also do not

"Show Him the Needs of Civilization"

appear to have any Indigenous traits or designs. Even though made in different shapes and sizes that could slightly resemble Native baskets from other regions, for example the well-known and prized California baskets, these works seem to be purely commercial, the kind that would appeal to an uninformed basket lover in search of something Indian-made to use for home decoration.[40] Furthermore, baskets could have been used by Indian girls, future homemakers, as functional household items. This was the reason why basketry was taught in other schools on the Great Plains. For example, at the Indian Training School in Springfield, South Dakota—another institution located by a non-basket-making tribe—this instruction served "to teach the making of baskets large enough to be of use in the house or on the farm for general purposes, such as market, bushel, and clothes baskets."[41] The presence of basketry in a school serving students from a non-basket-making tribe and the fact that even boys were taught this activity suggests that Reel was particularly adamant in having Indian pupils learn this useful and profitable craft, regardless of their tribal affiliation and gender—demands for baskets continued to rise and needed to be supplied.

Figure 17, included in one of Reel's annual reports, depicts the busy work in the weaving room of the Navajo School in Fort Defiance, Arizona. Four looms are set up in the background and are occupied by students, three of them of a tender age, working on their own designs. In the foreground, three additional pupils are seated on the floor and are intent at carding and spinning the rough wool, spindle in hand. The teacher, a Native weaver, is standing on the left-hand side of the picture and, holding the shuttle stick, demonstrates the weaving steps to one of the little children, possibly, as Reel reported, "how to string the warp upon the handmade loom." Her other responsibilities included teaching how to card and spin the wool and "dye the threads to suit the designs they are to work in the fabric."[42] Above the looms, seven finished blankets hang on the back wall, serving as decorations as well as examples for students to imitate or from which to get inspiration. While depicting the bustling activities carried out in this weaving room, this photograph also reveals an unrealistic scenario in which industriousness is once more paired with impeccable neatness. For example, despite the large quantity of yarn worked, not one thread is

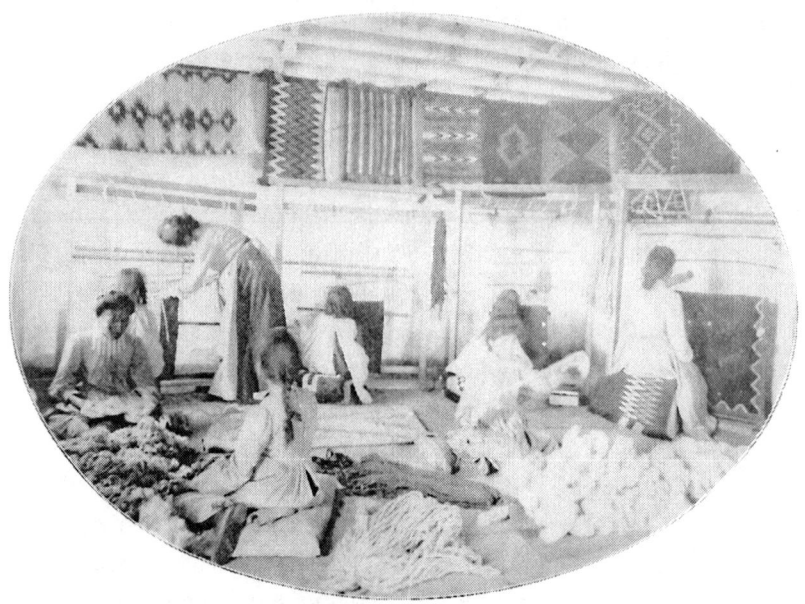

Fig. 17. Weaving room at Navaho Indian School, Fort Defiance, Arizona. From *Report of the Superintendent of Indian Schools for the Year 1905* (Washington DC: Government Printing Office, 1906).

misplaced or loose on the floor; the raw materials are carefully amassed in their respective piles. Also, yarn balls are nowhere to be seen around the young weavers and there are no strings of warp either hanging from the bottom of the rugs in progress or emerging from their most recently woven parts. If we compare this image with other photographs of weaving classes in Indian schools during the late 1920s and 1930s, for example at Albuquerque (see fig. 25) and Phoenix (fig. 18), we cannot but notice the strategically controlled environments that reigned during Reel's years; caught in these staged photographs, they aimed to instill ideas of order and tidiness in every aspect of girls' lives.[43]

Similarly disciplined settings can be seen in two additional photographs from Reel's annual reports; the first is from the Phoenix Indian School (fig. 19), while the second, not shown here, is from Grand Junction, Colorado. The first photograph, published in 1903, is titled "Teaching Blanket Weaving" and depicts two girls posing in front of their unfinished blankets

"Show Him the Needs of Civilization"

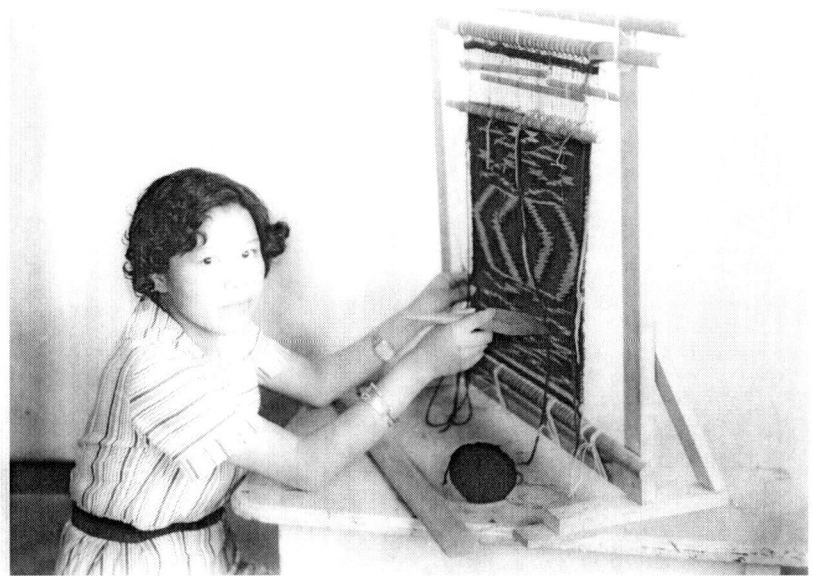

Fig. 18. A student weaver, Phoenix Indian School. National Archives and Records Administration, College Park, Maryland, 75-N-PH-8.

woven in homemade looms ingeniously fixed to the beams of a large bed frame. The girls are captured in a moment of work, as the warp in their hands indicates, and yet there is no additional evidence of this activity in the surrounding space.[44] The second print, "Teaching Basket Weaving" and dated 1908, presents an analogous situation in which five female students are photographed in the act of making baskets, undisturbed, while sitting on a porch. The two girls in the foreground are clearly employed, but the same cannot be said of the three girls behind the display table who seem to be simply holding baskets and posing for the camera. Bundles of twigs are nicely arranged in front of the table showing the progression from raw materials to the beautiful finished products. The girls are working on their own without teacher supervision or guidance and, as in the previous picture from Phoenix, they are placed in a tidy environment that does not realistically reflect the clutter involved with this kind of work but rather evokes images of a serene, domestic, and civilized activity and workplace. The absence of teachers or school personnel in both pictures was intentional

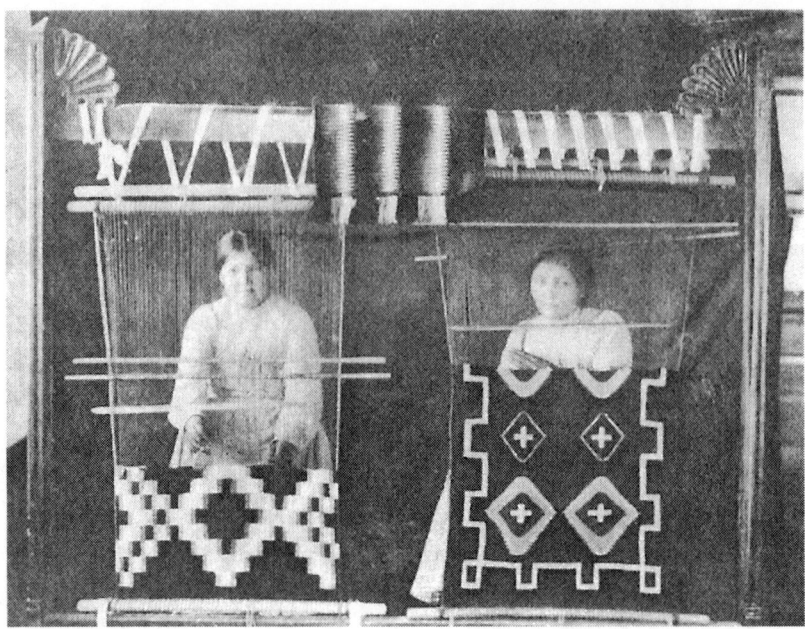

Fig. 19. Teaching blanket weaving, Phoenix Indian School. From *Report of the Superintendent of Indian Schools for the Year 1903* (Washington DC: Government Printing Office, 1903).

and meant to convey the message that the students were working during their own spare time; this, in turn, meant that Reel's civilizing plan was effective and bearing fruit.

Another photograph from the Phoenix Indian School, also analyzed by Lomawaima and McCarty and by Hutchinson, visibly contrasts with the images so far presented and more authentically depicts students in the process of making baskets.[45] Titled "Teaching Native Industries" and included in the 1903 report of the superintendent of Indian schools, it captures six girls at ease on the dusty floor of a school corridor, their materials arranged on an old rug spread out at their feet. Finished baskets are hanging on the walls below rows of framed poster boards displaying samples of students' drawings, likely nature studies. In its uniqueness, this photograph shows Native industries in an environment that is controlled and yet not suffocating and restraining, and students in natural

"Show Him the Needs of Civilization"

rather than obedient and mechanical postures. Art historian Elizabeth Hutchinson described this picture as indicative of the marginalization of Native industries in Indian schools. I see it, instead, as an excellent example of how students responded to a familiar feature—basketry—in a foreign school curriculum and took advantage of the occasion it presented to make it their own. The Phoenix School administration might have marginalized Indian arts and crafts and not taught them officially, but students certainly used this "window of opportunity" to engage in an activity that allowed them to feel at home, gave them something fun and culturally meaningful to do, and alleviated boredom. That basketry was carried out in these "unconventional" conditions and in the absence of a teacher means not only that school officials did not disapprove of it but also that girls eagerly used whatever time they had available for practicing it.

The inclusion of arts and crafts in the curriculum of Indian schools proposed first by Commissioner Hailmann and concretized by Superintendent Reel was not an impulsive act of benevolence toward a vanishing Indigenous population, but was part of a larger web of political, economic, social, cultural, and educational reforms that characterized the turn of the twentieth century and affected public schools as well as schools for American Indians. The lifespan of arts and crafts in Indian schools, however, was relatively shorter than in public schools and certainly motivated by different reasons. Although prompted by similar ideas that valued the manual skills acquired from the making of such handcrafted goods, Native industries in boarding schools were also supported by economic rationales directing students to become producers of decorative objects demanded by Anglo consumers. So while Indian pupils were taught to labor in order to supply market demands for their traditional crafts, children in public schools were encouraged to make crafts to find relief from labor.

Furthermore, Native industries in Indian schools presented additional advantages that, in the eyes of educators, could greatly benefit students and, consequently, mainstream society: the absorption of dominant values such as order, discipline, and industriousness, which facilitated Indian assimilation, and, marginally, crafts preservation, which guaranteed the salvage of America's Aboriginal arts. From the students' perspective, there was another more important advantage: these familiar activities reminded

them of home and were an occasion for reappropriating and perpetuating their cultures and traditions in foreign and often harsh environments. While student responses are, for the most part, missing, scattered hints in the historical records suggest that the inclusion of Native industries in the curriculum of boarding schools, attended miles away from home, was a welcomed and cherished addition to a life of routine and manual labor.

Francis Leupp and the Renewed Push for Native Industries

Estelle Reel continued to advocate for the instruction of Native industries throughout her tenure and constantly reminded employees in the Indian Service of their importance. She particularly stressed the need to hire Native teachers of basketry and weaving in schools that served students belonging to tribes with strong traditions in these crafts. In 1904, for example, she wrote:

> It would seem advisable for teachers in the Indian service to include as a practical part of their work the various arts and crafts for which Indians have become famous by their own unaided efforts—basketry, pottery, beadwork, tanning, blanket weaving, beaten silver, etc. . . . we are endeavoring to have the respecting schools preserve the industries of the tribes to which their children belong.[46]

The following year she underscored again the significance of this type of training in order to "add to the pupils' stock of profitable accomplishments" and once more emphasized the necessity of hiring Native instructors "capable of teaching these arts in their native purity."[47] While she often cited the need to safeguard the crafts' authenticity, Reel's main concern always remained their marketability, and thus their profitability. Starting from 1905, however, she slightly changed her tune and gave in to the outside pressures that called for cultural preservation per se. In her annual report for that year she stated, in fact, that "aside from the economic importance of preserving the native arts, there is a natural feeling among the well-wishers of the Indian which deprecates depriving his descendants of much that has been a distinctive feature of his former life."[48] One of these individuals was Francis E. Leupp, the recently appointed commissioner of Indian Affairs (1905–9) and personal friend of President Theodore Roosevelt.

A journalist by training, Leupp became involved in Indian affairs in 1895, first as the Washington agent for the Indian Rights Association and then as a member of the Board of Indian Commissioners in 1896. Even before his nomination, he had a clear vision of the changes needed in Indian education. Leupp did not believe that Indian people could or should completely assimilate into American society and thus rejected Pratt's ideas that the total eradication of Indian cultures was essential to their progress. He favored instead a gradualist approach based on theories of progressive evolutionism that saw civilization as the improvement of individual capabilities. He did not agree with some of his contemporaries who believed that "the Indian is only a Caucasian with a red skin" and had to be "made over" into something else. Stripped of all his distinctive characteristics, he was bounded to be "like the Navaho blanket from which all the Navaho has been expurgated—neither one thing nor the other." He liked the Indian precisely "for what is Indian in him."[49] As a consequence of this position, Leupp openly encouraged the inclusion of certain elements of the students' cultures and backgrounds into the curriculum of Indian schools without secondary motives. Native arts and music were among these.

Leupp outlined his views and his new take on Indian education in his first annual report to the secretary of the interior but also made them available to the American people in articles he published in the *New York Sun*, the *New York Tribune*, and *Outlook*:

> I have no sympathy with the sentiment which would throw the squaw's bead bag into the rubbish heap and set her to making lace. Teach her lace making, by all means, just as you would teach her bread making, as an addition to her stock of profitable accomplishments; but don't set down her beaded moccasins as merely barbarous, while holding up her lace handkerchief as a symbol of advanced civilization. The Indian is a natural warrior, a natural logician, a natural artist. We have room for all three in our highly organized social system. Let us not make the mistake, in the process of absorbing them, of washing out of them whatever is distinctly Indian. Our aboriginal brother brings a great deal which is admirable, and which needs only to be developed along the right lines. Our proper work with him is improvement, not transformation.[50]

Note how Leupp, through the words expressed in the second sentence—"as an addition to her stock of profitable accomplishments"—was parroting Reel's words from her 1905 report quoted earlier. Although used in reference to a different set of skills, this statement subtly yet powerfully criticized her policies of giving more importance to Anglo domestic arts than Native traditional ones. Similarly, the following two lines were a direct attack on Reel's convictions that Native arts were works of inferior quality because made by members of an inferior race.

The commissioner planned on personally presenting his views at the 1905 annual Department of Indian Education held in connection with the NEA meeting in Asbury Park and Ocean Grove, New Jersey, but due to official business, he was unable to attend. Ironically, Superintendent Reel had to deliver his speech in his place. She remarked that the commissioner was very committed in his efforts to "preserve and develop along the right lines the best of the children's inherited traits and attributes" and read the following statement on the subject of Native art:

> I wish all that is artistic and original in an Indian child *brought out*—not smothered. Instead of sweeping aside the child's desire to draw the designs familiar to it in Indian art, and giving it American flags and shields and stars to copy, the child should be encouraged to do original—or perhaps I should say aboriginal—work if it shows any impulse thereto. . . . We are in danger of losing themes and motifs of great artistic value, because of a stupid notion that everything Indian is a degradation, and must be crushed out.[51]

Leupp unmistakably discussed the significance of all forms of Indigenous art not only for the proper development of Indian children, but also for their contribution to America's artistic heritage. For these reasons, the best way to ensure their preservation and continuation was their instruction to Indian students in all government schools. Throughout the following year, Leupp worked "to rescue and develop the best ideals in the pictorial, plastic, and textile arts of the Indian" and also to ensure maintenance of "the native art ideals in decoration."[52] On February of 1906, he hired Angel DeCora, a professionally trained Winnebago artist, to be the new art instructor for Carlisle's Native Indian Art Department; Pratt, who would

"Show Him the Needs of Civilization"

have disapproved of this appointment and of the new department, had been relieved of his duties as superintendent in June 1904 and replaced by William A. Mercer, a sympathizer with Native cultures.

An 1891 graduate of Hampton Institute, where she had her first encounter with art classes, DeCora continued her art education first at the Smith College School of Art, where she studied from 1892 to 1896, and later at the Drexel Institute of Art, Science, and Industry, where she attended the School of Illustration from 1896 to 1898. Prior to her appointment at Carlisle, she had opened her own studio in Boston and worked as an illustrator for *Harper's Monthly* and for books such as Francis La Fleche's *The Middle Five*, Zitkala-Ša's *Old Indian Legends*, and Mary Catherine Judd's *Wigwam Stories*. Also, at the request of the Indian Office, she exhibited her works at international expositions such as the 1898 Trans-Mississippi and International Exhibition in Omaha, the 1901 Pan-American Exposition in Buffalo, and the 1904 Louisiana Purchase Exposition in St. Louis as part of the Indian Service displays.[53] All these experiences contributed to the development of her ideas on the value and role of Indian art in American society, particularly the use of what she called Native Indian design.

In hiring DeCora as an art teacher at Carlisle, Leupp hoped she would encourage students to "employ Indian combinations of line and color" and create products in the school shops that would "show the characteristic Indian touch as distinguished from the Caucasian design which pervade the same branches of industry elsewhere."[54] DeCora was pleased to accept the position knowing that the commissioner shared her belief that she should not teach in the white man's ways, but rather develop the art of her own people and apply it "to various forms of art industries and crafts."[55] As she later stated in a public presentation at the 1907 NEA meeting in Los Angeles, "We can perpetuate the use of Indian designs by applying them on modern articles and ornament that the Indian is taught to make."[56] These statements reveal that DeCora's and Leupp's views on cultural preservation greatly differed from Reel's. The superintendent urged teachers to instruct Native industries in a manner that was faithful to the traditional crafts of the students' tribes in an attempt to continue the art-making techniques of the past and thus produce those pieces so craved by white patrons. Leupp and DeCora, on the other hand, were concerned with the maintenance

of traditional designs but through modern adaptations that sprung from the students' own creativity, thus bringing together the past, present, and future of Indian art. What both positions had in common, however, was that they endorsed the production of art to satisfy market demands; as historian Jane Simonsen put it, both transformed "Indian culture into a commodity and Indian students into laborers."[57]

DeCora and the Carlisle Native Indian Art Department

Under DeCora, the art department at Carlisle took "a departure from the regular routine work of public schools." She declared, in fact, that "we do not study any of the European classics in art. We take the old symbolic figures and forms which we find on beadwork, pottery, and baskets for the basis of our study."[58] Despite the initial difficulties that she unexpectedly faced—students' estrangement from their traditions, lack of pride, and even fear—DeCora was able to revive the pupils' interest and dignity and push them to make original work that expressed their own artistic powers as well as cultural backgrounds. Because Indian art was characterized by "purely conventional lines," she decided to make Carlisle "a school of design."[59] Indian people depicted the world around them through symbols and geometrical shapes, so an understanding of tribal schemes of symbolism was essential. The first thing that DeCora did, therefore, was to develop Indian designs inspired by her students' tribes under three main styles, Alaskan, Southwestern, and Plains—encompassing all major geographical features of the country, although not tribally specific—and use them as tools to help pupils reconnect with their regional artistic heritage. This initial study of patterns was followed "by the combined figures, made up of two or more of the elements of design, then the still more complex figures made by repeated use of two or more elements of design" until "after much drilling in this geometric system of designing, the unit system was introduced."[60] In a way, this methodology did not differ much from the sequential approaches proposed by nineteenth-century art educators that moved from simple to more complex designs. In this case, students did not master lines and circles but Native symbols that were combined in progressive levels of difficulty.

DeCora then encouraged pupils to make their own designs and apply

them to beadwork, pottery, basketry, and rug weaving as well as to different kinds of industrial arts such as book and magazine covers, wallpaper, stencil work, lettering, friezes and draperies, embroideries, wood carving, tiles and metal work. In her first year at the school, students made "600 designs for borders and centers" that "suggested weaving," many of which were used as page ornamentation for the school publication, the *Red Man*.[61] Five undated crayon drawings (fig. 20), photographed and included in the page of a bound volume used by the Indian Office for exhibition purposes, could have been among the rug patterns designed by the students.[62] Diamonds, swastikas, zigzags, and terraced motifs in black, white, and red are some of the Southwestern patterns and typical colors used in these sketches. Also, while the drawings are clearly different, they utilize the same blueprint and decorative principles, indicating that basic patterns had to be masters before students could venture into more elaborate conceptions. Students transposed their designs and wove them onto rugs in the upright looms situated in the Leupp Studio, home of the Native Indian Art Department. DeCora had studied Persian weaving while residing in New York and she thought its technique of knotting the warp instead of using a continuous one was more appropriate for the conventional patterns drawn up by the students. Thus, the style of weaving students learned blended non-Native techniques with typical Indigenous (and later even pan-Indian) motifs. However, DeCora later suggested that a Navajo weaver be hired at the school in order to provide better and more authentic instruction than she could offer.

DeCora's students never used practice paper—"with steady and unhesitating hand and mind, they put down permanently the lines and color combinations you see in their designs"—and were repeatedly told not to copy the teacher or anybody else. This was a clear departure from the previous years of art training, as faithful reproduction of inanimate objects was the norm. Now pupils were left creative freedom and independence in their endeavors so that they could draw from their own minds and be true to their tribal designs. In this way, "no two Indian drawings are alike" because "each artist has his own style."[63] Another interesting facet of DeCora's methodology is that she often left the room while her students were completing a task or allowed them to work in their own spare time

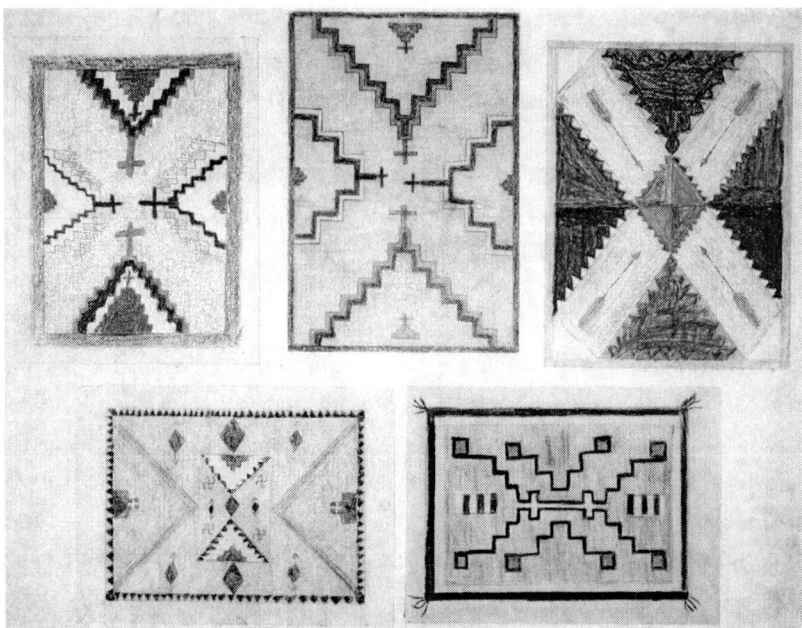

Fig. 20. Rug designs that could have been made by Carlisle students. National Archives and Records Administration, College Park, Maryland, 75-EXU-11.

(some of their best creations were made outside of the classroom!) so that they could be alone and, away from the influence of others, find inspiration like artists do. When asked where her discipline was (because "children only have to be disciplined when they are bored into refractoriness"), she responded, "No one is bored when he is creating something."[64] This is clear evidence that students sketched and made art on their own not because they had grasped the government's motto of using well one's spare time but because they truly enjoyed this activity and wanted to create original and meaningful works for themselves and their teacher.

Finally, in addition to encouraging the production of Indian artworks and the use of Indian designs on common household items and other objects, DeCora promoted their exhibition and sale within and beyond the perimeter of Carlisle. She organized weekly exhibitions and student competitions, set up a salesroom in the newly built Leupp Studio, and advertised the students' handicrafts through the pages of the *Indian Craftsman*, the

"Show Him the Needs of Civilization"

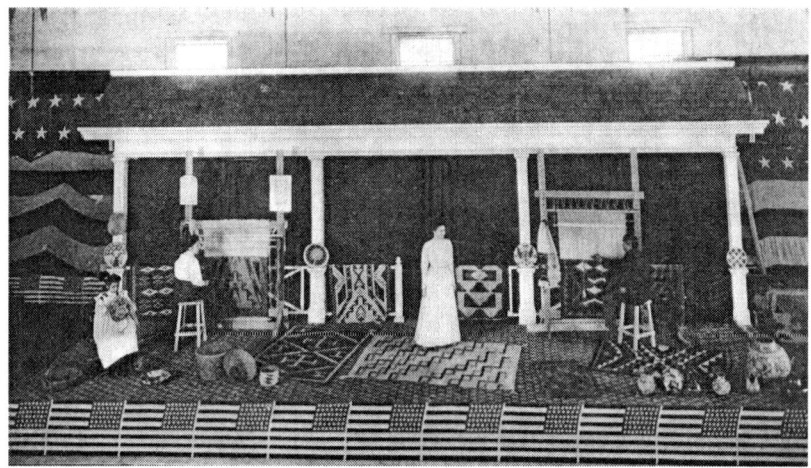

Fig. 21. Industrial talk—Native Indian art. From the *Indian Craftsman*, May 1909. Courtesy of Carlisle Indian School Digital Resource Center (http://carlisleindian. dickinson.edu/).

Red Man, and the *Carlisle Arrow* (see fig. 52). One of the most important occasions in which Native arts were exhibited on school grounds was the March 1909 commencement exercises that saw the participation of Commissioner Leupp, Hon. Moses E. Clapp (chair of the Senate Committee on Indian Affairs), Hon. Chas. D. Carter (representative to Congress from Oklahoma), Dr. George E. Reed (president of Dickinson College), and Hon. Carrol S. Page (member of the Senate Committee on Indian Affairs). As the events' detailed accounts from the *Indian Craftsman* were reported, at the end of the talk on the benefits of the outing system, the stage of the large gymnasium was quickly transformed and decorated with Native art in order to introduce the next practical demonstration and talk (fig. 21). Samples of Navajo rugs and Hopi baskets and pottery were placed around the stage or on columns along with products of the Native Indian Art Department showing "the application of Indian design to the Persian weave."

Speaking on the topic of Indian art, a Chippewa student from North Dakota, Elmira Jerome, described the origin and present processes of various art forms and "expressed a feeling that the art of the primitive Americans would be retained and developed." We can certainly hear echoes

of DeCora's ideas on the role of Native art in contemporary society in this student's remarks. As she talked, one Hopi student made a basket, while two others demonstrated different weaving techniques: to her left, a Hopi boy showed "the present method of weaving in vogue in Arizona," while to her right a female pupil demonstrated "the weaving according to the Persian method applied with Indian design."[65] Two samples of students' designs are posted to the frames of her upright loom; the pattern on the right seems to be the one the weaver was reproducing. The unfinished rug also resembles the work to its immediate right; although the imagery is slightly different, the overall arrangement of shapes, borders, and lines is the same, thus suggesting that students started from a basic layout and basic decorative elements and then developed their own personal variations.

All in all, during her tenure at Carlisle (1906–15), DeCora tirelessly worked to empower her students and to ensure that they did not forget their artistic heritage and the accomplishments of their people; and she constantly encouraged them to freely and creatively express themselves in art forms that encompassed past and present trends.

The Decline of Native Arts and Crafts

With the encouragement of Native industries coming from all fronts— the commissioner of Indian Affairs and the superintendent of Indian schools—and the successful example of the Native Indian Art Department at Carlisle, Native arts and crafts should have blossomed in all Indian schools by the mid-1900s. This, however, did not happen. Starting from 1906 and continuing to 1910, when Reel left her position, and a year after Leupp resigned, their instruction began to progressively decline. Coincidentally, Native industries were less frequently mentioned in the official reports, whether by Reel or Leupp (table 9). Carlisle was, undoubtedly, an exception in the Indian School Service as no other school established a Native Indian art department, hired a full-time Native teacher, or offered the kind of instruction available here. While its Native work was highly admired and praised, no other institution followed its example and went to the extent of replicating this successful experiment. Eventually, around 1913, even Carlisle's renowned art program was abolished by the Bureau of Indian Affairs; it outlasted Leupp and Reel, but only for a few years.[66] DeCora remained

"Show Him the Needs of Civilization"

among the faculty until 1915, but she was no longer teaching Indian art. Native arts and crafts experienced a short-lived blossoming, but by the second decade of the twentieth century they had progressively declined.

Table 9. Native Industries in Indian Schools between 1906 and 1910

Year	School	Native Industries
1906	Phoenix, Arizona	"Some attention has been given to the native industries, including *beadwork, basketry,* and *blanket weaving.*"
	Carlisle, Pennsylvania	"New native instructor to teach *weaving* and *Indian art.*"
	Hampton Institute, Virginia	"There are also special classes in lace-making, *rug weaving, pottery,* etc., for the Indian girls." (13)
1908	Sherman, California	"The girls also receive instruction in *lace making* and drawn work, and find profitable employment after leaving school." (10)
	Carlisle, Pennsylvania	"Classes in *native arts and crafts,* under the direction of native teachers, form an interesting feature of the work." (14)
	Hampton Institute, Virginia	"Whatever of value the Indian child has by race inheritance is preserved; and classes are conducted in native tribal music, *basketry, pottery, rug weaving,* etc." (14)
1909	Grand Junction, Colorado	"A *desirable interest* in native music, *arts and crafts* was apparent among both the faculty and the pupils." (7)

Emphasis added. Source: *Report of the Superintendent of Indian School,* 1906–10.

Why did Native industries slowly disappear? Why, despite encouragement from the Indian Office, did they not last? One of the main reasons is that they were no longer considered "safe." Lomawaima and McCarty explain that, for the first time, federal employees were brought "face to face with the real cultural knowledge and power embodied in Native arts and music,

and that difference was entirely too dangerous to handle."[67] Art is a core aspect of Indigenous societies and it has always been deeply embedded in life; it is a manifestation of cultural values and concepts that guide human behavior and proper social conduct through visually pleasant material objects made in the most diverse media. As such, it is a privileged means of providing visual and conceptual representations of culture, define gender roles and responsibilities—thus offering guidelines for social dynamics—and embody continuity and syncretism—thus reflecting historical, social, cultural, and environmental changes that impact Indigenous life. Although physically severed from the societal environments that produced them, arts and crafts were still too deeply rooted in those cultures and worldviews and could not be domesticated. They brought students into too close contact with their traditional values and expressed Native identity to a degree that school officials could not manage. DeCora clearly expressed this when she said that "most of the Indians of the Carlisle school have been under civilizing influences from early youth and have, in many instances, entirely lost the tradition of their people. But even a few months have proved to me that none of their Indian instincts have perished but have only lain dormant. Once awakened, they immediately became active and produced within a year some of the designs that you have seen."[68] Native material expressions remained quintessentially Indian in meaning and nature and inevitably engrained in the students' whole beings; because of this, their instruction could not and did not last.

This is demonstrated by the fact that, notwithstanding official notices and circulars during the Reel and Leupp years, school administrations did not support these industries at the local level or, if they did, they encouraged them to a very minimal degree, as table 9 shows. These data also suggest that policies designed at a macro level were not necessarily complied with at the micro level, but were rather adjusted to meet the needs of each individual institution and its surrounding community—students, employees, expenditures and appropriations, local citizens, and businesses. The attempt to homogenize all government schools through a uniform course of study dictated from above did not take into account the diversity that not only characterized but also shaped each Indian school; this, in the eyes of the local personnel in charge, made the presence of

"Show Him the Needs of Civilization"

Native industries more problematic and thus dangerous.[69] The examples from Albuquerque and Sherman that will be presented in the following chapters show that the superintendents of these institutions acted in what *they thought* were the best interests of the students under their care in those particular localities and with an eye to the environments in which they would return to live.[70] While obviously these two cases cannot be representative of all schools in the Indian Service, they exemplify the different attitudes that existed between a larger, bureaucratic central authority and its representatives at the local level.

Another important reason for the decline of arts and crafts was that Native teachers like DeCora pushed students to become artists rather than artisans, thus promoting an individual self-realization that was not subservient to white society. As boarding schools trained generations of Indian children to work, they also taught them to understand and acknowledge their marginal place at America's lower level. They could manufacture handmade goods that the public craved as industrialism and mass production made household arts indistinguishable and less valuable, but they were not expected to become full-time professional artists. They were prepared for economic subordination, not competition. DeCora tried to break away from this limited view and worked to empower her students to become "independent workers rather than dependent laborers," thus leading them in a direction that the government was not willing to accept.[71] This kind of education, according to policymakers, was going too far.

The presence of Native teachers proved to be dangerous as well because it promoted the image of an independent woman, which worked against the domestic ideal the government had been trying to inculcate for years. As domesticity was equated with civilization, Indian girls were expected to abandon their "savage" backgrounds by becoming homemakers, dependent workers, and especially mothers of future generations of well-bred Indian children; their education was meant to prepare them exclusively for these roles. Intensive domestic training, submission to authority, and strict regimentation of the body through clothing, posture, and behavior were thus the core aspects of their education.[72] The example of women such as DeCora, who successfully made a living outside of the home, particularly on their own, while still embodying their cultural traditions and

asserting their Indian identity, was a great threat to this domestic ideal. The government could not accept *this* level of self-support and independence.

After 1910, the year Reel left office and was replaced by Harvey B. Peairs, emphasis on vocational education grew. Local superintendents were pushed to enroll more students in public schools, thus delegating responsibility to states or limiting government control to only day and reservation schools. These actions additionally contributed to the gradual disappearance of Native arts and crafts from the curriculum. The significance of practical training was obviously not new; the subdivision of school days between academic and industrial instruction was already in place and was the main feature of all government institutions. Now it was called vocational training, but its nature and goals were essentially the same: prepare students for semiskilled or skilled dependent labor. In 1913, Commissioner Cato Sells issued *Rules for the Indian School Service,* a new set of guidelines that reiterated the importance of agricultural and domestic training to be used while he prepared a new course of study; there is no mention of Native industries in this document.[73]

The *Tentative Course of Study for United States Indian Schools* that was published in 1915 emphasized "the study of home economics and agricultural subjects," which were essential for "the improvements of the Indians' homes and to the development of their lands" but also stated that "the usual subjects of school instruction [were] not neglected."[74] It contemplated "a practical system of schools with an essentially vocational foundation" and divided instruction into primary (grades one through three), prevocational (grades four through six), and vocational (grades seven through ten). The academic training of the first six years mirrored the essential courses taught in public schools, while the industrial and domestic activities centered "around the conditions essential to the proper maintenance and improvement of the rural home."[75] Not much had changed, except for the addition of modern subjects such as botany, implements, soils, farm and household physics, agricultural chemistry, and insecticides, along with plant diseases for boys and more emphasis on nursing and child training for girls. Also, while public schools were shifting their orientation toward a training that provided the appropriate industrial skills to help America's growth and war effort in urban centers or factories, Indian schools were

still preparing Indian youth for employment in small rural areas or small-scale shops in villages. Apparently, there was no room for Indian people in modern America if not at the margins.

Commissioner Sells was not a great supporter of Native industries and did not express interest in officially maintaining them in the curriculum. However, he did not completely dismiss them, either:

> Where native materials, such as grass, roots, fibers, etc. are available for classroom use, Indian methods of hand weaving should be used in seat work to the exclusion of such things as paper weaving. Native industries differ as to locality and environment. Where such industries have been or can be locally developed to a degree of economic importance they should be undoubtedly encouraged; where they can not have much economic importance they may, nevertheless, afford opportunities to capitalize odd moments of time by utilizing materials readily accessible.[76]

There are a few observations that need to be made about this passage. Firstly, Sells did not emphasize the instruction of any particular Native industry *in the classroom*.[77] He talked about using "Indian methods of hand weaving" but not for the manufacture of rugs or baskets; rather, these techniques had to be employed for seat work, a practical training that did not have any Native character and was intended for making purely functional objects, likely for school use. Secondly, the commissioner stressed that Native industries were to be encouraged only if they could be of some economic significance and thus could somehow contribute to Indian self-support. It is also worth noting that crafts were to be "encouraged" but not taught, thus clarifying once more that these industries were not meant to have a place in the classroom and were only marginal in the overall education of Indian students. Finally, Sells stated that where these industries could not be economically relevant, they could still be promoted as activities for the spare time; this points further to the commissioner's belief that Native industries were irrelevant in Indian education but acceptable time fillers to avoid students' idleness.

The overall meaning that transpires from these words is that the commissioner did not care whether Native industries were continued or not

outside the classroom; he had encouraged them, but whether this was done or not was not vital. What this passage also suggests is that Native teachers were neither necessary nor desired since students could work on their own. By officially withdrawing Native crafts from the curriculum and severing students from the influence and guidance of Native craftspeople, Sells likely aimed to trivialize these industries and make them appear as irrelevant as possible. Students would have to wait until the late 1920s to see Native industries reinstated back in the schools' curricula as important and valuable to their education. The lack of any additional reference to Native industries in the historical records testifies to the commissioner's success at officially silencing them. This does not signify, however, that students were silenced. As scholars of American Indian education have amply demonstrated, pupils always found ways to assert their own identities and perpetuate aspects of their tribal cultures in school environments.[78] The documentary and visual records I examined in the context of Native arts and crafts instruction add to this knowledge. Because of these historical, human patterns, we can assume that students continued to play an active role in shaping their school experiences and thus found "windows of opportunities" even during Sell's administration. Further research is needed, however, in order to give these experiences a voice.

4

"The Administration Has No Sympathy with Perpetuation of Any Except the Most Substantial of Indian Handicraft"

Art Education at the Albuquerque Indian School

> For it must be by the use of such methods as those employed
> at the Albuquerque school that the Indian shall be lifted from
> barbarism to civilization, and the savage transformed to a citizen.
> —*Albuquerque Journal*, "Educating the Indian"

Up to the late 1870s, the education of Albuquerque children in the Territory of New Mexico had been, primarily, in the hands of the Catholic Church, first with a short-lived school run by the Sisters of Loretto, then a grammar school (later a boys' academy), established by the Jesuits, and finally a boarding school for girls and a public school for all other children by the Sisters of Charity. In 1879 Professor Charles S. Howe, founder of a Christian Congregationalist college in Colorado Springs, opened the first non-Catholic institution in the city, the Albuquerque Academy, which welcomed a class of twenty-six Anglo children. Its goal was to be "Christian in character," but "forever free from ecclesiastical and political control."[1] As the railroad brought about the physical and social fragmentation of the city with the birth of a "new town" near the train depot, the Anglo population, its businesses, and school moved to the new center of life. At

the time, 90 percent of the students at the Albuquerque Academy were Anglo (total enrollment was 337), while the Sisters of Charity educated over five hundred Hispanic pupils in their school, the St. Vincent Academy.

The St. Vincent Academy and the Albuquerque Academy were the two main educational institutions in nineteenth-century Albuquerque, but while the former continued into the twentieth century, the latter closed in 1891 after the passage of a law that established the Albuquerque Board of Education, terminated financing for the Albuquerque Academy and St. Vincent as public schools, and called for the construction of new public institutions.[2] The St. Vincent Academy was also affected in that, with no public money, it could not afford to educate all Albuquerque children, especially low-income Hispanics; the Sisters' institute thus became a private school for girls, while wealthy boys were sent to the newly established parish school of St. Mary's. This public law altered forever the city's educational system.

The Albuquerque Indian School: Historical Overview

The education of American Indian children from the neighboring areas was never contemplated by Albuquerque's two main institutions. However, plans for an industrial boarding school for the Pueblos to be located in the city of Albuquerque began to be discussed as early as the mid-1870s. Public lands were thought to be available and the Rio Grande would have provided the needed water supply for the maintenance of the school and its agricultural grounds. U.S. Indian Agent Benjamin Thomas of the Pueblo Agency in Santa Fe was instructed to survey the area and select a suitable piece of public land, but there was none available for that purpose. He was able to secure 160 acres of "excellent land" from the Indians of San Felipe who agreed to lease it to the federal government for a period of ninety years, but the Department of the Interior did not approve this plan.[3] Thomas then asked the citizens of Albuquerque for a donation of land to the government for the purposes of building the Indian school. By November 1880, after two years of negotiations with the city, a building was finally secured in the village of Duranes, just north of Albuquerque, in order to start a school the coming winter.

Missionaries of the Northern Presbyterian Church had been interested and actively engaged in the establishment of mission schools for American

"The Administration Has No Sympathy"

Indian children throughout the Southwest and the Rocky Mountain region from the late 1860s. When their local superintendent, Reverend Sheldon Jackson, learned that the Board of Trade of the city of Albuquerque would provide the site for a future institution for the Pueblo Indians, he entered into negotiations with the government to run the school.[4] The contract was signed between the commissioner of Indian Affairs and the Reverend Henry Kendall, secretary of the Board of Home Missions of the Presbyterian Church, and the Pueblo Industrial Boarding School was organized and became operational on January 1, 1881, in the Duranes rented facilities. The agreement between the U.S. government and the Presbyterian Church was for one year and was set to expire on December 31, 1881; however, it was renewed each year until the government was ready to take full control of the school in 1886.[5]

The Industrial School enrolled fifty students, twenty-five boys and twenty-five girls, from eight of the surrounding villages. In his first annual report as the appointed superintendent in charge, Professor J. S. Shearer wrote that parents were initially suspicious and not eager to let their children attend, particularly when they understood that the goal was to destroy their Indigenous customs; however, according to him, they slowly came to see the teachers as "their truest friends and the school of inestimable value to their children" and thus favorably consented to the education of their young.[6] The Territory of New Mexico's governor, William Thornton, also wrote of this initial difficulty in one of his reports years later, and like Shearer, remarked on the parents' changed attitude toward the school:

> For many years it was difficult to obtain the consent of the parents for the education of their children at these public institutions, as they had much hesitancy in permitting their children to leave home and go under the control of the teachers. This is now changed, and the parents are taking great interest in the schools, in many instances showing an anxiety to have their children educated.[7]

Shearer's tenure as superintendent did not last long. On July 1882, he was replaced by Richard W. D. Bryan, who remained in charge of the school until 1886, when the government took control and appointed P. F. Burke as the new superintendent.

The donation of land, in the meantime, did not take place. Thomas reported the progress made toward securing it in a letter to the acting commissioner of Indian Affairs, E. M. Marble: "They seemed quite in favor of the proposition, held public meetings, received subscriptions and finally nearly completed the purchase of the land, when, as I believe, on account of dislike of the *personnel* of the management of the school, which had in the meantime been opened under contract of the department in a rented building, they proceeded no further in the matter."[8] Although Albuquerque's citizens committee had reassured Thomas that they were in the process of finalizing the transfer of property, the Indian agent suggested to the commissioner that the school should be moved to Santa Fe, where it would be closer to the agency, the northern Pueblos, and major water works to increase the supply of water. The people of Albuquerque strongly opposed the move; since the construction and operation of an Indian school provided an opportunity for greater economic development, they did not want to lose the prospect and continued to work to procure additional lands. By 1882, they had raised over $4,000 to cover the purchase of "an excellent tract of land in Bernalillo County" and the construction of school buildings.[9] In October 1882, staff and students were moved to the new location (fig. 22).

The Curriculum of the Indian Industrial Boarding School

The Albuquerque Indian School (AIS) was initially designed to expand the mission and faith of the Presbyterians among the Pueblos. The curriculum centered on the Bible and instruction was entirely based on scripture passages. The ideals of citizenry and manual labor were also included as core edifying tenets. The Presbyterian Church thus set the framework of what the industrial school was going to become in the succeeding years. The educational philosophy of the Presbyterians, however, was slightly different from Richard Pratt's vision for Indian children: the Christian missionaries, in fact, while constantly pressing the students to abandon the customs and "immoral" lifestyles of their parents and become civilized, did not completely remove the children from their families and culture as pupils were allowed to be visited during the school year or to return home during the summer months.[10] Similarly to Pratt, however,

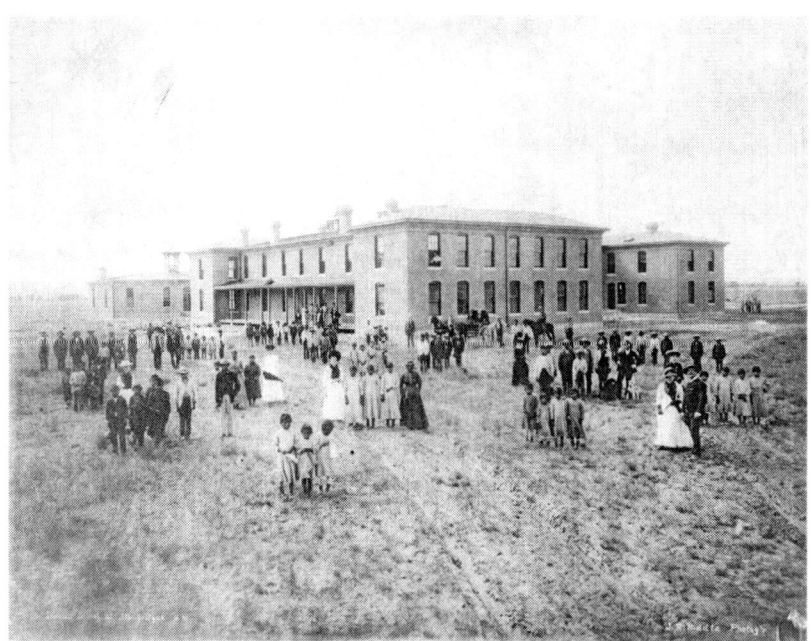

Fig. 22. Albuquerque Indian School in 1885, relocated from Duranes to Albuquerque in 1881, ca. 1885. National Archives and Records Administration–Rocky Mountain Region, Denver, Colorado, NRG-75-AISP-2.

the missionaries regarded Indian cultures, not the people, as inferior and attributed their primitive and backward state not to racial traits but to the natural and social environments in which they lived.[11] When the U.S. government took control of the Albuquerque institution, military discipline and a highly regimented schedule became additional fundamental aspects of the education of Pueblo children, as in other Indian schools around the country. It was believed that strict discipline would render students obedient and submissive to authority and ultimately able to achieve better results in their practical training.

As the school first opened its doors in 1881, children were instructed in reading, writing, singing, and drawing, as well as domestic science (girls) and farming (boys). According to historian Michael Coleman, other Presbyterian schools provided a curriculum that included "algebra, history, geography, chemistry, botany, physiology, natural philosophy (the

sciences), natural history (geology and biology), Latin and Greek," but there is no documentary evidence that these subjects, particularly the sciences and ancient languages, were taught at Albuquerque.[12] Similarly, while Coleman does not list drawing as one of the subjects taught by Presbyterian ministers at other institutions, the first annual report reveals that this was the case at the AIS. Early school records also show that in 1884, when enrollment had already increased to 158 pupils, the school had three teachers on staff: Miss Butler, the principal teacher who "taught chiefly by object lessons"; Miss Tibbles, who taught arithmetic; and Miss Wood, who taught geography, reading, and spelling.[13] Industrial education was introduced under the second superintendent, Richard Bryan: girls were taught sewing, cooking, laundering, and domestic work, while boys were instructed in carpentry, stone cutting, painting, and farming.

After the government takeover and the appointment of P. F. Burke as the new superintendent (October 2, 1886–May 24, 1889), the school experienced some difficult years. The teacher corps was too small for the increased number of enrolled students and there was no uniform government course of study to follow, so everything was left up to the superintendent and the teachers. Some years of stability came during the tenure of William B. Creager (May 25, 1889–March 31, 1894) as the Indian Office provided new rules for Indian schools and their course of study under the leadership of Commissioner Thomas Morgan. At this time, children were taught shoemaking, harness making, cooking, sewing, and laundry work in the industrial department; reading, writing, numbers, geography, history, and the rudiments of drawing were included in the academic instruction.

Instability was again a major feature of the AIS after Creager resigned. During 1894, four superintendents presided within a period of six months, and four more came and went within the next three years, some of whom were in office for only a few weeks.[14] A reasonable consequence of this frequent turnover of employees, which also often signified a replacement of other staff members, was that there was little concern for the quality of the curriculum or the instruction, the teacher-student ratio, or the well-being of the pupils. The educational matters of the school were mostly ignored, as superintendents found themselves engulfed in administrative and bureaucratic issues. As a result, there was very little improvement. Progress in

"The Administration Has No Sympathy"

the school during its first decade of existence under government control was experienced only under those superintendents who maintained their position for longer than a year: Burke, Creager, McKoin, and McCowan. The sentiment of powerlessness and frustration that resulted from this lack of organization was clearly expressed by McCowan in his first reports. In 1897, for example, about a year after his appointment, he wrote:

> Frequent changes in superintendents and employees has had [sic] the effect of unsettling the institution and very materially hindering its progress. The last change took away not only the superintendent and the matron, but also the principal teacher, senior teacher, disciplinarian, assistant disciplinarian, chief cook, shoemaker, and band teacher. Besides these transfers most of the older and better trained pupils were taken from us, leaving a new superintendent with a large portion of new employees and but few advanced pupils with which to conduct affairs. It is difficult to overcome such handicap, but the employees now here are in nearly all cases taking good hold of the work with a zeal and hopefulness that is most encouraging.[15]

From 1897 to 1908, five other superintendents and three supervisors crossed the door of the AIS, a rare number even for the Indian School Service.[16] With the exception of the supervisors who were temporary transitional figures, the superintendents headed the institution for an average of three years and were thus able to keep up and improve the work started by their predecessors. The literary department remained mostly unaltered in the course of the decade and included all grades from kindergarten to the eighth. Two additional grades were added in 1908, so students could receive an education up to the tenth grade. Also, new industrial trades for both boys and girls were eventually included in the curriculum. In 1908, boys were instructed in shoe and harness making, tailoring, blacksmithing and wagon making, carpentry, steam engineering, dairying, gardening, and farming, while girls learned housework, cooking, laundering, cutting, fitting and sewing, the care of the sick, and the care of chickens.[17]

The 1914–15 school calendar shows that the Indian school adopted the course of study for the state of New Mexico and that attempts were made to correlate the work of the academic and industrial departments. Teachers

had to make "weekly visits to the Industrial departments in order to secure practical material for use in language and arithmetic" and provide instruction that was "helpful to the pupil in learning his trade." In the industrial departments, boys learned "Farming, Gardening, Carpentry, Painting, Blacksmithing, Wagon-making, Tailoring, Shoe & Harness Making, Steam & Electrical Engineering, and Dairying," while in the domestic science department girls were taught "family cooking, serving, laundering and general house work. They are instructed in other departments in cutting, fitting and sewing, housework, care of chickens and school laundrying."[18]

The curriculum of the Albuquerque School experienced additional changes in the years to come, particularly the 1920s. Now that greater emphasis was placed on vocational education and less on book learning, students were taught prevocational work (which still balanced the academic and the industrial) and were subsequently assisted in their choice of vocational courses that would lead them to a profession. Boys were still instructed in the "classics" of carpentry, farming, blacksmithing, and painting, and saw the addition of new vocational courses for professions in steam engineering, auto mechanics, plumbing, steam fitting, electric wiring, and masonry. Girls were still taught domestic science—now called home economics—and learned cooking, serving, general housework, homemaking, and sewing; in addition to this, they could be trained in nursing, instrumental and vocal music, and for "positions of matron, seamstress, housekeeper, laundress and cook in institutions."[19]

Drawing

Records of the school's drawing curriculum are unfortunately scarce. Glimpses of what was done can be obtained thanks to a handful of primary sources and local newspapers, many of which show that this instruction preceded Morgan's *Rules for Indian Schools*. The first report of Superintendent J. S. Shearer to Benjamin Thomas, Indian agent for the Pueblos, dated 1881, informs us that drawing was one of the three fundamentals of the "common English branches" and was thus included in the curriculum of the industrial school from its establishment.[20] There is no evidence, however, that anyone was purposefully hired as a "drawing" or "art" teacher. Art, along with music and foreign languages, was the finishing touch to a

well-rounded education, particularly for women. Starting from the 1860s, when more and more women began to systematically enter the teaching profession, art was still taught as an important part of their overall formation; however, there was no formal training for teaching it. Aspiring teachers learned drawing procedures from books in print, but since art was considered a tool to cultivate morality, that is character, there was no "technique" for this. Only later, in 1873, did training in teaching methodologies begin at the newly established Massachusetts Normal Art School for a selected few who attended this institution. The majority of public school teachers or employees in the Indian Service had some knowledge of art and likely taught it in the manner they deemed most appropriate.

More information about drawing in the early days of the Albuquerque School comes from local newspapers. In 1883, the *Albuquerque Journal* interviewed one of the teachers on the children's progress and she explained that her pupils were given "every encouragement to draw" and that their favorite subjects were "ships and American girls in elaborately trimmed skirts."[21] The teacher evidently incorporated drawing in her daily lessons and made this activity an important part of the learning process. It is clear that the young pupils were encouraged to depict "civilized" subjects, rather than imageries from their own cultures or their own fancy, and so drawing was used as an instrument to teach them about the world they were expected to join one day. A later article, from the *Albuquerque Evening Democrat*, informed readers about the daily operations of the school in 1885 as the reporter wrote that "the school hours are from 9 to 12 in the forenoon, 2 to 5 in the afternoon and one hour after supper devoted to music and drawing."[22] Finally, a third newspaper recounted that "reading, arithmetic, writing, drawing, spelling, geography, and lessons in the use of language are daily taught."[23] These pieces indicate that drawing was taught along with other subjects as an integral part of the curriculum and that students, in addition to being instructed to sketch in class, were also encouraged to devote their spare time, that is, their evenings, to this creative and morally sound activity.

It is hard to tell whether teachers at the AIS devoted a daily, extended period of time to the instruction of drawing or simply interspersed their reading and writing lessons with drawing exercises. Public institutions at

this time were using drawing manuals and their systematic approaches to teaching drawing, something that would require time and practice in the classroom, but there is no evidence that this was happening at Albuquerque.[24] The first annual reports attest that drawing had been taught since the opening of the school; further evidence suggests that it became an important subject under Superintendent Bryan, who was head of the institution from 1882 to 1886. A monthly report card found among his papers shows, in fact, that students' advancement was evaluated in this area, along with arithmetic, reading, chart lessons, language lessons, spelling, penmanship, geography, physiology, civil government, Bible study, music, calisthenics, and industrial training.[25] Unfortunately, the card neither indicates when it was first issued nor speaks about the nature of drawing instruction—how often it was taught, for how long during each school day, and how—but it nonetheless confirms that drawing was an integral part of the curriculum a few years after the school opening.

The AIS made considerable progress under the leadership of Superintendent Bryan; his tireless efforts were able to secure additional funds and supplies from local citizens, recruit more pupils, and win the sympathy of their families. Also during his tenure, industrial training was introduced into the curriculum. Because of his recognized role in shaping the AIS and his goal of improving the education and thus the future of Indian pupils, it is likely that Bryan also mandated formal instruction in drawing, so that from an essentially auxiliary activity it would now be officially acknowledged and structured. This decision to include drawing could have been prompted by two factors. The first was Bryan's familiarity with the national debate on the value of art in schools. Educated in New York, he was a lawyer, educator, and astronomer who had come to Albuquerque by way of Washington DC. While a superintendent at Albuquerque, he contributed to the organization of the Territorial Educational Association of New Mexico and was elected as its first president.[26] His involvement with education, in and out of the Indian school, was constant and it is thus legitimate to conclude that he kept abreast of the theories and philosophies of his time.

The second factor was the "competition" with other Indian schools and the need to keep up Albuquerque's good name in the eyes of the Indian Office, the citizens of the territory, and the entire nation. In an 1884 letter

"The Administration Has No Sympathy"

to friends and supporters of the school, Bryan wrote that "the school ha[d] also gained a standing among similar institutions and was ranked by U.S. Indian School Superintendent Haworth in his speech at Ocean Grove last summer with Carlisle and Hampton."[27] This praise by Haworth could have prompted Bryan to improve the curriculum of his school and adapt it to that of these two giants of Indian education where drawing was already in place. At Carlisle, students were given paper and pencil as an "icebreaker" almost as soon as they arrived at the school, a practice that Pratt had already experimented with at Fort Marion; the drawings initially depicted the undomesticated life children had just left behind, but were soon supplanted by pretty pictures of more civilized life, including easel paintings of still life and portraits in the manner of European masters. At Hampton, on the other hand, Indian pupils were encouraged not only to make drawings but also to depict images of home and tribal life, which were often sold to visitors. In seeing what was happening at these schools with which the AIS was compared, Bryan might have felt pressured to follow their example in order to maintain the same quality of education they were offering.

Two local newspaper articles additionally confirm that drawing was part of the school curriculum under Superintendent Bryan. Interestingly enough, they both alluded to the Indians' innate artistic abilities and how these, when properly cultivated and directed, could produce very good works. The first piece, "Sons of Indians," let readers know that "these children can be taught to spell, to read and to write and draw, in a manner, that when all circumstances are considered is nothing less than remarkable."[28] The second reported that "in penmanship and drawing they do well, their imitative powers being highly developed."[29] What was being suggested here was that Indian children did have an artistic sensibility, albeit uncultivated and banal, good for imitating but not for creating, which could have been the starting point for further development. Through the correct means, they could have been lifted up from their primitiveness and brought to a level that was comparable to the white man, and this instrument was obviously education. These articles also reveal that schoolchildren were improving in their drawing skills and thus, in the eyes of a white observer, were making significant progress in their civilization. In order to advance,

the students needed to practice, and thus drawing was not simply a way to fill time or a marginal and occasional exercise but a stable feature of the children's education and learning process.

Due to the lack of original records from the school administration, it is difficult to say how Commissioner Morgan's mandates from the early 1890s were incorporated into the AIS curriculum. However, other sources can provide insights into what pupils were doing. For example, according to the report *The History of the Women's Exhibit from the Territory of New Mexico to the World's Columbian Exposition*, students, especially girls, were doing "black and colored crayon" drawings that received special praise at the exhibit.[30] At the yearly New Mexico territorial fairs, the Indian Industrial School often "made highly creditable showing" of the students' works either in the educational exhibits or in the parade floats. This is confirmed by an undated photograph (fig. 23) found in the Cobb Collection at the Center for Southwest Research at the University of New Mexico that depicts an exhibit area teeming with a variety of objects on display. A glass case about two feet long is positioned at the center of the expository area and is filled with photographs and specimen of Indian pottery and baskets. The content of the photographs cannot be distinguished but it is possible that they depict scenes of daily life at the local pueblos; similarly, the display of Native crafts was likely meant to provide a glimpse of the students' homes and cultural background. Samples of ceremonial clothing collected from the local pueblos and including two buffalo heads are arranged above and behind the case. This display of "Indians of the past" purposefully contrasted with the civilized industries made by students attending the Albuquerque School found in the remaining areas of the exhibit. This juxtaposition was a regular feature at international fairs and expositions and it meant precisely to show progress toward civilization and thus garner support for the work of government education.

The school displays on either side of the case represent the "Indians of the present" and completely surround the previous one, thus conveying the message that the Indigenous peoples of the past will soon be conquered by a better civilization through education. On the right side of the photograph is the display of the boys' department, where samples of leatherwork such as harness and bridles appear to be the most prominent feature; on the

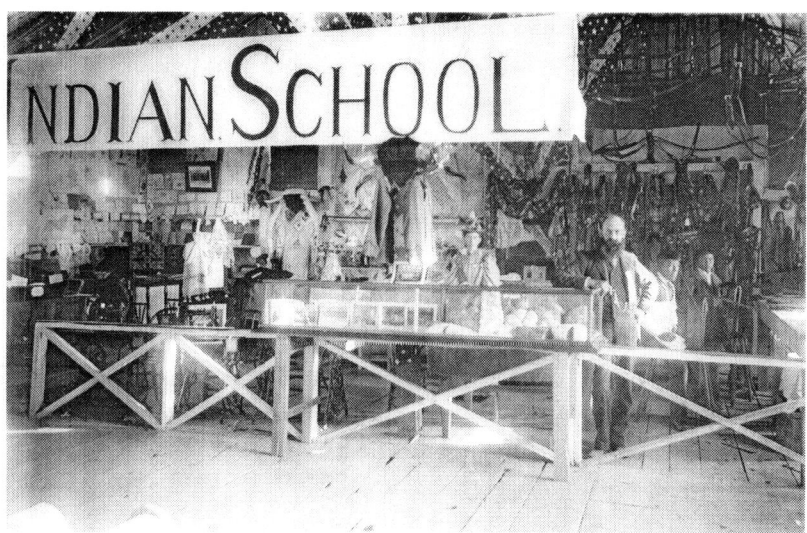

Fig. 23. New Mexico Territorial Fair. Cobb Collection (PICT 000–119), Center for Southwest Research, University Libraries, University of New Mexico. Photograph by New Studio (Albuquerque), 1890–93.

left side are items from the domestic science department, among which are some needlework, particularly centerpieces and napkins. Next to the needlework display is a wall covered with numerous drawing papers. While we cannot identify their content except for a few (an animal, a landscape), we can speculate that they demonstrated the students' progress in drawing.

Teachers and students are also featured in this photograph. In the center, a man and a woman are standing, respectively, to the right and behind the glass case, directly looking into the camera. On the right, two male students, nicely dressed in their school uniforms, are seated in the boys' department, intent at demonstrating their work to the curious passersby. On the left-hand side, almost unnoticeable, is a female student seated at a classroom desk in the act of writing. The people's spatial arrangement conveys an additional message on the superiority of white education: the two Anglo teachers, standing over the case filled with "Indians of the past," are the ones in a position of power, the instruments through which the new civilization is transmitted; the Indian students, obediently sitting in their chairs, are the passive recipients who cannot do anything but submit

and accept what is inevitable for them. Whether this photograph captured teachers and students intentionally posing or not, it subtly expresses the racial agenda of Indian boarding schools.[31]

From the early 1900s, school administrators complied with the changes mandated from the Indian Office. Evidence shows that, in the first years of the new century, training in drawing included simple studies as well as more elaborate illustrations, just as Morgan had recommended in his *Rules* a few years before. For example, at the 1902 Territorial Fair, "pastel studies, perspective drawings, unique illustrated booklets on geography, history, physiology, arithmetic, etc." impressed fairgoers for their display of "thorough training," while in 1903 the Indian school was "well represented by drawings and the usual exhibit of school work."[32] These excerpts testify not only to the kind of work that students did, but also to its quality and especially to the commendable efforts of government schools; as Indian children had become sufficiently civilized, their drawings were worthy of being displayed for public viewing and were compared to those of non-Indian students from the entire Territory of New Mexico.

This documentary evidence also reveals that the school had begun to comply with Reel's directives that drawing should be only an auxiliary activity meant to facilitate the learning of other more important subjects. The presence of illustrated booklets on history and geography at the above-mentioned fairs is proof of this adherence. Photographs of Indian exhibits organized by Reel in connection with the annual meetings of the National Education Association prior to 1906 also demonstrate that Albuquerque students used drawings in connection with other areas of learning, specifically geography and nature study; a few maps and sketches of animals, for example, were displayed at the 1903 exhibit in Boston.[33] Other than these kinds of exercises, drawing did not occupy much of the students' time in the classroom and did not constitute a subject of instruction per se. According to Superintendent Collins, in fact, "most time is given over to practical and useful work. Only enough attention is given to music and so-called accomplishments to serve as a diversion."[34] It is hard to measure instruction in terms of hours, and to quantify what Collins meant by "enough attention," but it seems that after he assumed charge of the school, drawing did not have a central role outside of the parameters specified by

"The Administration Has No Sympathy"

Reel. While it persisted as an activity for leisure time, the school administration was clearly more interested in emphasizing manual training and demonstrating to the outside world what Indian students could achieve in these areas if properly prepared. The American people might have been interested in seeing pretty and Westernized drawings, but in the eyes of the school administration the concrete work of Indian hands in objects of practical utility was more important and more efficacious in testifying to the nation the children's progress at the Albuquerque school.

Collins's successor, James Allen, had completely different opinions regarding drawing and other creative exercises, and it is not a coincidence that his tenure as superintendent almost coincided with the appointment of Francis Leupp as commissioner of Indian Affairs. In the article "Kindergarten and Primary," published in 1905 in the second issue of the *Albuquerque Indian*, the school publication, Allen introduced his readers— school staff, but especially supporters and patrons—to Friedrich Froebel's theories of education for the younger grades, particularly the importance of self-expression and creativity as vehicles for the development of a child's senses and power of observation:

> Froebel recognized that the most powerful factor in the education of the child and of great influence, physically, intellectually, morally, is to recognize the activity, the spontaneous life of the child, in allowing him freedom and self-expression. This properly handled in the kindergarten stimulates interests and adds life to the primary work as it is the real nature of the child. By means of the gifts and the occupations, as clay-modeling, paper folding, weaving, the sand-table, pencil, brush, etc., this activity is utilized, which gives the child power and ability to think, and makes him ready to express thought which is back of this work (not confined only to words) and thus awakens his creative powers. Through this training of the senses and perceptive faculties, ideas are aroused which must be awakened in the primary school through a continuation of the same, modified to meet the needs and changing conditions.[35]

Froebel's educational theories on the development of children had become very popular in the late 1880s and laid the foundation for the kindergarten movement. Indian schools were slow to catch up with public institutions,

but activities such as the ones described in the passage above had been used before (under both Morgan and Hailmann) and were not a novelty (see the kindergarten class in fig. 3 of this volume and the work displayed in fig. 5); in recent years, they had simply been discarded and marginalized by Reel. Now, however, in light of Leupp's renewed push for Native crafts in the schools, the importance of any kind of creative exercise had been reconsidered and it was certainly welcomed by Allen. Writing about Froebel's creative and "intelligent productions" was a way for him to explain and justify upcoming changes to the curriculum of the Albuquerque School. Were Froebel's theories actually put into practice? Were children occupied in activities such as clay modeling and weaving (which were neither Indian pottery nor blanket weaving) or painting? Unfortunately, this finding cannot be corroborated due to lack of additional evidence. However, considering Allen's positive attitude toward Froebelian occupations and that the education of Indian children at Albuquerque started from kindergarten, I conjecture a strong likelihood of their existence. Collins and Allen perfectly mirrored Reel's and Leupp's different approaches to art education.

Further records of drawing in the curriculum of the Albuquerque School date to a later period, 1915, when a local newspaper referred to it in the context of a school exhibit at the Albuquerque Public Library. The display, organized to showcase the objects awarded with a blue ribbon at the recent state fair, was described as follows:

> A display of tools made from steel is a marvel. A hat crocheted by a 16-year-old Pueblo girl is bound to win the admiration even of a trained milliner. The knitting, tatting, embroidery, patchwork, darning, penmanship, drawing and other exhibits are proof of proficiency of teachers as well as receptiveness of pupils. Quite attractive are botanical essays illustrated with specimens of the wood, leaf and flower, as well as blue print photograph of the trees described. Several illuminated mottoes suitably framed are works of art and also please because of the good cheer, hope, joy, and optimism expressed in the verses. All together, the exhibit is one that would do good to send to every city of the United States to prove that even the Indian is becoming a useful and self-supporting citizen.[36]

While the journalist did not describe the subject matter of the drawings, he indicated that they enhanced the students' learning of botany. The illustrations of specimens of wood, leaves, and flowers, in fact, were not mere creative exercises but practical activities meant to help the students better acquaint themselves with their natural surroundings and products, a kind of knowledge that was essential for the economic well-being of future independent farmers. By reproducing leaves, trees, fruit, and vegetables, students learned by doing and familiarized themselves with the physical characteristics of these natural objects. Drawing preceded practical training in the school gardens or the fields and was thus a hands-on activity that introduced students to the world around them.

Two comments offered by the unknown reporter need to be examined further: that drawing, like other things, demonstrated the "proficiency of teachers" and the "receptiveness of pupils." The first statement seems to indicate that students had no personal merit in the quality of their work; if they had produced such good items as to win them the highest awards at the state fair, it was not because of their own talents but rather because they had been patiently guided and trained by the expert hands of Anglo teachers. It was thanks to the tireless work of these committed individuals that "even the Indian [was] becoming a useful and self-supporting citizen." The persistence of this attitude toward Indian people is a sign that beliefs about their racial inferiority and the natural deficiency of their abilities were still prevalent. On their own, that is, without the education provided for them by the American people through the federal government, Indian students had no intrinsic value and could never progress.[37]

The second statement suggests that the good quality of the students' work was to be attributed to their receptiveness; otherwise considered blank slates, this seemed to be their only good attribute. In the mindset of a 1915 American, this "receptiveness" could have been read either as submissiveness, passive acceptance of a way of life that had proven to be unavoidable, or as genuine realization that the white man's ways were better than their ancestors' and that giving up the old life for what was being offered was in the end worthwhile. In either case, being "receptive" was equated with not questioning the establishment and completely giving up one's traditions. A century later, however, we can interpret this behavior

differently. In the case of drawing, for example, we could speculate that students were very interested and eager to learn because they actually enjoyed it. They could have happily executed whatever task the teachers gave them because drawing was a familiar activity. They could have positively welcomed it because, for many at Albuquerque, it was a form of art, and thus a way to express beauty, harmony, and balance. This does not deny the possibility that students might have had great teachers and responded positively to their encouragements to draw as a sign of devotion or desire to please. However, we cannot eliminate students' agency from their actions and cannot assume that they responded to boarding schools with homogeneity.

Numerous historians of American Indian education have challenged assumptions of Indian children as passive recipients and subjects of government educational policies and have powerfully demonstrated how individual agency was crucial in shaping the students' educational and living experiences at boarding schools. Records of the Albuquerque Indian School do not offer evidence of students' voices, but this does not mean that student agency was absent. In light of the new methodological approaches to the study of American Indian experiences in boarding schools, my reading of the *Albuquerque Morning Journal* cannot disregard that the scenarios mentioned above, even if conjectural, are likely. They would confirm that students at Albuquerque appropriated drawing, an activity imposed on them by a foreign educational system, and made it meaningful to their lives in their own ways, whether it was in class or in their spare time.

There is a substantial time gap, almost a decade, between the last historical records found. If drawing was a noteworthy activity in 1906 and in 1915, can we presume that it was continuously present? Was it originally part of the students' lessons but then came to assume an increasingly marginal role in their overall education? Could it be that at this time, in the mid-1910s, almost thirty years after the establishment of the first boarding schools, the American people wanted to see the practical results of manual labor rather than the students' academic accomplishments? The answer to all these questions is yes. Drawing never ceased to exist at Albuquerque between 1906 and 1915, but it slowly began to wane as the school administration emphasized training that would better prepare

"The Administration Has No Sympathy"

students for a life of menial work and help them contribute to American society at a time of global war and need.

The Native Arts and Crafts Curriculum

There is no evidence of arts and crafts at the Albuquerque Indian School prior to 1902. Estelle Reel's *Course of Study* had only been in print and effective for a year, so there is no reason to presuppose any official reference to weaving, basketry, or pottery before her mandate, not even when we consider that their instruction and sale had already been recommended and proposed by her predecessor, Hailmann. For about two decades, from the beginning of the 1880s to the turn of the twentieth century, the government's official policy had been assimilation and civilization through the destruction of Indian cultures; therefore, the encouragement of such artistic endeavors was not even contemplated.

In the case of the Albuquerque Indian School, local administrators and officials had an additional reason for keeping arts and crafts, vestiges of a primitive past, away from schoolchildren and their progress toward civilization: the railroad. The Southern Pacific Railroad was completed in 1880 with Albuquerque as one of the stops along the Atchison, Topeka, and Santa Fe Railway to California. Here, passengers had the opportunity to dismount the train for about half an hour and walk around the platform. Whether they took advantage of this or not, they still had the chance of seeing "real Indians," as Native men and women populated the railroad tracks offering their goods for sale. Native craftspeople immediately understood the advantages of the railroad and began selling their work to passengers soon after the first train came by. This practice of spending days by the train tracks waiting for the next load of passengers was not welcomed by the superintendent of the Pueblo Agency, Benjamin Thomas. In a letter to Commissioner Price, Thomas wrote, "The present effect upon the Pueblo Indians of railroads . . . is bad. Railroad stations have great attraction for the Indians, and many are there learning to loaf and sell trinkets instead of giving attention to their farms and domestic duties. I am trying to break up this practice and hope to succeed in a measure at least."[38]

The sale of crafts to tourists was regarded as a waste of precious time that could have been otherwise spent in "civilized" activities such as tending the

land and crops and improving one's home. In the eyes of federal employ-
ees, the marketing of traditional handmade goods could not replace men
and women's main duties, that is, farm labor and domestic chores. The
Indian agent's reluctance to promote the sale of arts and crafts, even when
this activity produced cash for Indian families, was shared by the super-
intendents of the Albuquerque School who, having to report to Thomas
as the head of the local U.S. agency, also had to obey his directives. Both
the Indian agent and the school superintendent (and their respective
replacements in the years to come) saw the Pueblos' continued interest
in the railroad and the tourists it brought as deleterious influences on
their progress and advancement, because it kept them away from "real"
work. Much to his disappointment, Thomas was unable to "break up
this practice" as he had hoped; local Pueblos, in fact, persisted in selling
their goods at the Albuquerque station well into the 1900s, even after the
opening of the Fred Harvey Company Indian Department at the Alvarado
Hotel in 1902.[39]

The appointment of Reel and her new curriculum guidelines soft-
ened the position of the current superintendent, James Allen, although
did not significantly change the Indian agent's antagonism toward these
marketing practices. As Reel was able to witness during her first visit to
the Albuquerque School in 1902, arts and crafts were carried out, and she
discussed them in two separate entries in her report to the commissioner
of Indian Affairs for that year. First, she wrote that "blanket making is
taught, and the girls have done creditable work. Several handsome rugs
have also been made" and then commented that "blanket weaving and
beadwork were done."[40] There is no indication of the tribal affiliation of
the students involved in these activities or the kind of items, particularly
beadwork, that were made. However, we can see what some of these arti-
cles might have looked like thanks to a photograph of the 1903 exhibit
prepared for the NEA annual meeting in Boston (see fig. 49 for the full
display). The school display assembled for this event, in fact, included
examples of both weaving and beadwork. The blanket, likely black or
red and with diamond designs and patterns typical of Navajo imagery, is
folded in half and mounted on a poster board measuring approximately
28.5 inches wide by 22.5 inches high, yet it can still be seen that its size is

"The Administration Has No Sympathy"

not large. Next to the small blanket are two beaded belts, one with floral motifs on a white background and the other one with a diamond pattern. The students' names, ages, and tribal affiliations are reported in the labels placed on each item, but unfortunately, they are unreadable, so the identity of their makers remains unknown.

Domestic crafts such as embroidery, knitting, and quilting were continuously produced at Albuquerque (boys did work in wood and leather), even prior to the passage of the *Course of Study*, but the same cannot be said of Native industries. Two years after the first official reports on the status of these activities, Allen wrote in his annual narrative that "a fine quality of workmanship was shown in the handicrafts. Pottery work among the Pueblo girls was very good. William J. Oliver was sent to escort Indians with pottery to the World's Fair at St. Louis. Many of the girls who had been taught weaving were so anxious to weave blankets that they frequently used the legs of an ordinary chair for a loom and it was no unusual occurrence in passing through the dormitory to find a number of chairs used as looms on which are unfinished blankets."[41]

According to this passage, Pueblo students made pottery that was exhibited at the Louisiana Purchase Exposition while other girls wove blankets. In her own account of her second visit to the school, in 1904, Reel borrowed Allen's words when writing that "the girls whose parents are blanket weavers are so anxious to carry on this work that they utilize the legs of an ordinary chair for a loom, and it is no unusual occurrence in passing through the dormitory to find a number of chairs used as looms on which are unfinished blankets." She also added that "the Albuquerque school is teaching blanket weaving and lacemaking."[42] Before leaving the school, she recommended the purchase of looms and the hiring of a Native teacher.

The *Course of Study* explicitly stated that children belonging to blanket-weaving tribes should be taught the art, but what it did not say was that this industry was to be taught exclusively to girls; this notion was implicitly understood because weaving was, according to Reel, an activity associated with civilization, domesticity, and the care of the home. The Albuquerque School's improvised looms, clearly for small-size items and not for rugs, could have been used by either Pueblo or Navajo students. The Pueblos had a tradition of male weaving, although women made belts and bands

using a back-strap loom, while among the Navajos it was predominantly a female activity where women used looms of different sizes, including smaller ones for weaving saddle blankets. The fact that weaving in Indian schools was conceived as a female-only activity shows that Reel had no regard for the gendered division of labor that characterized Native communities. Did the superintendent have knowledge of Indigenous sex-based traditions of craft production? We do not know for sure, but considering the overall ethnocentric tone of the *Course of Study*, I am inclined to think that she was aware of them and intentionally ignored them to impose her Anglo conceptions of gender roles. In her view, a man's job was outside the home while a woman's was inside; if Indian children were to assimilate into American society, they had to learn these "civilized" roles, even in the making of their own traditional crafts.

Two important points about Native industries at Albuquerque emerge from the above reports. Firstly, the school was not employing a Native woman to provide instruction in weaving. It was not uncommon in the Indian Service to hire Anglo teachers who also had a basic knowledge of arts and crafts; in this case, it might have been possible that the girls were taught by a woman, most likely the domestic arts teacher, who had learned "Navajo" weaving from other Anglo women or from specialized books written by experts.[43] Reel recommended the employment of Native teachers for a few selected female crafts, namely weaving, pottery, and basketry, but she also made it clear that while these instructors were being procured, teachers needed to learn the basics of these crafts on their own, so that they could start teaching the children as soon as possible. In regard to basket weaving, she wrote, for example:

> Cane Basket Work, by Annie Firth, London, contains a number of excellent illustrations, showing the work step by step, and the teacher who has not had the advantage of lessons in basketry will, by carefully studying the illustrations and the printed directions accompanying each, be enabled to weave baskets. She will therefore be able to teach the principles of weaving in the small classes and be well prepared to master the art as presented by the practical basket maker when the opportunity to learn basketry is presented.[44]

In the absence of a Native person skilled in the craft, Indian Service teachers had to learn and be ready to instruct. They could have found instructions, materials, and sources of inspirations in the references provided by the superintendent. In 1904, this was likely the case at the Albuquerque School. Despite the availability of many Native artists, both Pueblo and Navajo, living nearby or working as crafts demonstrators at Fred Harvey's Indian Department at the Alvarado Hotel, the school did not employ one at the time of Reel's visit.[45]

The second important point is that whether girls were taught Navajo weaving or a white-conceived "Navajo style," they were certainly eager to practice an activity they were very familiar with, that reminded them of home, bore deep cultural and spiritual values for them, and was likely more fun than cleaning, cooking, and laundering. It is also interesting to notice that, despite the statement that "the Albuquerque school is *teaching* blanket weaving" (emphasis added), girls were not making their blankets in a regular classroom setting, for example in the domestic art classroom where they would normally practice their sewing lessons, but in the dormitory, away from the controlling eyes of teachers and school administrators, although likely not unnoticed by their matron. This suggests that using leftover materials from their weaving lessons with the domestic arts teacher—cotton for warp, for example—girls set up their own personal looms and, in their spare time, without being encouraged or instructed to do so, carried on *their* kind weaving, the one learned or seen at home.

One could read the girls' willingness to weave on their own initiative as a sign that the goal of Indian education was ultimately being achieved: young Indians had finally learned to be productive, use their time well, and not be idle. Estelle Reel probably interpreted the scene she witnessed in this way. I prefer to read the girls' behavior as an expression of their Indianness, a sign of resistance, of ingenuity in front of a window of opportunity that had suddenly opened for them—some years earlier these actions would have not been tolerated and the girls would have been punished. Their crafts were now allowed in the school—the girls were well aware of this—and yet they took advantage of this change to the fullest, that is, by enjoying traditional weaving in their spare time. We can see this yearning to weave as a welcoming attitude toward a school

policy that, for once, did not try to repress their Indigenous culture, but rather encouraged it, although on Reel's own terms. The girls' eagerness to practice a familiar craft in the dormitory was an act of personal, albeit brief, liberation from the burden of white man's education; it was an expedient to 'escape' from the monotonous routine of the school day and signified a desire, a longing to be involved once again in known activities that spoke of their homes and traditions.

Despite his official statements, Superintendent Allen, like his predecessors, was not a big fan of Native industries and had no particular desire to perpetuate traditional crafts in the school under his charge. As a matter of fact, after the 1902 report, which stated that blanket weaving was taught, there is no other indication that he made any progress in developing this or any other Native craft as an organic, integral part of the curriculum. Yet as Reel's second visit in 1904 neared, he felt pressured to show that the school was making progress in complying with the *Course of Study*. In a way, the girls' eagerness to weave became his winning ticket, the tangible proof that work in Native industries was well under way.

Another explanation for Allen's sudden encouragement of Native industries is the considerable pressure to supply art and "successfully developed" students for the Model Indian School at the St. Louis World's Fair.[46] In their study of the 1904 exposition, Nancy Parezo and Don Fowler explain that the model school was an occasion to showcase the government's progress in the education and assimilation of American Indians, but it was also intended to expand federal allocations for Indian education. For each school, this meant not only the possibility of parading its own work against that of other institutions, particularly bigger schools such as Chilocco and Haskell, but also of receiving extra government support. Samuel McCowan, the superintendent in charge of the model school, wanted to "maintain a very extensive and very fine exhibit of the literary and industrial work done at various schools" and thus encouraged each institution to furnish articles.[47] It is possible that after receiving this circular, Allen decided to give some emphasis to Native industries so that Albuquerque could be part of this international exposition.

Finally, a third reason that prompted Allen to take more concrete steps toward the establishment of a Native arts curriculum was a letter from

"The Administration Has No Sympathy"

Reel, written upon her return to Washington DC after her visit and in which she restated the importance of teaching weaving:

> As you are aware, the sale of blankets woven by the Navaho Indians con-stitute [sic] a considerable portion of their income, and it is believed that this industry should be encouraged and perpetuated. Blanket weaving is being successfully taught in the Navaho School, and as there are a large number of Navaho children at your school, the Office is desirous that they shall receive similar instruction and hopes you will adopt means to accomplish this.[48]

In order to comply with Estelle Reel's requests, Allen announced in 1905 through the pages of the newly founded school magazine, the *Albuquerque Indian* (fig. 24), that the school would venture into "some additional lines of industry hitherto untried and make them self-sustaining industries."[49] The first new industry was

> the manufacture of handmade mission furniture, the common use of which is characteristic of this region. Studies will be made of the best specimens to be found and their manufacture by Indian boys in the locality of its historical significance is hoped to be made a feature of interest to the public as well as commercial values of the school.[50]

The second addition to the school curriculum was

> the weaving of Navajo rugs and blankets by the children of that tribe alone, and under the tutilage [sic] of a Navajo woman, herself adept in the art. This to occupy but a period of the daily domestic or manual duties of the child. The administration has no sympathy with perpetuation of any except the most substantial of Indian handicraft, so that the idea of maintaining this industry is entirely utilitarian in its object.[51]

According to this proposal, boys were to be taught furniture making in the tradition of the Arts and Crafts Movement, using a regional style that was readily marketed; sound craftsmanship was required to make good-quality American furniture and Indian boys could contribute to maintaining local traditions of furniture making. This trade was not new to the school as boys had made furniture since the opening of the institution. An 1885 article in

Fig. 24. First issue of the *Albuquerque Indian*, front cover. Center for Southwest Research, University Libraries, University of New Mexico. The bordered cover, found in other school publications, such as Carlisle's *Red Man*, Chilocco's *Indian School Journal*, and Chemawa's the *Chemawa American* was a typical Arts and Crafts Movement design. Photo by the author.

the *Albuquerque Evening Democrat*, for example, reported that "a number of school desks made by the boys in the carpenter's shop would do credit to any carpenter in the country, and one of them will be sent to New Orleans as a specimen of what a young savage can do under proper training."[52] However, the precise indication of the kind of furniture to be now produced—mission style—was what made this industry a novelty at Albuquerque.

An interest in mission-style furniture was part of the Mission Revival that originated in Southern California in the late 1880s and corresponded with the rise of tourism in the coastal state and the public pleas for the preservation of old missions by Helen Hunt Jackson and Charles Lummis.[53] As artists of the Arts and Crafts Movement tired of heavy, dark, ornate Victorian decor and looked for more simple yet handcrafted objects, the rough furniture of the California Spanish missions seemed to suit their desires for clean, uncluttered styles with high-quality craftsmanship. According to Kevin Rodel, the term "mission," originally applied to illustrate the work of Joseph McHugh, was later employed as a marketing campaign by large-furniture manufacturers, who enticed their consumers with images of the solid objects found in California missions.[54] Because mission-style furniture soon came to be heavily mass-produced, handmade pieces were greatly valued and sought after by those who looked for individualized quality crafts in the tradition of the Arts and Crafts Movement. By teaching Indian boys mission-style furniture making, the school hoped to open for them some venues in this lucrative business.

The second new industrial venue, blanket weaving, was to become part of the domestic training of girls but, as Allen clearly specified, only for "a period of the daily domestic or manual duties of the child," not as a main subject, and it was to be "entirely utilitarian in its object." This shows that the purpose of this training was neither the preservation of the craft nor the promotion of Native culture: rather, it aimed to develop the girls' skills in the production of utilitarian articles, that is, items that were functional and economically valuable. If girls had to spend some school time learning this craft, then it had to be something that could eventually bring some returns. Allen's statement also indicates that he was averse to this instruction and unwilling to sacrifice much of the time devoted to real work—the domestic training in cooking, sewing, laundering, and house work—for it. He would

allow Navajo weaving, but only for a very limited part of the girls' school day. It is also worth noting that this instruction was not to be imparted to all female pupils, but to "the children of that tribe alone." While this could be interpreted as a desire to preserve the authenticity of the craft—Navajo blankets made by Navajo students—and thus to obtain higher profits for these products, this imperative was rather a sign of the superintendent's reluctance to extend such teaching to a large number of students. It is true that Allen had to ensure that pupils kept the school running and received the instructions really needed for life, but his hostility indicated a strong disagreement with Reel's policy; he was disposed to comply with it only so far as to meet its minimum requirements.

The identity of the Native teacher to be hired was never revealed in the pages of the *Albuquerque Indian*. As a matter of fact, the publication, which only comprised twelve issues and was discontinued when Allen passed away, contains no further references to Indian arts and crafts at the school. This is additional proof of the superintendent's hostile attitude toward these industries: while he allowed their instruction to a small group of students in obedience to the directives from the Indian Office, he kept them "private" and did not give them much publicity. Since he was responsible for the progress and advancement of the pupils under his tutelage, he clearly did not deem the presence of these activities in his school particularly advantageous: he probably feared that they would take away time from the main industries children were supposed to learn in order to become self-sufficient. Furthermore, like U.S. Indian Agent Thomas, he could have been disturbed by the practice of adult Indians selling their crafts along the railroad tracks; by not overtly encouraging Native industries, he could have acted preemptively, thus diminishing the probability of seeing his graduates wasting their days and the skills learned in school at the train stops. While it is true that the Fred Harvey Company was now attracting Native craftspeople to work for its Indian Department, ensuring them steady income and the possibility of travel and notoriety, Allen apparently did not approve of this kind of "job" for his students either.

Nevertheless, despite his personal objections, a Native teacher was hired. Elle of Ganado, who began working at the Alvarado Hotel in 1903,

was an ideal candidate for the position of teacher at the Indian school, but there is no evidence that she ever worked there, not even in Albuquerque newspapers, which closely followed her activities and always reported on them. According to Parezo and Fowler, Allen noted the craftsmanship in weaving and silverwork of a Navajo family and approached them, asking them to attend the St. Louis Fair as demonstrators. Due to objections advanced by Lorenzo Hubbell, who wanted their products for his trading post in Arizona, the offer was withdrawn. It is possible that to compensate for this missed opportunity, Allen asked the woman to teach weaving at the school.[55] There are no data available, however, to confirm this.

Additional evidence of the superintendent's desire to make Native crafts in the school as unobtrusive as possible is provided indirectly by a short paragraph published in the first issue of the *Albuquerque Indian*, following the discussion on the "Future of Our School":

> In future issues of the magazine it is hoped to have the advertisments [*sic*] of the Indian traders located at different points throughout this Territory who handle the Indian wares of their particular locality, and try if possible to place the trader and the public who desire his wares in direct communication.[56]

Why was there no mention of advertising the students' crafts as other schools were doing, for example, Carlisle? Why not put the public in touch with the school and let them choose their desired wares from the ones made by the students? Was that not a good way to sell the crafts and help the students make some extra money, for themselves and for the school? It was, but Allen did not pursue this path. Instead, he purposefully neglected to mention his students' crafts and explicitly stated that advertisements would include only local traders. As a matter of fact, browsing through the few issues of the *Albuquerque Indian*, one can see ads for "genuine Navajo blankets and authentic curios" (meaning no Hispanic weaving and handmade Indian objects) from local traders, but nothing that publicized students' works. This is another sign that while Allen accepted arts and crafts in his school, he considered their utilitarian purpose strictly limited to the girls' training and nothing more. He clearly was not interested in encouraging the making of crafts for sale within the school premises or

creating sales venues for the students. Similarly, there were no advertisements of the boys' new industry, mission-style furniture. Allen stated that the manufacture of this kind of furniture was "hoped to be made a feature of interest to the public as well as commercial values of the school," but its sale was neither promoted nor announced through the pages of the school magazine. There is no evidence that the superintendent used other venues to foster, market, or sell either the Navajo blankets or the mission-style furniture made by his students.

The pupils' work in other industrial departments, however, was regularly exhibited at the annual territorial fairs. Local newspapers report of "the dusky lads engaged in various trades which are taught at the school," that "the manual training and domestic science products of the United States Indian School show the thorough work done in that school," or that "the little wards of Uncle Sam will demonstrate from several floats the things they are learning at the large government institution north of the city."[57] None of these articles, though, mentions weaving, pottery, or other industries such as furniture making. It is obvious that, with Allen's limited interest in promoting Native crafts within the perimeter of the school or publicly, his professed goal of making them "self-sustaining" could hardly have been achieved. No evidence suggests that these activities were continued or given any space and attention during his tenure.

When Allen resigned in June of 1906, he was succeeded by Charles H. Dickson, who left after a month, and Burton B. Custer, who remained at the head of the school until February 1908. The tenure of these two superintendents was so short that Native industries were likely not a priority. They were followed by Mr. Reuben Perry, the longest-serving superintendent, who led the school until the early 1930s. During his first years, things did not seem to change much from the Allen days: girls continued to be trained in "housework, sewing, cutting, fitting, laundering, and cooking," while boys received instruction in "carpentering, blacksmithing, wagon making, engineering, shoemaking, cement work, agriculture, especially landscaping and gardening."[58] Native industries were not contemplated, despite the fact that Reel was still in charge as the general superintendent of Indian schools and that open encouragement for these crafts had also come, in recent years, from Commissioner Leupp.

"The Administration Has No Sympathy"

The only reference to crafts in local newspapers is from 1910. At that year's territorial fair, the Indian school won three prizes in the art department; they included first prize in needle work, first prize in handicrafts—wood and leather work—and first prize in wool rugs.[59] It is hard to know whether these rugs were the Navajo-style ones produced under the Native teacher or just regular woven rugs or rag rugs made as part of domestic training. Because newspapers often reported that other exhibits at the fair used "Navajo blankets" for decoration (for example, the exhibits by the University of New Mexico, the Fred Harvey Company, or the Hyde Exploring Expedition Store), it is possible that the rugs made at the school were not Navajo in style. There is no further mention of crafts made at the school in the local newspapers of the time. Evidence that Native industries continued after 1905 is, therefore, very scant.

Indian arts and crafts instruction began to wane in all government schools in the last years of the 1910s despite official encouragement and support; at Albuquerque, they did not last after Reel's retirement. During the fiscal year 1910–11, the school adopted the New Mexico course of study for its public schools "for the purpose of fitting Indian pupils to enroll in the regular school system when the time arrived for them to do so." While emphasis was on "good citizenship, the development of the body, the necessity of living health, the ideals of the Christian religion, the desirability of learning a trade, and a love of the best in music and in books," industrial training constituted the main component of Indian education.[60] Boys were taught farming, gardening, care of horses, dairying, carpentering, blacksmithing, wagon making, shoe- and harness making, plumbing, and steam engineering, while girls learned housekeeping, laundry work, sewing, dress making, care of chickens, and family cooking and housekeeping. Native industries had no place in the new curriculum.

The only creative activities that were now encouraged were the "manual arts," that is, lessons that blended hand dexterity, rather than intellect, and labor. Practically, this meant industrial education with a craftsmanship twist, and, starting from the lower grades to the higher, lessons in paper folding, cutting, modeling, raffia work, weaving, block building, cardboard construction, and later leather work and block printing for boys, and stencil work and basket weaving for girls. Weaving and basket making did not

have any Native character; after all, they were activities conceived for all the pupils in the territory's public institutions. At the 1907 annual meeting of the New Mexico Education Association, Emma Woodman, supervisor of the Department of Arts at the New Mexico Normal University, had declared that "by means of manual arts, school gardens, workshops, domestic arts and handicrafts clubs we may help the young people to a work noble and God-like, for by the handy work of their craft they shall maintain the fabric of the world."[61] Native industries apparently did not help maintain the fabric of the world, because they were completely disregarded by New Mexican educators of the early twentieth century. The arts offered at the Albuquerque Indian School at the beginning of the 1910s spoke nothing of the Indigenous artistic heritage of its student population.

Furthermore, the fear that Native handicrafts might lead to an immoral way of living was once again used to justify their termination; Superintendent Perry clearly expressed this sentiment in his 1910 annual report when he wrote that those Indians *who congregate at Albuquerque and other places for the sale of pottery, etc. do not have a high standard of marality [sic, emphasis added] as those remaining in their homes and engaging in agricultural pursuits.*[62] While the exact locations of these parties of people in the city were not specified, the train depot was likely central. A decade after the establishment of the Indian Department at the Alvarado Hotel, Native men and women continued to station themselves by the railroad in order to sell their wares to incoming tourists. Twenty years after the completion of the railroad and the arrival of the first visitors, school administrators still considered the practice of selling Native crafts a waste of time, an activity to condemn and to discourage. Concerns that students, once they left the AIS, would follow the example of older Indians were still present. The persistent presence of adult Indians near tourist areas and the sale of their handmade crafts were considered morally unacceptable. Their immorality derived from the fact that this behavior did not encourage the performance of civilized duties such as farming, stock raising, and domestic chores, to which the government had dedicated effort, time, and money. Therefore, the promotion of Native industries at the AIS ceased to be supported and was discontinued because the superintendent was reluctant to compromise the civilization and moral education of the pupils under his charge.

Art and Native Industries after 1915

The Albuquerque Indian School followed the New Mexico course of study until 1915, when Commissioner Sells introduced a new curriculum for all Indian schools. Drawing was included as a subject that increased knowledge of the natural environment and of important religious and secular celebrations but also as a tool to develop the students' power of observation and sense of taste. At about the same time, this subject was also growing in importance in New Mexico public schools and it was a frequent topic of discussion at state educational conventions and gatherings. At the 1916 New Mexico State Teachers' Association meeting, for example, there was a section on music and drawing, with speeches on the development of art training since 1840, the current emphasis of the art curriculum, the method of teaching watercolors, art as growth, the art instinct and untalented pupils. The following year, numerous presentations on drawing with titles such as "The Present Day Aim of Public School Drawing," "The Relation of Art Instruction to the Requirement of Home Life and Industrial Life of Our Time," and "Art Appreciation in the Schools" were offered at the New Mexico Education convention.[63] These public forums suggest a renewed interest in drawing not merely as a necessary foundation for industrial or manual training but as art and creative endeavor. Unfortunately, these discussions never crossed the threshold of the Albuquerque Indian School. The Indian sessions at these statewide gatherings, in fact, were limited to stock-raising lessons and discussion on the new *Course of Study* from a classroom standpoint. There was no room for personal creativity at the AIS.

As far as Native industries were concerned, students would have to wait until the fiscal year 1924–25 to see them fully reinstated in the curriculum of the Albuquerque School. Superintendent Perry and the principal teacher, Mrs. Harrington, expressed the desire to add to the curriculum "trades that might have a monetary value to Indian girls of the Southwest" and that would allow them to "earn some money at home" and so a Native Crafts Department was created.[64] While the reasoning behind its establishment was strictly economic, the new courses in Navajo blankets and jewelry under the instruction of Native teachers were very popular and welcomed by the students, who enrolled in large numbers, particularly in weaving (fig. 25).

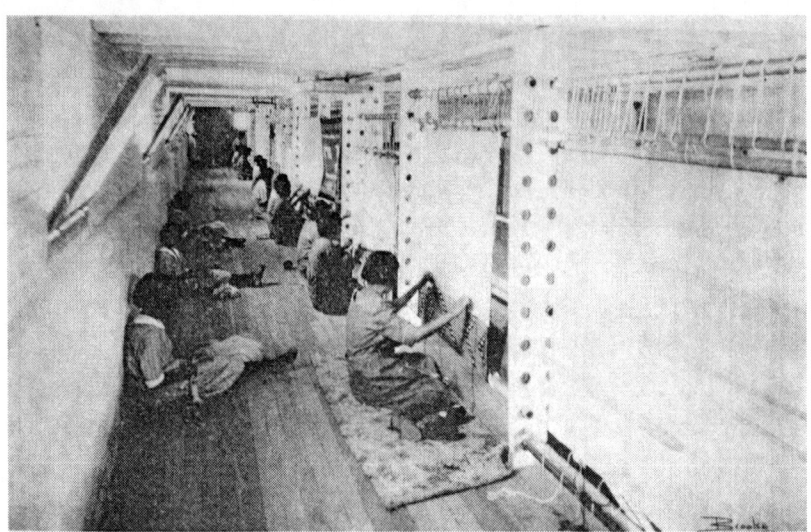

Fig. 25. Weaving Department, Albuquerque Indian School. From the Albuquerque Indian School Calendar, Albuquerque, New Mexico, 1925–26. Collection no. 994–046, Albuquerque Photograph Collection, Center for Southwest Research, University Libraries, University of New Mexico. Photograph by Brooks.

The department was expanded in the mid-1930s, after the formation of the Indian Arts and Crafts Board, to include beadwork, basketry, pottery, doll making, painting, drum making, silversmithing, turquoise and shell bead making, and creative art.[65] Students could now use their school time to make a wide variety of traditional crafts and express their own ideas in contemporary art forms. More importantly, they could now contemplate a career as artists and not merely as crafts makers.

I expected to find a vibrant art curriculum at the Albuquerque School, particularly a large presence of Native pottery and weaving, well-known and highly marketable crafts of the nearby Pueblo and Navajo people. Because the school was located near numerous pueblos and in a popular tourist destination, and Indian crafts were so extensively and overtly marketed thanks to the railroad, the Fred Harvey Company and its Indian Department at the Alvarado Hotel, the many curio stores located throughout the downtown area, and the presence of numerous Native vendors, it seemed reasonable to expect that students were taught their heritage crafts so that

"The Administration Has No Sympathy"

they could participate in the local economy of the area. Documentary evidence, however, has shown that these assumptions were wrong; despite its close proximity to Pueblo communities, art markets, and tourist centers, the Albuquerque Indian School encouraged the instruction of Native crafts only at a minimal level, for a very short period of time, and not of its own will (weaving was included only after Reel's insistent requests). Both drawing and Native arts were part of the school curriculum, but short lived in different ways.

Theoretically, the AIS followed the chain of command by complying with the Indian Office's mandates and instructions, but in practice it carefully considered first its own needs and those of its student population. This means that it observed government policies only insofar as they did not retard or impede local assimilation efforts in that particular environment. Likewise, the school administration did not accept compromise even with the local Pueblo communities. Historian John Gram has argued that "the Pueblos exercised power in their relationships with the schools' superintendents and consequently turned Albuquerque and Santa Fe Indian Schools into resources that often helped assure the various pueblos' cultural, social, and economic survival."[66] This was not the case for art education or other curricular matters. While superintendents had to negotiate many battles with the nearby Native communities on various issues pertaining to the students' lives, the curriculum was not negotiable. Parents did not have any influence on what was taught in the classroom or the shops; this was completely within the superintendents' spheres of action. Once again, administrators in charge pursued what kind of schooling *they thought* was best for their Indian wards.

5

"Drawing and All the Natural Artistic Talents of the Pupils Are Encouraged and Cultivated"

Art Education at Sherman Institute

> This is an Industry that is doing much good, not only for the appearance of our school but also assists the Indians in making their home present a good appearance and opens up a means by which the women can make money.
>
> —Harwood Hall, letter to the commissioner of Indian Affairs

"To get a true history of Sherman Institute we must go back to the year 1897 to the old Perris School near Perris, California. There, in that little place, wholly inadequate to the growing needs of the advancing Indian youth of Southern California, the idea of a larger school in more favorable surroundings originated in the mind of Harwood Hall, then Superintendent of the Perris School."[1] Sherman Institute in Riverside was not the first Indian school in Southern California. The original site of a government institution for American Indian education was, in fact, Perris, about seventy miles from Los Angeles and about fifteen miles from the current location in Riverside. The Perris Indian School, erected under Maj. Horatio N. Rust, U.S. Indian agent for the Mission Indians, was built as a training school for Southern California Indian children on eighty acres of land donated by the Perris citizens, about four miles from the town.[2] It opened in 1892 with an enrollment of only eight students, in facilities

with an initial capacity of one hundred. The Perris School was built on supposedly "choice land, suitable for cultivation of all crops grown in the valley" with "deep and rich" soil, with the belief that the San Bernardino Mountains and the underground water supply would be sufficient for the school's maintenance and agricultural purposes.[3] By the late 1890s, however, Superintendent Hall, in charge of the school since 1897, had become convinced of the unfeasibility of operating a school in that location due to scarcity of water and the unsuitability of the rocky, arid land for farming purposes.[4]

He brought his concerns to the superintendent of Indian schools, William N. Hailmann, and to the commissioner of Indian Affairs, William A. Jones, citing the impossibility of teaching soil cultivation, overcrowding, and the large number of unserved Indian children in need of an education as the main reasons for relocating and expanding the school. Thus, it was decided that the Perris institution should be abandoned.[5] The local community did not approve of this decision and petitioned the government to maintain the current school, indignantly saying that Hall had neither sufficient knowledge of the territory nor the professional qualifications to provide a correct assessment of the land. Had Mr. Hall been more truthful in his evaluation, he would have concluded that Perris had the necessary resources for the maintenance and the operation of the school. To their dismay, the citizens of Perris saw their chances of winning the battle for an economically important institution fade when a visit from Estelle Reel in 1899 confirmed what Hall had already expressed: the lack of water made it impossible to continue school operations. Within a month of each other, Reel and Hall wrote to Commissioner Jones outlining their reasons for the relocation of the Indian school; both portrayed an environment that was unsuitable for the school's maintenance and thus for the proper education of its pupils.[6]

Superintendent Hall's choice of Riverside as the site of the new Indian school was the result of pressure from local citizens and businesses. The most noteworthy proponent was Frank A. Miller, owner of the renowned Glenwood Mission Inn and an active member of the Republican Party. As news that the Department of the Interior was planning to open a new and larger Indian school in Southern California reached him, Miller began

"Drawing and All the Natural Artistic Talents"

a campaign to ensure that Riverside would be the chosen location over Los Angeles. His reasons for conducting this development campaign were purely economic. In a letter to Riverside County Republicans, dated January 11, 1899, he wrote that an Indian school "cannot help but be of inestimable value to the city that secures its location, as it will require an expenditure of at least a quarter of a million of dollars for the erection of the buildings, and a yearly trade of at least $50,000 to the community in which it is located." In a subsequent letter, he restated that an Indian school in Riverside would mean "a great deal to tourist business," particularly his own.[7] As the proprietor of the most exclusive hotel in town, in fact, Miller had much to gain from this venture: an Indian school would have attracted even more tourists to the already popular area of Riverside and brought more money for him and his hotel. Furthermore, Miller recommended a specific tract of available land for the school, one that coincidentally belonged to his relatives. The site was located at the end of the Riverside and Arlington Railway streetcar line, which Miller had had built for his own hotel and of which he owned the majority of stock. Miller also understood that if he profited from the new institution with a regular influx of federal monies, other local entrepreneurs would also increase their returns. This would gain him the support of the entire Riverside business community.[8]

Historian Nathan Gonzales provides a detailed account of the political maneuvers that eventually granted the site of the new school to the city of Riverside. Numerous articles in the *Los Angeles Times* also detailed this controversial issue and the turmoil it created in Southern California. Several reporters animatedly criticized the "Riverside gang of politicians" for scheming and pushing the transfer of the Perris School and frequently accused Hall not only of being a puppet in their hands, but also of pursuing his own interests rather than those of the Indian pupils and the taxpayers whose money would go into financing the new buildings.[9] According to one aggravated reporter, "The true reason for the move is that the head teacher of the Perris school—who seems to have something of a pull at Washington—and his wife, both find it too lonesome in their present location. The charms of society are lacking, and the teacher is quoted as saying that it is 'almost as bad as living on a reservation.'"[10] Relocating to Riverside was preferable and more convenient for both Hall and his wife.

Apparently, the Perris valley was inhospitable not only to the Indian school but also to its "first" couple, while the city of Riverside was attractive for its beauty, location, and entertainment.

On July 31, 1900, Congress approved the purchase of land in Riverside and on September 14 signed the deed. It later ordered the transfer of Perris facilities and students to Riverside, and mandated the closure of the Perris School within three years. While the relocation was in process, the Perris School was to be conducted in conjunction with the new institution, Sherman Institute. The cornerstone of the Riverside school was laid "with appropriate ceremony" on July 18, 1901, by Acting Commissioner of Indian Affairs Capt. A. C. Tonner before a crowd of several thousand people coming from all over the country.[11] The school opened to students exactly a year later, on July 18, 1902, "when a party of eighteen pupils from the Pima Reservation arrived for enrollment," and became fully operational in September 1902, when all work and activities officially started for the new academic year. By 1908, the school had grown considerably in size and student population: the campus consisted of thirty-four mission-style buildings, surrounded by beautiful lawns, trees, shrubs, and rare flowers (fig. 26), and its capacity of 550 was supposed to meet the needs of all the local Mission Indians.

The Curriculum of Perris School and Sherman Institute

Before examining the course of study of Sherman Institute, it is important to consider its predecessor, the Perris Indian School, and its curriculum. The Perris School opened under the brief tenure of Edgar Allen (June–November 1892), who was followed by M. H. Savage (November 1892–August 1894), and William F. T. Bray (August 1894–August 1895). Allen eventually returned in 1895 but was transferred to the Albuquerque Indian School in 1897. In May 1897, Harwood Hall took charge of Perris as its fourth superintendent in five years. As with other Indian schools around the country, Perris did not have an easy beginning; frequent turnovers of administrative and academic staff made it difficult to create a stable environment in which the focus was the students, their welfare, and the improvement of their education. The superintendents' short tenures did not facilitate the proper implementation of directives coming from the Indian Office and

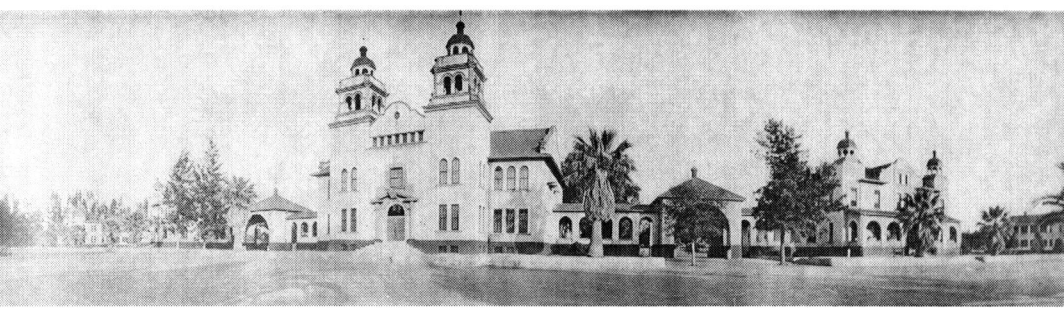

Fig. 26. Church and other buildings, Sherman Institute, California. National Archives and Records Administration, College Park, Maryland, 75-PA-3–3.

did not allow sufficient time to make the necessary changes to ensure that curriculum requirements were met. Hall, originally from Missouri, had been working in the Indian Service for eight years; prior to his appointment at Perris, he was superintendent of schools in South Dakota (Quapaw and Pine Ridge) and Arizona (Phoenix). Young—only thirty-four—yet with experience in Indian education, he brought stability and continuity of work.

Academic training at Perry was divided between primary and advanced grades. Children in the primary grades were taught reading, numbers, geography, language, penmanship, music, and arithmetic, while in the advanced grades they were also instructed in orthography, observation lessons, methods, general exercises, history, physiology and hygiene, and civil government. The main industries were agriculture and the raising of livestock, along with related rural activities such as gardening, irrigation work, milking, dairying, and the care of hogs and chickens. Dry seasons and scarce water, however, made work difficult if not impossible. In addition to training in these areas, boys received some instruction in the shoe shop by a temporarily employed shoemaker, while girls were taught kitchen and laundry work, dressmaking, and care of the house. Two years after the opening of the school, students also began to be placed in the home of neighboring families as part of the outing system. Finally, as in many other Indian schools, children had regular lessons in music; boys, in particular, learned band instruments.

By the time Reel visited the school in 1899, additional industrial trades

had been established; blacksmithing, carpentering, and harness making existed although the shops were in very poor condition and, according to Reel, "hardly worthy of the name." Due to the lack of water, pupils did not practice any farming or gardening. Reel, however, felt that "a great deal of attention is paid to the teaching of the duties pertaining to home life, the girls being specially well-drilled in sewing, many of the larger ones butting and fitting their own garments, and also earning sums of money by doing fancy work and plain sewing for others."[12] The importance of working with their own hands for the production of pretty and useful items to sell for extra money was only to be more reinforced and encouraged in the years to come.

The curriculum of Sherman closely mirrored that of its predecessor, but with the addition of new industrial trades. The academic department consisted of nine grades that took pupils through the first year of high school, after which they could continue their education in one of the Riverside public schools. Children were taught reading, spelling, writing, recitation and memorization, arithmetic, and geography. In fourth grade, they learned about the state of California, while from the fifth grade they started the study of history. Composition and the study of English grammar began in the seventh grade with the use of a textbook. Manuals were also employed for reading lessons in geography and history; otherwise, they were rarely used, as teachers taught mostly through objects. Instruction on the civil government of the county and of California was added in the eighth grade. One of Sherman's main objectives was to correlate literary and industrial work, so classroom lessons in reading, writing, counting, and problem solving focused on practical activities such as farming and the care of animals, or on personal health and hygiene.

Music and athletics were important components of the curriculum at Sherman. Besides classroom singing, which started as early as the first grade, students could get involved in various music organizations such as the boys' band, the girls' mandolin and guitar club, the choir, and glee club. The band and the mandolin and guitar club were extremely popular among the local community, and pupils were often invited to provide entertainment at local as well as state events. Also very popular was the Sherman football team, the Sherman Braves, which always gathered great crowds of faithful

supporters and curious onlookers.[13] Other athletic activities included team sports like baseball and basketball, this last one played also by the girls.

Industrial training for the boys pertained to the Southern California climate and focused on "orange culture, caring for extensive lawns and grounds, flower beds, shrubbery, as well as cultivating the ten acre sewer tract, and raising such crops as are best suited to the quality of land." Furthermore, it also included "mechanical work, steam engineering, carpentry, painting, cabinet making, upholstering, blacksmithing, shoe making, tailoring, wheelwrighting, harness making, plastering and masonry, printing and cabinet making, and as far as possible given a certain amount of practical instruction in electrical mechanism." In the Domestic Science Building, girls were thoroughly trained in "preparing and cooking all food, together with the washing and ironing, darning and mending, chamber work, serving meals as they should be served in a refined home, and answering calls at the door." In short, they were to learn "what home means" and how to care for one—whether theirs or their employers'—and were prepared to become domestic servants or wives. In addition to the industrial preparation outlined above, every student received fundamental instructing in the school kitchen, bake shop, steam laundry, dining rooms, hospital, and dormitories. Every Sherman graduate was going to be prepared to lead a productive adult life and become "self supporting *at once.*"[14]

Agriculture and horticulture were to receive "the closest attention," so for this purpose a school ranch was built about a mile from the school on a one-hundred-acre tract of land; it accommodated forty pupils who lived there for a period of three months. Here, they spent half a day in literary work and the other half in farm and ranch labor. Boys learned "to raise and care for stock in up-to-date methods, gardening, farming, dairying, fruit culture, and everything that pertains to a well regulated ranch and farm home," while girls were instructed in farm housekeeping and in "cooking, washing, ironing, darning and mending, and care for the home generally."[15] They were also taught milking, butter and cheese making, raising chickens and other small farm animals, and planting and caring for a kitchen garden. Girls were supervised by a teacher/matron and a housekeeper; boys were under the care of the gardener and principal farmer and his assistant, all of whom resided at the farm.

New industries were added in the course of the years as the school grew and expanded its facilities and curriculum. Among these were painting and cabinet making, steam laundry, and "a practical course in steam heating, steam fitting, electrical connections (as in wiring buildings), and plumbing" for the boys.[16] Additionally, a training hospital was built to train girls in the art of nursing, soon making this one of the most popular and important departments at Sherman. Lastly, a printing office was created in 1909 for the publication of the school magazine, the *Sherman Bulletin*, and to provide additional lines of useful training for the boys who were, in fact, to "perform the mechanical work and, as far as possible, edit the paper."[17] In the academic department, a major change came in 1910 with the elimination of the ninth grade in order to align the classroom work to that of local public schools as well as schools in Arizona and New Mexico.

Drawing

There is a two-year gap between the opening of the Perris School and the earliest documents available. Considering the administrative turn-arounds and the relative difficulty of implementing new changes under such conditions, it is very possible that the curriculum in use in 1894 had been implemented from the school's founding. Direct evidence of drawing at the Perris School is, unfortunately, scarce. There are no primary documents that can offer a good glimpse into what was done in this area. According to the pamphlet *Estimate of School Books and Supplies for the Fiscal Year 1894–1895*, issued by the Indian Office, schools were prescribed to instruct pupils in drawing from the primary to the advanced grades and use Prang's *Complete Course in Form-Study and Drawing* and *Teacher's Manual* as textbooks.[18] Superintendent Savage did not request either one of these books for Perris. This could signify that, in his opinion, lessons in drawing were not as important and that teachers needed rather to dedicate their efforts to more critical subjects. The lack of drawing books at Perris, however, does not eliminate the possibility that this creative exercise was included in the teachers' daily lessons as a supplementary learning tool. Savage's choice for the school under his care also reveals that, despite the Indian Office's clear curricular expectations, local administrations did not always follow general directives *ad literam* because the distinctive

conditions of their schools prevented it. With an average attendance of one hundred students and a staff body of only three classroom teachers and ten additional employees overall, Perris simply did not have an adequate workforce to implement these guidelines and, consequently, did not place much emphasis on drawing.

As the years progressed, Perris adjusted its curriculum to the requirements of the Indian Office and drawing was eventually taught throughout the grades as a supplementary aid to lessons in language, arithmetic, and geography as a few documentary records confirm. What this information does not disclose, unfortunately, is the practical, day-to-day manner of instruction that was carried out in the classroom. For example, in 1895, upon request of the commissioner of Indian Affairs, Perris sent samples of classroom work to the Cotton States and International Exposition held in Atlanta. A. J. Standing, assistant superintendent at Carlisle, who penned the report for the Bureau of Indian Affairs section of the United States Government Exhibit wrote, "The schoolroom work consisted of papers representing all grades from kindergarten to algebra, together with well-drawn maps and freehand drawings, clay modeling and relief maps."[19] While we do not know exactly the nature of the material submitted by Perris, the report indicates that it included drawings.

Five years later, in April 1900, the Indian school exhibited its work at the Riverside Street Fair, positively impressing visitors and reporters. According to the *Los Angeles Times*, the Indian school was the greatest attraction of the event with its specimens of boys' and girls' work displayed in a beautifully furnished and decorated booth. In addition to items from the various industrial shops such as cabinets, shoes, metal work, and needlework, the school displayed "writing, drawing, language work, etc. of pupils of all grades and ages."[20] It is impossible to determine, from the minimal information provided, which grades submitted which work; we are told, however, that the specimens were made by students of different educational levels and ages. If this were the case for all types of schoolwork displayed, then drawing was taught from the lower to the more advanced grades and likely reflected the government's syllabi issued by Morgan and Hailmann. Superintendent Hall also mentioned the Riverside Street Fair in his 1900 annual report to the commissioner of Indian

Affairs, but unfortunately did not describe in detail the items on display. He simply stated that "for two weeks our musical aggregations took active part, which together with an extensive exhibit of class work of all kinds as well as industrial (the exhibit occupying a booth 10 by 40 feet), was a great attraction for the thousands of visitors, and I may say proved to be the most interesting feature of many good features."[21]

When the Indian School was moved to Riverside and all educational activities commenced in the new location, the academic curriculum of Perris was brought along, likely unaltered and, if government directives continued to be followed, drawing was supposed to be taught in every grade as in the preceding year. An interesting letter by Superintendent Hall to Anna M. Lukens of Redlands, California, in the summer of 1902, reveals something more. Lukens had previously written to the superintendent asking for employment as drawing teacher at the school that was to open the coming September. On July 2, Hall replied thanking Lukens for her application and then stating that "the drawing teacher has already been selected."[22] Did Hall make changes to the curriculum of the Riverside school and decided to place more emphasis on drawing instruction in a way that was never done before? Who did he employ specifically for this position? There was no "drawing teacher" listed for any fiscal year between 1902 and 1917 in the school's *Record of Employees*, with the exception of a "Mechanical Drawing teacher" appointed in 1913. Employees hired for teaching positions were otherwise listed as either "Principal teacher," "Teacher," or "Music teacher."

Similar letters to the superintendent dated a few years later confirm that the position of drawing teacher did not exist at Sherman. Like any other Indian school, with the exception of Carlisle, Sherman was never allowed to create the *position* of drawing teacher, that is, it could not employ an individual to work specifically in this role. The position never received appropriations and because it was never established, it does not figure in any official records. This does not mean that nobody taught drawing, but simply that he or she was never identified by the title of "Drawing Teacher."[23] Of the faculty members employed at Riverside, only Myrtle Freeland was a transfer from Perris; the principal teacher and the other three teachers were all new hires (see table 10). It is possible, therefore, that one of these

"Drawing and All the Natural Artistic Talents"

teachers also provided drawing instructions. Because additional evidence of the drawing curriculum during Sherman's first years is scarce, it is difficult to add to this information. We know, though, that more drawing paper (two hundred packs), Prang's set of color boxes (two), and boxes of colored crayons (forty-eight) and chalks (four) were requested for the academic year 1903–4, clearly for classroom use.[24] Student enrollment at this time was about 180, which means that there was a box of crayons per every six students; color boxes and chalks were likely used by the teacher. This low quantity of supplies suggests that drawing was not a priority in the classroom, but rather a marginal tool that supplemented the more important academic subjects.

Table 10. Employees of Perris and Riverside Indian Schools

As of June 30, 1902		As of June 30, 1903	
NAME	POSITION	NAME	POSITION
C. Edward Kant	Clerk	Edwin Shanandore	Disciplinarian
Clara D. Allen	Principal teacher	Oscar M. Waddell	Principal teacher
Frank Farnham	Teacher	Maggie Naff	Teacher
Myrtle Freeland	Teacher	Carrie M. Darnell	Teacher
Blanche McArthur*	Teacher	Myrtle Freeland	Teacher
H. E. Mitchell	Industrial teacher	Laura M. Cornelius	Teacher
Rachel A. Maris	Matron	Fanny D. Hall	Matron
Juliana Amago	Assistant matron	Rachel A. Maris	Assistant matron
Daisy D. Kant	Nurse	Ada M. Warren	Nurse
Olive Ford	Seamstress	Jessie W. Cook	Outing agent
Laura Armstrong	Laundress	Emma L. Dickinson	Seamstress
Charles C. Meairs	Engineer	Olive Ford	Assistant seamstress

John Pugh	Shoe and harness maker	Juliana Amago	Laundress
Fred Long	Farmer	Lydia Long	Baker
		Alice Lamar	Cook
		James F. Cruickshank	Gardener
		Fred Long	Carpenter
		Charles C. Meairs	Engineer
		John P. Cochran	Laborer
		John Pugh	Shoe and harness maker

Employees marked with * do not figure in ARCIA but are listed in the Record of Employees. Source: *Annual Report of the Commissioner of Indian Affairs*, 1902 and 1903.

The publication of the *Sherman Bulletin*, starting in the spring of 1907, afforded Californians and people all over the country a glimpse into the lives of teachers, staff members, students, and visitors at the school as its columns recounted "the happenings of Sherman Institute and matters of interest therewith."[25] Understanding that articles were written by pupils and employees under close supervision of the school administration, and thus never fully reflected the writers' opinions and perspectives, we can still use these primary documents to help reconstruct the daily historical panorama of Sherman and its activities as they pertain also to drawing. Numerous scholars have relied on school publications as supplementary evidence for their historical analysis of boarding school life. Extracts and information from journals such as the *Arrow*, the *Indian Craftsman*, the *Indian School Journal*, and the *Indian Leader*, just to name a few, have been used to complement official school records, presenting a less bureaucratic and more personal portrait of their institutions, modus operandi, and own unique character, in order to reveal hidden facets of an otherwise one-sided history.[26]

It is thanks to the newsfeed published in the weekly *Sherman Bulletin*

that we learn the most about drawing. However, because this publication started five years after the opening of the school, the gap between 1902 and 1907 unfortunately cannot be filled. The central pages of the *Bulletin* generally provided all kinds of school information through sections titled "General News," "General Items," "Pupils' Notes," "School Room News," or "Industrial Notes." Each section dedicated a very brief paragraph, normally between two to fifteen lines, to what needed to be made public. Personal news was collected by teachers and students alike, but was compiled by the teacher in charge of each section of the publication; what was printed and the amount of editing the original materials received ultimately depended upon the designated teacher. While each section included a variety of topics, discussed the progress and achievements of different students, and described an assortment of activities that happened at Sherman, we have to remember that they were conditioned to the subjective choices of the person who compiled them and thus cannot present an accurate portrait of the school and the lives of its students. In theory, only the information in the section "Pupils' Notes" was written exclusively by the students; in practice, the final editing was still in the hands of a teacher. It is not until June of 1909 that students' voices became more prominent as the editor announced: "The pupils have taken considerable interest in THE BULLE-TIN this year. A large part of the items were written by them and edited under the head of 'Pupils' Notes.' This column can be made still more interesting to the student body. It is 'up to you,' boys and girls, to make it so."[27] Whether this more personal involvement was a result of the students' own willingness to speak their minds or of an administrative decision is unclear, but we can perceive a slight difference in the style of these notes.

Briefs on drawing are found in all of the above sections, except in "Industrial Notes." At times, they refer to the work of a specific classroom, at others to the creations of individual students. The first year of the *Bulletin* presents a concentration of drawing news; after that, however, interest in what students were doing in this area seems to decrease. Starting from November 1907, there is less and less discussion of drawing as a creative and educational exercise for the pupils. Drawing is mentioned only a few times in volume 2 (1908) and no more than three times in volume 3 (1909); as the years progress, news about it appear even more sparingly.

This decline was not a coincidence, but rather reflected a diminished interest in drawing on the part of the new school administration and a shift toward mechanical drawing.

One of the first entries about drawing is from March 27, 1907, where we read that "pupils of Mrs. Benavidez's room take great interest in drawing, especially the Hopis and Emory Pease."[28] Mrs. Fannie Benavidez was hired as a teacher in the summer of 1905 for the upcoming academic year, likely for the fourth grade. Her classroom work, probably English, arithmetic, and geography, incorporated the use of drawing, an activity that was well received, particularly by the Hopi students and by one Crow boy. The student population of Sherman was comprised mostly of California Indians, but also included Pimas, Papagos, Hopis from Arizona, and even a few Crows. Of all the students in Mrs. Benavidez's class, the Hopis showed the greatest interest in this activity as they were likely the ones with the strongest pictorial tradition, which included not only decoration of utilitarian objects but also wall painting. Kiva mural painting in particular was a long-established practice among the peoples of the Mesas and was a way of visually representing their worldview and ancestral knowledge. Kivas were the centers of men's social and ceremonial life but were also places in which daily activities were carried out: men gathered there to hold ceremonies, councils, social gatherings, but also to tell stories, weave, work silver, repair tools, carve kachina dolls and other ceremonial paraphernalia. Mrs. Benavidez's boys were certainly familiar with the environment of these sacred places, as Hopi children accompanied adult relatives in their daily chores and spent, particularly in winter, entire days in the kivas, playing and listening to stories. Their reaction to drawing—one of great interest—speaks to their eagerness to practice an activity that was well known, albeit in a different format and environment. They welcomed the opportunities to draw pictures because these exercises likely reminded them of their upbringing in the Hopi villages, their relatives, and their traditional stories told through images.

The same can be said of Emory Pease. A Crow student from Lodge Grass, Montana, he displayed a great interest in drawing because this activity was part of his tribal upbringing, particularly in the traditional painting of animal skins and hides used for clothing, tepees, winter counts,

"Drawing and All the Natural Artistic Talents"

parfleches, shields, and storage boxes. While the decoration of clothes and utilitarian objects was done by women, the painting of a tepee or a winter count was exclusively a male art; it was something, therefore, that a young boy would have carefully observed and eventually emulated. It is very likely that Emory was also familiar with ledger drawings, as pencils and ledger books had become quite available among the Plains Indians in the nineteenth century thanks to explorers, traders, and Indian agents. He could have seen members of his community draw their typically flat and stick figures in hunting or warfare scenes on the lined pages of these books. Either way, like his Hopi classmates, Emory positively embraced the chance to feel closer to his family and the aesthetic traditions he knew so well through this classroom activity.

News of Mrs. Benavidez's classroom work recurs in later issues of the *Sherman Bulletin*. On May 1, 1907, for example, we learn that "the Hopi boys in Mrs. Benavidez's school room remain every evening after school to make drawings from Indian pottery. The Hopis show unusual skill in this kind of work."[29] A couple of weeks later, the *Bulletin* informs us that "the Hopi and Mojave pupils of the adult primary grade have been drawing pictures relating to their homes."[30] A subsequent issue reported the following: "Several pupils of fourth grade wrote very interesting papers about the customs and occupations of their tribe; and on most of their papers were drawings of their homes. The pupils of the fourth grade deserve much credit for remaining after school and working Saturday afternoons to prepare drawings for exhibit work. Their efforts are appreciated."[31] All these entries refer to the work of students from the same class: the first and third entry tell us that pupils stay after school to draw; the first and the second mention the Hopi boys; and finally, all three talk about the students' drawings of their homes. There is no doubt, after reading these briefs, that Mrs. Benavidez's artists were in the fourth grade and were directed to draw things pertaining to their homes for an exhibit display.

A couple of observations are necessary here. First, after learning that the boys remained to draw past regular school hours, the "great interest" discussed in the March 27 piece could now assume two different connotations: one the one hand, it is possible that boys felt the need to stay in order to finish their works in time for the exhibit and that this behavior

was interpreted by others as a sign of dedication. On the other hand, the boys sincerely desired to spend as much time as possible in drawing, because of the familiarity of this activity and the closeness to home they might have felt while doing it. We cannot state for sure what the reality of the situation was, but it appears that students were the ultimate winners, that is, the ones gaining the most benefits, as they were able to enjoy extra hours in an activity from which they clearly derived pleasure and fulfillment.

The second important observation concerns the nature of the drawings. According to the *Bulletin*, the works depicted Indian pottery and the students' homes, either dwellings or aspects of tribal life. The presence of themes so overtly "Indian" does not come as a complete surprise, despite the fact that we do not see this kind of work at Albuquerque or at other institutions. For example, none of the works from the Carlisle, Oneida, Pawnee, and Fort Mohave schools discussed in chapter 2 portray Indian subject matters. What we see instead are flowers, fruits and vegetables, farm tools, still life, and children doing school chores (see figs. 9–14 and 45). Similarly, the few drawings made by Albuquerque students for which we have some historical data reveal that non-Indian themes were preferred. The Sherman drawings, on the other hand, seem to be in perfect compliance with the directives outlined in Reel's *Course of Study* a few years earlier, as she discussed the use of these kinds of pictures in geography classes. Another reason for the Indian content of these works is that they were being prepared for an exhibit, possibly at the Indian Institute that was going to be held in Los Angeles from July 8 to 12 in connection with the NEA annual meeting. Sherman was not the only Indian school to exhibit student work at summer institutes or at state and national fairs; it was the only one, however, to stage a performance of traditional Indian dances, the Hopi Eagle Dance, to be precise, at such an event. It is possible that these artworks were to be displayed in connection with this occurrence.

Both the Hopi drawings and the public performance of a traditional dance indicate that Sherman was a unique institution and that things there were different: there was no fear or anxiety in displaying the students' Indian heritage. Superintendent Hall was in fact convinced of the harmlessness of showcasing Indian culture, particularly Hopi songs and dances, and was actually very eager to do so if this could benefit the

"Drawing and All the Natural Artistic Talents"

school, its reputation, and especially its finances. The performance of traditional Hopi songs and dances started in 1907 after the arrival of Chief Tawaquaptewa, who had come to Sherman with his followers in November of the previous year after the Oraibi split.[32] According to Hopi historian Matthew Sakiestewa Gilbert, Chief Tawaquaptewa had a central role in proposing and staging these performances at the school and his willingness to share Hopi customs with Anglo audiences is likely to be attributed to his cooperation with Natalie Curtis in her efforts to preserve Hopi traditional songs.[33] The first public presentation of Hopi songs was in March of 1907 in the school auditorium; this was followed two months later by a performance of the Eagle Dance in traditional Hopi attire. Hall saw the economic potential of these shows and the publicity they could afford the school, so he strongly encouraged them, even to the point of organizing special events during which pupils and Chief Tawaquaptewa entertained visitors and local citizens on school grounds. The May 1907 commencement exercises, for example, were such an occasion.[34] In addition to this, contingents of Hopi boys were often invited to participate at community events and celebrations, such as inaugurations, parties, balls, and concerts, which were catalysts for great crowds and always perfect occasions for Hall to not only promote the school and find patrons, but also to "sell" the students and their work.

In their studies of this non-reservation school, scholars William Medina and Matthew Gilbert have pointed out the systematic promotion of Sherman through sports, music, and patriotic events. However, their opinions differ as to what Hall actually wanted to promote. Medina believes that through a display of students' progress in activities such as football, band music, and Christian organizations, the superintendent marketed Sherman's ability to transform them into cultured citizens, while also turning them into "carnival 'freak' shows for the enjoyment of tourists." While the school promoted its civilizing work, students enjoyed being part of the band and cherished these moments as "respites from the school's routine," although they were, according to Medina, largely exploited.[35] Gilbert, on the other hand, observes that Hall wanted to publicize not only Sherman's advancements in educating Indians, but most of all the progressive character of this education: by valuing Native cultures and allowing

the performance of Hopi traditional songs and dances, Hall showed how innovative his institution was and what a "visionary administrator" he had become. This distinctive and countercurrent trait of Sherman Institute would have certainly gained him respect and the financial assistance of local citizens and businesses. While, according to Gilbert, other school administrators saw the threat the promotion of Hopi traditions posed to the educational goals of the federal government, Hall felt "completely in control and that his objectives overruled the objections of others."[36] Hopi dances, therefore, were another way to attract attention and money to the school as well to interest the tourists that visited it through activities that were under tight supervision.

I believe the popularity of the school and its Hopi performances, as well as the constant flux of visitors who walked the grounds and checked out the classroom work, almost on a daily basis, also explain the subject matter of the students' drawings. As people dropped in and complimented the accomplishments of the young boys and girls, they were probably swayed to contribute financially to their education. Also, a souvenir of their pleasant experience at the institute or of the Hopi dance they had recently attended—perhaps a drawing made by one of the students— would have been a great memento of their visit. In light of this and of Hall's open attitude toward Native culture, teachers did not hesitate to encourage the representation of Indian themes. Four pencil-and-crayon drawings made by Hopi students from around 1908, and preserved at the National Anthropological Archives, could be examples of such teacher-and-administration-approved subjects (figs. 27–30).[37]

The drawings, identified by archivists as Tuskiapaya Kachina, Hehea Kachina, Kae or Corn Kachina, and kachina wearing body paint, were a gift from Mary Anna Israel to Dr. D. S. Lamb of Washington DC and were included with a letter dated November 16, 1908, written from Sherman Institute on official letterhead. On August 13, 1923, Lamb donated them to the Bureau of Ethnology. Because the drawings are not dated, they could have been made anytime between 1902, when the school opened, and November 1908, when they were sent to Lamb in Washington. I believe these drawings came from Mrs. Benavidez's fourth-grade class and were thus made in the spring of 1907, that is, around the time Hall began

allowing the performance of Hopi dances. The letter that accompanied them indicates that they were made by Sherman students:

> With this I send a few drawings some of the boys made of their peoples dances in costume. They are Mokis and they dance for rain, for hunting success, and for everything under the sun. I believe they wear the Kachinas or masks over their heads. These masks are made of wood and painted. Thought they might interest you. The children cannot explain in English what all the symbols mean, but the principal ones are snakes, rain drops, clouds, lightning, growing plants, and phallic emblems. . . . For untutored savages who have never had a lesson, I think they draw remarkably well, especially as all is from memory here.[38]

Mary A. Israel (of Washington DC) was hired as a nurse on February 13, 1907, and was actually a trained physician with experience in surgery and treatment of trachoma. She left Sherman in the spring of 1909 after having been appointed physician of the new trachoma hospital at the Phoenix Indian School.[39] Dr. Israel, who apparently preferred to go by her middle name, Anna, was undoubtedly a staff member at Sherman in 1908 when the Hopi dances were held.

With the exception of one drawing, Tuskiapaya Kachina, made by a student named Clarence, as the inscription at the bottom of the paper states, the identity of the artist (or artists) remains unknown. The *Sherman Bulletin* reported in June 1907 that "Pierce Kewyantewa has completed a set of twelve drawings of Hopi head dresses, to fill an order left by Mr. Mills a few weeks ago." But whether this student was also the author of one of the kachinas cannot be confirmed.[40] What this entry clearly says, however, is that Hopi drawings were on demand and students made them even on commission. There are no other instances of Hopi boys working on Indian-themed drawings in the subsequent issues of the *Bulletin*, so additional information on the artist or artists is unavailable.

The kachina drawings are very similar, but the presence of some minor stylistic differences—body posture, proportions, use of color, quality of drawing—suggests the work of four different hands. "Body Paint" (fig. 27) and Corn Kachina (fig. 28) resemble each other in many aspects and while at a first glance they appear to be made by the same student, a few

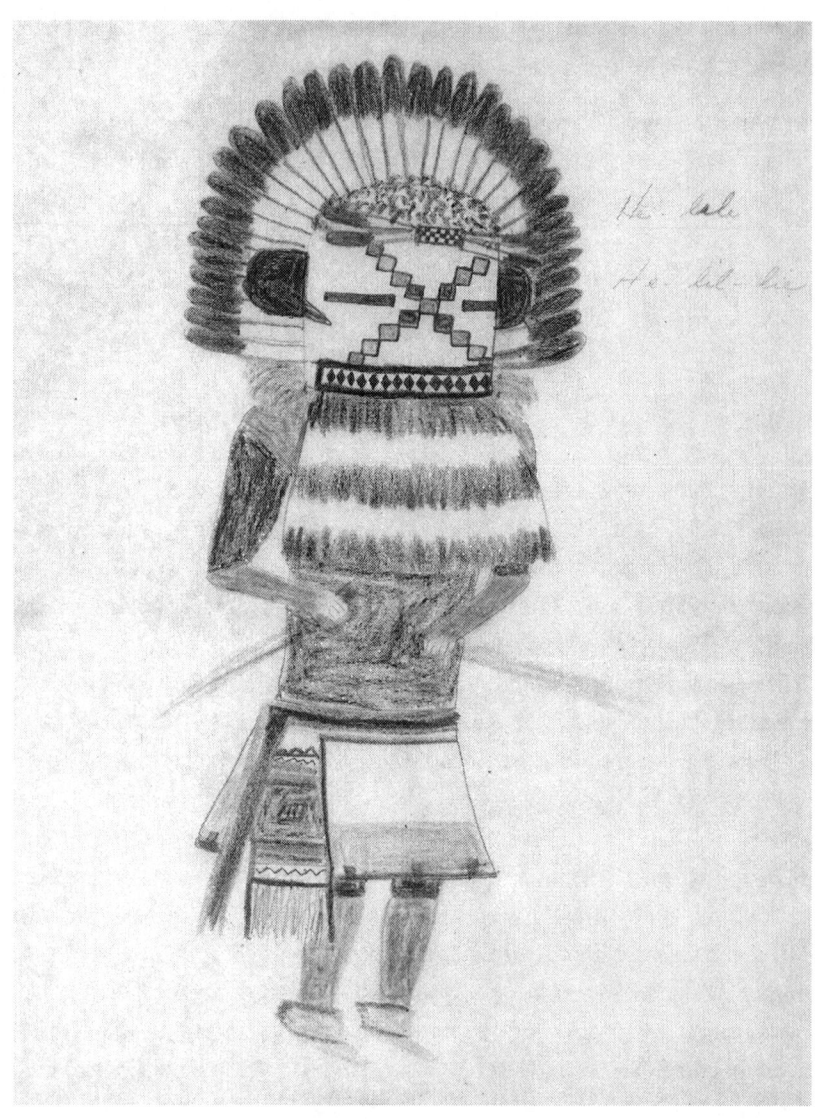

Fig. 27. Kachina wearing body paint, mask painted with geometric designs, feather headdress, dance kilt, sash, and holding pine boughs. National Anthropological Archives, Smithsonian Institution, NAAINV 08654800.

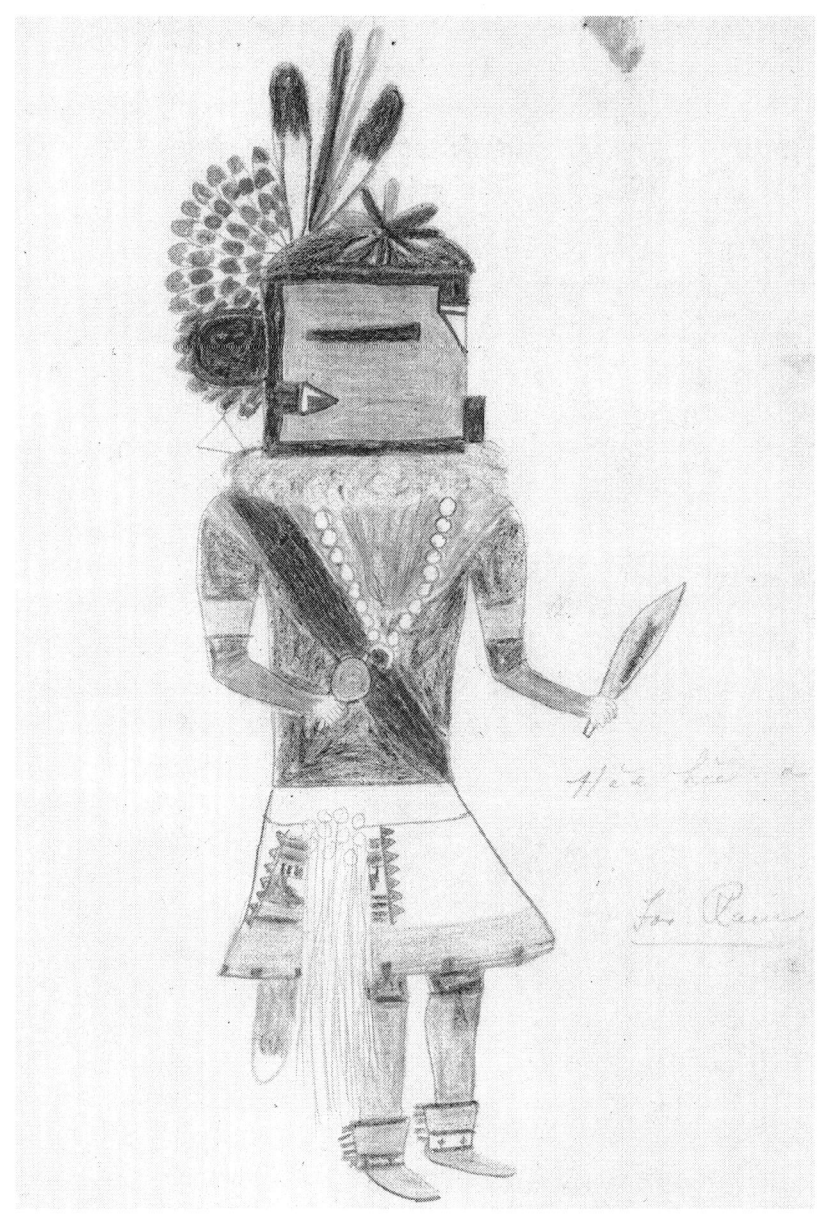

Fig. 28. Kae or Corn Kachina wearing body paint, painted mask, dance kilt, squash blossom necklace, feathers, and holding gourd rattle and feather. National Anthropological Archives, Smithsonian Institution, NAAINV 08654700.

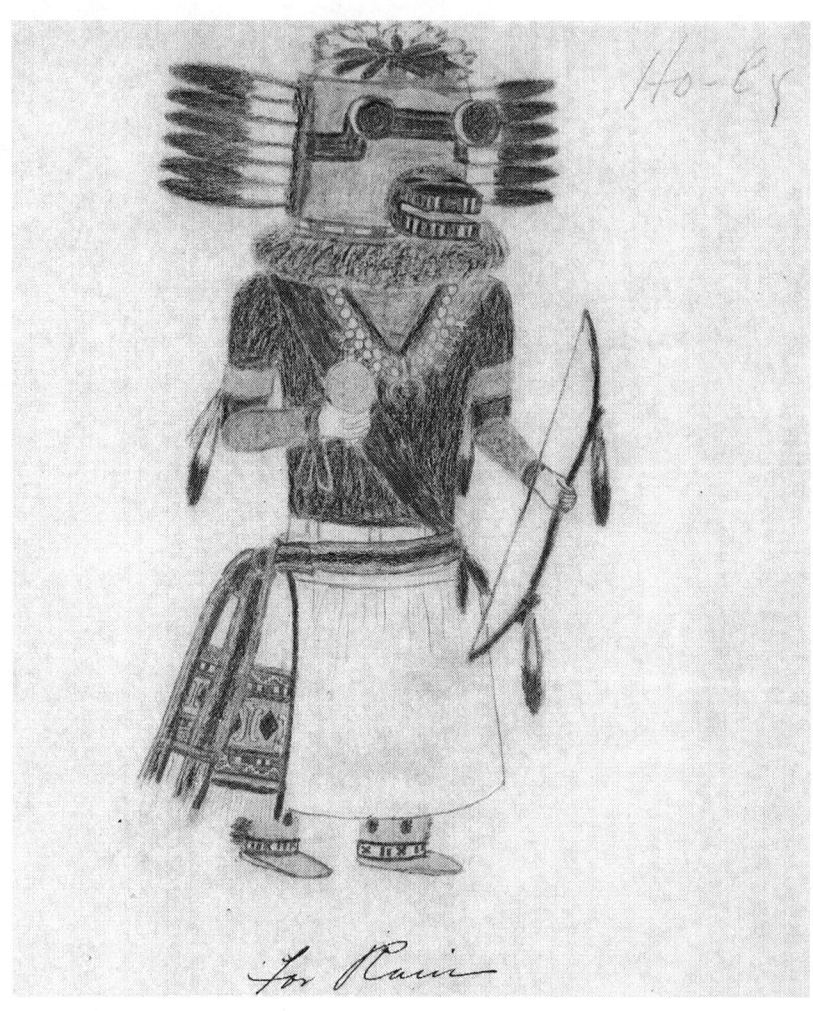

Fig. 29. Drawing thought to be of Tuskiapaya Kachina wearing body paint, painted and feathered masks, squash blossom necklace, dance kilt and sash and holding gourd rattle and bow. National Anthropological Archives, Smithsonian Institution, NAAINV 08654500.

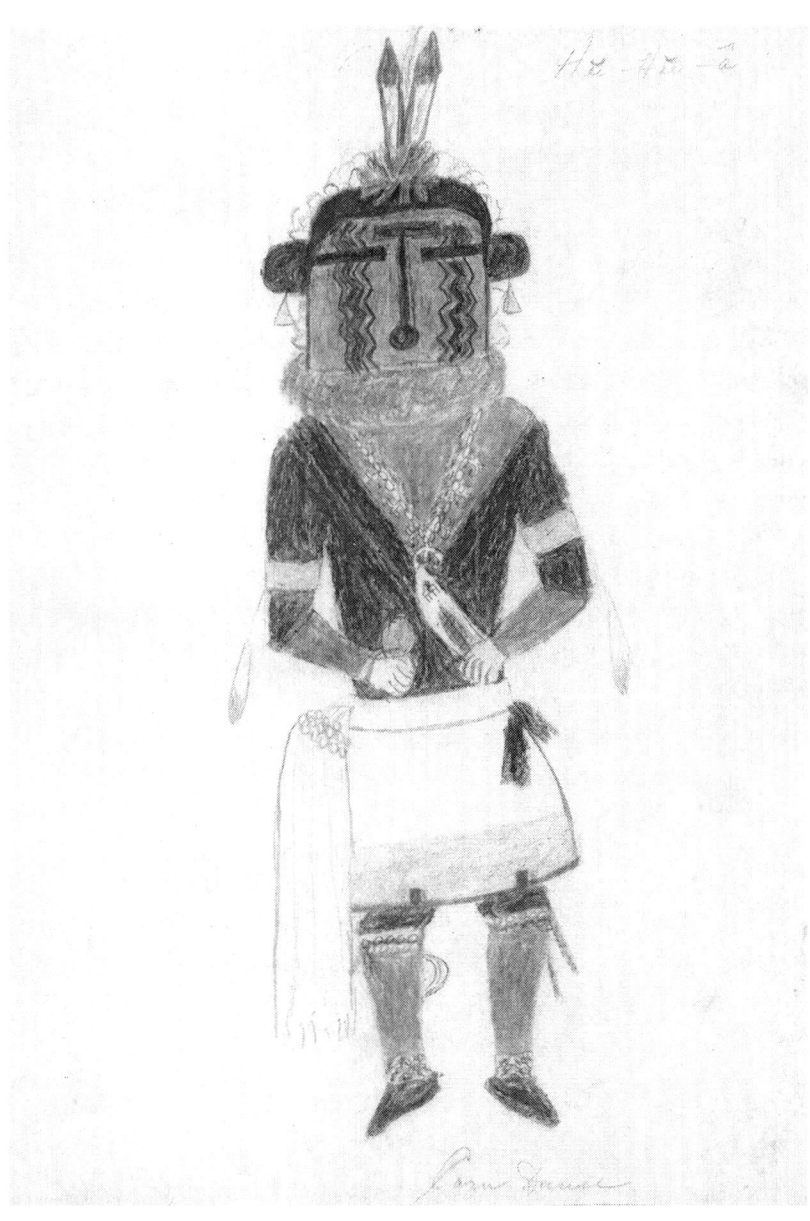

Fig. 30. Drawing thought to be of Hehea Kachina wearing body paint, mask Painted with zigzag design, dance kilt, bells on legs, squash blossom necklace, feathers, and holding gourd rattle and feather. National Anthropological Archives, Smithsonian Institution, NAAINV 08654600.

details indicate two separate artists. Both kachinas are drawn from a tilted perspective and employ a similar use of crayon colors that are not uniformly distributed. However, while the artist of "Body Paint" neither marked his contours nor paid particular attention to details, the maker of Corn Kachina demonstrates a precise use of the pencil and more thorough care in the particulars of the attire. Clarence's Tuskiapaya Kachina (fig. 29) is also slightly tilted and drawn with exceptional and exquisite details, particularly in the moccasins, sash, and the squash blossom necklace. The last drawing, Hehea Kachina (fig. 30), differs from all the others: it presents its kachina in a full frontal view; the moccasins have some details, but the kilt and the sash are otherwise left rather unadorned; the colors are more marked and uniformly distributed; and finally the artist distinguishes himself by using blue strips around the leggings. Each student also drew with careful consideration to all the particular characteristics of each kachina face.

The Hopi boys did not have a physical reminder of the kachinas at Sherman, but because of their training from infancy, they had a profound understanding of their own cultural background and thus were able to draw from memory what they had seen for years back home. According to art historians David Penney and Lisa Roberts, young Indian boys and girls sent away to school treasured the ancestral teachings received from their relatives, and their experiences in the environment of boarding schools contributed to a strengthening of their cultural awareness. Being away from home made students hold on to their traditional customs and retain what they had learned before their departure for school. Drawing aspects of ceremonial or everyday life achieved this purpose. Artist Fred Kabotie, who attended the Santa Fe Indian School from 1915 to 1920, wrote, for example, "When you're so remote from your own people, you get lonesome. You don't paint what's around you, you paint what you have in mind. Loneliness moves you to express something of your home, your background."[41] Distance from their family, community, and place of upbringing, therefore, not only helped students hold on to their memories, but also reinforced them.

Pictorial representations have always been part of Pueblo life as manifested in rock art, mural painting, and pottery. They had ritual and sacred purposes but were also central in the decoration of everyday utilitarian

objects. According to art historian J. J. Brody, except for three-dimensional objects like pottery, where paint was applied following the shape of each vessel, images of humans, animals, or supernatural figures in Pueblo art have always been "flatly painted within voids; their proportions lifelike, and their postures ranged from the stiffly conventional to the naturalistic."[42] Mural paintings found at most pueblos along the Rio Grande and on the Hopi mesas displayed these characteristic traits. The Hopi students at Sherman were likely familiar with such representations as they were found on kiva walls. Works made at the San Ildefonso Day School under the encouragement of Esther B. Hoyt in the early 1900s, and at the Santa Fe Indian School, thanks to the support of Elizabeth DeHuff, around 1918, presented the same pictorial features. While scholars agree that these drawings resulted from the intersection of two cultures and the encouragement of people within the environment of Indian schools, they were undoubtedly rooted in a common heritage and well-established Pueblo pictorial traditions.[43]

Drawings from the San Ildefonso Day School were made at an earlier date than Sherman's, as Esther Hoyt left her position in 1907; it is possible that word had traveled to Riverside and inspired the school administration to emulate this example. I believe, however, that the most important antecedent for the Sherman drawings may be seen in the works of four Hopi men commissioned by Jesse Fewkes, an anthropologist working for the Bureau of American Ethnology. Their paintings are the earliest documented Pueblo watercolors on paper. Fewkes wanted to study the "symbolism of the tribe" through depictions of the kachinas and requested the drawings for scientific purposes. He provided paper, colors, and brushes and asked the four men—chosen because of their minimal contact with white teachers and thus with minimal exposure to a foreign and non-Indigenous art—to draw authentic kachinas. The drawings were to serve ethnographic purposes, so Fewkes wanted them as accurate and detailed as possible, with particular attention to the ceremonial attire. He provided no suggestions as to the style of the depictions but "left the execution of the work wholly to the Indians." The men "carried the materials to the mesa, and in a few days returned with a half-dozen paintings, which were found to be so good that they were encouraged to continue the work."[44]

The representation of static individual figures on a blank background came straight out of their pictorial history of mural painting.

The similarities between the Fewkes drawings and the ones made by the Hopi students are striking, and there are reasons to believe that the Sherman boys were familiar with the watercolors commissioned by the anthropologist. First, it was no secret that these drawings had been prepared; Fewkes himself reported that they were made public and that many other Hopis were involved in the study as they had been asked to identify the painted kachinas to verify their authenticity. Thus, the larger Hopi community knew about them. Second, the four students were likely home when Fewkes's kachina watercolors were completed; since they were in fourth grade at the time they made their drawings at Sherman, we can presume that they left for Riverside around 1904. Third, it is possible that the boys had heard of and even seen these drawings because of the controversy they stirred. According to Fewkes, in fact, when villagers were invited to examine the watercolors and offer their insights, rumors about a possible association of these paintings with sorcery began to circulate and ultimately inhibited the artists from making more. Because of this incident, the production of such images at Hopi stopped for several decades. The fact that Hopi kachinas were drawn at Riverside when they had been previously considered with suspicion on the mesas could be explained by the presence of Chief Tawaquaptewa, who favored the public display of Hopi customs, or simply by the students' desire to make memory of their heritage and honor it. When encouraged by their teachers to illustrate something from home, they remembered the works of the adult Hopis and used them as their representative model, thus explaining their unmistakable likeness; the peculiarities of each student's kachina, however, were drawn from their own personal recollections.

References to and appreciation of the students' innate artistic talents—and not only of Hopi pupils—are found in Anna Israel's letter as well as in the pages of the school publication. Readers were informed, for example, that "Augustine Montano has great talent as an artist. His drawings are of high order"; that "the Hopis show unusual skill" in drawing from Indian pottery; that "the many beautiful drawings on the boards in the class rooms were a revelation to our visitors. . . . The animal sketches by

"Drawing and All the Natural Artistic Talents"

Arthur Sehavema in the third grade are worthy of mention, as they show considerable talent in drawing"; that "the drawing of a Hopi Indian basket, by Myron Nashingayumtewa, in room 4, is the best ever done at Sherman. The shading and coloring is so natural that at first sight the beholder thinks a real basket is hanging on the wall"; and that the drawing of a fish pond curtain was "a work of art, and Silvas Lubo was the artist."[45] These passages express the belief in the natural artistic gifts of Indian children, yet at the same time, subtly betray a certain pride for the fact that the higher development of those untrained skills can be attributed only to the great work of the school, that is to say, of government education.

Indian people did have innate artistic abilities, and the popularity of their traditional art forms—whether among anthropologists, art collectors, or simple middle-class consumers—testified to this; however, as Reel had plainly put it years before, with the government's help even this primitive art could be raised to a higher level. This is exactly what Sherman was doing. Not only did it emphasize the "practical in the pupil's education," it also ensured that "at no time is the aesthetic side of human nature forgotten or neglected." It was for this reason that "music, drawing, and all the natural artistic talents of the pupils [were] encouraged and cultivated."[46] Sherman confidently promoted itself as a progressive and unique institution where the whole person was nurtured and educated. The broadcasting of students' achievements, whether through the pages of the *Bulletin* or the public displays of classroom and industrial work, was obviously an effective way to impress visitors, patrons, and faraway readers, showing them Sherman's true character.

A few other entries in the *Bulletin* attest that drawing was used to enhance classroom instruction and its correlation to industrial training. In the fourth grade, for example, children sketched maps of California as part of their geography studies.[47] Fifth and sixth graders received lessons in dairying, and the "very good cow" drawn by Archie Mashewistewa was presented to Mr. Turner, one of the teachers.[48] Finally, Pierce Kevanwytewa painted California poppies after studying this plant on the campus grounds, while each girl in the domestic science department who was studying different cuts of beef had to "draw a cow first."[49] Albeit few, these examples reveal that independently of the academic or industrial subject, drawing accompanied

and facilitated the students' learning process. Proof of this also comes from local newspapers in their frequent coverage of the school activities. For example, a *Los Angeles Herald* article on the Indian Institute held during the 1907 NEA meeting discussed the lesson in alfalfa presented by one of the teachers and described how it "demonstrated in a practical way how problems in arithmetic, composition work, drawing, English speaking, etc., may be taught in the class room in connection with industrial subjects."[50] Another article reported that Mr. Clarence Gates, principal teacher, illustrated "how he teaches drawing, composition, language, arithmetic and reading and writing in the classroom through carpentry," while a third one pleasantly observed that Miss Darnell's students, ages seven to ten, "went through an arithmetic exercise illustrated with vegetables."[51] As these excerpts show, drawing was a key element in relating classroom and industrial work.

Some teachers used drawing also in connection to Native crafts. In two instances in particular, the *Bulletin* reports that drawings were to be employed in the production of blankets. In the first occurrence, Miss Arnold, in charge of the Domestic Science Building, requested "to have designs submitted for rugs to be made for the Wigwam," a boys' dormitory that consisted of sitting rooms, reading rooms, play and recreation rooms decorated in a comfortable and attractive manner.[52] Student-designed and -made rugs would have certainly added to the homely atmosphere the school administration wanted to create. The second occurrence describes drawing exercises as a means to teach Indian art and English:

> In schoolroom No. 2 the pupils are copying a single figure from a Navajo blanket as a drawing lesson. When that figure is learned they will take another, and so on until all the parts are learned. Then they will be asked to unite them and form a perfect whole. In this way they will have lessons in Indian art and will learn the names of the different figures and designs. Later they will be required to take two or three different figures and design their own blankets.[53]

This passage conveys some information as to the methodology used in teaching drawing. Students were presented with an object that needed to be observed and reproduced, not in its entirety, but one detail at a time.

A full replica was done only when each part had been mastered. As they drew each section of the object, students learned its purpose and its name, thus enhancing their power of observation and of speech in the English language. When the time came to design their own object, in this case a blanket, students had to choose among the shapes they had already mastered. This guided step-by-step process ensured that pupils were able to create their own works, but ultimately did not allow them to freely use their personal creativity.

References to drawing in the *Sherman Bulletin* diminish and eventually completely disappear. The last piece of information provided dates to the early spring of 1909 and states that Caroline Eve made "over 90 per cent in the recent examination" in art.[54] Drawing continued to be part of the curriculum but school records for the next ten years are, for the most part, silent. This suggests that under the new superintendent, Frank M. Conser, appointed in 1909, this activity was kept to a minimum and did not receive the same attention as under the previous administration. No more pictures of Indian pottery, homes, and especially dances; this activity was now strictly relegated to purely educational matters and classroom work. Similarly, students' achievements were no longer paraded to the larger community and discussed publicly, even in the context of school exhibits at local and state fairs.[55] Conser did not seem to have much sympathy for drawing as a creative exercise in general, let alone for subject matters associated with the students' backgrounds. What he favored was, however, more systematic instruction in mechanical drawing.

Mechanical Drawing

Mechanical drawing never really featured as a component of any art curriculum because it was a strictly industrial kind of training. However, a brief parenthesis on this course of study at Sherman illustrates the changes that happened at the school in the second decade of the twentieth century, and indirectly, Conser's different attitude toward drawing, a position that mirrored the contemporary trends in American education.

There is no evidence of mechanical drawing in the curriculum of Sherman prior to the 1908–9 academic year, as no instructor was authorized for this position. In October 1908, the *Sherman Bulletin* communicated

that "plans are being prepared in the Indian Office to enlarge our warehouse, giving additional room for supplies and also arranging rooms for the mechanical drawing and band practice."[56] Exactly a month before this public announcement was made, Hall wrote to Frank Sorenson, superintendent of the Indian Warehouse in Chicago, requesting six sets of drawing instruments from the Eugene Dietzgen Company catalogue.[57] Sherman was getting ready to offer this training to its boys.

Of the two industrial teachers already at the school, neither one of them was to take charge of this new subject. H. E. Mitchell, hired in 1899, resigned at the end of the 1908–9 academic year, while Joseph Scholder, appointed in 1908, was too inexperienced. Conser thus immediately began a search for a mechanical drawing teacher. In June 1909, he wrote to John Charles, supervisor of construction in Washington DC, anxiously requesting "a good, practical man" who would be able to "map out a course of study" and give students "some instruction in mechanical drawing—at least sufficient for practical work."[58] Similar requests were sent to the superintendents of Haskell Institute and of the Albuquerque Indian School. In his letter to H. B. Peairs, Conser expressed his desire to hire "a man who is a good mechanic, particularly a carpenter, one who could take a class and teach mechanical drawing—sufficiently to give the boys an idea of how to draw plans for ordinary work." In writing to Reuben Perry, he said that he wanted "a good person who is a good mechanic, one who would be able to map out a course of study for the different tradesmen, who could draw plans, and give elementary instruction in mechanical drawing, and could do practical work in the line of carpentry."[59] This search apparently did not bear much fruit as additional correspondence from early 1910 indicates that the position had not yet been filled. Eager to find a teacher who could immediately take up instruction of mechanical drawing, in addition to supervising the industrial department, in January 1910, Conser personally solicited the superintendent of industries at Haskell, but with no success. After a long search, M. A. Collins was finally hired as the new superintendent of industries and mechanical drawing instructor for the 1913–14 academic year.

Even in the absence of a mechanical drawing teacher, Sherman managed to provide instruction in drawing in tandem with the boys' industrial trades. The vocational course outlines prepared for the 1911–12 academic

"Drawing and All the Natural Artistic Talents"

year show how drawing was taught as a foundational skill for carpentry, plastering and concrete work, and printing. In the senior vocational training in carpentry, for example, drawing was taught for various tasks related to the construction of parts of a house: roof layout, construction of scaffolding sections, geometrical layout for openings, types and details of frames, types of door construction, details of drawers for built-in features, details of cabinets, stairs, and parts, just to name a few. In the senior vocational course in plastering and concrete work, drawing was taught in order to make rough sketches of the job, while in the printing courses it was essential for designing letters, characters, and the distinctive elements of old and modern styles of typing.[60] Knowledge of mechanical drawing, therefore, was essential for the acquisition of the technical abilities required in the industrial trades Indian boys were expected to learn; by forcing students to consider layouts, measurements, proportions, and details of the objects to be made, drawing allowed a more precise execution and manufacture and, ultimately, better-quality products.

Mechanical drawing, built from the basic elements learned in classroom drawing, provided the additional training in precision, care, and attention to details that was required in many occupations and was thus an important subject to teach to Indian boys. Collins's program followed the preliminary work used at the Massachusetts Institute of Technology of Boston, and written by Linus Faunce, but in a simplified form. First, the instructor chose examples of drawing tasks, "problems," that "suited the needs of the students"—that is, it reflected what the students would encounter once they left the school. Sherman boys were not instructed in all the principles of mechanical drawing, but just what was useful to them. We can already see here the prejudiced and preconceived notion that Indian students would be able to do *only* certain jobs in their adult lives and so they should be trained for those positions and nothing more. Their training, therefore, needed to be realistically fitting for the trades that, according to their teachers, were more appropriate for their condition. Second, the preliminary knowledge of drawing was applied to the specific trades that the boys were learning at the school and was applied to all aspects of that particular area of work. This ensured that they acquired the ability to draft anything that future professions in those selected fields

required. Again, this was not a well-rounded preparation in mechanical drawing, but sufficient enough to allow students to perform the basic tasks of a specific trade.[61]

Interestingly enough, according to Collins, his classes in mechanical drawing were an occasion for students to "make the drawings just to use away the time." In other words, boys used his lessons to get away from the daily routine and often burdensome work of the shops in order to find some diversion. This means that they found pleasure in this somehow creative activity and that they tried to do it at their own pace, perhaps to avoid its more practical applications to trades. This is a subtle form of resistance to a curriculum that was imposed upon them and on which they did not have much input. Even mechanical drawing was a tool through which students "voiced" their discontent.

Sherman Institute continued to provide instruction in mechanical drawing at least until 1917, as evidenced by requests for drawing supplies and instruments. Later documents have not been considered for the purpose of this study, since the final year of this investigation is 1915. However, mechanical drawing became an integral part of the school's vocational course of study in the 1930s when the curriculum was revised to add new and more contemporary trades. Now called trade drawing, this type of technical exercise was a foundational class for many of the new industrial skills boys could acquire while at Sherman.

Native Arts and Crafts: From Perris to Sherman

There is no evidence of Native arts and crafts instruction at the Perris Indian School; the institution opened in 1892 and Reel's *Course of Study* was not disseminated until about a decade later, which is exactly when Perris slowly began its relocation to Riverside. California Indian baskets were prized items of trade, sale, and collection, valued not only for their anthropological significance as specimens of disappearing peoples, but particularly because of their artistic qualities and the fine skills of the weavers. The display of baskets at international fairs and expositions, as well as in private "Indian corners" that characterized the turn-of-the-century Victorian home, fueled this impulse to collect. It was not unusual for people interested in purchasing such specimens to contact an Indian

school, as many advertised and sold their student-made crafts. Perris, being the only institution for American Indian children in Southern California, often received such requests by local patrons, and copies of reply letters sent by superintendents testify to this. One such letter by Superintendent Hall to Clara Sanford, manager of Woman's Exchange in Los Angeles, unmistakably informs that, as of March 1900, there was no basket making at the school: "Regarding Indian baskets," Hall wrote, "I have to say that the children of this school do not make any."[62] Thus, in its brief life, the Perris School did not contemplate any instruction in basketry.

As far as Native weaving was concerned, this craft was not part of the curriculum, yet girls began to receive instruction in this finger activity at the turn of the century. In the summer of 1900, Superintendent Hall requested weaving materials from the commissioner of Indian Affairs, specifically carpet warp in assorted colors (orange, white, light yellow, black, light and dark blue, pink, light and dark green, and purple) to be used in "making rugs for beautifying school buildings." The superintendent said that this was "an Industry that we teach the Indian who can easily learn [the] same and it is the means of bringing in considerable money to them."[63] According to Hall, female students were taught rug making because they had a predisposition to learn this craft; rugs could be used to decorate school buildings, classrooms, and dormitories; and because this activity could bring income. It is unclear whether the rugs were made according to traditional Indigenous techniques or not, but the fact that they were taught because of their economic potential implies an "Indian" appearance. In truth, unless there was something overtly "Indian" that enticed prospective buyers and made the object appealing, a plain carpet made by Indian girls would have been unattractive. Thus, while girls were not taught Native weaving, there are reasons to believe that they learned to make European or American-style rugs with Indian motifs. All Indian people were thought to have natural artistic abilities and were regarded for their crafts-making skills; Sherman's female students were not an exception and Hall's allusion to their ease of learning reveals his belief in this congenital gift. Consequently, teaching them a new kind of weaving would have been as easy as a walk in the park.

This activity, however, was justified by more than a natural predisposition

for artistic endeavors used in the production of pretty school decorations; it had an economic rationale. Through weaving, Indian girls could contribute to their own financial well-being and, eventually, to the economic stability of their families, thus advancing in their progress toward self-sufficiency. In another letter to the commissioner of Indian Affairs, Hall explained that weaving was "the most useful and important industry" for girls because it was a "money producer." It was doing much good in beautifying the school's appearance and the Indians' homes, but more importantly, it opened up "a means by which the women can make money, as the tourists and other white people are very anxious to secure the rugs as made by Indians."[64] Like other crafts, weaving was encouraged for the enhancement of one's current and future home; Indian schools took great concern in teaching their female students how to properly make and maintain a civilized residence. A nicely adorned abode reflected cleanliness, industriousness, discipline, and taste and was the ultimate indicator of civilization and domesticity. However, the main reason for making rug weaving an essential school industry was purely economic: girls could bring in considerable income by the sale of their handwoven works.

Despite the potential for immediate economic gain, students did not sell and profit from their crafts while at Perris; possible earnings were intended for the future, that is, for the "upon graduation" time when girls would be able independently to use their skills for their economic well-being. There is no documentary evidence indicating that student-made rugs were sold to tourists on school grounds or that girls received any amount of money for their work. Instead, the rugs produced at Perris were used exclusively for the beautification of buildings and dormitories. Furthermore, Hall did not specify whether instruction in weaving was going to be tribal-specific, that is, only for certain groups of students. This means that, in his opinion, any Indian girl could have learned weaving as a money producer; as long as rugs were made by Indians—regardless of their tribal affiliation—and displayed Indian motifs, they were Indian enough and thus authentic enough for sale. Therefore, whether Hopi, Mission, or Pima, Indian girls at Perris were taught an "Indian" craft so that, upon leaving school, they could use this skill and earn an income by making what Anglo patrons craved. That this form of art did not necessarily belonged to their traditional

heritage was irrelevant; it was economically significant and that was reason enough to make it into an industry.

Craft instruction at the Riverside school remained the same as at Perris: rug making was taught as "the means of bringing in considerable money to the pupils after leaving school" and for the beautification of the new buildings, while basket making was not contemplated.[65] The introduction of basketry, however, was eventually suggested by Acting Commissioner Tonner who proposed the development of this industry in light of its potential economic benefits not only to the students but to all the Indians of Southern California. In a letter to Superintendent Hall, dated February 1902, Tonner wrote:

> Sir, it has been suggested that perhaps by the development of a willow basket industry the Indians of southern California might build up a business which would make some addition to their scanty sources of revenue. I have asked the Forestry Bureau to send you Bulletin No. 19 upon osier culture. If there is a chance for it to amount to anything in any of the Indian reservations which you visit to collect pupils you may perhaps find it practicable to make some experiments, either on the reservations or at Riverside. The matter is now submitted to you tentatively with the fear that the prevailing lack of water on the Mission Indian lands will make any attempt at osier culture impracticable. However, any opportunity though small, to better the condition of the Mission Indians ought not to be lost.[66]

At the time of this letter, Estelle Reel had already issued her *Course of Study* and emphasized the importance of this craft, so obviously Tonner's idea was rooted in the recent official endorsement of Native industries. The acting commissioner's main focus was the introduction of willow basketry among Mission Indians, but he mentioned that this industry should also be tested in *any* reservation from which students were gathered and at Sherman in general. This meant that, once again, no particular attention to tribal affiliation or craft-making traditions had to be paid in teaching this craft to either adults or students. The reasoning was, once more, strictly economic: Indians, whether living on or off the reservation and whether from a basket-making tribe or not, could have supplemented their income

and bettered their overall lifestyles by manufacturing a very specific kind of basket that was vastly requested. The revenues derived from the sale of handcrafted baskets were a step forward toward economic self-sufficiency.

Southern California Indians such as the Chumash, Cahuilla, and Chemehuevi were renowned for their basketry; why were they to learn osier culture? Commercial wickerwork had a lesser economic value than Indian basketry, but its popularity was nonetheless extremely high, and the profits for non-Native weavers were substantial; if Mission Indians could carve for themselves a space into the made-for-sale basket business in order to satisfy consumers' hunger for Indian-made home and garden decorative items, they could increase their production and sales and, consequently, enjoy higher returns. Whether these baskets belonged to the Mission Indians' traditional crafts, or to tribal groups to which the Sherman children belonged, did not matter to Tonner or to the uneducated consumer: demand was so high—and the possibility of real income so tangible—that somehow Indians were expected to do the job.

The need to generate income opportunities for Indian women and meet the desire for Indian-made objects was the driving force behind this impetus to promote basketry at Sherman. As such, the endorsement of this profitable craft was envisioned as a charitable act for the well-being and the future interests of Indian people. Obviously at stake here were also the future interests of the American people who, on the one hand, could see their cravings for primitive objects satisfied and, on the other, would no longer have to support the Indian cause with their own tax money. Hall responded favorably to Tonner's suggestion and decided to include basketry in the curriculum of his school; in a letter to the commissioner from late March, he wrote, in fact, that he was "of the opinion that basket willow can be raised and osier culture established, and made a profitable and successful branch of our school work."[67] About a month later, Hall wrote again with a definite outline of Sherman's industrial work: "Basket making and the manufacture of rugs will also constitute a branch of the school work. In fact every branch of labor wherein Indian girls may be taught to make home keepers, wage earners and good housewives, will be persistently and untiringly pushed, with the one object in view, to make the pupils self supporting at once."[68] Both basket making and rug weaving

"Drawing and All the Natural Artistic Talents"

were to be taught for the same, unmistakable rationale: immediate self-sufficiency. Indian girls attending Sherman were to learn these crafts so that they could produce what American consumers were demanding and, upon graduation, earn some cash and progress toward financial independence.

Yet both basketry and weaving did not have a strong Native character and this did not escape Estelle Reel's "expert" eye. In a letter to Hall at the closing of the 1903 Indian school exhibit in Washington DC, Reel praised Sherman's excellent quality of work, but also asserted that "the arts peculiar to the tribes will be given particular attention" in the next exhibit for the upcoming NAE meeting in Boston.[69] This suggests that the students' baskets and rugs reflected neither the traditional crafts of their tribes nor the ones of Southern California Indians. Reel, an enthusiast of Native baskets, had recognized the commercial nature of the works made at Sherman and had consequently admonished Superintendent Hall to ensure that he complied not only with her *Course of Study* but also with the president's wishes.[70]

"These Samples Will Illustrate the Valuable Instruction Given at Sherman": Weaving

Instruction in rug weaving was carried on in the following years as the school continued to purchase carpet warp for shop use, and rugs were manufactured for dormitory floors and buildings, not for tourist sale. It is difficult to discern whether Sherman complied with Reel's request and taught girls Native weaving, but we do know that girls wove blankets with overtly Indian motifs and that these creations were praised for their quality and the example they could offer to other institutions. In the fall of 1906, Reel wrote to Olive Ford, the seamstress in charge of the sewing department, asking for two blankets for the Indian Exhibit to be held at Philadelphia. Measuring five by three feet each, one had to be of white wool, while the other "of black wool with a large, well proportioned, swastika design, done in scarlet, in the center." Reel was anxious to "display the very best possible specimens of work of this kind from Riverside," yet did not simply call for any rug or the best rug made there; she unequivocally "commissioned" a specific one with the well-recognizable swastika design, one that viewers would have certainly identified as Indian.[71] Because she wanted Sherman

to be an example for all other schools, we can assume that the weaving done here was in accordance with her criteria, that is, it reflected the art of a blanket-making tribe, in this case the Navajo. However, Olive Ford was neither Navajo nor culturally affiliated with any other tribe; she was an Anglo sewing teacher who had also been appointed the task of teaching rug weaving. The fact that she could direct her students to design Navajo-looking blankets was apparently sufficient to make weaving at Sherman a "Native industry" and a valuable instruction from which the entire Indian Service could learn. Additionally, although a few Navajo students attended Sherman, their percentage was small compared to students from basket-making tribes. This shows that the pupils' backgrounds were irrelevant; weaving was to be taught to all for its economic profitability and it could be done without much knowledge of Indigenous techniques, as long as Indian elements were included in the designs.

The methodology through which students learned to design blankets is described in a brief article from the *Sherman Bulletin* titled "Indian Art in the Schoolroom":

> In schoolroom No. 2 the pupils are copying a single figure from a Navajo blanket as a drawing lesson. When that figure is learned they will take another, and so on until all the parts are learned. Then they will be asked to unite them and form a perfect whole. In this way they will have lessons in Indian art and will learn the names of the different figures and designs. Later they will be required to take two or three different figures and design their own blankets.[72]

Like their Carlisle peers, Sherman students were instructed to first draw the rug designs and then weave blankets using their sketches. The examples of students' designs discussed in chapter 2, and illustrated in figure 20, could have been made in Riverside just as well as at Carlisle. Contrary to DeCora's methodology that centered on students' own creativity, however, the process used at Sherman ensured that pupils did not make up their own figures—thus avoiding the possibility of creating "inauthentic" designs—but merely reproduced what they saw in the Navajo blankets in front of them. All the teacher had to do was to simply control the accuracy of the reproductions in the students' designs; thus, her lack of Indian heritage

"Drawing and All the Natural Artistic Talents"

was irrelevant for the purpose of this instruction. Whether this teaching approach was purposefully intended to restrain students' creativity or not, its outcome points to a suppression of any individual agency in the making of rugs. Whether this actually happened or not, however, is another story. I believe, in fact, that even if the school wanted to strictly control students' creative powers by offering them limited design options for their blankets, no two drawings of the same figure could have ever been exactly the same, as each person always retained her own particular style. The significance of this passage from the *Bulletin* lies in its outlining a teaching methodology that, no matter how well-intended, sharply contrasted with the way rug weaving was learned in a tribal context. Here, individual experimentation and the envisioning of the entire blanket design in one's own mind preceded the weaving.

Numerous entries in the *Sherman Bulletin* inform us that after 1907 rugs were made in the intermediate sewing department and were used at the school only for decoration purposes, although they always attracted and interested visitors. Once completed, they were sent to the girls' sitting rooms, the boys' lodges, the ranch home, and the school halls. Mary Knox (Pima), Natalia Guassac (Mission, La Jolla), Bertha Goode (Mono), Julia Diaz, Hazel Elliott (Pomo), and Margaret Hernandez were some of the students praised as the designers of the pretty rugs: none of them came from a blanket-weaving tribe.[73] Other entries report that girls worked at a very fast pace and attempted to complete more than one rug at a time.[74] These excerpts are particularly interesting and can be read from two different perspectives. On the one hand, we can interpret this as a scenario in which girls are pressured to maintain a steady work rhythm by their teachers, so that a work ethic of industriousness, dedication, and productivity can be learned. In order to stimulate the interest and desire for success of all weavers, their deeds were publicized and encouraged through the pages of the school weekly journal. On the other hand, the girls' eagerness can be read as a desire to weave as much as possible now that they have mastered a more creative, and certainly more Indigenous, activity than what they were accustomed to. This second scenario seems more plausible: girls rushing to the sewing room for their weaving class and enthusiastically setting themselves to work at something they truly enjoyed.

While blankets used for the decoration of the various school buildings often attracted the visitors' interest and attention, they were not available for sale. Tourists stopping at Sherman could buy Indian blankets, but these were not made by the students; rather, they were procured from other places.[75] One of the major providers of Navajo blankets for Sherman Institute was C. C. Manning of Fort Defiance, Arizona. Likely associated with a trading post, Manning was contacted several times by Superintendent Hall with requests for small rugs, namely twenty-two specimens in natural wool, pretty colors, and designs. Eleven of these were sold to employees, while the remainders were placed "in the Domestic Science Building here for sale to tourists."[76] These letters also reveal that school employees did not benefit from the student-made blankets, either; if they wanted rugs for the decoration of their own living quarters, they had to buy them from other venues.

Why did Hall sell tourists blankets manufactured on the reservation? Why could he not sell the students' work? Unfortunately, there is no documentary basis to properly answer these questions. It is possible that because of the tribally unspecific nature of the weaving instruction imparted to pupils, he thought their blankets—good enough for display around the school and at Indian Service exhibits and good enough to provide future income opportunities for his students—were of insufficient quality for Sherman's visitors; they could have earned the school some money, but were certainly of lesser value than the rugs made by expert weavers on the reservation. As Hall vigorously promoted Sherman and commercialized his students' Native heritage to benefit the reputation and the standing of the institution, he used the school as a sort of cultural center and trading post. Visitors could admire the students' progress toward civilization while enjoying the most peculiar aspects of Indian traditions (music, dancing, weaving, and basketry) and buy "real" arts and crafts from nearby reservations. The sale of authentic Navajo blankets or, as it will be discussed later, Hopi baskets, was simply another opportunity to please patrons and curious onlookers and entice them to leave more of their money in Riverside.

This practice continued throughout Hall's entire superintendency. Blankets were received from the Navajo reservation and were arranged in the Domestic Science Building by Miss Arnold, the teacher in charge. Between

December 1907 and May 1909, the *Sherman Bulletin* reported the arrival of four new shipments. Readers were informed that the Navajo blankets received "are the finest ever exhibited at Sherman for sale . . . [and] were procured direct from the Navajo looms on the reservation"; that "a lot of handsome Navaho rugs from the Navaho reservation are on sale at very reasonable prices"; that "another lot of very fine Navaho rugs, which are for sale at reasonable prices" had arrived; and finally, that more "Navaho rugs of beautiful designs and excellent weave have been received and are on sale at reasonable prices."[77] The last shipment was reported at the end of May 1909; there are no additional records of blankets ordered from the Navajo reservation after this date. Unsurprisingly, this time corresponded with the change in school administration and the appointment of Frank Conser who, contrary to his predecessor, did not seem to be particularly sympathetic to the overall marketing of the Indian school and its promotion of Native culture.[78] In a 1913 letter to Esther Fowler, who inquired about Navajo rugs, Conser replied that the school did not carry any, thus confirming that the practices of his precursor had been discontinued.[79]

Albeit marginally, weaving instruction was carried on under Superintendent Conser, but what little Native character this industry had had in previous years completely disappeared. Records on weaving during the first years of his administration are scarce, but later documents show that during his tenure this activity was undoubtedly Euro-American and for the production of rag rugs. According to the vocational course outlines for the academic year 1911–12, specifically for the months of October and May, instruction in weaving was part of the training in dressmaking and intermediate sewing. Lectures for the vocational dressmaking class for the month of October 1911 focused on topics such as color and harmony, primitive methods of weaving, spinning different kinds of fibers, and the study of cotton from the field to the loom. Lectures on each topic were carried on for two consecutive days and were complemented by review sessions. The intermediate sewing classes for the month of May 1912, on the other hand, centered on lessons in spinning, weaving, and fabrics.[80] These courses were not sequential and were likely offered in different grades.

Guidelines for sewing lessons in Indian schools had been first provided by Reel's *Course of Study*. Teachers of all grades were advised to give frequent

talks on textiles and their origin, but also to systematically inform students as to "the process of manufacture of the different articles and materials used in the work" so that they could "work more intelligently."[81] Because sewing continued to be a central feature of the girls' domestic training, its instruction remained unaltered. It is not surprising, therefore, to see lectures on fabrics, spinning, and weaving after Reel left office. Teachers often recurred to the aid of manuals written by professionals especially for classroom instruction or for use by amateur learners. Sections on primitive weaving normally discussed the methods used in ancient times by primitive communities and briefly covered American Indian weaving, particularly Navajo, as these people were continuing their well-established traditions, albeit with a few adaptations.[82] These manuals discussed types of primitive looms and the techniques used in working the raw materials into finished utilitarian objects. Whether teachers at Sherman used any of these manuals is unknown, but these official outlines seem to suggest that their lectures on primitive weaving followed this blueprint.

According to the vocational course outlines, students were taught the ancient methods of weaving, but this does not necessarily mean that the talks were followed by practical demonstrations and individual execution. As a matter of fact, I believe that, at the time, girls did not have any practical weaving experience. In a 1912 letter to the commissioner, Conser requested authority for the expenditure of fifty dollars for "weaving rag carpets and rugs" that would have "add[ed] considerably to the appearance of the buildings."[83] The remainder of the letter specifies that "this request is for the purpose of enabling us to have the carpets and rugs woven" and that "we will have carpets and rugs of different widths woven but we will get the best prices obtainable for such work as we will have done." These statements indicate that the above amount was not for purchasing materials, but to pay for the weaving done by third parties. Carpets and rugs for the beautification of the school were no longer made by students in the sewing department; the administration had apparently decided to employ and pay outside services.

Less than a year later, Conser wrote letters to the Reed Manufacturing Company of Springfield, Ohio, and to the Newcomb Loom Company of Davenport, Iowa, asking for catalogues of their products and books for

instruction in weaving.[84] Both companies made horizontal looms. Conser's correspondence with these two loom manufacturers is indicative of a few important things: first, the superintendent wanted to either expand the existing weaving classes or start them anew; second, he did not intend to hire a weaving teacher; and third, the weaving was unlikely to be in an Indian style. As far as the first point, it is obvious that the school needed to purchase looms; this could mean that either the Domestic Science Department needed additional machines or that it had none. Records from the Hall administration show that students wove carpets for the ornamentation of school halls and buildings, so it is unlikely that Sherman did not have any looms. However, Conser's letter requesting expenditures indicates that under his rule carpets and rugs were done by others. Why they were not made on site and what happened to the looms that were used in the past is difficult to tell. Nonetheless, these letters reveal that Conser desired to procure looms for classroom use, possibly because commissioning a third party was becoming very costly.[85] Through the manufacture of carpets and rugs, girls could once again contribute to the physical and economic maintenance of Sherman and to their own domestic education.

The second important element that emerges from Conser's correspondence is that he did not intend to hire a weaving teacher; had he contemplated this option, he would not have been so adamantly inquisitive about instruction booklets. These manuals not only provided information about the looms' functioning and operation, but also included practical step-by-step guidelines, weaving designs and patterns, and suggestions for care and washing. As with other crafts manuals, all the teacher had to do was read; no previous weaving experience was necessary. In this way, a domestic science teacher, maybe the seamstress or one of her assistants, could have been in charge of the students' training in the use of the new machinery and could have supervised their work.

Finally, the weaving Conser had in mind was likely non-Indian. Conser was no sympathizer of Native industries and departed from Hall's permissive policies of tolerating and displaying Indian cultural heritage; it is unlikely, therefore, that he considered the purchase of a loom for the weaving of Indian rugs. The other factor that excludes the Indian character of the weaving is the loom itself; traditionally, in fact, Indian weaving had

always been done on an upright or vertical loom, while the ones made by the companies Conser contacted were all Euro-American, that is, horizontal. Not all Indian communities used an upright loom, as the Zunis and the Pueblos, for example, wove on a horizontal apparatus; however, the "Native weaving" promoted and encouraged in the schools of the Southwest was by default in the Navajo style, because of the high percentage of Navajos among the student population (except at Sherman), and because Navajo blankets were considered the rugs par excellence. They were the crafts that had sparked high interest, demand, and as a consequence, commercialization throughout the region and beyond and thus the ones that had economic promise for the students. If school administrations encouraged Native weaving in their curriculum, they likely opted for the use of upright looms; photographs in chapter 3 from a number of institutions visited by Reel attest to this (see figs. 17 and 19).[86] There is no evidence that Hall procured upright looms for the girls or had them custom-made by boys in the carpentry shop while he was in charge of Sherman, and the possibility that this happened under Conser is even more remote.

By the middle of the 1915–16 school year, Conser was still begging for money to pay for the weaving of carpets and rugs by a third party, as the school still did not have a loom. The reasons why the purchase had not yet happened are unknown, but Conser "expected" to acquire one.[87] A lack of machinery meant that girls did not have the opportunity to do any carpet weaving. It is understandable that, with the beginning of Conser's tenure, the Native character of the weaving previously done at the Sherman, already minimal, completely disappeared. Why carpet and rug weaving also ceased, however, remains unknown. Records seem to indicate that Conser was willing to have girls weave these kinds of textiles for the school, but was unable to obtain appropriations for materials and possible additional looms from the Indian Office.

"A Department Where the Girls May Be Kept Up in Their Basket Making": Basketry

Hall had positively welcomed Acting Commissioner Tonner's suggestion to include basketry among the industries of the Riverside school; in April 1902, he announced to the commissioner of Indian Affairs that "basket making

and the manufacture of rugs will also constitute a branch of the school work."[88] Yet no action was taken in the following four years. The reasons for this are multiple: Hall was contemporaneously managing two institutions and had to take care of more urgent administrative and academic matters; Reel's *Course of Study* had only recently been published and Hall did not feel pressured to make all the required curricular changes; there was no public display of Indian cultures and traditions at the school yet, although its doors had already been opened to visitors; and finally, Hall needed to establish Sherman's name and reputation and prove that the new Riverside location was the best for the education of Indian children in Southern California. Basketry likely was at the bottom of Hall's long to-do list.

Important steps toward the establishment of a basket industry were finally made starting in March 1906. Why at this particular time and not sooner? By now, Hall should have been more compliant with the *Course of Study*, as Reel had repeatedly demanded the introduction of Native industries and had specifically directed Sherman to give more attention to "the arts peculiar to the tribes" in her January 1903 letter concerning the exhibit for the Boston meeting.[89] What prompted him to take action in this matter at this particular moment? The catalyzing event was Reel's visit—the first one since the opening of the Riverside complex—in June 1906 on the occasion of Sherman's commencement exercises. In the course of her travels, Reel inspected more than one institution within the same geographical region, so plans were arranged in advance and considerable notice was provided to superintendents in charge. Once Hall learned that Reel would be coming to appraise the quality of Indian education at Sherman, he quickly acted to improve those areas of the curriculum that did not meet the criteria of the *Course of Study*. Basketry was one of these. It is not a coincidence that the spring of 1906 was also when Hall began to more seriously emphasize instruction in weaving.

In March of that year, probably in a race against time, Hall wrote to his friend, Joe Kinsman of North Fork, in central California, and to Reverend L. M. Ewing of Ukiah, in northeastern California, asking them to procure raw materials for the making of baskets. There is no explanation as to why Hall did not request materials from southern locations, where the majority of his California students came from. In the first letter, Hall explained

that he was "quite desirous of securing materials" because he wanted "to have the girls make a few baskets in our school for general work" and was hoping to "install a department where the girls may be kept up in their basket making."[90] In the second, he noted that he was "quite anxious to have some baskets made in this school by some of our pupils."[91]

Both documents reveal an impatient desire to have the materials shipped as soon as possible, so that the girls, in the few remaining weeks before graduation and Reel's arrival, could undertake some basketry as part of their general industrial education. Hall may have calculated that doing this work in the two months preceding Reel's visit would be sufficient to demonstrate that the Native industry requirement was being carried out at Sherman and thus it would satisfy the superintendent's expectations.[92] The content of these letters, however, is not limited to Hall's restless request, but conveys additional information: it reveals, in fact, that basket making was not going to be simply a temporary activity to "put up" in light of the upcoming inspection, but was envisioned as a permanent feature of the school. Hall's words to Kinsman are clear: he was hoping to establish a department where girls could continue to exercise their basket-making skills. Through this, Sherman's superintendent finally accomplished what he had intended to do years before.

The institutionalization of basketry, however, did not happen before Reel's visit, but coincided with the arrival of the Hopi contingent in November of 1906. Hall initially envisioned this craft for the adult women who accompanied Chief Tawaquaptewa—so they would have something to do—but soon saw their presence at the school as the expedient for eventually establishing an industry for female students. This shows that the superintendent not only welcomed Native crafts, but also the possibility of having Indian women serve as teachers, role models, and influential presences at Sherman. An actual basketry department, however, was not created; this industry was added to the art needlework training the girls received in the domestic department along with embroidery and fancywork.

Before the Hopis settled at Sherman, Hall began corresponding with Miltona Keith, a matron at the Oraibi School in Arizona, on matters regarding their welfare. In one of his letters, Hall asked for materials and the necessary paraphernalia for making baskets to be sent to Riverside directly

from the Hopi village and justified this request by saying that "the two Indian women are quite anxious to commence that [making of baskets] at once and fall into my plans with considerable enthusiasm."[93] The two Hopi women were Nasumgoens Tawaquaptewa and Susie Seyumtewa, wives of Chief Tawaquaptewa and Frank Seyumtewa, one of the adult followers, and all the items requested by Hall were thus destined for them. A few months after their arrival, Hall informed Commissioner Leupp that "the women have secured basket material and are making a great many baskets, using one of the rooms in the Domestic Science Building for such purpose, and they sell their baskets to the tourists."[94] When Susie Seyumtewa left Sherman in March of 1907 and returned to Hopi, due to a health issue, basket making continued and was led by the other women who remained. In May 1908, the *Bulletin* reported that "a box of material with which to make baskets has just been received from Oraibi for the wives of Chief Tewaquaptewa and John Poseyesva."[95] Upon Hall's solicitation, Miltona Keith, now Mrs. Staufer, continued to send materials for the Hopi artists.

Another important element that emerges from Hall's correspondence with Keith is that the women's desire to make baskets fell into his plans. Their presence served his purpose and helped him in the establishment of this Native industry without significantly unsettling Sherman's industrial curriculum. As women who were skilled in the traditional craft of their people, Mrs. Tawaquaptewa and Susie Seyumtewa could have imparted their knowledge to the young Hopi girls, or whoever wanted to learn basketry, thus sparing teachers in the needlework department from having to learn this craft on their own through books and manuals. Native craftswomen were now living at the school, were available to students and able personally to guide the girls and demonstrate basket making techniques. Therefore, there was no need for Hall to change his employees' regular teaching duties. Ultimately, the arrival of the Hopi women and their desire to make baskets at Sherman worked to the superintendent's advantage, as he did not have to modify the curriculum to accommodate the inclusion of this industry. Mrs. Tawaquaptewa and Susie Seyumtewa could contribute to the young girls' practical training and to the overall life of the institution.

Furthermore, having "real" Indian women making their renowned baskets on the school grounds also facilitated Hall's promotional plan for

Sherman; this, in fact, was another sure way to attract visitors and their money to Riverside and parade how good and progressive the institution was in the education of its Indian children. It is evident, though, from Hall's correspondence with Miltona Keith, and from other sources, that the profits from the sale of the baskets went to the women and not the school. For example, in one of his letters Hall wrote that "these people will make considerable money out of their baskets, because they will have no trouble to find plenty of buyers and they can really ask their own prices for same."[96] A few months later, Hall informed Commissioner Leupp that the women "sell their baskets to the tourists," while a brief note in the *Sherman Bulletin*, after Susie's departure for Arizona, announced that she was "a good basket weaver and accumulated quite a goodly sum selling the baskets she made while at the school."[97] Despite the fact that revenues from the sale of baskets went directly to the women—there is no evidence that a part also went to the school to cover the cost of materials and their shipping expenses—Hall likely had a different motive; as word of the talented basket makers in the Domestic Science Building got around, the number of visitors could increase and bring monetary gifts as well as positive publicity to the school. All this certainly contributed to spreading Sherman's (and Hall's) good name.

The adult Hopis in the art needlework department undoubtedly enriched the lives of the students who learned from them or simply spent time in the Domestic Science Building for their practical daily trainings in sewing, mending, embroidery, or needlework. Whether their involvement was minimal, as in Susie's case, or more substantial, we cannot underestimate the influence these women had. Being away from home, the Hopis were eager to take up basket making in their new environment, and Hall noted this enthusiasm as soon as they arrived; upon receipt of a second shipment from Oraibi, he wrote Miltona Keith, "I seldom have seen any persons more happy that they seemed to be upon receiving it."[98] Such fervor could not go unnoticed among the young girls and not profoundly affect them. If, in fact, adult women who had just left their communities felt uneasiness in this foreign setting and yearned for something intrinsically Hopi to alleviate their homesickness and estrangement from home, we can only imagine how young girls, who had been away from their relations for longer

"Drawing and All the Natural Artistic Talents"

periods of time, must have felt. Whether Indian girls, either Hopi or from other tribes, enjoyed their experience at Sherman or not, there can be no doubt that basketry added a new, yet familiar dimension to their schooling.

The extent of the Hopi women's involvement in the teaching of basketry is not well documented; no direct evidence confirms that they actually taught students. Yet, considering Hall's openness to their presence and his promptness in allowing them to make baskets, we can presume that once they stepped into the Domestic Science Building they became magnets for the young pupils. Various excerpts from the *Sherman Bulletin* indicate that three women—Mrs. Tawaquaptewa, Mrs. Seyumtewa, and Mrs. Poseyesva—carried on their own work in the "art room," the area of the building reserved for art needlework. Here, girls were taught crocheting and knitting in the first grade, bead work and basket weaving in the second, and embroidery and drawnwork in the third. The division was directed and supervised by Olive Ford and her teacher assistant, Solida Tortuga, a former Perris student who was originally hired in 1905 as assistant laundress, but it is very possible that basketry was taught by the Hopi women.[99]

Interestingly enough, the *Bulletin* reports focus more on the women's basket work than on that of the students. In April 1907, for example, the school publication noted that the art room was beautifully and artistically arranged with items made by the girls, particularly "school banners, sofa pillows with yells embroidered with the dear old purple and gold," but also with "baskets made by the wife of chief Tawaquaptewa." A month later, it reported that "the art needlework department has some very pretty baskets made by Mrs. Tawaquaptewa."[100] Both passages indicate that the principal basket maker at the school was the chief's wife. It is possible that the exclusive mention of Mrs. Tawaquaptewa's baskets was a marketing strategy to lure local readers, many of whom were sponsors and benefactors, into visiting the school and personally buying these handcrafted items made by none other than the wife of an Indian leader.

Contrary to what other scholars have suggested, there is no evidence that Hopi students sold their baskets. A few issues of the *Sherman Bulletin* inform readers that articles made in the needlework division were for sale to tourists, but they do not explicitly state that among crocheting, knitting, bead work, embroidery, and drawnwork there were also Hopi

baskets. For example, in the March 1907 publication, we read that "for the past two years, under the good management of Miss Ford, the girls of this department have secured a sufficient fund, by the sale of their work, to supply Christmas presents for the five hundred young people of the school."[101] Basket making was listed as one of the industries in this area of training, but later issues disclose that the main articles for sale were others: in October, for example, the *Bulletin* declared that "the girls are taking training in crocheting, knitting, beadwork, embroidery, drawnwork, and lacemaking. . . . Solida Tortuga has charge of this department, which the tourist thinks the most interesting in the building" and that "Miss Tortuga in the needle art room has a class of second-sized girls who are beginning fancy stitches, crocheting, and beadwork. They are completing some neat little articles for the tourist sales."[102] These three passages, the only ones that reference the sale of art needlework items, emphasize fancywork over basketry, thus suggesting that the money raised was from the former rather than the latter. This information might not be sufficient to prove that student baskets were not sold, but it is also inadequate to establish that they were; when considered together with other excerpts that mention and advertise only the work of Hopi women, it raises reasonable doubts as to whether Hopi students, or students in general, sold their baskets at Sherman Institute.

A photograph of the needle art department (fig. 31), published in a 1908 pamphlet on Sherman, provides visual evidence of the work done in this room and of the pretty arrangements described in the *Bulletin*. Girls are posing in the corner of the room next to a curiosity cabinet, thus creating their own version of an "Indian corner." In the foreground, sitting on a floor adorned with Navajo blankets, are three students surrounded by different kinds of baskets. They are not depicted in the act of making a basket; each is simply holding one and showing it to the camera. In the middle row are eight girls, seated on chairs, and posing with their respective needle arts: knitting, crocheting, embroidery, sewing, and lace making. Standing behind them, against a wall covered with wicker plaques likely made by the Hopi women, is a teacher. Also hanging on the wall are Sherman banners and a Navajo rug. In the wooden cabinet on the left side of the photograph, possibly a product of the carpentry shop, are finished

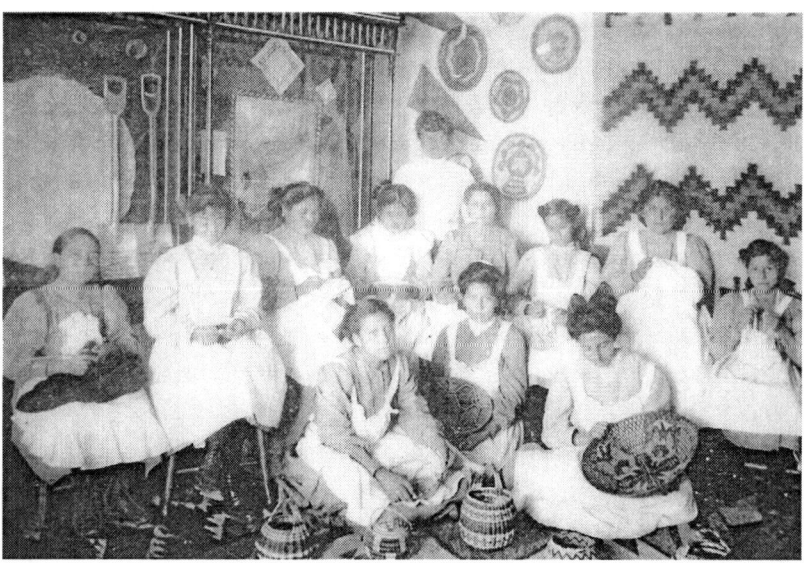

Fig. 31. Art Needlework Department. *Sherman Institute, U.S. Indian School, Riverside, California.* Riverside CA: Sherman Indian School, 1908.

samples of the girls' handiwork: a round embroidered centerpiece in the left window, a few laced napkins or handkerchiefs, and a larger square item with what seems to be a flag in the middle.

The baskets placed on the floor do not reflect the traditional craft of the Hopis; some of them more closely resemble the works of California tribes. Similarly, because of their bowl-like shape and their designs, the baskets in the girls' hands are rarely found among the weavers of Arizona or New Mexico. They display complex motifs, particularly the larger piece on the right, and could be examples of Mission baskets but also of bowl baskets from Northern California tribes, such as the Yokut, Karuk, Hupa, or Mono, which were well known for these kinds of shapes. Of the five baskets placed on the floor, only one differs from the rest in that it does not have a handle; this might be the only specimen of a central or Southern California basket; its shape and simple geometrical designs could be Mission or Miwok. The other four baskets with handles, one of which also has a lid, do not seem to belong to any of the California traditions, although they might be attempts at imitating them. They appear to be made in a

different material, possibly willow or raffia, which would also explain heir apparent shininess and sturdiness. One has only to compare this photograph to the numerous pictures of Indian corners featuring collections of California basketry to realize that none of them include the kind of baskets with handles displayed here on the floor. It is possible that these items were the result of training in general basket making, as Tonner had suggested, that is, a finger skill that had no connection to any traditional Native craft in particular, and were for purely educational purposes, to teach girls how to produce made-for-sale items. They are included here to show that among the work of the art needlework department there were baskets "made by Indians."

Obviously the Hopi women would not teach Yukot or Hupa or Mission basketry. From whom then did the girls learn? If the superintendent's goal was to develop a willow basket industry for the Indians of Southern California among his students, was there someone else who taught this type of basketry? As far as we can gather from the historical records, the Hopis were the only adult basket makers at the school; thus, it is reasonable to concede that one of the domestic science teachers, perhaps someone who had learned from manuals, instructed girls in general basketry. I think some of the baskets featured in this photograph were made by the students, specifically the ones with handles, placed on the floor, while the remaining others were not and belonged to Hall. Documentary evidence shows that over the years, the superintendent used his school connections to procure baskets, particularly from Northern California, for his own personal collection. Letters written between 1904 and 1908 attest to this.[103] It is possible that Hall, in order to awe the receivers of Sherman's first official booklet, decided to expand and ameliorate the needle art department basketry display by including some samples of "real" California Indian baskets from his private acquisitions.

The three larger baskets in the girls' possession were part of Hall's collection, and not student-made, for another reason: the girls' absent and disinterested look. This can be read as a sign of their personal detachment from the objects they are holding and thus additional evidence that the baskets were not made by them or at the school. Compare their appearances to the ones of the girls sitting behind them working on their own

"Drawing and All the Natural Artistic Talents"

crafts: some of them reveal a content smile, while others seem to be eagerly showing what they are making. The "basket" girls, on the other hand, do not show any special connection to their objects and do not display the pride one would normally exhibit if she had been the creator of such a beautiful work. One of them even looks as if she were examining the basket in her hands for the first time. Furthermore, if we compare this to the other photographs of Native industries described in chapter 3, we immediately notice that in all the other pictures girls are captured in the act of making their craft; here they are not. These apparently trivial details can actually be very revealing and can be supplementary proof that the baskets were not the work of the girls' hands, but were simply placed there for the circumstantial occasion of the photograph. This move was probably intended to demonstrate the superior and diverse quality of Indian girls' domestic education: training the fingers in every kind of fancywork, including American Indian basketry, as recommended by the superintendent of Indian schools.

Contrary to the baskets held by the girls, the plaques hanging on the walls of the needle art room can be identified as made by Hopi hands, likely by Mrs. Tawaquaptewa, Mrs. Seyumtewa, and Mrs. Poseyesva, the three women who sojourned at the school with Chief Tawaquaptewa. As previously mentioned, there is no evidence that Sherman students actually made Hopi baskets, but we are abundantly informed by the *Bulletin* and other sources that the women wove, displayed, and sold their works. Traditionally, these particular baskets (plaques) were woven with two different techniques, wicker or coiled, dyed in three or four different colors, and decorated with geometric motifs or life designs such as birds, butterflies, kachina heads, or figures. Wicker plaques were woven only on Third Mesa, where the village of Oraibi is located, while coiled plaques were made in the villages on Second Mesa. Both types of plaques were made for ceremonial use, most notably for the Basket Dance and for wedding ceremonies, but also for trade and eventually sale to tourists. The basket makers at Sherman were from the village of Oraibi, so they would make wicker plaques, which is exactly what is on display in the photograph. A total of six plaques are hung on the wall; four present geometric designs, while two have kachina heads, including one with the traditional maiden hairdo and symbols of

clouds.[104] The remaining two cannot be identified. Some of the plaques are also accompanied by a tag likely reporting the name of the artist, the price, and possibly the name of the design. Unfortunately, the photograph does not allow us to read the content of these small papers.

This class photograph and the documentary sources cited above confirm that when promoting Hopi basketry, the school administration never mentioned the work of the students, but rather emphasized and advertised what the adult women were doing. This, in a way, seems to follow the pattern established with Navajo rugs: Native crafts (or something that resembled them) were promoted and taught, but when it came to sales to tourists, the school used the works of adult Indians rather than that of the students. Navajo blankets were purchased from trading posts on the reservation, particularly in Arizona; Hopi baskets, on the other hand, were made on Sherman grounds and, at times, also procured from Oraibi. There is only one documented instance of this practice and it is from a letter to Horton H. Miller, superintendent of the Moqui school and agency in Keams Canyon, Arizona, in which Hall wrote the following: "Relative to baskets that Tewaquaptewa brought to Riverside to sell for Nelson Oyaping, will say that there has been no demand for baskets this fall and that all the baskets are still here. Soon, however, when the tourists begin to invade the region, I think they can be sold."[105]

It is difficult to ascertain whether this practice occurred on a regular basis or was a one-time event; because the baskets were brought to Riverside by Chief Tawaquaptewa after one of his visits back home, we cannot exclude that this routine happened whenever the Hopi leader returned to Sherman from his temporary leaves. It is also unclear whether bringing baskets back to the school was the chief's idea or to satisfy a request from Hall. Knowing the superintendent's tendency of buying crafts from Indian reservations in order to sell them at Sherman, one could conclude that the initiative came from him; however, in light of the language in the above letter—baskets to sell for Nelson Oyaping—I am inclined to think that it was a result of the chief's ingenuity: he was aware of the economic benefits his women derived from the sale of their baskets and saw this as an opportunity to help other people from his village.

Only one reference is available concerning student-made baskets, and

"Drawing and All the Natural Artistic Talents"

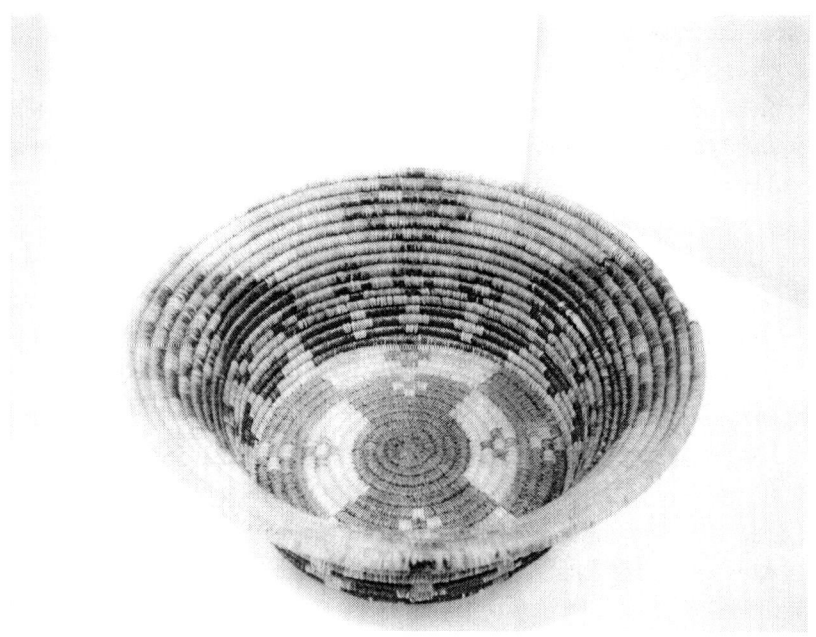

Fig. 32. Coiled basket made by a Sherman Institute student, early 1900s. Courtesy of Sherman Indian Museum and Archives, Riverside, California. Photo by the author.

it appears in the May 1908 issue of the *Bulletin* where readers are invited to "come and see the pretty little papoose baskets Brigida Ward is making in the art department."[106] Brigida Ward, a Mission Indian, was about eleven years old at the time of this announcement. While we do not have any additional information on her works, a coiled basket found in the collections of the Sherman Indian Museum (fig. 32) could be such an example, or at least indicative of what students made in the department. According to Lorene Sisquoc, the museum curator, it is a raffia coiled basket from Southern California measuring six to seven inches in diameter, three inches in height, and seven and a half inches in the mouth, and it was made at Sherman in the early 1900s. It is shaped like a hat and has, according to the cataloguing description of the museum, triangular patterns. It is made with black and natural raffia and presents geometric designs and recognizable motifs such as stars and clouds. Its shape does not belong to a typical Southern California basket, and its designs too are

more Southwestern, thus revealing the influence of the Hopi women's work on the student's craft.

References to basketry become increasingly scarce as we approach 1909. This can be attributed to two reasons: first, Chief Tawaquaptewa and his followers returned to Hopi in the spring of 1909; second, the leadership of the school passed from Superintendent Hall to Conser. The correlation between these two events is not a coincidence; Hall believed that the Hopi men were ready to go back to their homes and start farming the lands they had been assigned through allotment and wanted to see this accomplished at the end of his tenure. Similarly, the effect of Hall's transfer and the Hopi's departure on basketry is not a happenstance; with the Hopi women gone, production decreased and the Native influence in the needle art department diminished. More important, however, was Conser's attitude toward the promotion of Native industries in the school: as with weaving, he did not favorably consider instruction in Indian arts and crafts and worked toward the suppression of this kind of training.

By 1912, basketry no longer existed at Sherman, and Conser had no intention of reestablishing it as an industry. In a lengthy letter to Commissioner of Indian Affairs Robert Valentine, Conser presented his arguments against the establishment of a willow industry at Riverside and he advanced suggestions as to what needed to be done with this industry and where it could be more appropriately introduced.[107] He did not think it advisable to add a basket industry at Sherman for practical reasons, namely, because there were at least five basket-making tribes represented at the school, each with its own distinctive weaving style and techniques. In light of such diversity, this industry seemed to be an impossible undertaking. Furthermore, Conser thought it a mistake to teach an unspecific willow-basket industry because it would devalue the students' works; the more the baskets departed from the traditional styles of their tribes, the more they lost their economic value. One of the ways to avoid this unspecific craft was to have an Indian elder as teacher, but this meant hiring a person from each basket-making tribe represented at the school; obviously Conser did not consider this a feasible option. Conser believed, then, that the most appropriate place for teaching basketry was on the reservation, and it was here that Indians had to be encouraged to continue in the footsteps of

"Drawing and All the Natural Artistic Talents"

their predecessors and helped to learn how to grow the materials needed for their crafts. Willow basketry could make Sherman more appealing to tourists, as they would find more Indian-made items to purchase, but in the long run it was not a good idea for the students who were expected to find employment in the white community and take upon themselves the responsibilities of a civilized life.

In contrast to his predecessor, Conser displayed a very managerial and conservative approach, and yet he appeared to be more respectful of students' personal dignity. If, on the one hand, he did not take the risk of exposing the pupils to the cultural power of their own crafts and tribal craftspeople, on the other hand, he refused to objectify them and turn them into producers of popularly demanded goods for the sake of Sherman's economic well-being and good name. This does not mean that Conser was a better superintendent than Hall; I think, however, that while he reflected the changing political attitudes toward American Indians and the new educational trends of his time that looked with suspicion on Native industries as dangerous, he seriously took to heart the education of his pupils and tried to do first what he thought was in their interests rather than the interests of the school.

Conser did not oppose Native basketry at Sherman because he was a purist and wanted to teach it the "right way." On the contrary, he did not see its usefulness in the Indian children's future lives and thus considered it as an activity unworthy of attention. His claim that he could not have taught only one type of basketry because his students belonged to different basket-making tribes was a convenient excuse used for justifying his unwillingness to hire or simply invite elders and for not making the effort of establishing more tribal-specific Native industries. He might have sincerely cared about teaching authentic, traditional Native crafts, but what emerges from the documents is an antipathy to anything that did not contribute to the students' civilization and their assimilation into white American society.

Art and Native Industries after 1915

At the end of the 1915–16 academic year, Conser reiterated that no Native industries were "being carried on here"; and by this time, records on

drawing are hard to locate.[108] With the exception of mechanical drawing, which continued after 1917, art education disappeared from the curriculum of Sherman during this administration. Conser was a conservative super-intendent who preferred not to depart from the educational policies for Indian children designed in Washington and avoided anything that would slow down their march toward civilization and self-sufficiency. Documents from his superintendency seem to indicate that his choice of eliminating art and Native industries was dictated by these reasons.

As Indian policy changed beginning in the 1920s, so did Conser's administration of Sherman: Navajo blanket weaving and basket weaving were reinstated as part of the girls' industrial training and once more proudly exhibited to the people of California and beyond.[109] Vocational courses in fine and applied arts for the boys and in handicrafts as part of home economics for the girls were established in the 1930s and became an important feature of Sherman's curriculum. According to a 1934 issue of the school publication *Sherman Purple and Gold*, "Art instruction is being given at present to the entire seventh grade including both boys and girls." Girls in home economics "work out Indian designs to be used on household linens and on articles of clothing when appropriate," learn to make rugs, construct furniture, and decorate their rooms (fig. 33). As part of a fine and applied arts education, "all tenth grade boys take a course in related art under the direction of this department;" courses offered included "water color and oil painting, commercial art, silversmithing, and photography." According to the publication, "This is one of the ways in which the home economics course preserves the Indian arts and customs. It also teaches the Indian girl to use her natural arts in the modern way of dressing and living."[110] As part of a larger trend in Indian policy and education that now aimed at valuing and preserving every form of Indigenous expressive culture, Sherman once more opened its doors to Native arts and crafts and expanded its fine arts offerings.

Curricular choices on the subject of art and Native industries at Sher-man heavily depended on the disposition of the superintendent in charge who, in his own right, decided to what degree *his* school complied with national mandates on Indian education. While Harwood Hall welcomed and organically incorporated into the curriculum the art education proposed

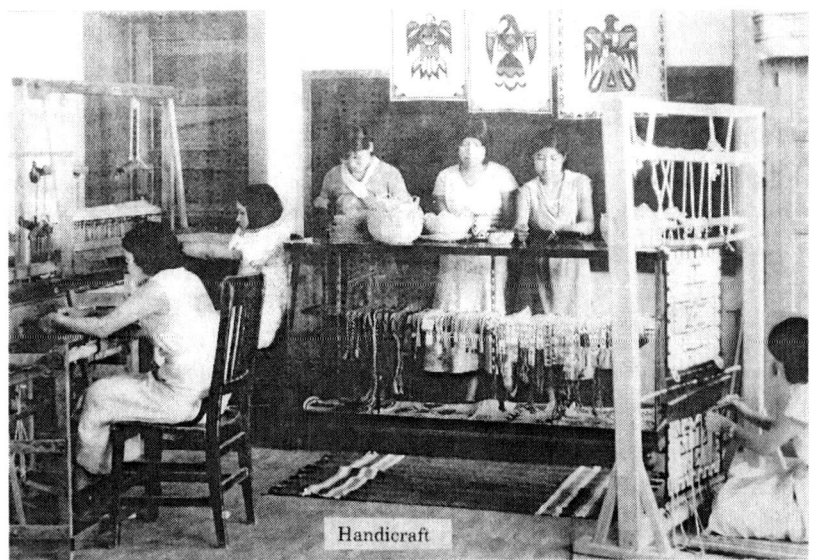

Fig. 33. Handicrafts in the Home Economic Vocational Course. From the *Sherman Purple & Gold*, 1934.

by Washington bureaucrats, Frank Conser did not. Hall's and Conser's very different terms demonstrates that, despite clear directives issued from the Indian Office, each acted in what he thought was in the best interests of the students under his care and could have best helped them in their future lives as American citizens. Sherman's example is also particularly interesting in that despite the lack of nearby Indian art markets, such as the ones in New Mexico, the school was able to exploit the popularity of its geographic location and attract tourists to visit the campus and buy Indian-made goods. Whether through city- and statewide events such as football games and band concerts, or on-campus activities such as plays and Indian dances, Hall managed to market Indian education, including art, for the economic well-being of the school—aiming to ensure its finances and its continued success.

6

"Susie Chase-the-Enemy and Her Friends Do Good Work"

Exhibits from Indian Schools at Fairs and Expositions

> All of this work is done by very young children, and compares favorably with the best work of the kind by white pupils much older.
> —*Detroit Free Press*, "Interesting Exhibition of Indian Children's Work"

Regional, national, and international expositions attracted and awed visitors from the mid-1850s to World War I through displays of states' and nations' industrial advancement and their progress as modern and culturally enlightened entities. These world's fairs and regional shows strove to demonstrate the economic development and educational improvements of civilized Euro-American societies and their manifest march toward the future, while at the same time exhibiting the primitive peoples that still lingered within their borders or colonial possessions. Native Americans were among these "others" on display, either as specimens of a long-ago past from which advanced nations had already evolved, or as successful examples of the domesticating effects of civilization. Thus, while anthropological and ethnological villages paraded tribal men, women, and children in traditional attire employed at their day-to-day occupations and traditional

dances, government buildings showcased the impressive achievements of scores of Indian pupils presently attending boarding schools.[1]

The presentation of missionary and federal government work in the education of American Indians had been included in these "carnivals of the industrial age" since the Philadelphia Centennial Exposition of 1876.[2] By this time, education exhibitions played an important role in the overall pedagogical scheme of world's fairs, as the public now had the opportunity to see and evaluate for themselves the work of each institution of learning and the overall progress of states and foreign nations. Extensive displays of Indian students' academic and industrial work, placed in government buildings rather than in the education pavilions, were meant to contrast with the savagery of their tribal ancestors and convince the American public that Indian schools were succeeding in their efforts, education was bearing fruit, and taxpayer money was being spent wisely. All in all, school exhibits were designed to present the progress of Indian people and gain public support for the assimilationist agenda advanced by turn-of-the-century policymakers. World's fairs such as the World's Columbian Exposition in Chicago (1893), the Louisiana Purchase Exposition in St. Louis (1904), and the Panama-Pacific International Exposition in San Francisco (1915) were the major international events in the United States for which the Indian Office prepared exhibits of Indian schools work as part of the Department of the Interior displays, but they were not the only ones. Other international expositions of a smaller or more regional character also featured exhibits prepared by the Indian Service. As public perception of the Indian question changed, however, so did the image of Indian people projected at these world's fairs.

A Typical Indian School Display

Photographs and narrative reports of Indian Service employees—typically the superintendent of Indian schools, the commissioner of Indian Affairs, or an external curator personally appointed by one of the above—provide a wealth of information on the layout and content of these exhibits. Additionally, they allow us to identify recurring patterns in the way objects were positioned and distributed within the designated expository areas. The Office

"Susie Chase-the-Enemy and Her Friends"

of Indian Affairs was usually represented inside the Government Building as part of the Department of the Interior displays; one of its sections, varying in size and available wall space, was allotted to Indian education. Early exhibits (such as the ones at the Philadelphia Centennial Exposition and the World's Industrial and Cotton Centennial Exposition held in New Orleans, Louisiana, in 1884) focused exclusively on the products of classroom and shops from a few selected institutions.[3] As time went by and the government opened or took control of additional schools, more and more were asked to participate by sending samples that concretely and more thoroughly illustrated the progress made in each. The walls of the exhibit area were normally covered with framed poster boards filled with samples of academic work, which included penmanship, compositions, arithmetic exercises, the study of history and geography, English exercises, as well as letters written by the pupils to their families, maps executed from memory, and original drawings. The central space of the exhibit was occupied by large wooden and glass cabinets (normally two to four) that contained a variety of items made in the industrial shops by both boys and girls. These articles were at times organized by gender—so that certain cases exclusively contained products of sewing departments and others displayed only work in wood, tin, leather, and the like—while on other occasions they were mixed according to school of provenance or geographical region.

Starting with the 1893 World's Columbian Exposition in Chicago, school exhibits began to be not only larger but also more attractive. Indian handicrafts, particularly Navajo blankets, Hopi baskets, and Pueblo pottery, started to be used as decorations, thus transforming the sterile environments of the expository areas into more pleasing and comfortable rooms. They later came to be nicely organized into "cozy corners," typical middle-class, turn-of-the-century domestic arrangements that consisted of purposefully amassed, large amounts of handicrafts in designated areas, that is, "corners," to attract attention.[4] This new device aimed to entice the viewers to come in and spend more time in admiring not only the crafts but especially the academic and industrial work of the young pupils and thus their potential for education and civilization. In addition, Native crafts placed strategically alongside samples of the students' school achievements encouraged

viewers to consider the Indians' past and present and to ponder which of these could offer younger generations a better future.

Numerous photographs of Indian displays have survived in albums preserved in the records of the Department of the Treasury. They were part of larger collections commissioned by the U.S. Board of Government Exhibits to document each exposition, including general views of the ground, buildings, and all government exhibits. They are excellent visual evidence of what was presented and how. Sociologists have argued that photographs are rarely a copy of the reality they depict, yet the historical images of world's fairs that have survived seem to be, for the most part, of a documentary nature. They were material objects used for display and for print in government pamphlets and reports as well as in fair publications aimed at mass audiences. This does not mean, however, that they were completely objective; even these images reflected the choices of their makers and those who commissioned them in terms of temporal and spatial editing (for example, when the picture was taken, what it depicted and what it left out, its angle of shot, the lighting available). Despite this, and the fact that they were the work of different photographers, there are some recurrent patterns in the way the Indian schools' exhibits were captured on film.

First of all, the displays are normally depicted from a distance so that viewers can perceive the scale of the entire display and see all of its contents. Only in a few instances do we see a close-up of a section or an interior space. Secondly, photographers were generally shooting from an angle and not from a frontal position. This means that they were interested in capturing a larger view of the exhibit space and were thus working toward documenting as accurately as possible what was in front of them, something typical of Victorian photography. Lastly, there is no sign of human presence and activity. With very few exceptions, there are neither visitors strolling around the fairgrounds nor laborers at work. The floors are immaculate and the buildings are not only empty, but silent; there is neither trace nor echo of the hustle and bustle that large crowds would cause. This suggests that the photographs were taken before the events' official opening to the general public so as to capture the displays as faithfully and comprehensively as possible and without any obstructions. Their main purpose was thus to record, not to propagandize.

Philadelphia: Setting the Stage

The first major U.S. world's fair that, for the first time, put American Indians on display on the public stage was the Philadelphia Centennial Exposition of 1876. This grand event was organized as a patriotic celebration commemorating the nation's one-hundredth birthday, but also as a venue for the reconciliation between North and South in the aftermath of the Civil War, the improvement of public education, and the showcasing of America's natural resources and emerging industrial power to Europe and the world. The Indian Office initially planned to prepare a display of American Indians' past and present living conditions, but the magnitude of gathering sufficient objects was so great that they decided not to move forward on their own. Instead, they left responsibility in the hands of the Smithsonian Institution. Prepared by Assistant Secretary of the Smithsonian and naturalist Spencer F. Baird, the exhibit occupied the largest section of the Government Building and displayed "the reports and other publications of the office, maps of the Indian Reservations, photographs and paintings of the Indians, their mode of life, habits, etc., costumes of males and females, weapons of war, models of wigwams, tents, canoes, domestic utensils, and specimens of the arts and manufactures of the tribes."[5] In addition to this "magnificent collection of Indian curiosities," canoes, tepees, totem poles, models of cave and cliff ruins, and life-size papier-mâché reproductions of "famous or obscure Indian braves . . . streaked on the face with red paint, and wearing the head-dress of feathers" were dispersed throughout the exhibition area.[6] Government Indian schools had not been established at this time, yet mission schools had already started the work of civilization and Americanization that was to become characteristic of federal institutions in succeeding years. A small exhibit with "specimens of chirography, patchwork, and other efforts made by the Wyandot children" demonstrated such efforts.[7] It is unclear whether this material was located within the Indian Office exhibit space or was part of the Education Office displays, which also paraded the work of public schools and other "charitable and benevolent institutions." Samples of classroom work included writing, ciphering, and penmanship, which were to become staple indicators of academic progress.

The Indian Office exhibit made a strong impression on the general public as it conveyed the idea of a barbaric, backward civilization that stood in stark contrast with the overall advancement of the American nation. The endless and apparently chaotic displays, the predominance of primitive objects and tools, and a marked emphasis on the warlike nature of Indians did not help visitors in gaining a better understanding of these Indigenous cultures, but rather left them with little sympathy for their present state and future destiny. Furthermore, news of Gen. George Armstrong Custer's defeat at the Battle of the Little Bighorn during the months of the exposition only contributed to strengthening people's belief that Indians had no place in a fast-growing, industrialized society and that they needed to either assimilate or disappear. Future Indian exhibits at world's fairs and expositions would show precisely this: how the old Indian ways of life were vanishing, thus leaving room for superior and civilized ways.

New Orleans: Demonstrating the Potential of Indian Education

Eight years after the Philadelphia Centennial Exposition, the first smaller-scale fair that included an exhibit of Indian schools' work was the World's Industrial and Cotton Centennial Exposition held in New Orleans, Louisiana, in 1884. The purpose of this fair was to boost the Southern economy, facilitate the recovery of its agricultural and industrial businesses, and encourage the use of the New Orleans port for national and international commerce.[8] The Office of Indian Affairs was represented by a large exhibit of "specimens of art and mechanical work from the Indian training schools which have been established by the government," particularly Carlisle, and a separate display illustrating the progress of the Omaha Indians, prepared by anthropologist Alice Fletcher; both arrangements were organized by the fair corporation and located in the Education Department.[9] Two smaller exhibits by the industrial training schools at Forest Grove, Oregon, and Albuquerque, New Mexico, were set up in the Pacific Slope division of the Woman's Department, likely because they were organized by the Board of Home Missions of the Presbyterian Church, which ran these institutions at the time.

The Carlisle exhibit, designed by Pratt, was divided into three sections: the first two (A and B) contained specimens of the students' work in the

industrial departments, each item labeled with the name, age, and tribal affiliation of the pupil. Among the articles made by girls were dresses, uniforms, and other clothing items, pillow shams, and samples of darning and patching. Works by boys included shoes and boots, coach and wagon harnesses, tin articles such as coffee boilers, pans, and cups, and specimens produced by welding and forging. Interestingly enough, both sections included something "Indian": section A exhibited "specimens of pottery painting by Carlisle students, [and] original designs," while section B had "specimens of Indian art in leather, by the harness makers apprentices in their odd moments."[10] The leather articles were likely made by pupils according to the traditions of their own people and could have been moccasins, belts, bags, or pouches. Years before Reel's *Course of Study*, Carlisle students were thus making Indian-themed drawings and depictions of utilitarian objects. This suggests that students were allowed to incorporate motifs that belonged to their cultural heritage and were thus not completely severed from it.

It is also significant that boys were making specimens of Indian art—leather—in their odd moments. This shows that familiar activities pertaining to the students' cultural heritage were not only permitted but also welcomed as substitutes for idleness for both boys and girls. One of the main objectives of Indian schools was to regulate every moment of a child's life in order to instill a strong work ethic and teach young Indians the value of labor, money, and time. Educational and recreational activities such as reading, singing, drawing, fancywork, and sports were particularly stressed and promoted because they kept children busy and thus contributed to the eradication of the Indians' tendency to inertia. One of the reasons Indian arts and crafts had been welcomed in Indian schools was because they were activities to practice during one's leisure time, in unoccupied moments between daily school routines. Carlisle teachers, likely encouraged by Pratt, had realized the potential of Native traditional imagery in rousing the boys' interest toward work and had allowed them to make industrial items with these motifs if they had free time on their hands.

The third section of the Carlisle exhibit, a wall on the left side of the expository area, was dedicated exclusively to schoolroom work from all grades and included examples of penmanship, compositions, arithmetic

exercises, the study of history and geography, English exercises, and samples of letters written by the students to their families. In addition to these, the school presented specimens of maps, executed from memory, and original drawings. Among the latter were two men on horses against blank backgrounds sketched in the tradition of Plains ledger art, once again implying that students, contrary to Pratt's claims that every aspect of Indian culture had to be censored, were not entirely disconnected from their tribal backgrounds.[11] Photographs of students and buildings and a copy of the school's monthly publication completed the display on the far right end of the wall.

Taken together, the three sections exhibiting Carlisle's work demonstrated the potential of education and the many possibilities for advancement and civilization that were now open for young generations of Indians. In his annual report to the commissioner of Indian Affairs, Pratt wrote that "the whole, displayed in suitable cases loaned by the National Museum, constituted by far the most complete showing of Indian progress in labor and education that the exhibition contained."[12] National and international visitors were attracted in great numbers and expressed their approval of the government's successful course of action in educating the Indians. There were no reports from W. V. Coffin, superintendent of the Forest Grove School, or R. W. Bryan, superintendent of the Albuquerque School, on their participation at the New Orleans exposition.

Chicago: Displaying Indians of the Past versus the Possible Indians of the Future

The 1893 World's Columbian Exposition in Chicago, Illinois (May 1–October 30), was one of the grandest fairs of all time. Organized to commemorate the four hundredth anniversary of the "discovery" of America, the Chicago fair came at a critical moment in the country's history as social and economic disparities caused by fast industrial growth, waves of immigration, and class and racial tensions were shattering society. The American people needed to believe once more that their nation was unified and working toward the common good, and the exposition provided this reassurance. In order to convey this message, the government and corporate displays were larger and even more attractive than the ones presented in Philadelphia.

For the first time, the fair showcased living Indian demonstrators and did not merely use static specimens to represent their handiwork.

Exhibitions of Indian past and present were created by two different groups: the fair's Anthropology Department, under the direction of Frederick Putnam of the Peabody Museum of Ethnology at Harvard University, and the Smithsonian Institution, under Otis T. Mason and W. H. Holmes. An exhibit of the Bureau of Indian Affairs planned by Commissioner Thomas Morgan was supposed to be under Putnam's care and placed in the Anthropology Building; however, due to disagreements with Richard Pratt, who did not want to associate his Carlisle students with "savage" Indians, it was installed in an independent schoolhouse near the Native villages. Nevertheless, Pratt eventually prepared his own separate display in the Liberal Arts Building.

Putnam's display was in the Anthropology Building and was organized chronologically following the development of the Americas' primitive peoples from the pre-Columbian era up to the present time; Mayan stelae, reproductions of Yucatecan ruins, cliff dwellings, and other types of traditional lodgings from North America, namely a Kwakiutl village and an Iroquois longhouse, were installed in and outside the building. Additionally, members of a few selected North American tribes such as Eskimo, Navajo, Seneca, Kwakiutl, Pueblo, Sioux, Apache, and Nez Perce resided at the fairgrounds in villages located either on the Midway or in the outdoor ethnographic park by the Anthropology Building and gave daily demonstrations of their skills and handicrafts. The Smithsonian exhibit, on the other hand, was located in the Government Building and was very static, featuring archeological specimens, artifacts, photographs, and full-size dioramas of Indians in daily occupations. A large section of the exhibit was called "Woman's Work in Savagery," and it meant to show what women "of every savage area are capable of doing" in craft or trade, thus demonstrating that industrial arts originated, among all primitive people, with women and that they were responsible for great advances in civilization in harvesting, milling, cooking, tanning, pottery making, and weaving.[13] Display cases contained specimens of "embroidery, bodkins, beadwork, needles cases, work bag fasteners, baskets, pots, dishes, spoons, dolls, weaving implements, and Navajo blankets" made by African,

Polynesian, and American Indian women. A Navajo weaver from Arizona employed at the loom was the only demonstrator stationed in this area.[14]

While these displays represented past Native societies or the current state of primitive women, including Indians, the exhibit of the Indian Office centered upon present advancement. In a two-story replica of a boarding school—erected near the ethnographic exhibits by the south pond, south of the pier, and not too far from the Anthropology Building—students from selected institutions such as Albuquerque, Haskell, Genoa, Chilocco, Osage, and the Lincoln Institution in Philadelphia alternated in demonstrating their newly learned academic and industrial skills in the model classroom, kitchen, dining hall, dormitory, and industrial room. The school was plainly furnished but decorated with Indian handicrafts from the Southwest, particularly Navajo blankets, Hopi baskets, and Pueblo pottery, which were especially requested from Thomas Keam's trading post in Keams Canyon, Arizona, and "scenes illustrative of Indian life and surroundings."[15] The building accommodated thirty students and employees at a time, so schools took turns in participating at the fair, each residing between two to four weeks. Commissioner Morgan wanted this exhibit to "set forth as graphically as practical the progress made by Indians in the various lines of civilization" in order to illustrate "not only what Indians *can* but *will* do if opportunity and training are given," thus proving to the American public that education was the solution to the Indian problem and the necessary instrument for "evolving United States citizens out of American savages."[16]

Commissioner Daniel Browning, who succeeded Morgan after he resigned in March 1893, just a few months before the opening of the exposition, explained in his annual report to the secretary of the interior that students attending the fair were expected to live as they did at their own institutions and naturally "carry out and exemplify the routine and methods prevailing in their respecting schools." Due to budget cuts, pupils had to bring "their own tools, implements, bedding, specimens of schoolroom work and products of their shop" and give visitors "a fair representation on a small scale of an Indian boarding school."[17] The only difference was that they would be under the constant and curious gaze of strangers. Young Indian pupils could thus be closely observed while doing

their academic work in the demonstration classroom or while perfecting their skills in industrial trades such as bench work, cooking, and sewing. A Colorado paper recounted that "hourly, each day, the boys and girls can be seen in the schoolroom, in the workshops, at work" and during the leisure time "around the grand piano [to] exploit with voice or deft touch of fingers the harmonies they have learned in school hours." The same reporter also observed that "pupils range all the way from '5-year-old Nancy and 6-year-old Tom,' two cute little ones, to young men and women 20 years old" and had been in school for different amounts of time, from a few months to numerous years.[18]

Indian schools that were not physically represented in Chicago were still able to participate in this great event and showcase their work in Indian education through the poster board displays especially prepared for this occasion and used to adorn the schoolhouse walls. Each school was asked to submit a book containing "six specimens each of composition, maps, drawings, arithmetic papers, and kindergarten work, with some needlework, and articles made by boys" each with the name, age, and tribe of the student who made it. Classroom and industrial samples such as these would become staples in all future displays of Indian-school work. According to Browning, "the contributions of the various schools have been highly creditable" and the products of the students' handiwork are "plain facts not to be disputed, even if they fail to fit cherished theories as to what the race is or is not capable of."[19] The journalist from Colorado, mentioned above, seemed to be of a contrary opinion when he remarked that the creditable work on display seemed "the work of journeymen rather than that of apprentices."[20] Interestingly enough, in appraising the drawings on display in the building, this reporter also noted that "the Indian artist, so far as he has been developed in our schools, doesn't affect in his character sketches Indian features and distinctive racial marks." This could mean that the colonization of consciousness was already taking root in some of the young Indian students as they drew their subjects from the white, American perspective they had been taught and were expected to follow. This also signifies that their transformation, while unsatisfactory in the eyes of government officials, appeared quite remarkable to a general public unfamiliar with Indian education (and clearly quite unacquainted

with Indian pictorial traditions that did not include distinctive Indian features and racial marks).

A column published in the *New York Times* brings additional insights into the nature of the collection and what kinds of work students made. According to the reporter, maps and kindergarten work such as a "sheet of scarlet concentric circles cut from paper and pasted on a white background," made by Frank Wolfe, hung on the walls along with numerous drawings— "specimens of designs suitable for tiles, oilcloths, and wall papers, besides countless sketches of flowers and scenes from Western life." In addition to these, "a cluster of nodding daffodils drawn gracefully around a little rhyme," made by a Pawnee student from Chilocco, and a "modest panel of tulips," drawn by Susie Six Shooter, particularly stood out for their artistic quality.[21] Other items that made an impression on the reporter included a neatly cut-and-sewn cambric dress, red and blue yarn stockings, dark-blue boys' suits, a russet saddle, and a farm wagon painted in red and green.

Upon the request of Captain Pratt, Carlisle was not featured in the Indian Office exhibit, but rather in a separate alcove in the Liberal Arts Building among other educational institutions. Pratt did not agree with the use of real Indian people to illustrate their savage ways and customs as carried out by the anthropological exhibit (and Buffalo Bill's Wild West Show in the Southwest zone of the fair) and wanted to completely dissociate himself from this display of barbarism. He also intended to distance himself from Morgan's Indian exhibit because he disagreed with the commissioner's choice of giving western Indian schools prominence; he did not believe in the effectiveness of reservation schools in the process of Americanization of Indian children and thus preferred to emphasize the progressive work of his own institution separately. His exhibit featured, according to the *Chicago Daily Tribune*, "the products of the brightest of the students" and consisted of four cases, two displaying harnesses, shoes, and other industrial tools made by the boys, and two in which "all manner of feminine trifles are placed together with the photographs of the Indian girls whose work they are" (fig. 34). Among these were two dresses "that show the most careful handling and artistic taste" displayed on "the somewhat angular figures of two sweetly daughters of the famous Chief Cochise." Other items praised by the reporter included embroidery and paintings.[22]

"Susie Chase-the-Enemy and Her Friends"

Photographs of students and of their life at Carlisle as well as samples of printed materials embellished the walls on both sides of the expository space; a wooden cabinet and a desk, likely products of the carpentry department, furnished the area between the cabinets where students welcomed visitors and guided them through the exhibit. Hanging above in the very center of the display is a large school banner with the words "U.S. Indian Industrial School Carlisle, Pa." and the school motto "Into civilization and citizenship," used in the opening ceremonies.

To demonstrate the advancement of the Carlisle students, Pratt had also insisted on having 322 of his boys and girls, including thirty-one instruments, in the fair's opening-ceremonies parade on October 20 along the streets of Chicago. Three boys carrying the large school banner described above led the way, immediately followed by the school marching band and by ten platoons of students in two ranks. Each platoon represented "a characteristic of the school by which they [were] expected to attain civilization," such as reading, writing and arithmetic, printing, agriculture, baking, carpentry, blacksmithing, shoemaking, harness making, tinsmithing, and tailoring; students in the first rank of each platoon held the tools and implements of these trades, while those in the second rank carried the products of their work.[23] The same contingent of students had already taken part in the New York City parade of schoolchildren on October 10; Pratt had received so many compliments for the "athletic appearance," "dignified bearing," great example of "military training and discipline," and "splendid marching" of his students that he "felt justified" to include some of the press extracts from both parades in his annual report.[24]

The first institution to demonstrate its work at the Chicago Fair was the Albuquerque Indian School, which was scheduled to be on the grounds from May 1 to June 12. Due to a delay in the construction of the model school, however, students did not arrive until two weeks later, thus missing the opening ceremony in which they were supposed to participate. Haskell, Genoa, Chilocco, and Osage followed Albuquerque, occupying the building with about two hundred pupils over a five-month period. In analyzing public responses to this exhibit, historian Robert Trennert has concluded that, despite Commissioner Browning's positive appraisal of the fair experience ("The interest manifested in this exhibit has been even

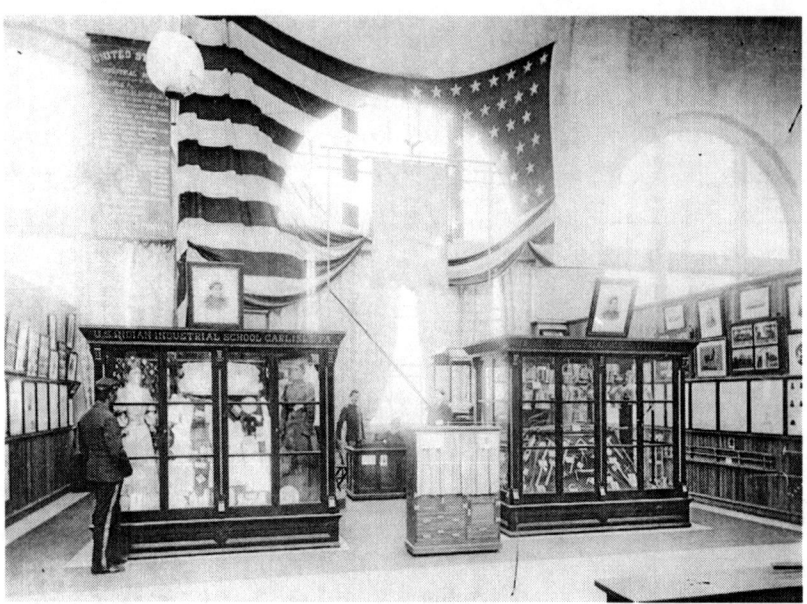

Fig. 34. Carlisle Indian Industrial School display at the 1893 World's Columbian Exposition. National Anthropological Archives, Smithsonian Institution, photo lot 81–12, John N. Choate Negatives, NAAINV 06908300.

greater than was anticipated"[25]), the educational display of the Indian Bureau was a failure and basically went unnoticed; most visitors reacted with indifference or minimal curiosity, while fair guidebooks either only briefly mentioned or completely disregarded it. Negative criticism also came from Daniel Dorchester, the superintendent of Indian schools, who reported to the commissioner that because of the distraction and discomfort caused by the visitors, students were able to demonstrate only an insignificant part of their actual training; as a result, the exhibit did not accomplished what was expected.

The corporation's display of "Indians of the past" and all correlated activities, including ceremonial songs, dances, and Wild West Shows, were, on the other hand, a great success: not only did they attract millions of visitors, but they also inadvertently fed people's romanticized curiosity about the old traditions of America's ancient inhabitants. In fact, what the general public witnessed in Chicago were once-fierce groups of "savages"

"Susie Chase-the-Enemy and Her Friends"

now tamed and domesticated for the entertainment and enjoyment of the masses. For these reasons, the civilized "new" lost its battle to the backward "old."[26] This interest in "blanket" or primitive Indians and their antiquated way of life at the time when Frederick Turner had declared the frontier closed and safe for settlers would be mirrored and even exalted at later fairs, particularly in Omaha and St. Louis. In the meantime, the Indian Office had to concern itself with better emphasizing the government educational triumphs over the younger generations.

Atlanta and Nashville: Focusing on the Present

The Chicago extravaganza was followed by two minor fairs, the Atlanta Cotton States and International Exposition of 1895 and the Tennessee Centennial Exposition of 1897, the first two to be held in the South in approximately a decade. Because of their regional character, they had neither the same impact nor the same import of the Columbian Exposition, but were nevertheless effective in conveying their messages. Due to a limited budget, the Indian Office exhibits at both events did not feature a showing of "Indian history, ethnology, sociology, linguistics, etc.," but simply portrayed the educational aspect of the government work.[27] The Atlanta Exposition (September 18–December 31), organized to compensate a poorly represented South at the 1893 World's Fair in Chicago, was designed to advance the region's economic growth by attracting the industrial capital and workforce from the Northern states to its bountiful lands and natural resources. In the midst of this, organizers also wanted to emphasize the region's progress and racial harmony, embodiments of the American dream. Indians were not considered part of the exposition plan because, as people of the past, they did not embody the present Southern reality. According to historian Theda Perdue, however, the U.S. government had great interests at stake here since it was dealing with the land issues of the Seminoles and Eastern Cherokees and wanted to show its achievements in preparing these Indian tribes for allotment and citizenship. For this reason, along with an exhibit commissioned from the Smithsonian and the Bureau of Ethnology, the Indian Office decided to have a display on Indian education.[28]

Commissioner of Indian Affairs Browning asked more than fifty schools from eighteen different states and territories to submit samples of classroom

and industrial work, although due to the limited space, the industrial display could not feature farming or training in domestic science. Almost all of the invited schools responded: sixteen non-reservation schools, twelve reservation boarding schools, a few day schools, and two mission schools.[29] The Perris Indian School was one of the institutions invited to participate. In a letter to Superintendent Edgar Allen, likely similar to the correspondence sent to other schools, Commissioner Browning specified that "the exhibit would consist of specimens of schoolroom work, such as spelling, arithmetic, geography and composition papers, with drawing, designing, and map drawing and kindergarten work, not over three papers on each subject." He also asked for a limited amount of representative and creditable examples of industrial work, particularly sewing, carpentry, harness making, and shoemaking.[30] Unfortunately, no records detail what Perris sent to this exposition.

Classroom work was framed and hung along the walls of the expository area and consisted of "papers representing all grades from kindergarten to algebra, together with well-drawn maps and freehand drawings, clay modeling, and relief maps." The sewing rooms and the tailor shops "sent all sorts of needlework, from patching and darning and neatly made (and sometimes elaborately trimmed) underclothing to finely finished uniforms for men and cloth suits for ladies, not omitting crocheting, knitting, drawn work, and embroidery."[31] Schools also furnished samples of work from the shoe, harness, blacksmith, and carpentry shops. The industrial items were arranged in six large display cases according to their department of origin. In addition to these, the exhibit was beautified with Pueblo pottery (three to four samples were placed on top of each cabinet), Navajo rugs, Chippewa rush mats, pictures of Indian schools, paintings by Carlisle students, and a birch-bark canoe hanging from the ceiling. According to the commissioner, visitors at the fair showed much interest in this exhibit.[32] Overall, despite limited finances and exhibit space, the Indian Office felt its philosophy of education was well represented; Southerners had the opportunity to see that young Indian children from all over the country could survive in this industrial age if they became assimilated through a rigorous training in manual skills and a productive use of their hands.

Two years later, the government presented a similar exhibit, albeit smaller

"Susie Chase-the-Enemy and Her Friends"

in size, to the Tennessee Centennial Exposition of 1897 (May 1–October 30) in Nashville, a fair organized to promote Tennessee as an ideal location for the investment of capital: this "unobtrusive" display represented only eight non-reservation schools, fifteen reservation schools, and several day schools. Classroom work was exemplified by writing samples, maps, drawings, and clay models; the sewing department supplied specimens of darning, mending, and fancywork, while items made by sloyd workers, carpenters, blacksmiths, and shoe and harness makers illustrated the boys' industrial trades.[33] Branches such as cooking, housekeeping, and care of stock, which constituted an essential part of the children's training, were not acknowledged due to a lack of space and funds; however, there was a reference to farming thanks to the samples of cotton, grain, and hay on display.

Despite fewer classroom and industrial artifacts and no new additional items, Emily Cook, in charge of the exhibit and its final report, boldly wrote that this display marked "a decided advance over that in Atlanta, not only in installation, but also in the quality of the work shown."[34] Her involvement in the organization of this section might explain her overstatements and her lack of objectivity in the assessment. Commissioner Browning's report, on the other hand, seemed more balanced and unbiased; he wrote that the works submitted adequately testified to the progress students were making as well as to the quality of the teachers employed in the Indian Service. In his opinion, anyone who visited this exhibit gained a "fair idea" of what the government was doing in the education of Indian children and how it was succeeding in this endeavor.[35]

Omaha: Showing the Potential of Educated Indians

The 1898 Trans-Mississippi and International Exposition of Omaha (June 1–October 31), organized to stimulate the economic progress of Midwestern states, was envisioned by an influential newspaper owner as a different kind of fair: a "grand ethnological exhibit" that would illustrate "the life, customs, and decline of the aboriginal inhabitants of the western hemisphere" through the participation of an Indian Congress of over five hundred delegates.[36] In a letter to all Indian agents, Commissioner William A. Jones explained, "It is the purpose of the promoters of the proposed encampment or congress to make an extensive exhibit illustrative of the mode

of life, native industries, and ethnic traits of as many of the aboriginal American tribes as possible" and added that while Indians were "rapidly passing away or modifying their original habits and industries by adopting those of civilization," many tribes still retained their "quaint habits and mode of life, which have remained practically unchanged since the days of Columbus." A glimpse into these unknown ways of life and customs before they completely disappeared would have been very educational and of great interest to the American public. Thus, Native men and women from twenty-three western tribes were brought to the fairgrounds where, housed in traditional dwellings, they "conduct[ed] their domestic affairs as they [did] at home."[37] If Indian people in Chicago were intended to show that the savage had been tamed, here they were displayed as "curiosities," the last vestiges of a past way of life about to be forever vanquished.

While Indian Congress delegates amused and entertained the public through costume parades, dances, and faux battles in what turned out to be a sort of Wild West Show that defied the organizers' imperialist ideas, an Indian school exhibit in the government building paraded the Indian Office assimilation efforts.[38] Planned by anthropologist Alice Fletcher and Omaha ethnologist Francis La Flesche, it focused on the Indian as a member of a vanishing race that had no future in American society if not through education and sought to demonstrate that Indian peoples were evolving from their primitive state, represented by the members of the Indian Congress, to the civilized life taught in government schools. The exhibit was similar to the previous ones in Atlanta and Nashville and illustrated "the progress made by education" both intellectually and industrially; due to the unavailability of a large space, it could not show the progress of educated Indians in adopting the habits of civilized life and occupations as initially hoped. The non-reservation schools represented were Genoa (Nebraska), Haskell (Kansas), Carlisle (Pennsylvania), and Carson (Nevada). The reservation schools were Winnebago (Nebraska), Sager Colony and Riverside (Oklahoma), Oneida (Wisconsin), Crow Creek (South Dakota), and Hoopa Valley (California). Day schools were represented by Pine Ridge and Rosebud (South Dakota) and from the Mission Indians (California).

Two "life-size figures, in complete Indian costume, of a Sioux warrior and a Sioux woman with her baby" welcomed the visitors to the exhibit.

Each mannequin was placed inside a glass case topped by a large basket and located at the front of the expository area as a sort of passageway from savagery into civilization, from the old life style into the new. Between them was a smaller cabinet containing "finest needle work, and infants wardrobe, lace, made in the lace schools for Indian women, loaned by Miss Sybil Carter, and drawn-work from California Indians."[39] Training in domestic science, farming, gardening, and care of stock was illustrated only through photographs. The industrial trades, on the other hand, were well represented with "blacksmith and wheelwright work, from a bolt to a farm wagon; wood-work, from sloyd to a finely finished cabinet; leather, from the sewing of two pieces together to a complete harness and well-made shoes; needlework, from patchwork and darning to fine embroidery, drawnwork and "real" lace" as well as tinsmithing, printing, and painting. Classroom work was represented by "papers, from kindergarten exercises and first attempts in English to geometry, physics, bookkeeping, typewriting, and stenography," which "differ little from those that would be furnished by white schools of similar grades," and samples of drawing and penmanship, which demonstrated "a rather unusually good average."[40] A table with photo albums, plans of school buildings, and copies of school publications completed the display.

One interesting feature of this exhibit was a set of three oil studies of Indian life made by a Winnebago woman graduate of Hampton Institute who showed exceptional promise in her artistic ability. This woman was Angel DeCora, and the oil paintings she added to the display were *The Medicine Lodge* and two untitled portrayals of heads. According to historian Linda Waggoner, they had been made the previous summer while DeCora was at the Fort Berthold Indian Agency in North Dakota visiting an old classmate from Hampton. The *Omaha Bee* reported that the two untitled paintings were "a portrait of a young man with a war bonnet on his head" and "a portrait of an Indian girl."[41] Finally, to distinguish the Indian school exhibit from the educational displays of white schools, the expository area was decorated with Native art and crafts such as "blankets, matting, plaques, baskets, pottery, beadwork, articles cut from red pipestone," which meant to represent "the aboriginal soil upon which education sows its seeds."[42] They were nicely organized in a "cozy corner" for the purpose of demonstrating the Indians' innate craftsmanship and

creativity and, consequently, their believed potential in responding to the government's call to education. Fletcher echoed this expectation: "How the esthetic abilities manifest in these native products could be cultivated by our methods was evidenced in many ways by the drawing, carving, and handiwork of the Indian pupils, which filled several large cases."[43]

According to the *Omaha Daily Bee*, the exhibit had been "a pleasing one to Commissioner Jones," while a representative of the Department of the Interior commented, "On the whole, this was the best presentation of Indian school yet made at an Exposition and by far the best installation of material gathered."[44] Despite this, as government officials realized, the exhibit was not particularly successful because the American people "held little interest in the educated Indian of the time. They wanted to see him in his wild state, in his blanket and aboriginal tepee."[45] Fletcher, too, lamented that the "the little unheralded space of fifteen by forty feet" did not receive as much attention as the picturesque assembly of the Indian Congress, yet she was pleased that many Indians, including former students of some of the largest institutions, were among the visitors. She was delighted to watch them as "they picked out among the photographs their particular school room, or some remembered friend or teacher," and commented that "their bright faces, their neat and thrifty appearance often formed a sharp contrast to that of other visitors who strayed by with only harsh words for Indians in general."[46]

Buffalo: Highlighting the Complete Transition from Civilization to Assimilation

The first fair of the twentieth century was the Pan-American Exposition held in Buffalo, New York, in 1901 (May 1–November 2), which intended to "illustrate the progress and civilization of the nations of the Western Hemisphere, to strengthen their friendships and to inaugurate a new era of social and commercial intercourse with the beginning of the new century."[47] Additionally, fair organizers wanted to use this venue to celebrate the successful conclusion of the Spanish-American War and the United States' role as an imperial power. To achieve this, architectural design, including a well-crafted use of color, ethnological exhibitions, and other attractions were all intended to solidify America's evolutionary ideas and its place at the highest level of

"Susie Chase-the-Enemy and Her Friends"

civilization. The Indian Office exhibit followed previous models in showing the educational advancement of young Native children and their responses to the "opportunities offered them."[48] At the same time, it also presented a new design that revealed what had only been hinted at in Omaha and that revolutionized the strategy of display: students' achievements after their graduation from government schools. The exhibit marked an improvement from previous expositions in both quantity and quality of materials sent by the many schools throughout the country, a total of twenty-five between reservation and non-reservation schools (see appendix B).

Designed by anthropologist Alice Fletcher, in consultation with Commissioner Jones, it encompassed Indians of the past, present, and future in three separate sections: the first displayed the accomplishments of adult Indians (Indians of the past), the second of students in government schools (Indians of the present), and the third of graduates (Indians of the future) (fig. 35). By focusing on the three different stages of Indian civilization, Fletcher wanted to garner support for the government efforts and show that with proper training, younger generations of Indians could truly advance from the backward state of their ancestors. The first section consisted of four cases (in the foreground) that illustrated the natural artistic abilities of Indian people and displayed the two life-size models previously used in Omaha along with "fine examples of weaving, pottery, and basketry" and "native foods and implements."[49] Among the woven items were a Moqui ceremonial kilt, a bridal girdle, and a red sash as well as an unfinished Navajo blanket on a miniature loom. Roots, seeds, corn, and wild rice were displayed in different kinds of baskets among which were featured a Moqui ceremonial plaque, with a Mother Corn design, and a Nez Perce winnowing basket.[50]

The second section displayed the methods used in Indian education and the work done by students from kindergarten through high school. Samples of classroom work hung on walls and included papers, typewriting, stenography, bookkeeping, freehand and mechanical drawings; some "very creditable work in water color and oils" was also added to this section. Industrial trades (large case between the life-size Indian male and the model building) were represented with manufactured articles from numerous departments such as "tailoring, shoe and harness making, wagon making,

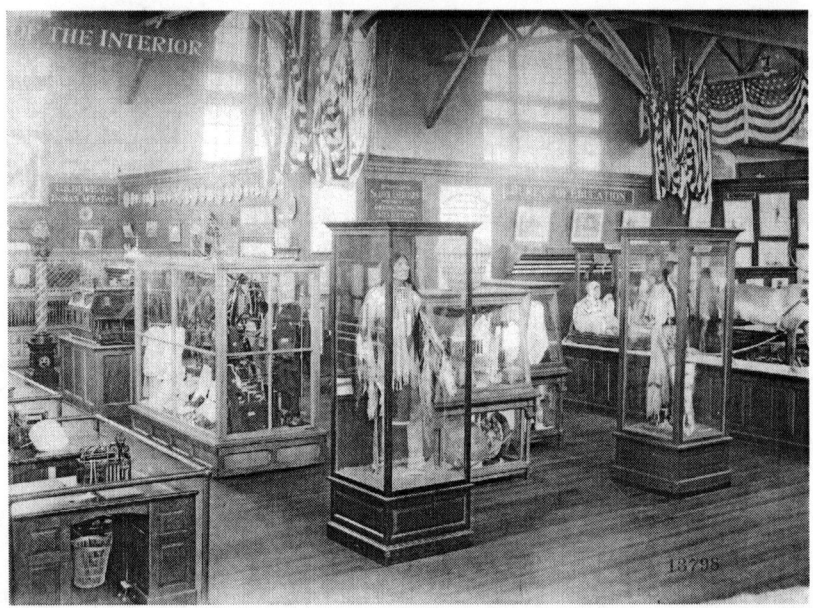

Fig. 35. U.S. Bureau of Indian Affairs Exhibit, Pan-American Exposition, Buffalo, New York, 1901. National Archives and Records Administration, College Park, Maryland, 56-E-13798.

tinning, carpentry and painting, plain sewing, mending, dressmaking, embroidery, and lace work."[51] The beautiful model of a house behind this case was made by Charles Blackeyes, a Seneca student at Chilocco, and was so meticulously executed that doors and windows opened to the paneled rooms inside. To its left was a carved pillar, the work of students from the Phoenix School, made with colored, inset wooden shards; its pedestal had "four faces on which are inlaid mythological designs and symbols of Indian allegories" of ancient origin, while its capital had "four heads of Moqui Indian maidens, clusters of oak leaves and acorns."[52]

The third section of the exhibit was located behind a grillwork screen made by Hampton students and was designed as a separate room detailing how Indians made use of their training; it visually symbolized the entrance, the passage, into a new, civilized life. Commissioner Jones explicitly requested furniture items made by advanced students and graduates living among whites and, interestingly enough, asked for a very specific

"Susie Chase-the-Enemy and Her Friends"

style: simple, minimally decorated, pieces and with a good-quality finish, all characteristics that reflected the current trends brought about by the Arts and Crafts Movement. Pupils from Haskell provided a bookcase, seat, and table, while an inlaid table and onyx work came from the Phoenix School. In addition to these pieces, Jones had also commissioned Angel DeCora the design of a settle and a mantelpiece with andirons and some of her own paintings for the beautification of the room. DeCora envisioned an oak settle decorated with Indian designs and requested that the work be done by Indian people whom she believed would have been sympathetic with her efforts to introduce some aspects of Indian art into industrial school work and would have ensured the faithfulness of the design. The settle was eventually made by a former student of the Chemawa School. The mantel, on the other hand, was made at Haskell and was placed in the center of the inner room, "a poem in wood," as one reporter described it; hanging above it was *Fire Light*, a painting of the prairie, Indian tents, and a pair of lovers at sunset that DeCora had recently made.[53] Unfortunately, it is not visible in figure 35, but we may gather a vivid and detailed explanation from Alice Fletcher's report to the Indian Office at the conclusion of the exposition:

> In this design Miss Decora combined the native symbolism of fire with our own tradition of the fireside. Upon the space below the shelf, in low relief of red wood, is a conventionalized "thunder bird," the plumes of its wings flashing out into flames. On the side uprights, and in a band around the upper part of the mantel, making a frame for the central painting, are conventionalized forms of the sticks used in making the "sacred fire" by friction. The scene of the picture painted by Miss Decora is on the rolling prairie, at sunset, suggesting the hour of gathering about the hearth; off to the left is a cluster of Indian tents, each one aglow from the bright fire within; while in front, a little to the right, against a background of golden clouds, stand a pair of lovers, the beginning of a new fireside. The poetic conception of this design has been carried out by Angel Decora with a charm, simplicity, and skill which make this mantel a work of art.[54]

A local newspaper published a sketch of the "dainty apartment," but it has to be taken with a grain of salt as it exaggerates the overall size and grandeur

of the exhibit, particularly the screen through which visitors could access the room. According to this image, in fact, what divides the two sections of the exhibit is a majestic entryway framed by carved pilaster strips surmounted by an arched alcove within which the grill is inserted. The famed mantelpiece beyond it is, on the other hand, a monumental sculpture likely taller than the average visitor. None of this appears in the photograph. Perhaps this was the reporter's way of conveying the exhibit message that education was truly the Indians' necessary passageway to civilized life.

The school display was very successful and overall well received, even though Fletcher believed visitors were particularly attracted to the sitting room because it confirmed that Indians were now able to earn a livelihood through the work of their hands. Furthermore, she was of the opinion that furniture and artwork revealed that *by means* of education, the Indian had acquired "the power to express his native ability and artistic feeling in a way understood and appreciated by us through the various articles of skillful handicraft here displayed, as well as through art and literature."[55] It was only through the refinement of education and civilization that, according to her, strange and inaccessible Native art forms could be transformed into beautiful objects worthy of America's appreciation, a belief she had already expressed during the Omaha exposition. For this reason, government schools needed to be praised not only for their role in teaching Indian children how to live and work in the manner expected by mainstream society, but they also had to be commended for their role in cultivating primitive, innate artistic abilities and turning mere skill into high craftsmanship. This is the message a reporter for the *Washington Post* took away from the exhibit as he wrote, "The evolution of the Indian under the influence of civilization is told in the systematic installation, until the final group, enclosed in beautiful grill work, shows the educated Indian to be artist, poet, scholar, and author."[56] The transition from savagism to civilization to assimilation into American society alluded to at the Omaha exposition was at last fully exemplified here.

St. Louis: Solidifying Formal Education as the Only Key to Indian Future

The largest and most successful display of the United States government educational work was without any doubt the Model Indian School on the

"Susie Chase-the-Enemy and Her Friends"

St. Louis fairgrounds during the Louisiana Purchase Exposition of 1904 (April 30–December 1).[57] Located in the anthropology section of the exposition, on the northwest side of the park, the model school was part of the corporation exhibit and was built at the top of a hill, signifying association with civilization. A three-story imposing structure able to accommodate a total of 150 students and employees, it consisted of classrooms, workshops (including printing, blacksmithing, carpentry, manual training, sewing, harness making), laundry, kitchen, and dining area for daily student demonstrations, a second dining room for the students and staff in the basement, and sleeping quarters on the second floor. The first floor was divided into two compartments by a wide hallway so that on one side were the various school departments and on the other were sixteen booths for "old Indians." Children carried on their normal academic and industrial work under visitors' scrutiny, thus displaying how they had advanced in the ways of civilization thanks to their exposure to formal education, while adult Indian men and women from different tribes demonstrated their skills and sold their traditional crafts.

According to anthropologists Nancy Parezo and Don Fowler, the interior of the model school was decorated with samples of student work such as "composition, penmanship, arithmetic exercises, drawing, sewing, lace, beadwork, china painting, and photographs" that were routinely changed.[58] The domestic arts classroom was particularly attractive as it displayed numerous illustrations of girls' lacework and embroidery, activities that were regularly made on the fairgrounds and that were associated with domesticity and civilization. Native arts and crafts such as weaving, basket making, pottery, and beadwork were not demonstrated by the students residing at the Model Indian School. With the exception of Zah Tso, a young Navajo weaver from the Santa Fe Indian School, no other pupil was involved in the public production of Native crafts. This is not happenstance, since the goal of the Model Indian School was to illustrate the progress and results of government-funded education; it was only to be expected, therefore, that the younger generations were displayed in refined Anglo-American activities, while older Indians pursued their traditional crafts. Juxtaposition of old versus new ways of life had become the standard exhibitory strategy at such national and international events and was the most effective way

to impress the American public with the government's good work. Thus, while students were never involved in any public artistic endeavor for the entire duration of the exposition, Acomas, Comanches, Navajos, Osages, Pimas, and members of other tribes regularly demonstrated their skills in pottery, beadwork, silverwork, blanket weaving, basket making, and even fry bread making, thus attracting great crowds to the building.[59]

The model school, however, was not the only edifice showcasing Indian education: a smaller, static collection, in fact, was planned by Reel (unbeknownst to Samuel McCowan, the organizer of the model school) and arranged in the Government Building on the other end of the fairgrounds as part of the Department of the Interior exhibits. The presence of this minor arrangement, organized by Emily S. Cook, a teacher, with the help of fair veteran Alice Fletcher, was to ensure that the Indian Office was not omitted from the government agencies. The exhibit (fig. 36) reproduced the layout used at Buffalo—past, present, and future, the last two separated by a gateway—while displaying less material in a larger area and featured "the intellectual training given in Government Indian schools, its practical application, and the ability of the Indian to assimilate the 'book knowledge' as well as hand skill of the white race."[60] The living conditions of the Indians in the territory prior to the purchase and at the present time were exemplified through a model of a Wichita grass house positioned in the middle of the exhibit, while a small wigwam and miniature tepee were placed inside a large glass case in front of it and labeled "One Hundred Years Ago." Chitimacha (Southern Louisiana) baskets of various shapes and sizes and a woman's dress (Cheyenne) decorated with elk teeth were placed in the large case in front of the grass house, while "old-time implements, and utensils and articles of dress and ceremonies were arranged" in a smaller one on the opposite side of the room.[61]

Behind the grass house were cases labeled "Work of Indians of Today," which illustrated the civilized pursuits undertaken by young pupils in government schools. The first cabinet contained a model hay baler, a model wagon and harness, as well as "a pair of shoes, uniform, brooms, samples of joinery, and a completely furnished bed" made by students from Haskell Institute.[62] The model hay baler was made by a former Haskell student, a Pottawottomi Indian now employed as blacksmith at the Shawnee School

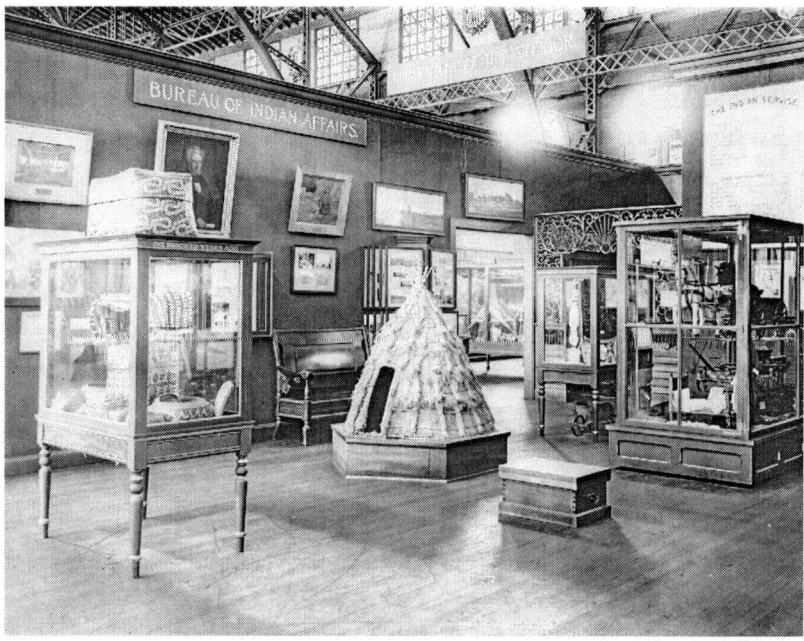

Fig. 36. U.S. Bureau of Indian Affairs Exhibit, Louisiana Purchase Exposition, St. Louis, Missouri, 1904. National Archives and Records Administration, College Park, Maryland, 48-LPE-19.

in Oklahoma. Additional items from other institutes across the country included samples of sewing, a cobbled shoe and ax handle, leather work, baskets, knife work, iron and wood work, a hayrack and bobsled.

A smaller case to the right displayed lace and embroidery work. A photograph of this fancywork, printed in the 1905 *History of the Louisiana Purchase Exposition*, offers the following caption: "Works of Indians of today. In striking contrast to the primitive adornments and appliances exhibited elsewhere, was this case of lace made by Indian pupils in the schools maintained for their race by the Government at Haskell and Carlisle."[63] With the exception of the "collar of 'real' Milanese pillow lace" (on the top), which was made by Sioux women in the Sybil Carter Lace School at Birch Coulee, Minnesota, all other articles were manufactured by students, although not from Haskell and Carlisle. According to other sources, in fact, the lace, embroidery, and drawnwork here displayed were

made by girls from Chilocco, Cantonment, Rainy Mountain, and Seneca (Oklahoma); Fort Lewis (Colorado); Fort Berthold (North Dakota); Leech Lake (Minnesota); Pine Ridge (South Dakota); and Shoshone (Wyoming).[64] Each item is accompanied by the name, age, and school of provenance of the maker, but this information, unfortunately, is impossible to gather from the photograph.

The students' aptitude for assimilating "book knowledge" was exemplified by numerous samples of uncorrected classroom papers, from kindergarten through the eighth grade, from eighteen boarding schools and several day schools (see Appendix B). Along with photographs of individual schools and daily activities and drawings, they were mounted on large poster boards (approximately 28.5 inches long by 22.5 inches wide) and arranged on swinging display frames (behind the grass house and possibly in the inner room). A new arched grill, more elaborate and imposing than the one used in Buffalo, separated this area from the inner sitting room. Visitors had to walk under this beautiful design—a creation of the students from Hampton Institute—in order to access the last room. Here, they could admire handmade pieces of furniture such as chairs, settees (from Haskell), bookcases, tabourets (plant stands that could also function as decorative stools, from Cantonment), and tables (Phoenix), most of which were carved from freehand drawings, as well as the mantelpiece previously used in Buffalo and designed by Angel DeCora. The "work of little fingers in sloyd" and a "display of fine drawnwork, embroidery, and lace" completed the contribution of Indian schools to this portion of the exhibit.[65] Pictures and paintings, including four of DeCora's oil paintings of Indian life, adorned the walls of the entire expository area, while "a large collection of rare and beautiful specimens of native Indian wares" filled empty spaces, likely in the inner section, since none of them, besides the Chitimacha baskets in the foreground, are visible in the photograph.[66]

Another photograph of the inner room set up for the Lewis and Clark Centennial and American Pacific Exposition and Oriental Fair held in Portland, Oregon, the following year (see fig. 38), provides some visual clues as to what the St. Louis room looked like. Not everything that is captured in this photograph was used in St. Louis—for instance the beautiful carved desk in the center was made by the Phoenix students for the Portland

exposition—and unfortunately, not everything that was at the Louisiana fair is documented here. One example is the DeCora fireplace, which was not exhibited at the Lewis and Clark Centennial and thus does not figure in this image; sadly, there are no visual records of this apparently stunning piece of work.

It is difficult to quantify the number of visitors that this static portion of the U.S. Government exhibit received daily, but we can presume that it was not as popular and well attended as the Model Indian School. All in all, however, Reel received her share of compliments. A. M. Dockery, governor of Missouri, in attendance at the Congress of Indian Educators held on the fairgrounds at the end of June, congratulated teachers and Indian Service employees for "the splendid showing" made in "several exhibit palaces" and for providing "ample evidence of progress." Similarly, Howard J. Rogers, chief of the Department of Education and director of Louisiana Purchase Exposition Congresses, congratulated Reel and all teachers for "the very intelligent and masterful way in which [they] have presented the work of [their] Department."[67] McCowan too was very satisfied with the unprecedented success of his Model Indian School and the number of visitors it attracted daily; in his view, this display exceeded all previous ones. Thus, according to their organizers, both the model school and the Indian Office exhibit succeeded in solidifying the belief that formal education was the only key to the Indians' future.

In St. Louis, the American people saw hundreds of Native boys and girls in dark uniforms and white pinafores, versed in English, drawing, lacemaking, carpentry and so on, and no longer displaying any Indian traits; assimilation into mainstream society had now become a visible and concrete reality. The exposition showed that the government's mission had been and would continue to be accomplished. Yet no matter how successful Indian people were in their endeavors—either in a civilized profession as exemplified by graduates or in book learning and manual trades as shown by the pupils—they would always be considered Indian and, therefore, not accepted in society on the same footing as Anglos. We could almost say that fairgoers had a love-hate relationship with Indian people; while on the one hand they loathed the "savage" customs of the past and praised the remarkable accomplishments of the younger generation, they were

fascinated by the more colorful displays of Indianness in the anthropological village. As a reporter candidly wrote, "Most of us, of course, have been to the Indian School; and most of us probably would confess to Mr. McGowan that we devoted our time and attention principally to the west side of the building."[68] No matter how successful the exposition had been and how clearly the message of "personal redemption" through education delivered, "real Indian" men and women were, in the popular imagination, not the ones in school uniforms or civilized clothes. Stereotypical views of Native peoples were going to persist for many years to come.

The Louisiana Purchase Exposition was the greatest and the last of the truly universal world's fairs, not only in size and scope but also in terms of anthropological perspective on display. Franz Boas, speaking at the International Congress of Arts and Science held in September on the fairgrounds, addressed the need for a new direction that would move beyond the evolutionary paradigm paraded in St. Louis. Boas argued instead for the intrinsic value of each individual culture. Later expositions, starting with the Lewis and Clark Centennial Exposition in Portland (1905), were less focused on the anthropological and didactical aspect and more concerned with asserting American imperialism and international economic power. The advancement and triumph of the assimilationist agenda continued to be the predominant catalyst of each exhibit through static displays of Indian schools achievements, but more emphasis was placed, for the first time, on the contributions of Native cultures and their inherent values. Also, for the next three "minor" fairs at Portland, Jamestown (1907), and Seattle (1909), the commissioner of Indian Affairs delegated the work of preparation and installation to local school superintendents, rather than renowned anthropologists, under the directives of Estelle Reel.

Portland: Continuing on the Road to Progress (with a Twist)

The Lewis and Clark Centennial and American Pacific Exposition and Oriental Fair of 1905 (June 1–October 14) was held in the city of Portland, Oregon, and celebrated the completion of Lewis and Clark's westward expedition, while justifying America's new commercial oceanic expansion into Asia and the possibilities of trade with its nations. The expansionist rhetoric of fair planners was once more reflected in the racial categorizations

on display as cultural, territorial, and industrial advancement was equated with white Anglo-American supremacy over less-fit ethnic populations. Educational programs at the fair meant precisely to show how government action and "compassionate rule" toward its wards—be they American Indians or Filipinos—could improve society and, consequently, all its members. Thus, as historian Lisa Blee writes, "Representations of Indians at the fair shed light on how white westerners justified the past and applied it toward their present-day imperialism."[69] Just as the savage Indians had been tamed through allotment and government-sponsored education, so too could be other colonial subjects.

While Native dancers, singers, and craft makers—representatives of vanishing societies and lifestyles—fueled the romantic imagination of fairgoers in the Indian Village on the Trail, the Bureau of Indian Affairs showcased the good work done by the wards of the government. The display, located in the Government Building alongside other exhibits prepared by the Department of the Interior, was organized by Edwin L. Chalcraft, superintendent of the Chemawa School, and included, for the most part, selected articles previously employed in St. Louis: specimens of literary and industrial training, mainly from schools west of the Rocky Mountains (see Appendix B), and a few arts and crafts made by students. In his report to the commissioner of Indian Affairs, Chalcraft stated that this was "the first exhibition of Indian work made on the Pacific coast where the general public had an opportunity of examining the character of the training given pupils in the Government Indian schools, and the results fully repay the labor and expenses incurred."[70]

The spatial organization of the expository area emulated the layout of the previous three fair exhibits (Omaha, Buffalo, and St. Louis), but was divided into only two sections separated by the metal arch made by the Hampton students for the Louisiana Purchase Exposition. The outer section comprised four cases, labeled "Work of Indians of Today," containing articles from the industrial departments of various schools, while in the inner area were pieces of furniture—set up to create a resting place for visitors—samples of classroom work, and photographs. The first case contained items previously exhibited at St. Louis, such as a miniature wagon and harness, a model hay baler and rack, samples of blacksmith and tin

work, shoes, and illustrations of carpentry work made by boys from the Phoenix, Seneca, Carlisle, Carson, Haskell, and Morris Schools. The second and third cases (fig. 37), visible on the right-hand side of the photograph, were for the tailoring and sewing departments and predominantly displayed samples of plain sewing, along with a few pieces of lacework, beadwork, and baskets made by students. It is unknown from which schools these articles came. The fourth case (not pictured) was dedicated to the Salem School and exhibited pieces from the sewing and blacksmith departments, with the addition of a few athletic trophies.

A fifth case, labeled "One Hundred Years Ago," presented the work of Indians of the past. It was filled with "many old-time articles, some of them dating back to the time of the Lewis and Clark expedition": a buckskin dress, cornhusk hand bag, saddle with bow and arrows, miniature Shoshone tepee, Makah fishing canoe, carrying basket, tobacco pouch, beaded moccasins, musical instruments, and samples of native plants.[71] Baskets of different sizes, shapes, designs, and materials were placed in the remaining space. Months before the opening of the exposition, the *Washington Post* announced that this was going to be "the finest collection of baskets ever displayed," and it certainly was.[72] None of the previous Bureau of Indian Affairs (BIA) exhibits boasted such an array of quality handiwork in the art of basketry. Current views on the Indians' past and present were clearly expressed by the number of cases used to display each state: the cabinet of the past contained the last remnants—the only ones worthy to be preserved—of a vanishing race and was surrounded—rather, outnumbered—by the occupations of the present, the only bridge to the future.

On the other side of the arch (fig. 38), Chalcraft created a "sitting room" for visitors who wanted to rest in the exhibit area while still admiring the fruits of Indian education. A table, bookcase, and settee came from the St. Louis exhibit, but a beautifully carved desk was made especially for this event by the boys of the Phoenix School. Swinging frames with classroom papers and a case of drawnwork from the Pacific Coast schools were also novelties of this exhibit; on the other hand, the small objects on the bookcase, the photographs, and the oil paintings by Angel DeCora were all reused from the Louisiana Purchase Exposition.[73] DeCora's fireplace was not exhibited on this occasion. Navajo rugs rendered this room more

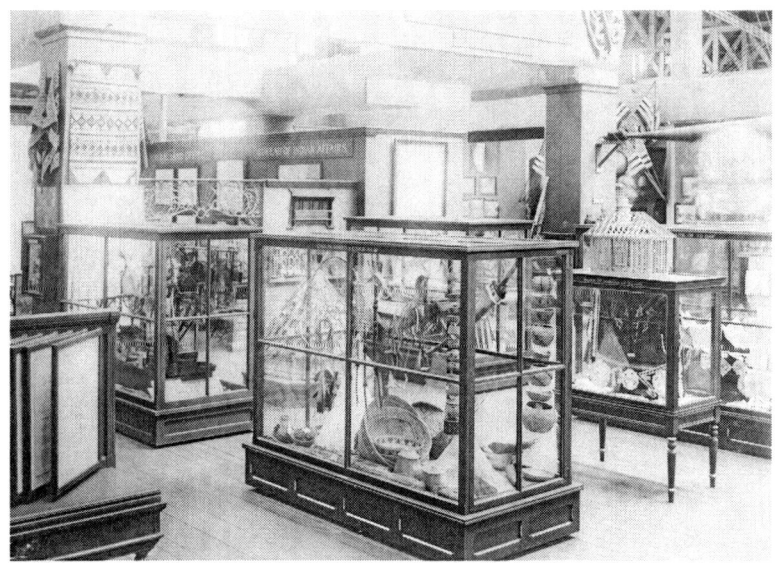

Fig. 37. View of the Bureau of Indian Affairs Exhibit, Lewis and Clark Centennial and American Pacific Exposition and Oriental Fair, Portland, Oregon, 1905. National Archives and Records Administration, College Park, Maryland, 56-PE-45.

comfortable and pleasant and the overall exhibit colorful. Chalcraft thus designed a quiet corner in which the achievements of "modern" and educated Indians could be observed and appreciated with the certainty that the traditional crafts of "old" Indians were not left to die out and could fit within the contemporary world. For the first time at an international exposition, Native cultures were truly valued for their great contributions to the American artistic panorama.

Jamestown: Reevaluating the Past for the Benefit of Future Generations

Not officially a world's fair, and not officially completed at the time of its grand opening, the Jamestown Tercentennial Exposition of 1907 (April 26–November 30) was smaller in scale and number of participating nations than most of its modern predecessors. As President Theodore Roosevelt declared, it was intended to be "an international naval, military, marine and military celebration" for the present and future generations that commemorated "the birth of the American nation" from the first English

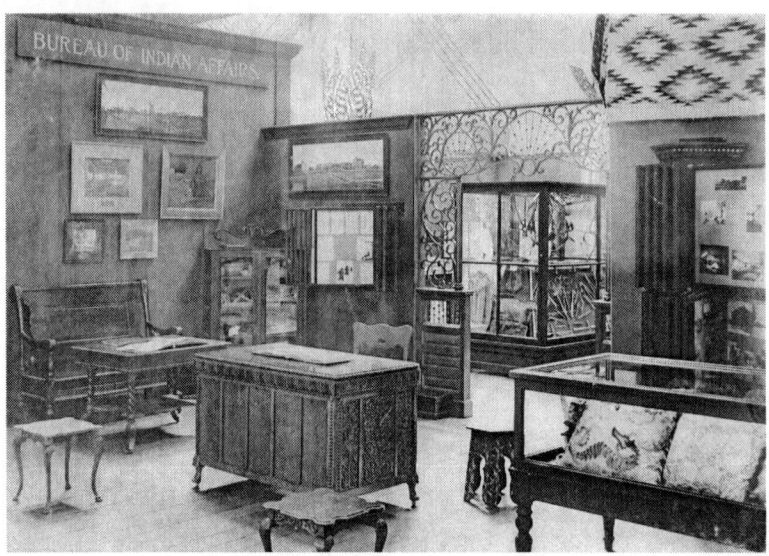

Fig. 38. Interior view of the Bureau of Indian Affairs Exhibit, Lewis and Clark Centennial and American Pacific Exposition and Oriental Fair, Portland, Oregon, 1905. National Archives and Records Administration, College Park, Maryland, 56-PE-48.

settlement in the New World, three hundred years prior, to "the great events of American history which have resulted therefrom."[74] These events were particularly represented by the recent victory in the Spanish-American War, which consolidated the nation as a great military and naval power. As in previous expositions, live demonstrations and static displays stimulated people's imagination and helped them reflect on their past and present history. A limited number of ethnic groups, including American Indians, Mexicans, Filipinos, and African Americans, referred to as "colored people," were invited to the grounds to provide reenactment shows and other kinds of entertainment. The majority of Indian participants came from Oklahoma and the Great Plains and could be seen in the daily performances of "cowboys and Indians" that provided local Americans with an imagined glimpse of life in the Wild West. The popularity of these events revealed, on the one hand, people's curiosity toward these oddities of an age past and, on the other, the persistence of certain stereotypical assumptions about Indians.

"Susie Chase-the-Enemy and Her Friends"

Static displays of American Indians had been prepared by the Smithsonian Institution and the Bureau of Indian Affairs and were both located in Government Building A, next to the massive pier. The Smithsonian exhibit included artifacts of the local Powhatan Indians and the Indigenous peoples of other Atlantic states along with a large diorama of Captain Smith trading European items in exchange for food, specifically corn. The model included twenty-two life-size figures of Indians and British explorers (eleven each) in historically accurate costumes and personal belongings. Six Powhatan men were placed inside a canoe, while the British crew was housed in a small boat, both vessels floating in a tank of water created for the occasion. Smith, standing in the very center of the boat, was portrayed "actively engaged in 'trafficking' with two stalwart savages" as they contracted on the bushels of corn in exchange for pieces of cloth. A small group of men gathered on the prow of the boat was represented exchanging beads and other ornaments with Native women standing ashore. To further ensure authenticity, organizers used corn grown for the occasion from seeds that the Tuscarora Indians brought to New York in 1711, as well as corn obtained from the Arizona Indians who had an uninterrupted history of harvesting the native plant.[75]

The BIA exhibit of Indian-school work was similar to the ones presented at previous expositions, although quite extensive and with few new items. According to Commissioner Leupp, it showed "by articles manufactured by Indian pupils in school shops and by classroom papers, the course of instruction given in Government schools and the ability of the Indians to assimilate it."[76] The layout of the exhibit followed the now-established blueprint of inner versus outer space, separated by a grill. At least six cases in three rows were used to display specimens of "plain sewing, dressmaking, millinery, lace and embroidery, uniform suits well tailored, shoes, harness, blacksmith tools and horseshoes, a miniature hay baler, and a model wagon, a cupboard, and other examples of woodworking," all the products of students' hands. Behind the cabinets and on the other side of a dividing wall was the sitting area (fig. 39). Here were pieces of furniture previously exhibited, such as "carved desk, chairs, table, settee, bookcase and andirons," while, for the first time, photographs lent by Edward S. Curtis depicting Indians and scenes of Indian life decorated the

walls.[77] According to Leupp, this collection was "the principal setting for this exhibit" and had been selected from a large series Curtis was making in order to provide a pictorial history of all North American Indian tribes.

On the left-hand side of the photograph is a display case with samples of pottery from the Pueblo and the Catawba (South Carolina) Indians, mats, and baskets from other tribes (Cherokees of North Carolina and Six Nations of New York), while hanging from a water pipe in the middle of the room is a beaded baby carrier. On the right wall, behind the beautifully carved desk is a small rug; Leupp described it as "a rug of oriental weave" that was designed by pupils in Carlisle's art department under the direction of Angel DeCora (see fig. 20 for studies of similar blankets).[78] Similar examples of "applied Indian design" were also found in picture frames and pillow covers spread around the room. A frieze, not visible in the photograph, likely to the left of the rug, was also designed and constructed at the school. The rug in this image is one of the few visual records of a student-made Native craft exhibited in the context of fairs and expositions.

Furthermore, this sitting room presented quite a change from previous ones; at Buffalo, Omaha, St. Louis, and Portland, in fact, the inner section always showcased the work of educated and accomplished Indians, particularly former students who had succeeded in their lives after school. Here, for the first time, visitors experienced a celebration of Indian past through a wide selection of traditional Native crafts and, most importantly, through Curtis's romantic and poignant historical photographs. Baskets, beadwork, and rugs had always been used in BIA exhibits: in the outer section, for contrasting the handiwork of Indians of the past with what was done in Indian schools; and in the inner room, for the beautification of the display area. Here, however, they were arranged differently: firstly, they were not amassed in large anonymous glass cases, but carefully positioned in cabinets and on shelves (or pipes!) as if in a museum hall; secondly, they were presented as pieces of art worthy of admiration, particularly because they were products of a bygone era. The Curtis photographic collection completed this picture of sentimental reminiscence of what Indian life looked like in the recent past. This bygone era was now, surprisingly, reveled in and honored.

Internal social turmoil and class antagonism due to the constant flux of

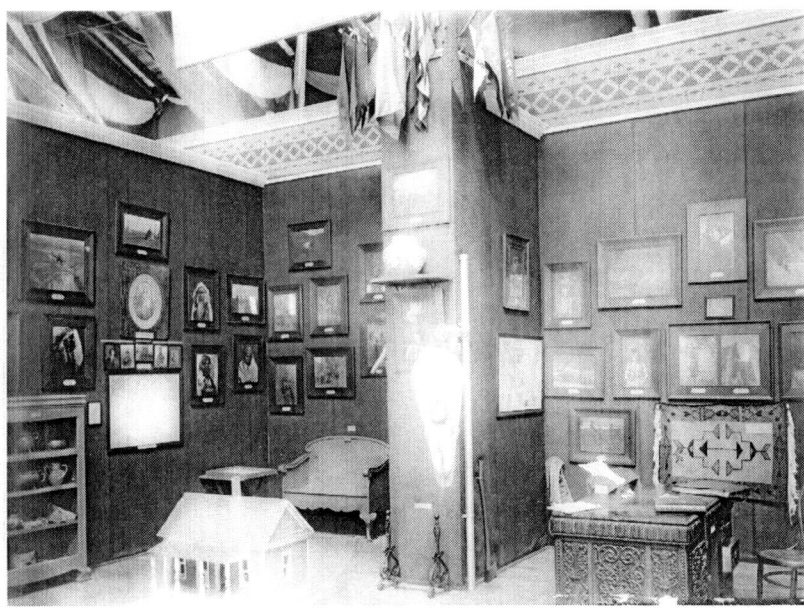

Fig. 39. Interior of the Bureau of Indian Affairs Exhibit, Jamestown Tercentennial Exposition, 1907, Norfolk, Virginia. National Archives and Records Administration, College Park, Maryland, 121-EX-9–29.

immigrants, and the new international expansion policy that sought to assert America's cultural hegemony abroad, had brought the nation to look back at its own beginnings and rediscover its own past. Commissioner Leupp, like many others around him, had come to the realization that certain aspects of Indian cultures had some intrinsic value and thus needed to be preserved for posterity. Curtis himself had expressed this view in the first volume of his magnum opus: "The passing of every old man or woman means the passing of some tradition, some knowledge of sacred rites possessed by no other; consequently the information that is to be gathered, for the benefits of future generations, respecting the mode of life of one of the great races of mankind, must be collected at once or the opportunity will be lost for all time."[79] The Indian exhibit at Jamestown, while continuing to prove to the general public that the Indians' future rested in assimilation into American society through education, also confirmed that some Indigenous cultural traits were safe and thus worth saving.

Seattle: Showing What Indians Can Do While Remaining Indians

By conveying an image of Indians as "handicapped by their race and limited by their 'backwardness,'" the Louisiana Purchase Exposition had set something in motion, and public interest in American Indian education had begun to change.[80] It was believed that Indian people, because of their lesser natural capabilities and inherited racial traits, were unable to assimilate into white society and become self-supporting, independent citizens. As a consequence, they were no longer expected to. A shift from educational policies centered on the eradication of Native traits—conducive to complete assimilation—to ones that gradually incorporated aspects of traditional cultures into the curriculum reflected this swing in public perception. Static exhibits parading the achievements of Indian schools no longer drew the attention they used to because, by now, fairgoers no longer desired to see the same pretty, old pictures and industrial implements created by Indian students. This is probably one of the reasons why BIA participation at the last "minor" fair of the early 1900s, the Alaska-Yukon-Pacific Exposition (AYPE) of 1909, was not particularly successful. If people expected to see something worthy of their support and more in line with the current government policy that encouraged children's Native roots, unfortunately, they did not find it in the Indian exhibit.

The AYPE, held in Seattle from June 1 to October 16, celebrated the natural resources and the commercial and industrial growth of the Pacific Northwest, while promoting the possible future relations of North America with Asia, Australia, and the United States' foreign possessions (Hawaii, Samoa, and the Philippine Islands).[81] The Indian exhibit was organized under the direction of H. H. Johnson, superintendent and special disbursing agent of the Puyallup Consolidated Agency, and unpretentiously encompassed a small illustration of schoolwork. A model school like the one at St. Louis was financially impossible, as Johnson had declared in a letter to Indian agents and superintendents six months prior to the opening of the exposition, so the accomplishments of government schools in the education of the Indian had to be shown only "by picture and articles."[82] For this reason, he simply requested items such as classroom papers and drawings, articles from the industrial shops, specimens of crops, and

photographs of schools, farms, and the homes of adults and graduates. Native arts, utensils, and implements were also solicited in order to give the display an Indian character and thus attract more visitors. Additional records, whether textual or visual, are unavailable, but the presence of these articles and the absence of others typically used on previous occasions—for example, student-made pieces of furniture—suggest that the exhibit was not organized according to the "inner versus outer section" dichotomy and simply comprised glass cases and poster boards. Due to the lack of official reports, it is difficult to assess fairgoers' attendance and response; the absence of newspaper coverage, however, may be an indication that it was not one of the most popular attractions of the Government Building.

If visitors could not find anything of interest in this display, they had many more opportunities to explore the lives and employments of America's Aboriginal peoples, young and old, simply by walking around the fairgrounds and perusing the exhibits set up in the Alaska Building, the Forestry Building, the Utah Building (designed as a model Hopi Indian pueblo), the Fine Arts Building, and by the Smithsonian Institution (also in the Government Building). Still, if these were not enough, people could always stop at the Eskimo Village, a "stupendous attraction" ranked "first of all the amusement attractions of the A-Y-P Exposition," and observe one of the many performances in "skill, marksmanship, canoeing, dancing, singing, and seal catching never before seen" by those "strange people" living in the icy north.[83] For a short time, about a week, something else caught the attention of visitors and reporters alike, although not quite as much as did the Eskimo Village: the classroom displays and the students' craft demonstrations in the hallway of the Auditorium—located next to the Government Building, on the northwest corner of the fairgrounds—that accompanied the Congress of Indian Educators from August 23 to August 27.

A more in-depth examination of this additional showcase will be provided in the next chapter on school exhibits at the annual meetings of the National Educational Association. Suffice it to say here that seeing Indian students dressed in American (i.e., civilized) clothing while perpetuating their own traditional crafts left a much deeper impression on the viewers than a thousand papers, harnesses, and sewed aprons. Students, in fact, proved that they could learn to live in mainstream society and at the same

time maintain those few facets of Native culture that that very society had deemed valuable. After almost two decades of government "experimentation" in the schooling of Indian children, taxpayers had already heard about the possibilities of such an education; now they wanted results that, in keeping pace with the current times and trends, did not, a priori, disregard centuries of Indigenous history and artistic patrimony. In their unassuming way, the presentations and direct illustrations of students' skills, particularly in traditional crafts, that took place in the auditorium achieved their goal: to offer viewers a chance to see for themselves that education no longer had to mean cultural annihilation. After Seattle, whether government schools focused on assimilation or gradual acculturation of Indian people came to be irrelevant; by 1915, more important issues were at stake globally.

San Francisco: Presenting a Successful Story of De-Indianization

At the time of the 1915 Panama-Pacific International Exposition in San Francisco (February 20–December 4) and the almost concurrent Panama-California Exposition in San Diego (1915–16), public perception of Indian people had changed drastically and their future was no longer a concern to the majority of the American public. By now, they were considered either fully settled into the habits of a civilized and productive modern American life, and no longer thought to be "Indian," or, particularly with respect to those still living on reservations, seen as unredeemable. This viewpoint toward the country's first inhabitants, and more universally toward so-called weaker races, was reflected in the overall plan of the exposition as it expressed a story of progress brought about by natural selection. In the specific case of the American Indian, it was also symbolically and powerfully visualized in the sculpture *The End of Trail*, by James Earl Fraser; located at the entrance to the Court of Palms, through which thousands of visitors passed daily, it fixed in the public imagination the notion that the Indian race had forever vanished.[84]

Exhibits for this exposition were "carefully and intelligently *selected*"— rather than being promiscuous collections of "everything from everywhere," as in the past—in order to show "the multiform representations of man's physical and industrial achievement."[85] However, while Euro-American nations were respectfully acclaimed for their accomplishments, other

cultures—that is, other races—were often presented as mere sources of entertainment and thus stereotyped, belittled, and even ridiculed. American Indians made their appearance in a replica Hopi pueblo constructed by the Atchison, Topeka and Santa Fe Railway and placed on the roof of the building that housed the company's reproduction of the Grand Canyon; about twenty families, among whom were Navajo weaver Elle of Ganado and her husband, Tom, engaged in day-to-day occupations such as corn grinding, food preparation, jewelry making, and blanket weaving. Outside of the Pueblo Indian Village, there were no displays of traditional life, no additional adults employed at making crafts, and no students demonstrating their acquisition of civilized skills.[86] Indian schools illustrated the "course of study in schoolroom and shops by means of classroom papers and articles manufactured by the pupils" on display in Government exhibits in the Palace of Liberal Arts.[87]

In early 1914, Commissioner Cato Sells, corresponding with agents and superintendents, instructed that the exhibit was to be "educational, not spectacular"; for this purpose he requested the submission of work that showed "the progress already attained by the Indians, both in assimilating an English education through schools and in adopting in their homes the arts and customs of our surrounding civilization."[88] Everything had to testify to the Indians' advancement and consequent abandonment of past ways. In particular, Sells requested items in three categories: articles that presented "in tangible form the actual products of Indian labor and handicrafts in schools, shops, and farms"; classroom papers showing "the response of the Indian to educational opportunities"; and photographs that showed "Indians at work, Indian homes and farms, school plants, and school activities, etc." Items had to be made by students during the current year. Despite an obvious emphasis on the effects of civilization, the comparative model of "old versus new" persisted. The commissioner, in fact, intended to continue the practice of contrasting all of the above materials with decorations such as "examples of native handiwork show-ing utensils, arts, crafts, and customs, supplemented by photographs of primitive conditions and occupations" that could be easily recognized as Indian.[89] These items were not to be made by schoolchildren, but by men and women living under the jurisdiction of agents and superintendents. So

while on the one hand Sells did not envision a celebratory or romanticized display of traditional lifestyles and customs, on the other, he still included objects that reminded viewers of the Indians' past to demonstrate how far they had come. His intention, however, was to present a striking contrast between the civilized Indians on the reservations and those few who were still living in "primitive conditions." It had to be clear to the American audience that, in 1914, the work of the Indian Office had succeeded.

In a subsequent letter to all school superintendents, Sells outlined his final plan for the San Francisco exhibit and stressed once more the importance of presenting work that showed "the results of home economy, agricultural, industrial, and academic instruction."[90] Submissions were to be divided into six categories: home economy, agriculture, industrial, academic, photo display of school buildings, and physical training. Home economy included plans of homes and articles made in domestic art departments, such as plain sewing (articles made for housekeeping and personal use), embroidery, lace, bead work, leather work, and weaving (blankets, mats, baskets, etc.); in addition to these were samples of domestic science work. The display of the agricultural section needed to include dairy and farm products as well as those items that each school regularly presented at local agricultural and state fairs. The examples of industrial training included articles and drawings from which items of the following trades were made: blacksmithing, engineering, plumbing, woodworking, painting, leatherwork, printing, pottery, silversmithing, and so on. Lastly, the following academic areas of study were represented: composition (illustrated); penmanship; geography (drawings, samples of maps, products, rainfall, relief and contour forms, and cross-sections of different parts of the country were requested); hygiene and physiology (accompanied by diagrams, drawings, molds of different organs from papier-mâché); nature study (mounted wild flowers with descriptions); and drawing, which was divided into the five following subcategories:

1. freehand drawing: figures, persons, animals, still life, landscapes, trees, flowers, vases, jars, glasses, architecture in charcoal, lead pencil, crayon, water color, and pen
2. mechanical drawing: lettering, projection, cabinet, isometric

3. mechanical sketching: building construction, exterior and interior plans for houses, perspective and working drawing of solids, furniture drawing
4. decorative designs: for rugs, blankets, pottery, magazine covers, oilcloth, linoleum, wall paper, lace, calico, woolens, etc., embroidery, table, linen, dress goods
5. cartoons (caricatures)

According to this document, the Indian Office expected schools to offer training in domestic arts, which included decorative beadwork and the weaving of items for everyday use as well as for the beautification of the home, and instruction in drawing, which was clearly divided between decorative and industrial art. Beadwork and weaving, however, did not have any Native character; they were simply considered other forms of fancywork. All the Native crafts exhibited in San Francisco were made by adult artists and illustrated "the innate ingenuity and deft workmanship of the Indians in their original state, as well as the value, artistic and intrinsic, of the skill which they bring with them to their latter-day life."[91] This indicates that while handcrafted works from Indian men and women were welcomed and accepted, they were not deemed appropriate for students in Indian schools.

Student-made items that were actually sent to the San Francisco exposition included "specimens of printing and magazine work," which revealed a "latent artistic temperament," furniture and model houses, canned goods, needlework, and other industrial articles from the sewing, domestic, agricultural, and engineering departments.[92] A total of thirty-five schools submitted samples of work, and while an inclusive list is unavailable, records show that Sherman Institute, being the largest institution in California, was one of the participants. It is difficult to determine the full extent of its display, but the few primary sources available reveal that many of the items submitted were made by the boys. For example, in a letter to Superintendent Conser, M. A. Collins, head of industries, provided a list of articles from the mason, engineer, blacksmith, tailor, printmaking, cabinet making, and shoe and harness shops. Among the pieces of furniture exhibited were "tabourettes, lamp stand, mission table, mission chairs rocking and straight, chair made from dry goods box, chair made

from sugar barrel."[93] In a handwritten note, dated July 27, 1915, Mrs. E. B. Hutchison, of the U.S. Indian Exhibit at the fair, described the mission table as a "very fine piece of furniture" and asked for its price because it had caught the special attention of a visitor who expressed interest in buying it.[94] Collins informed Conser that the cost for material and labor was fifteen dollars, but the "retail price in tour" was twenty-five dollars; in the end, Conser decided not to sell any of the school materials.[95] According to Commissioner Sells, the exhibit at the San Francisco exposition "awakened much interest" and showed "the amenability of the individuals of the race to the civilizing influences which have been thrown around them." Its success was also recognized by the supervising jury of the international exposition, which awarded the Bureau of Indian Affairs a medal of honor for its collective educational display and a gold medal for its "betterment of social and economic conditions of the Indians."[96]

If the Government Building exhibit at the San Francisco fair told a successful story of American Indian transformation, visitors at the San Diego Panama-California Exposition saw a realistic portrayal of Native life untouched by modernity, yet in danger of being forever lost. Held from January 1, 1915, to December 31, 1916, the Panama–California was the last great fair of the 1910s and, like her contemporary, celebrated the completion and opening of the Panama Canal. Because of its smaller size and scope, fair organizers focused exclusively on Southwestern states and illustrated in a friendlier atmosphere the opportunities for the good farm living these regions offered, manufactured products obtained through modern machinery, and the latest scientific advances in irrigation. At the time of this exposition, Estelle Reel had already left office and the new commissioner, Cato Sells, had just issued his *Tentative Course of Study for United States Indian Schools*, which initiated substantial changes from Reel's era. Neither the commissioner's nor Superintendent H. B. Peairs's annual reports discuss participation at the San Diego fair; furthermore, additional documentary evidence seems to indicate that the work of Indian schools was not exhibited here as all efforts were put into the organization of the San Francisco display.

Native people and cultures, however, were not missing from the fairgrounds, as displays prepared by Dr. Edgar L. Hewett of the School of

American Archaeology in the Indian Arts Building and the Indian Village ensured their inclusion. After all, the fair corporation wanted to "illustrate, as has never been done before, the progress and possibilities of the human race," so the Native tribes of America could not be excluded.[97] The Indian Arts Building, adjoining the Fine Arts Building, housed static anthropological exhibits from the Americas and the Philippine Islands that depicted the life and achievements of Indigenous peoples through dioramas and miniature models of dwellings, as well as a collection of five thousand pieces of Indian pottery, rugs, original drawings, and others relics from the Southwest. A series of paintings by Gerald Cassidy depicted the desert environment in which the relics had been found, while photographs by Roland W. Reed captured the stoicism of the Indian race. To attract more visitors to the building, Hewett invited nine San Ildefonso adults and five children from the Indian Village to provide regular crafts demonstrations; the frequency of these activities, unfortunately, is unknown. This exhibit strongly contrasted with the evolutionary displays in the nearby Science and Education Building, curated by Aleš Hrdlička of the U.S. National Museum: here "casts of skeletal remains and of skulls of aboriginal peoples, busts of primates and of Java, Neanderthal and Cro-Magnon man, and facial molds of Indians, Negroes and whites from birth to death" were used to explain the Darwinian theory of natural selection and survival of the fittest races, and consequently of the unavoidable disappearance of the more primitive peoples.[98]

For the Indian Village, too, Hewitt wanted to avoid a portrayal of a vanishing race, so he asked the Santa Fe Railway to recreate a pueblo settlement where members of Southwestern tribes could show their achievements. In so doing, he brought back a tradition of "live displays "already used at many previous world's fairs. This ethnological village, also known as the "Painted Desert," was designed by Herman Schweizer, owner of the Fred Harvey Company, and included replicas of Southwestern dwellings (adobes, winter and summer hogans, wickiups, and cliff houses built by tribal members from Arizona and New Mexico), each situated in a specific part of the six-acre area to show the differences in modes of habitation and overall lifestyle, and a Harvey trading post. About two hundred Indians from at least seven tribes lived in their respective lodgings, cooked, drove

their animal herds into corrals, performed ceremonial dances, demonstrated their artistic skills in weaving, pottery making, and jewelry, and exchanged their handiwork for American food and clothing at the trading post. Among the participants were Pueblo potters Julian and Maria Martinez and watercolor painter Crescencio Martinez.[99]

Indian people in San Diego attracted a lot of attention with their dances, their ways of living, and their craft-making techniques and were not only looked at, but also frequently photographed and sketched. Yet the audience perceived them neither as curiosities in a freak carnival show nor as people on the verge of extinction; rather, what Americans saw were cultural traits that deserved to be preserved and valued for what they could offer to the nation at large. For a country on the verge of global conflict, the once-feared savages no longer posed a threat to domestic progress and ideals, but now appeared to be treasures to cherish and defend, particularly in their artistic endeavors. Public attitude at the Panama-California Exposition thus perfectly exemplified what Renato Rosaldo has termed "imperialist nostalgia," that is, the mourning and innocent yearning of "the very forms of life they [agents of colonialism] intentionally altered or destroyed."[100] From Philadelphia to San Diego, world's fairs had a tremendous impact in shaping the image of the American Indian for the American public and certainly contributed to either generating support for or drawing criticism to governmental policies on their behalf, particularly in the area of education. By the end of the last great exposition of the prewar years, Indian savagery had long been conquered and the few remaining "real" Indian tribes had been fixed in a primitive, romanticized past from which they could not escape.

7

"The Comparison with the Work of White Scholars Is Not Always to the Credit of the Latter"

Art Training on Display at Educational Conventions

> One can spend a whole day examining this interesting exhibit.
> The names of the children are placed upon the work and their
> odd names add a curious interest.
> —Unknown Washington DC newspaper

When Estelle Reel took office in 1898 as superintendent of Indian schools, the exhibition of schoolwork took on a new direction as she inaugurated the trend of showcasing it at the meetings of the Indian School Service Institute (later called Department of Indian Education) held in conjunction with the annual NEA convention (for a list of institutes, see appendix A).[1] In addition to instructing other professionals and the public at large on the current state of Indian education, these displays intended to benefit Indian Service employees. To superintendents, teachers, matrons, and others, in fact, this was an occasion to flaunt one's school and its accomplishments and inevitably compare it to other institutions, thus inciting a healthy competition, the desire to do better, and to win Washington's accolades (and possibly additional funding). The Indian Office also encouraged individual institutions to display their work to the citizens of their respective states

by attending local, county, and state fairs as well as Indian fairs near or on reservations.[2] For Indian schools, these were occasions to present a more detailed display of the educational activities carried on in their unique facilities; for the local population, this offered the chance to compare the progress and the fruits of Indian education to that of private and public schools in the area and to buy student-made products.

The first Indian Institute was convened in Puyallup, Washington, in 1884, and saw the participation of only four boarding schools and two Pacific Coast day schools. Similar meetings held in the following years experienced an increased institutional attendance, but were neither convened from Washington nor inclusive of all Indian schools. The first gathering that brought together Indian Service educators and employees from all over the country was held in Los Angeles, from July 10 to 25, 1899, and organized by Estelle Reel. This was the second institute for the superintendent; the previous one had occurred in Colorado Springs from July 12 to August 5, 1898, less than a month after she assumed her position. Contrary to the Department of the Interior exhibits prepared for world's fairs and expositions, which also featured the work of adult Indians from reservations or former students, the displays installed for these gatherings focused exclusively on the products of Indian schools, concretely and thoroughly illustrating the progress made in each institution. Early exhibits usually included samples of classroom work in several academic subjects such as penmanship, writing, drawing, arithmetic, and occasionally geography and civics, and a limited selection of student-made articles from the industrial shops, typically the sewing and carpentry departments. After Reel published the *Course of Study* and emphasized the need to teach Native industries, crafts such as rugs and beadwork also began to be displayed.

Photographs of school displays at Indian Institutes from the Estelle Reel Papers provide a wealth of information that was unavailable or often inaccessible in the visual records of fairs and expositions; by admitting us into a closer view of the artifacts, many of these snapshots allow us to see with our own eyes what the art curriculum was like. They also permit us to recognize a discernable pattern in the way items were positioned and distributed in the designated expository areas. Normally, poster boards filled with classroom papers, drawings, photographs, and stitched articles

such as needlework or embroidery systematically covered the walls from floor to ceiling, with samples from the sewing department at the bottom. The school names of provenance were printed in big bold letters at the top of each board; the items on each board usually reported the name and age of the student who made it, either on an attached slip of paper or written directly on its surface. Small wooden tables or chests were often found in the corner of the room to accommodate Native crafts used as decorative elements; typically made by expert hands, not by students, these were arranged following the tradition of the "Indian corners." Similarly, rugs made by adult Indians were at times positioned on the floor or on pieces of furniture for decorative purposes. Student-made blankets, generally smaller in size, and beadwork were affixed to poster boards and displayed alongside other items made by a particular school. It is difficult to tell whether student-made pottery and baskets were also displayed, as they were not fixed to the boards on the walls. If they were placed in the Indian corner among the other crafts, they were not labeled with the name of the maker and the school he or she attended.

The display of students' work, particularly drawings, was a common practice at all public institutions as they participated first at world's fairs and then at national educational conventions. According to education sociologist Martin Lawn, the practice of comparing objects—that is, tangible representations of modern educational systems—was a means to communicate ideas about progress as well as methods and procedures; in these spectacles, "the gaze was drawn to difference and then to comparison."[3] Reel, a member of the NEA, was not a stranger to the educational trends of her time and did not want Indian schools to be left out of the conversation, particularly now that she had risen to the prestigious role of superintendent. She had to prove that, under her direction—the first woman in that position—government schools for Indians could improve, could achieve the desired results, and fairly compare to public institutions. Drawing was a measurement of this success. Displays of neatly drawn fruits, vegetables, household items, school activities, and chores demonstrated that students in Indian schools not only had improved those "uncultivated innate artistic abilities" so widely recognized by educators and the public at large and learned important lessons in the English of language,

housewifery, or agriculture, they had also assimilated those notions of domesticity, discipline, individuality, self-sufficiency, and hard work that were at the very core of Indian education. These simple and apparently banal illustrations spoke of these kinds of achievements. In a 1911 speech at the first meeting of the Society of American Indians, Angel DeCora lamented that the artwork of Indian school exhibits was the same as was prescribed for public schools, the usual spray of flower or budding twig done in "wash" after the manner of Japanese brushwork, and some stilted forms of geometric figures apparently made under the strict directions of a teacher. The only trace of Indian about the exhibition were some of the names denoting clannish nomenclature.[4]

Unfortunately, this was the case. With few exceptions, student drawings did not reflect their makers' backgrounds and heritage; on the contrary, they had to provide a powerful testimony to the outside world that the Indian child had left behind his or her savage cultural baggage and was slowly being transformed into what public educators, and American society at large, expected to see.

Between 1898, the year she took office, and 1910, the year she resigned, Reel supervised the organization of twelve exhibitions in various cities across the country. They included Los Angeles (1899), Charleston (1900), Detroit (1901), Buffalo (1901), Minneapolis (1902), Boston (1903), St. Louis (1904), Asbury Park, New Jersey (1905), Tacoma (1906), Los Angeles (1907), Cleveland (1908), Denver (1909), and Seattle (1909). Each of these shows presented a display of the work carried on at numerous institutions from east to west, particularly those located in the hosting state, in order to emphasize service to a diverse Indian population. Through a combination of visual and textual records, this chapter provides a content analysis of the most notable of these exhibits and pays particular attention to the artwork made by the students as part of their training in drawing and Native industries.

The Early Exhibits: Los Angeles, Charleston, and Detroit

As the first nationwide Indian Service Institute, the 1899 Los Angeles gathering centered on presentations, roundtable discussions, and practical demonstrations for the benefit of all teachers and employees, but it

was also timed so that participants could attend the meetings of the NEA from July 11 to 14. Pupils from the Perris School's marching band and the Mandolin and Guitar Club provided music at the beginning and closing of a few sessions and also entertained guests in the exhibit parlors with brief performances and recitals, winning "credit for the several selections rendered."[5] A small exhibit of schoolwork was installed at the convention's National Indian School Service headquarters in the Westminster Hotel and was "calculated to impress the visitors with due appreciation of the labor performed at the various institutions."[6] It is unknown which schools contributed to this display, but we can presume that western schools were largely featured. Figure 40 shows an unidentified man standing next to a large section of embroidered work depicting patriotic themes (American eagle and flags), flowers, and plants. Behind the small corner table with California baskets are samples of lace and needlework in various shapes and sizes. On the left side of the baskets are drawings of geometrical shapes and combinations of shapes and colors evocative of Arthur Dow's examples of notan, discussed in chapter 1. Above these articles are poster boards with students' drawings that, unfortunately, cannot be distinguished. According to Reel, "the articles excited much favorable comment as reflecting credit on both teachers and pupils," while Commissioner Jones believed that "contributions of work, educational and industrial, from the various schools formed a most interesting material exhibit of the methods of each school and the progress attained by the pupils."[7] Among the many articles from the industrial departments, plain sewing and fancywork were particularly noticed by visitors and press alike.[8] As the first showing of Indian progress of this kind, the display was, in its small size, a big success.

The following year, the Department of Indian Education gathered during the NEA meeting in Charleston, South Carolina, from July 5 to 13, 1900. The display prepared for this occasion was the first substantial testimony of the breadth of skills taught in Indian schools. Both Reel and Commissioner Jones described the display prepared by Indian schools in their annual reports, offering different insights. Reel wrote that the "admirable collection of literary and industrial work" consisted of "regular classroom work, drawings, paintings, fancy work of all kinds, plain sewing, mending, and work in wood and iron, illustrating the character of the instruction given

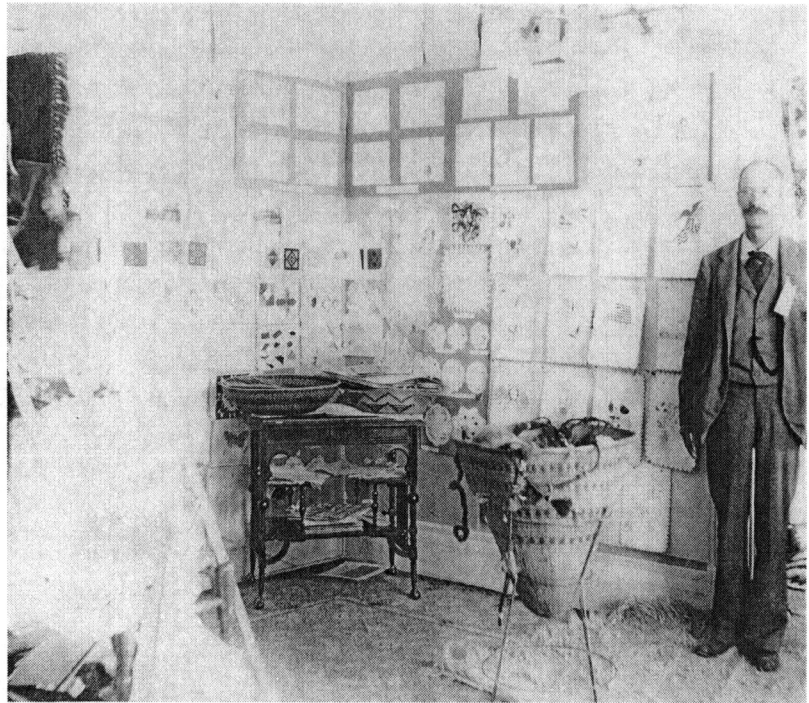

Fig. 40. Indian Institute exhibition, Los Angeles, 1899. Estelle Reel Collection, Northwest Museum of Arts and Culture / Eastern Washington State Historical Society, Spokane, Washington, MONAC no. 357.

at these institutions." She was particularly proud of the excellent quality of the classroom samples and praised the admirable craftsmanship of the iron work, which showed "the thorough and practical training these Indian youth are receiving."[9] The commissioner similarly commended the items made by boys and girls in their respective departments:

> Neatly made gingham dresses, woolen garments, bonnets, aprons, girls' and boys' uniforms, showed the deft fingers of the girls, while the great variety of articles in wood, iron, tin, and leather was a credit to the boys. The collections of hammers, anvils, horseshoes, model gates, wrenches, saws, bureaus, harness, and shoes illustrated the diversified industrial training at several schools.[10]

"The Comparison with the Work"

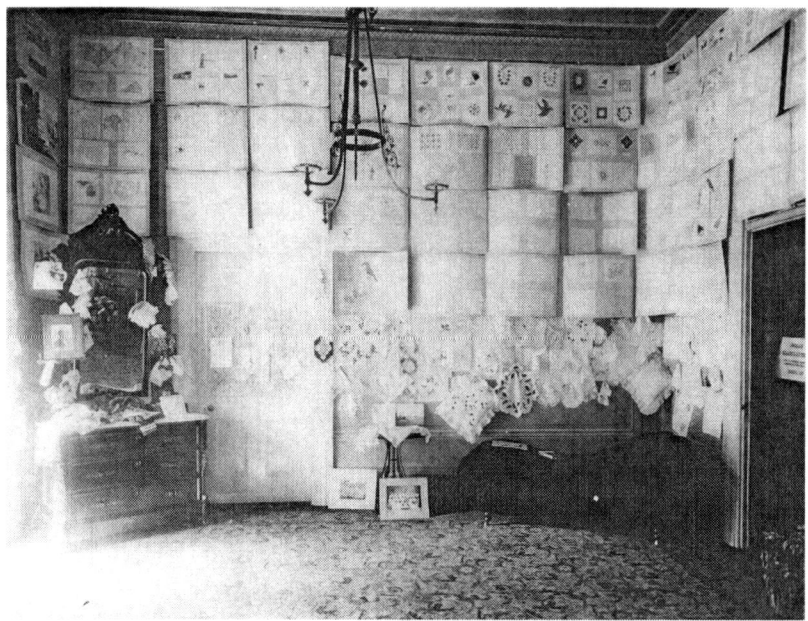

Fig. 41. Department of Indian Education, Charleston, South Carolina, view from the side. Estelle Reel Collection, Northwest Museum of Arts and Culture / Eastern Washington State Historical Society, Spokane, Washington, MONAC no. 34.

A photograph from the Reel collection (fig. 41) offers a comprehensive view of the classroom and fancywork displayed at Charleston. About forty poster boards neatly lined in rows and columns are hanging from the walls of this room; none of them bears the name of the school from which they came. The majority of the boards are filled with drawings and samples from the sewing department. Among the drawings, the following subject matters can be distinguished: animals (birds, dogs, horses, bear, camel, a horned animal [possibly a goat], quadrupeds [maybe a cow and a pig], lizard, turtle, fish, pig, and deer); a tent; kitchen items (pitcher, pans, pots, tea pots, cups); geometric forms and combinations; leaves; three or four pottery items; fruit (strawberry); a book; a man; and an Indian person in traditional attire. On the bottom right-hand side of the photograph are samples of fancywork such as lace, embroidery, decorated pillows, and drawnwork, while a gingham dress and a woolen garment are placed on

the dresser in the left corner. The dresser, the small table, and the settee are among the work in wood described by both the superintendent and the commissioner.

According to Reel and Jones, this exhibit was a great success and attracted a large number of people. Both expressed their satisfaction with the quality of the materials exhibited and the overall organization of the display. Commissioner Jones was particularly impressed by it and repeatedly voiced his amazement to the secretary of the interior when he wrote that everything was "excellently done," that it showed "the marvelous improvement that has been accomplished in the education of the Indian youth," and that it was "altogether a splendid exhibit of the talent and capacity of Indian pupils."[11] News reporters seemed to agree with this "official" assessment of the schools' display. A Detroit article, for example, stated that "the adaptability of the Indian child to take up and successfully master the details of industrial work" was well proven at Charleston and that although not all the lines of training could be shown, what had arrived for the exhibit "fully demonstrate[d] the capacity of the Indian child."[12] The numerous drawings received from different schools, showcased alongside other articles that typified education and civilization, were paraded as indicators of the progress made by Indian children through formal schooling.

A few days after the NEA meeting ended, the school exhibit was erected for display in an old post-office building in the U.S. capital. Two newspaper articles offer additional glimpses into their content. A first, lengthy piece provided a positive review of the work on display:

> The exhibit has been tastefully arranged by two of the teachers and comprises all branches of art, needle work, mechanical drafting, designing, implement making, as well as the practical work of the household. . . . A large portion of the exhibit is devoted to drawings and paintings, and here the natural aptitude of the Indian as an artist manifests itself in quaint designs, original sketches and copies of well-known paintings. There are in this collection several very beautiful designs for book covers. Some of the artists are of a tender age and the work as a whole is one that commends itself. In the mechanical department the excellence of some of the tools manufactures by the young braves is marked. The

love of the Indian for display shows itself even in this class of work, for all of the implements are ornamented and many bear the name of Superintendent Reel, whom the Indians, it is said, revere and love. . . . One can spend a whole day examining this interesting exhibit. The names of the children are placed upon the work and their odd names add a curious interest. For instance, Amara Bad Face has made a very good dress; Alice Eaglehawk has painted some ducks in realistic style, and John Comes-to-Drink has a landscape on exhibition without any water in it, fire or otherwise.[13]

Except for giving the names of a few schools that sent artifacts (Carlisle and Hampton), and some of the students who produced them, this article adds very little detail to our knowledge of the exhibit content. Nonetheless it is interesting for its romanticized and stereotypical view of Indian people as quaint. The author of this piece, in fact, more than once referred to their innate artistic abilities and their love for ornamentation and design, which were manifest in everything they did. The above words, however, also revealed that these talents were commendable especially because they had been steered in the right direction by teachers and had thus produced beautiful, that is, civilized, objects. Had Anglo-Americans not intervened, these natural gifts would have remained untutored. This is exactly the idea that government officials wanted to convey to the average viewer through these displays: Indians' unique aptitudes for art and beauty needed to be cultivated so that they could reach their full potential and, some day, be of use to American society.

The second article, published in the *Washington Post*, offers more specific details in regard to the objects displayed and provides the names of some schools represented. According to this reporter, "The drawings are especially fine. The Indian takes naturally to drawing, and in this line of work excels. The outline and colored maps prepared by these sons of the forest are perfect, and the other drawings and paintings, some being original conceptions and some from copy, are excellent." Readers were also informed that the following items were on exhibition: examples of point lace, embroidery, drawnwork, and general fancywork (which received great praises); suits of clothes and wearing apparel such as calico and gingham

dresses, bonnets, aprons, and girls' uniforms; examples of forge work such as hammers, saws, anvils, and knives; farm implements such as rakes and hoes; and useful articles such as harnesses and shoes. In addition to these, "beautiful rugs made by these children and spread here and there on the floor of the exhibit room [were] very attractive."[14]

Among the schools represented were Carlisle, with "exceptionally fine" classroom work, drawings, and wood work; Phoenix, with "water color, oil paintings, and drawings"; Eastern Cherokee School, with "exquisite fancy work" and excellent drawings from Miss Casey's pupils; Fort Lewis (Colorado), with "a number of large drawings, which are greatly admired"; Fort Shaw, with "a pair of delicately carved Indian clubs," among other things; and Perris (California) with "fancy work, school work, and beautiful rugs."[15] Drawings and articles with "Indian character" were certainly the items that most caught the visitors' attention. This article, like the previous one, describes the pleasant surprise viewers experienced in seeing the high quality of the work done by the little wards of the government, particularly the drawings and paintings. Once again, this quality was not necessarily attributed to the students' own abilities, but to the untiring and commendable work of educators through public money.

The 1901 exhibit prepared for the meeting of the Department of Indian Education was to be "the finest ever shown" according to Reel; it was set up at the Cadillac Hotel in Detroit (July 8–12) and later in Buffalo, New York, for the Congress of Indian Educators, which convened during the Pan-American Exposition (July 15–20).[16] This display was separate from the one organized by Alice Fletcher for the Buffalo fair discussed in the previous chapter; Reel helped the anthropologist by soliciting classroom and shop samples from various Indian schools, but this was the extent of her involvement. Her energies were fully employed in the preparation of "her" exhibit. It is unclear where this display was housed in Buffalo, but it is unlikely that it was included in Fletcher's installation, even if only for a week, because of space limitations at the fairgrounds. Furthermore, despite the presence of a few Southwestern plaques used as wall decorations (see fig. 35), Fletcher never mentioned Native crafts in her reports. As I will discuss shortly, these constituted a big part of Reel's display.

Pupils from three hundred government schools contributed to the

Detroit exhibit. Reporters especially noted "a collection of essays written by the young Indians on subjects relative to agriculture, stock raising and housekeeping" and "conventional Indian wares, including beadwork, baskets and fancy articles wrought of buckskins and bird feathers."[17] Other items included "shorthand and typewriting, drawings, paintings, fancy work of all kinds, plain sewing, patching and work in wood, iron and leather." According to the *Detroit Free Press*, drawings and paintings were "especially fine" due to the natural disposition of the Indian and his capacity to excel in this line of creative endeavor; colored maps and outlines appeared "well done" while "the other drawings and paintings, some being original conceptions and some from copy, are excellent." The reporter seemed particularly impressed by the fact that this work was done by very young children and concluded that it "compares favorably with the best work of the kind by white pupils much older." Examples of industrial work received similar praise as indicative of the practical instruction given in Indian schools. Among the articles on display were calico, gingham, and lace-trimmed dresses, woolen garments, suits and uniforms, boots and shoes "of the latest patterns, which would grace any foot," harnesses, bridles, inlaid tables, and many other tools used in the farm and the shop. The lacework, embroidery, and drawnwork made by the students of the Oneida School in Wisconsin and by some reservation Indians (Leech Lake) received particular attention and was greatly admired.[18]

The Native work consisted of beadwork, blankets, reed work (likely mats), and baskets, with rugs being used mainly for floor decoration. Unlike the classroom work, these items had been made by adult Indians and collected by Reel during her travels in the West.[19] This exhibit took place in July of 1901 and the *Course of Study* had only been released a few months prior; the lack of student-made arts and crafts is therefore logical and anticipated. Reel's goal in displaying such an extensive collection of baskets from the Southwest, California, and the Northwest was to attract public attention to the beauty and craftsmanship of these handmade objects in order to promote her newly established efforts at reviving and preserving these Native industries through instruction in Indian schools. While the Detroit exhibit was still relatively small in size, it was very successful and became the blueprint for future displays of Indian arts and crafts made by both students

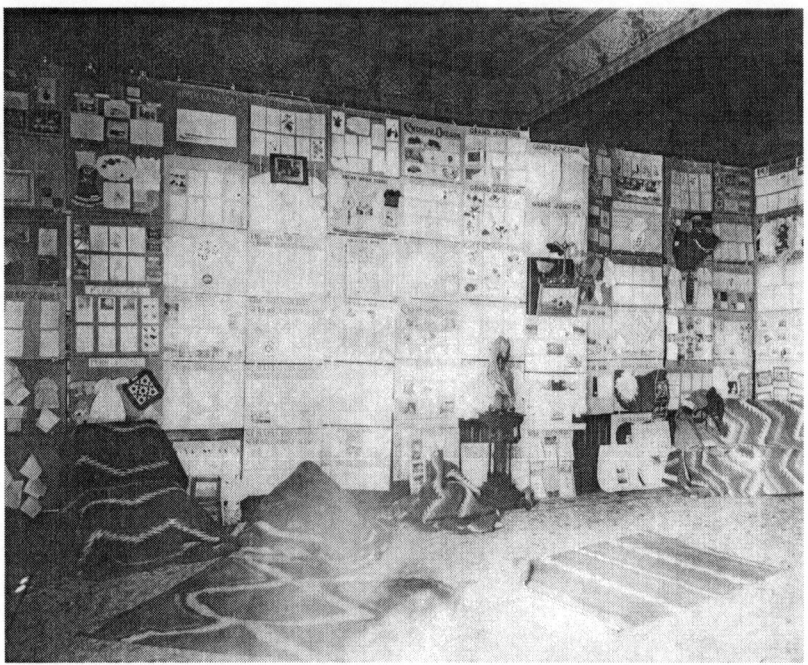

Fig. 42. Minneapolis Exhibit. Estelle Reel Collection, Northwest Museum of Arts and Culture / Eastern Washington State Historical Society, Spokane, Washington, not numbered.

and adults at the NEA annual meetings; from this moment on, all school exhibitions organized by Reel would include a well-presented Indian corner.

The Grand Displays: Minneapolis and Boston

The following year, the Minneapolis exhibit at the West Hotel consisted of an impressive and vast array of schoolwork and beautifully arranged Indian corners (fig. 42). In a circular letter to agents and superintendents, dated March 1902, Reel requested schools to prepare and submit two kinds of poster boards: the first ones with "color work, drawings, paintings, and classroom work, which correlate with the industrial work, as set forth in the Course of Study," as well as photographs showing children at work in the various departments; the second ones with samples of industrial work from the sewing department, particularly "practical and ornamental

needlework, drawn work, lace, embroidery, etc."[20] Interestingly enough, articles from the boys' shops were not called for on this occasion but were nonetheless present in the form of wood, iron, and leather articles, which apparently "were shown in abundance," as Reel later noted.[21]

Schoolwork was the undisputable protagonist of the Indian exhibit at this convention. The progress of Indian education could best be shown by contrasting its fruits to those of public institutions. Reporters and people in attendance at the NEA meeting saw a very large display comprising "industrial, literary, and native work prepared, under the direction of the Superintendent of Indian Schools, by the pupils of the different institutions."[22] Over fifty schools were represented with at least one hundred different poster boards of classroom specimens and fancy needlework, which hung on the walls of the Department of Indian Education hotel headquarters (see appendix B). Settees and chairs covered with Navajo blankets were placed in the corners of the room and were adorned with displays of Native baskets, likely from Reel's own collection, and hand-sewn garments made by schoolgirls. Additional Navajo rugs embellished the bare floor (figs. 43 and 44). Beaded items such as necklaces, wristbands, and pouches could be mainly found on the poster boards submitted by the Oneida Indian School. A close visual analysis of the photographs of the Minneapolis exhibit permits us to distinguish the subject matter of many of the drawings prepared by the schools here represented. Table 11 provides an approximate list.

Table 11. Subject Matter of Drawings Exhibited at the Department of Indian Education, Minneapolis, 1902

School	Subject Matter
Carlisle	bird; fish; branch with berries and fruit; dog
Chemawa	still lifes with pears and apples in charcoal or crayons; a pencil portrait in an oval frame of what looks like George Washington; two branches with leaves; a dog; still lives with apples in charcoal; flowers; one small branch with leaves and fruit; leaves
Crow Creek	grapes; a man; abstract designs; bird; bird house

Eastern Cherokee	fruit on a branch
Flathead	sketches of flora
Fort Lewis	apples; peaches; pumpkin; cherries
Fort Shaw	still life with pear and apples; a butterfly; map of South America
Grace, S. Dakota	bird; flowers; geometrical shapes in various combinations and colors
Grand Junction	three drawings of leaves; two drawings of flowers; a carrot; a radish
Greenville	one drawing of a fruit, possibly a strawberry; a plant
Haskell	six pointed star; Indian village with people and men on horses; tree; branches; leaves on a branch; three drawings of pottery; one drawing of a basket with lid
Kiah Day School	American flag
Lac du Flambeau	leaves; a prism in different colors with shamrocks above and below
Morris	still life with fruit; tree branch
Odanah Day School	geometrical shapes likely from paper cut-out work
Day School, Pine Ridge	pencil sketch of a house with bell on top and flag on roof, probably a school; rifle, ranger hat, saddle; pencil sketch of chickens; beetles and bugs copied from the specimens to the right of the drawing; pencil sketch of a tepee surrounded by beaded belt, small Indian figure with arrow, arrow point, and head of animal, either dog or horse
Pine Ridge	bird on a branch; four drawings of flowers and stems with leaves
Rosebud	a tiger; branches with leaves and berries; paper folding and braiding
Round Valley	leaves and nuts
Seneca	drawing of flowers
Unidentified school in South Dakota	a black vase with branches
Warm Springs	carrot, probably in crayon

"The Comparison with the Work"

What clearly emerges is a recurrence of subject matters; from east to west, from north to south, drawings depict the same things: flora (flowers, trees and plants, fruits and vegetables), fauna (birds, fish, mammals, insects), and more scarcely, humans and other things of relevance in the students' lives. This tells us two significant things: first, drawing exercises were carried on for the sake of developing elementary pictorial and artistic skills and proceeded from the representation of simple forms to more complex and elaborate ones; second, drawing pictures was a creative activity that reinforced more important kinds of learning, for example of nature and farm life. Creative work in the schoolroom was thus not imaginative and original, but strictly correlated with the industrial instruction pupils received outside the classroom. As Indian children were expected to become self-sufficient farmers and homemakers, it is only logical that every aspect of their education centered on this ultimate goal.

Local newspapers paid special attention to these artistic displays by young Indians from schools all over the country. A reporter from the *Minneapolis Journal* was impressed by the way in which sketches and watercolors showed "a universally correct appreciation of form and love of color" and commented that, despite their lack of "delicacy of shading and perspective arrangement which is expected of other artists [i.e., whites]," they were overall very pleasing samples of work. Particularly worthy of notice were a painting of oranges and one of an Indian camp from the Warm Springs School in Oregon; the excellent drawings of fruits, flowers, and vegetables from Chemawa (visible in fig. 42); and the drawings in pen and pencil from Carlisle. A Carlisle student's crayon drawing of an Italian greyhound (visible in fig. 43, as well as in the classroom photograph, fig. 2, where it is hanging on the wall in between the two busts on the bookcases) was identified by the journalist as "the most striking piece" in the entire exhibit: "The head fairly stands out from the wall and gives a momentary impression of meeting the real animal in an unexpected place. The work is that of a Chippewa Indian, C. Bender."[23] Another reporter praised the watercolors and the pencil and ink sketches made by the pupils and stated that any of his junior readers would be proud to claim these studies as their own; furthermore, he stated that some of these drawings were of such excellent quality that

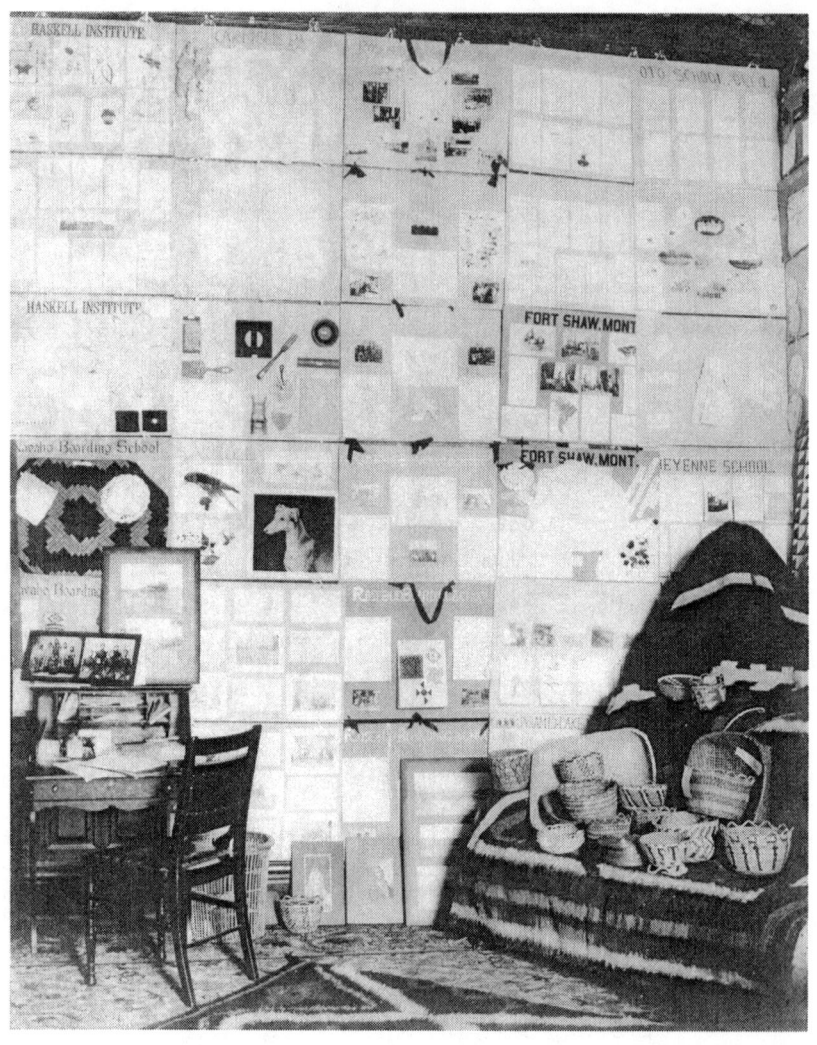

Fig. 43. Minneapolis Exhibit. Estelle Reel Collection, Northwest Museum of Arts and Culture / Eastern Washington State Historical Society, Spokane, Washington, MONAC no. 93.

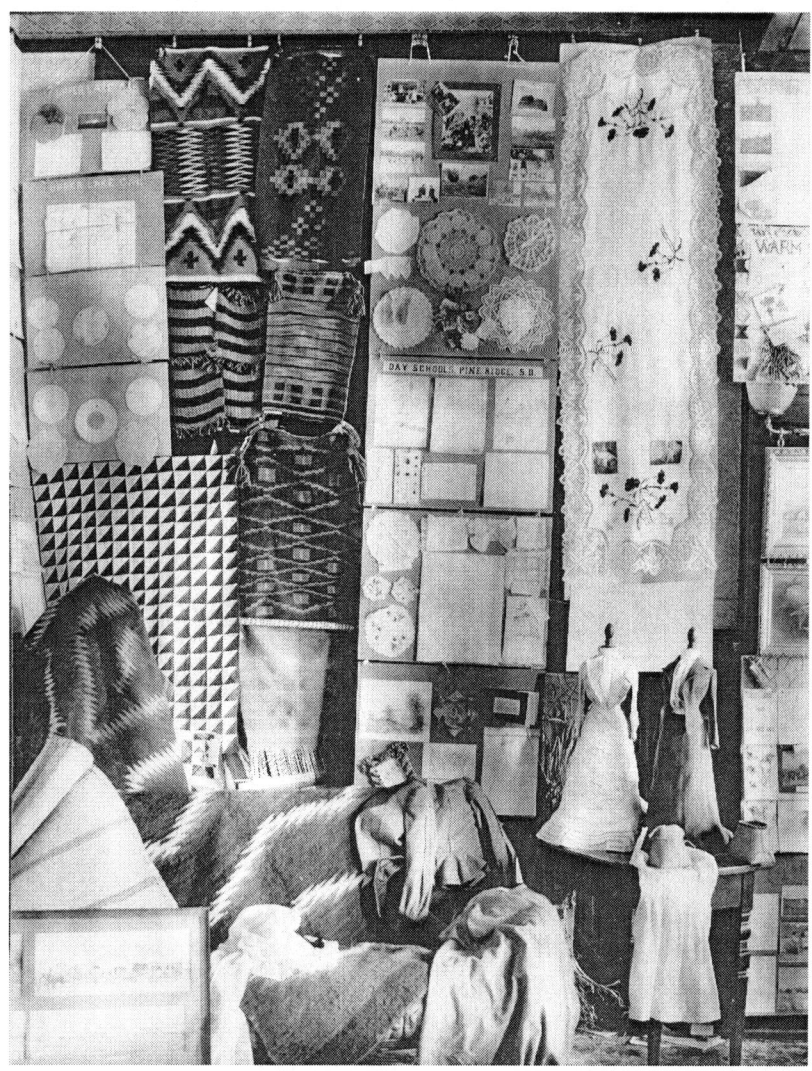

Fig. 44. Minneapolis Exhibit. Estelle Reel Collection, Northwest Museum of Arts and Culture / Eastern Washington State Historical Society, Spokane, Washington, MONAC no. 98.

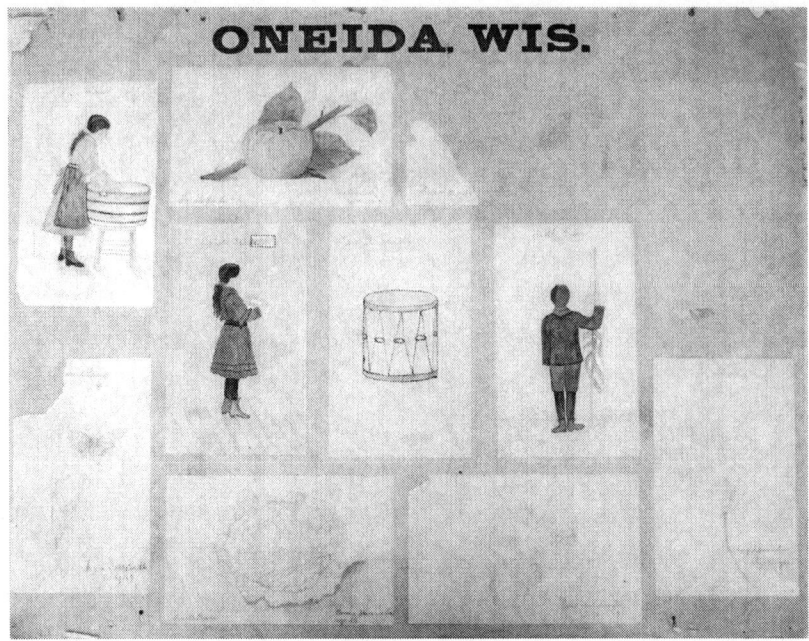

Fig. 45. Display board with nine examples of student drawings, Oneida Indian School, Minneapolis Exhibit, 1902. Estelle Reel Collection, Northwest Museum of Arts and Culture / Eastern Washington State Historical Society, Spokane, Washington, MONAC no. 15. Photo by the author.

"the comparison with the work of white scholars is not always to the credit of the latter."[24]

Two poster boards with drawings from the Oneida Indian School on display in Minneapolis have miraculously been preserved. They can be seen in figure 42, fifth column from the left; they are, respectively, the fourth from the top (fig. 45) and the very bottom one (fig. 46). The first poster board originally included eleven drawings, but only nine have survived. All eleven pieces are visible in the Minneapolis photograph; the two missing ones depicted a basket with fruit, probably apples (center right, below the school name), and a girl either seated or kneeling, next to what seem to be two large jars (to the far right). The other drawings from left to right are: a girl in profile washing clothes; an apple with leaves; a flower with

"The Comparison with the Work"

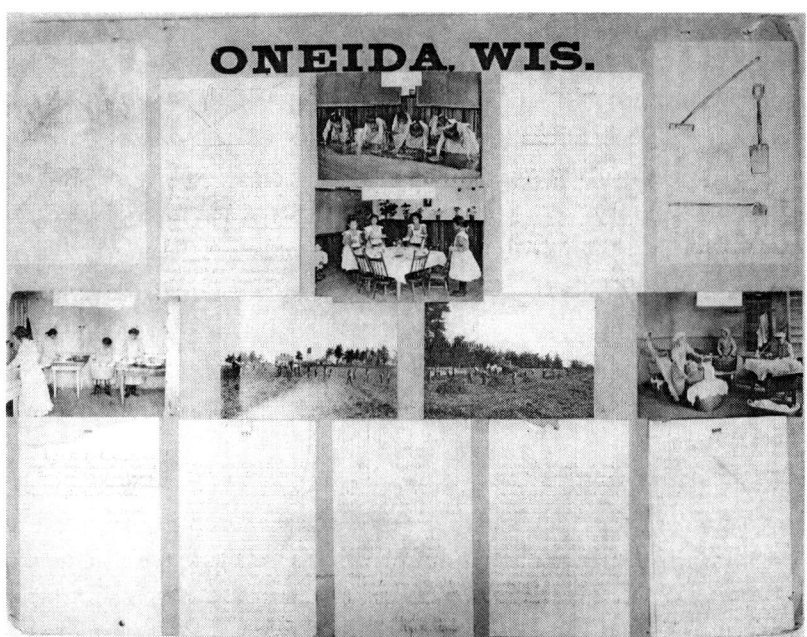

Fig. 46. Display board with student drawings and problems, Oneida Indian School, Minneapolis Exhibit, 1902. Estelle Reel Collection, Northwest Museum of Arts and Culture / Eastern Washington State Historical Society, Spokane, Washington, Miscellaneous Inventory no. 19. Photo by the author.

butterfly; a girl standing in profile holding yarn; a drum; a boy dressed in uniform and boots holding a flag; a cabbage; cherries on a branch; and a yellow flower. The bottom drawings are sketched with pencil and crayons, while the top ones are pencil, crayons, and watercolors. There is great attention to detail in all and, in some, an attempt to convey a sense of perspective and depth. The young artists range from kindergarten to fifth grade, with the oldest stated to be fifteen years of age. As discussed in chapter 2, the students are depicted against empty backgrounds so that the focus is their activity.

On the second poster board (fig. 46) are writing samples, photographs, and a few drawings that were likely made in connection with the study of nature, geography, and farming, as the accompanying texts reveal. The

top left drawing in pencil and crayon represents three different kinds of leaves (oak, maple, and elm) of changing colors, albeit not exactly realistic as pink is predominant, and a handwritten poem by Inez Denny, age ten, that says, "Put on your dresses of red and gold. Summer is gone and the days grow cold." One can imagine children of the lower primary grades learning about seasons and observing the changes these bring, while also receiving subtle admonitions about proper attire for the colder weather in order to avoid illnesses. Drawing was thus an activity to facilitate learning about trees, the natural passing of seasons, weather, and personal health. The other two drawing exercises displayed on this poster board were connected to the study of geography, particularly of the Oneida Reservation, and farming. The first one is a simple map of the reservation in which the student marked the railroad line, the river, and the six main towns; the second, made by a kindergartener, depicts three farming tools, a rake, a spade, and a hoe, accompanied by the lines "My rake. See the spade. This is a hoe." It is obvious that the young Oneida students were taught about the natural features of their surrounding landscape and how to work its land. In all, these display boards testify that the schoolwork exhibited at well-attended events such as the NEA annual meetings aimed to demonstrate not only the progress made in Indian institutions throughout the country, but also their up-to-date methods of instruction that stressed the correlation between academic and industrial training.

While photographic evidence shows that Native arts and crafts were exhibited at the West Hotel, apparently they did not attract much attention. Few documentary sources mention them. In her annual report to the commissioner of Indian Affairs, Reel herself simply listed "baskets and beadwork of native design and manufacture" among the many articles on display.[25] According to the *Minneapolis Journal*, "work adapted to the traditions and aptitudes of various tribes is shown in the clever basket work, rug weaving, manipulation of birch bark and intricate bead work"; the reporter also informed readers that the Oneida School displayed "fine bead work" in various ornamental form, while Fort Shaw was represented with Navajo blankets of varied patterns that were "a bright dash of color."[26] Without going into too much detail, another journalist wrote, "There were certain kinds of handiwork that none but Indians have the knack of

making."[27] Besides these, the only other crafts that received commendable praise from the press were drawnwork in the Mexican style (made by pupils of the Albuquerque School), lacework (from Pine Ridge, Round Valley, Santa Fe, St. Mary's, and Carlisle), and fine embroidery (Carlisle). This could be an indication that the crafts included in the display had not been made by the students and, for this reason, did not generate as much attention and interest as if they had been.

According to Reel, the Minneapolis meeting was the largest in the history of the Indian Institutes and the excellent exhibit, along with the music provided by the pupils of the Chamberlain School, added much interest to it. For those who visited it, the exhibit was "the finest collection of this kind ever shown, and to those unacquainted with the progress that has been made through the Government schools was an object lesson and a revelation."[28] Local newspapers concurred with this estimation and the overall positive impression the display had on the public. A reporter who inspected the exposition area during the second day of the convention, for example, wrote that "the room is thronged with curious and interested spectators who marvel at the high standard of excellence attained in all the work shown," while another commented that "one of the most interesting exhibits for the N.E.A. was that by scholars at the various Indian schools throughout the country."[29] The Minneapolis meeting and the success of the Indian exhibit were discussed also by national newspapers; the *Washington Post*, for example, said that "a more instructive object lesson of what the government is doing for the Indian could not have been presented to the public than this exhibit."[30]

Before the next NEA convention, which took place in Boston in July of 1903, exhibits of Indian-school work were prepared for two other occasions: the first was the annual meeting of the National Indian Association (NIA) in Washington DC in December of 1902; the second was a fine art exhibit in the headquarters of the Prang Educational Company in Boston in January of 1903, likely in anticipation of the larger NEA display to be installed for the summer. These particular displays are extremely significant because they seem to indicate that Reel strategically planned the content of Indian school exhibits according to the facets of Indian education that needed to be emphasized at a certain moment and the particular circumstances of the event in which they occurred.

The Washington exhibit was Reel's second display in the capital, coming two years after the one erected in the old post-office building in the summer of 1900 at the conclusion of the Charleston meeting. This display, however, was placed at the Church of the Covenant during the sessions of the NIA (December 10, 11, 12) but was nonetheless open to the general public. Among the articles prepared by pupils of several schools were classroom papers, drawings and paintings, lace and embroidery, sewing, work in wood, iron, and leather—all intended to demonstrate the practical training students were receiving in order to become self-supporting and independent citizens. Included in the exhibit were also specimens of beadwork, basketry, weaving, and pottery.[31] According to the *Washington Post*, every geographic area of the country was represented with well-executed items:

> Haskell Institute, Kansas, exhibits, besides its literary work, exquisite lace and embroidery made by the deft fingers of the Indian girls. Phoenix School, Arizona, sends fine lace work and well executed drawings; Santa Fe, N.M., shows a case of iron implements made by the pupils, besides classroom specimens. Two articles in the exhibit that are exciting much admiration are a beautiful onyx table made by the pupils of the Phoenix School and an inlaid table from the Santa Fe School. Albuquerque School, New Mexico, has furnished two Navajo blankets, for which these Indians are famous, and Mescalero School, in the same territory sends baskets. Colorado's two large schools, Fort Lewis and Grand Junction, have interesting collections, the ironwork of the former including several hundred pieces made by the boys who had been in the shop but a few months and the proficiency they exhibit is remarkable. A large iron gate made by these pupils is ornamented with brass taken from old lamps. The largest agricultural Indian school in the United States, the Chilocco School of Oklahoma, demonstrates the practical character of its training by an exhibit of industrial articles relating to the farm and household, the work of the girls in patching, plain sewing and fancy work being especially interesting. In accordance with the course of study recently issued the native arts are now taught in the various schools, Oneida School, Wisconsin; Leech Lake School, Minnesota, and Fort Hall School, Idaho, have sent in collections of

beadwork, consisting of pouches, belts, hatbands, napkin rings and moccasins, of neat workmanship and [sic.] Included in the exhibit from the Oneida School, Wisconsin, are a bead hatband for the President and a bead belt and chatelaine bag for Mrs. Roosevelt, made by two little girls attending this school.[32]

This display was undoubtedly different from the Minneapolis one five months prior, as the emphasis here was on the industrial and practical side of Indian education. Reel was not exhibiting alongside public institutions, so this was not an occasion to compare the work of Indian and non-Indian children. Rather, it meant to demonstrate to members of the NIA that manual training was bearing fruit. For this reason, the superintendent could not simply show pretty exercises in penmanship and drawing, but had to give precedence to those acquired real-world skills taught in schools. Consequently, the numerous articles made by boys illustrated successful assimilation of civilized trades and useful occupations; the variety of fancywork created by the deft fingers of girls demonstrated that their innate artistic talents were well employed in womanly activities; finally, the Native crafts made in some institutions spoke of the Indian Office's commitment to the preservation and perpetration of Indian art. By selecting very little classroom work and an extensive number of articles from the industrial departments, Reel made a clear statement with this exhibit: schools under her supervision were successfully working toward ensuring that America's expectations for the future of the Indian became a reality.

The January 1903 exhibit in Boston was of a totally different nature. Housed in the headquarters of the Prang Educational Company, publisher of the renowned Prang's *Course in Form Study and Drawing*, it focused exclusively on students' drawings. Its goal is not documented but presumably it proposed to illustrate how Indian schools were advancing in teaching drawing through the Prang system (the Prang books were still in use at this point). Unfortunately, additional information on the purpose and intent of this exhibit is lacking and it is even more unfortunate that none of the art works exhibited have survived.

The display included about three hundred drawings made by students aged six to nineteen, mainly from western schools. The subject matters

were diverse and encompassed everything from still lifes and studies of vases and bowls to copies of prints and original drawings of animals and Indian life. The *Washington Times* informed readers that the exhibition included "some very amusing and somewhat infantile ideas of art, represented in a crude, but graphic manner."[33] A reporter for the *Boston Transcript* found the drawings "exceedingly interesting" and was struck by the creativity and keen capacity for observation of such young artists, particularly the Sioux and Cheyenne students:

> They depict the wigwams of the aborigines, the horses, dogs and wild animals, and many of the Indian customs of life, in a highly interesting manner. Most of the drawings are crude enough, but expressive and graphic. One shows a group of ponies feeding in a pasture, with no more notion of perspective than a Byzantine mosaic. Some of the tribes are evidently possessed of a sense of humor, as the children show a marked preference for pictorial satires of a delicate and delightful sort.[34]

The journalist noticed the accuracy and attention to detail, and while he commented on the lack of perspective and sense of depth—a distinctive feature of the ledger drawings of the Plains tribes and likely an intentional stylistic choice on the part of the Sioux and Cheyenne students—he clearly appreciated their beauty and execution. Interestingly enough, the author also alluded to the sense of humor that pervaded some of these drawings; in his eyes, this was a distinctive feature of the Indians' artworks. Similar opinions were expressed in another article published in the *Boston Sunday Post* twenty days later (see fig. 47). The students' well-developed sense of humor was the first trait observed in the drawings, particularly in the illustration of Mother Goose stories and in the depiction of "long-bodied cows" in the water. The reporter praised the quality of the works and their likeness to the ones made by white students of similar ages, but also added that such "vein of humor and appreciation of satire would not be allowed in a Boston school."[35] He attributed this to an intentional leniency of the Indian-school teachers who seemed to lack the disciplinarian methods of white schools and thus allowed their Indian pupils an unrestrained freedom of expression.

Subtle criticism was advanced with regard to perspective; students

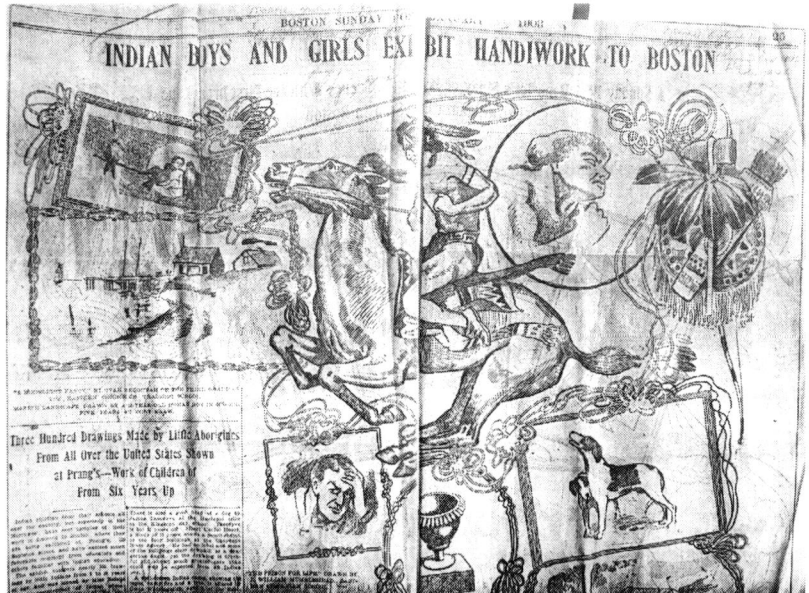

Fig. 47. Newspaper page featuring reproductions of drawings made by Indian students for the exhibit at the Prang Educational Company in Boston, January 1903. Printed in the *Boston Sunday Post*.

demonstrated remarkable inventiveness, power of observation, and truthful choice of colors, but no sense of perspective. According to the author, "efforts have been made to teach the principles of perspective," yet the results revealed "either a slavish adherence to the requirements of the horizon and the vanishing point or a naïve dismissal of such bondage."[36] On the one hand, this sounds like a disapproval of the imprecise and approximate methods of instruction, which were probably considered not efficacious and resolute enough for these rough students. On the other hand, the journalist seemed to acknowledge that teachers did all they could, but ultimately had no control of the final outcome of the students' drawings. This interpretation opens the door to recognizing students' individual agency; young boys and girls were told how to draw, but in the end they were the ones deciding how to use their talents. It is undeniable that their drawings were infused with their own understanding of the world as learned in their home communities. Albeit suppressed and channeled in

different directions, their artistic traditions inevitably surfaced and made their works uniquely original.

As in the *Transcript* article, the creative skills of Sioux and Cheyenne students were particularly commended. Why were only these two groups singled out in both papers? The answer is simple: because easterners needed to see that if the "wildest and most savage" of the Indians could be tamed and civilized through the work of government schools, then all Indians could be brought away from their old lifestyles and assimilated into American society. The remarkable accomplishments of Sioux and Cheyenne pupils in the refined art of drawing signified that their primitive traits had been conquered and they had finally been domesticated. In a similar fashion, the reporter praised the drawing made by a fifteen-year-old Pueblo boy because it showed "care and patience"; this remark was intended to show that even "lazy" Indians could improve. These students were thus the prime example of the success of Indian schools' educational efforts and concrete evidence that taxpayers' money was being well spent.

Of all the drawings exhibited, the *Boston Sunday Post* admired a few in particular: an "ambitious watercolor" of a cow herd in excellent colors and a copy of an engraving of St. Cecilia by Bert Martinez, nineteen years old, from Fort Lewis; a shore scene (reproduced in fig. 47, bottom left) with "astonishing" technique, lines, and shadows by John Courchene, thirteen, of the Fort Shaw Industrial School; a very good mountain landscape with lake by Baptiste Couture, seventeen, Fort Shaw; a "fine study" of a horse's head by George Welham, fifteen, of the Pyramid Lake Indian School; a "good head" of a dog by James Tasevyve, twelve, from the Kingman Day School; and a "well-drawn" Indian camp by Owen Walkingstick, nine, of the Eastern Cherokee School. A few other drawings were mentioned more for their bizarre characters rather than their artistic qualities. The first one was a "purple robin holding a purple worm, while standing upon a purple bough," by Ruth Bear of Carlisle, which testified, wrote the reporter, to how the use of color was highly favored, especially among girls, even if not exactly in accord with reality.[37] The second was a "pathetic drawing of a lopsided vase" (visible in fig. 47, in the center) by Willie Black Thunder, sixteen, of the Rosebud Agency, who included a handwritten explanation for this "inferior drawing," which read: "My right hand shot off July

4, 1899. Drawn with my left hand, May 4, 1900." While according to the author this work lacked quality, the young student had to be praised because, contrary to other boys who lost an arm and never drew again, he continued in his efforts. This episode revealed a surprising tenacity on the part of the student that the reporter clearly did not expect to see in an Indian boy. Similarly, the journalist did not envision that Indian boys had the ability make something with care. Drawings by Albert Useful Heart, a thirteen-year-old Sioux at the Cheyenne River Agency, and Francisco Montoya, the fifteen-year-old Pueblo mentioned above, contradicted this belief and all the negative stereotypes about Indian boys that came with it.

The Prang exhibit attracted numerous visitors and curious onlookers and was quite successful in showcasing the progress toward civilization made by young Indians in government schools. Furthermore, it was also efficacious in dismantling some of the common deleterious assumptions about American Indians that existed at the time, particularly in the East. The concluding lines of the *Boston Sunday Post* article exemplify these ideas: "The exhibition is full of interest to educators and artists who can appreciate the difficulties under which the teachers labor and the nat-ural disinclination the pupils *are supposed to have* to close application" (emphasis added). Because of their backward heritage and upbringing, Indian students were thought to be careless, negligent, and not disposed to learning, but these drawings revealed quite the opposite. This display presented Bostonians and neighboring Americans with a different facet of young Native boys and girls: artistry, diligence, and success.

Additional insights into the advancement of Indian children came from the exhibit prepared for the NEA July meeting. Each school was asked to submit five poster boards displaying as completely as possible their practical education program. In her *Education Circular* number 57, Reel requested the following items: (a) sewing: plain and fancy, drawnwork, lace, embroidery, and other ornamental needlework; (b) Native industries: beadwork, baskets, blankets, leather articles, and the like; (c) art work: drawings and paintings of scenes in Indian life and original sketches, designs, and the like; (d) other industrial work, such as sloyd, woodwork, small articles and models from the tailor shop; and (e) classroom work and photographs of garden scenes, milking, haying, and the like, along with written compositions

explaining the photographs and the correlation between classroom and shops. For the lower grades, small articles of weaving, netting, elementary doll furniture, and so on were to be mounted on these boards.[38]

In this list, Reel asked for drawings and paintings of Indian life scenes. Illustrations of this kind were not new; they had also been present at the Prang exhibit in January and in Minneapolis the previous year. However, as with Native arts and crafts, they reveal that the superintendent's attitude was not one of complete eradication of Indian heritage and that she was not afraid of encouraging the production of "Indian" things or imageries in schools. Reel saw no harm in these activities, because she considered them void of cultural values and religious meaning; drawings in particular were simple representations of a past that students were taught to criticize and look upon as backward; they could bring no danger of inducing students into "going back to the blanket." Sketches of villages and tepees were nothing more than romanticized illustrations of the students' family past; she did not see in them any nostalgia or longing for home and thus retained them as acceptable. In addition, Reel's request for small samples of weaving, netting, and doll furniture by younger pupils indicates that weaving as a household art was taught to all female students, but also that Indian blanket-weaving techniques were introduced only in the higher grades, particularly in those schools that had a population from blanket-weaving tribes. As Indian girls were expected to become first and foremost homemakers, either as wives or domestic aids, knowledge of all settler-style domestic activities was necessary in order to succeed in their future lives; elementary weaving was one of the "trades" of the business.

In addition to scenes of Indian life, drawings included geometrical shapes, plants, farm animals, and objects relevant to the students' education as in previous displays. Two photographs of the exposition room (figs. 48 and 49) show the following images: drawings of birds, flowers, leaves, a butterfly, a rooster, some of them as part of writing samples, from Klamath; leaves, a horse, a stem of flower, a bird, chickens from Cahuilla; abstract forms, leaves, flowers, a big animal, possibly a lion, snowflakes or stars paper cut-outs from the Santa Fe Day Schools; drawings of an American flag from Crow Creek; drawing of a turtle and maps from the Albuquerque Indian School; flowers, fruit (apples), bird, and two baskets

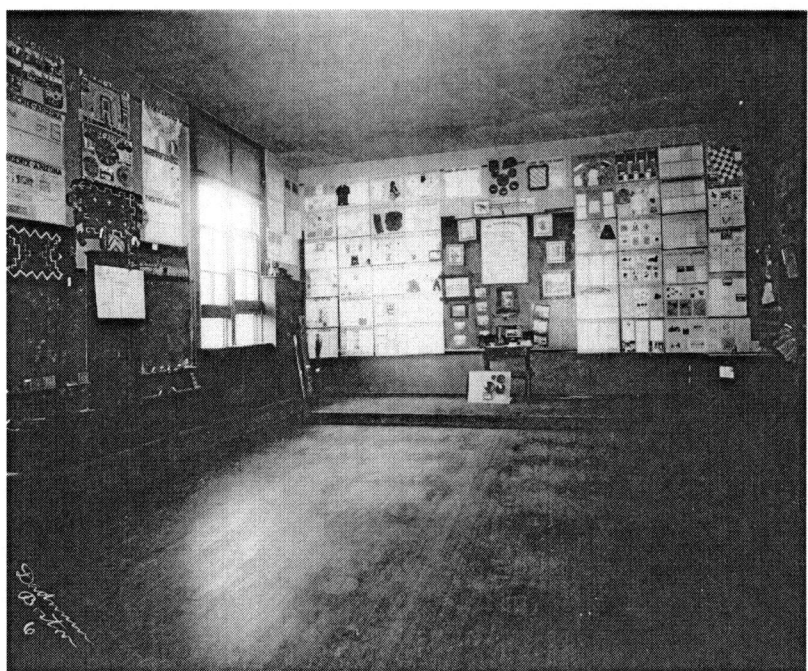

Fig. 48. Boston Exhibit. Estelle Reel Collection, Northwest Museum of Arts and Culture / Eastern Washington State Historical Society, Spokane, Washington, MONAC no. 71.

from Round Valley; pencil drawings of animals such as a bird, butterfly, quadrupeds that could be bear/dog or cow/pig, snake from the Carson school; bird, people from Fort Apache; abstract motifs, pottery pieces from the Albuquerque Day Schools; geometrical shapes in different colors and combinations; school building surrounded by trees from Uinta; two draw-ings of the American flag from Pierre; snake, orange (or branch of tree with fruit), two ducklings; a kiln; a standing figure holding a stick in one hand and something round in other, possibly a dancer from Hoopa Valley.

While children were taught to draw basic geometric shapes and colors, they also practiced their form knowledge and finger skills with paper cutting, folding, perforating, braiding, and sewing with colored threads, activities that were made in kindergarten and in the first grades following Froebel's occupations. Examples of these accomplishments were included in this exhibit as well as in the previous ones. A poster board from the

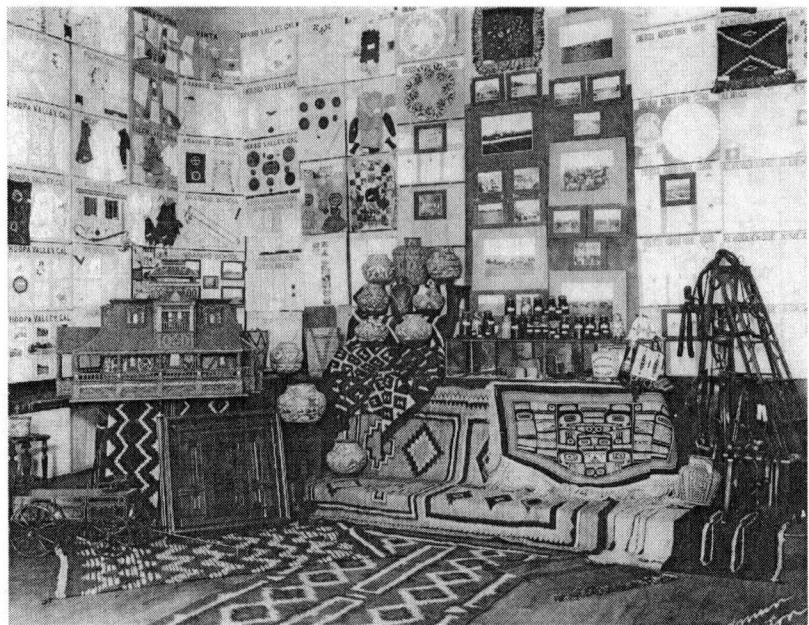

Fig. 49. Boston Exhibit. Estelle Reel Collection, Northwest Museum of Arts and Culture / Eastern Washington State Historical Society, Spokane, Washington, MONAC no. 213.

Indian school at the Wind River Reservation contains such specimens (see fig. 5) and although there is no evidence that it was displayed in Boston, it provides a better illustration of this kind of work.

These two pictures also tell us that the quantity of Native arts and crafts markedly increased in comparison to the Minneapolis exhibit as schools began to implement the *Course of Study* and its call for beadwork, baskets, blankets, and other student-made crafts. Their presence is more conspicuous on each side of the room; table 12 details the items that can be recognized among them.

Table 12. Native Arts and Crafts Exhibited in Boston, 1903

School	Artifacts
Albuquerque	a small rug; two samples of beadwork (beaded belts)

"The Comparison with the Work"

Albuquerque Day Schools	a beaded necklace; a beaded belt
Arapaho School	two boards with beaded items such as two string necklaces; one beaded necklace; five belts, one of which also includes a small pouch; a string necklace. All belts are different, with different motives and colors, although all have geometrical designs
Cass Lake	a beaded purse with floral motifs; a string beaded necklace
Chilocco	two beaded belts
Crow Creek	a woven rag; two beaded necklaces; a beaded coin purse
Fort Yuma	seven baskets of different sizes, including a miniature one, all with Indian designs; a beaded purse; a beaded belt
Grand Junction	a board with two baskets and six plaques of different sizes and with Indian designs
Leech Lake	a few pieces of beadwork (belt), the cutout of a canoe, possibly in birch bark; one woven rag with a checkered design
Morris	square mats
Neah Bay Day School	three woven placemats
Phoenix	beadwork; baskets and plaques; three Navajo rugs
Pierre	moccasins; two beaded belts; beaded necklaces; two small woven rags
Red Moon	small samples of beadwork; a belt; a miniature beaded baby carrier
Round Valley	eight miniature baskets; an oval plaque; four round plaques, all with Indian designs
Santee	two beaded moccasins; three beaded belts and what seems to be a beaded necklace
Southern Utah	three woven plaques with no Indian designs
St. Mary's	a beaded belt; two beaded moccasins; a woven rag
Uinta	beaded moccasins, beaded round necklace
Wind River	some samples of beadwork; necklaces; belt

The "Indian corner" of this exhibit consisted of Navajo rugs, a Chilkat blanket, a few samples of California and Southwestern baskets, beaded bags, and some ten pieces of Pueblo pottery. These items, likely made by adult Indians and collected by Reel or some school superintendent, were surrounded by products of Indian schools such as a harness, canned goods from Chilocco's domestic science department, and a miniature Victorian building similar to the one made by Charles Blackeyes of Chilocco for the Pan-American Exposition in Buffalo (see fig. 35). While the Albuquerque School was well represented with both drawings and Native industries, there appears to be nothing from Sherman Institute.

In her report to the commissioner of Indian Affairs, Reel wrote of the success of this exhibit in illustrating the value of the *Course of Study* and the positive results achieved since its adoption; she added that manual teachers from all over the country praised "the excellent and superior quality of the samples of industrial work, and the marked improvement shown over the work of the previous year."[39] Minneapolis and Boston were, without any doubt, the most successful exhibits organized by Reel in conjunction with the Department of Indian Education and the NEA annual meeting. Subsequent displays were not as grand and impressive. Five more exhibits were organized by Reel before her resignation in 1911, and they were in Asbury Park and Ocean Grove, New Jersey, in 1905; Tacoma, Washington, in 1906; Los Angeles, in 1907; Cleveland, Ohio, in 1908; and Denver, Colorado, in 1909. Substantial records for the 1905 and 1906 displays are unavailable at the present time, so I will not discuss them here.

The Last Exhibits: Los Angeles, Cleveland, Denver, and Seattle

The 1907 meeting of the Department of Indian Education in Los Angeles was particularly significant because it brought some important innovations not only to the program of the institute—demonstration lessons with students from local institutions, in this case Sherman—but also in the organization of the Indian exhibit. The convention took place around the time of the Jamestown Exposition, to which schools were called to submit substantial samples of classroom and industrial work; because of this, the Los Angeles exhibit was relatively small and included only a limited number of articles. What distinguished it from previous exhibits, however, was its

inclusion of a separate Native art display prepared under the supervision of Angel DeCora. While Reel remained in charge of the entire exhibit and organized the classroom section, DeCora planned the content of the arts and crafts area. It was not the first time DeCora was involved with Indian school exhibits; she had previously submitted her own works for the 1901 Pan-American Exposition in Buffalo and the 1904 World's Fair in St. Louis and, more recently, she had instructed her students to create articles for the Indian Office display at the Jamestown Exposition. On this occasion, however, she was not simply adding her contribution to something organized by others; she was the mastermind of the Native art exhibit.

Unfortunately, records of this display are scarce and do not offer substantial descriptions of its content. In his annual report, for example, Commissioner Leupp simply wrote that every part of the exhibit prepared by DeCora "attracted marked attention, but especially the specimens illustrating aboriginal ideals in decoration" and added that because of the Jamestown Exposition, "there was a small though creditable exhibit of classroom papers, art needlework, basketry, pottery, etc."[40] Specimens illustrating Indian designs, created by students and inspired by their own artistic traditions, could have included pottery and rugs of Persian weave (knotted, without a continuous warp thread). A July issue of the *Los Angeles Times* informed readers that "basketry, pottery, bead and leather work, specimens of native art and other exhibits" were shown, while the *Los Angeles Herald* reported that the display was devoted to "Indian arts and crafts, consisting of pictorial, plastic and textile arts, original sketches in water color, specimens of pottery, Navajo blankets, bead work, basketry, lace work, etc."[41] This newspaper also added that the exhibit was supervised by a full-blooded Winnebago Indian woman who had been employed by Commissioner of Indian Affairs Francis Leupp "to cultivate the original artistic talent of the young Indian."

One question that remains unanswered is whether the specimens of Indian art exhibited came solely from the Carlisle School or had been collected from numerous institutions as in the past. Because DeCora was fully responsible for and had complete control of this display, it is possible that only the work of her Carlisle pupils was included, so that she could showcase the achievements of this school as it lead the way in preserving

and promoting Native art. Since her appointment as art teacher in February of 1906, DeCora had worked to create a school of Indian design and encourage the artistic traditions of Indian people, rather than an Anglo conception of them; her exhibit for the NEA convention was an occasion to demonstrate that her endeavors were bearing fruit and that students' artwork had more traces of the Indian than the mere "signatures denoting clannish names."[42]

The exhibition prepared for the 1908 NEA meeting in Cleveland recycled displays from the Jamestown Exposition of the previous year with the addition of a few new samples of classroom and industrial work. Native industries included blankets, baskets, pottery, beaded belts, leather work and lacework, all of which attracted great attention.[43] The most interesting features that accompanied the display, however, were the practical demonstrations in rug weaving by a group of Carlisle pupils under the direction of Angel DeCora. Indian girls worked at Native looms set up for the occasion, while DeCora provided explanations of Indian designs, how they could be best applied "in the manufacture of rugs of Persian and other weaves of common use," and how teachers could best carry on this type of work in their classrooms. DeCora believed that the Persian kind of weaving, rather than the Navajo, was more appropriate and offered an easier technique for the conventional designs produced in Indian schools. The weaving sessions and talks offered in Cleveland meant to show the work of revival and perpetuation of Aboriginal art in Indian schools and the possibilities it opened for "the sale of products of the Indian," but also how the Native art of America could contribute to the art of the world.[44] According to the *Cleveland Plain Dealer*, "a number of drawings and patterns for rugs made by her pupils at the Carlisle school" were also included in the exhibit.[45] The examples shown in figure 20 could have been among these. Reel later wrote that "the exhibit made at the Cleveland Institute, of blankets, pottery, beadwork, drawn work, lace, drawings and paintings of original and characteristic native color schemes and designs, exemplified the effort made to develop the natural artistic genius of Indian children" and "unmistakably evidenced the great good" that Commissioner Leupp was accomplishing in encouraging native industries.[46] Through these words of praise, she reiterated her belief that, with proper guidance and support,

Indian students' innate abilities could be transformed into valuable skills with great economic potential.

Upon accepting the teaching position at Carlisle, DeCora explained to Commissioner Leupp that she would not teach the white man's art and needed to have "complete freedom to develop the art of my own race." However, she also clarified that her goal was to "apply this, as far as possible, to various forms of art industries and crafts."[47] She was adamant in promoting the arts of all Indian people and believed that design constituted the nucleus of Native art. At the same time, though, she insisted that students learn to decorate non-Indian art forms with Indian designs so that they could keep up with "modern methods" and apply their natural abilities for decoration and pictorial art to "modern articles of use and ornament." She had long realized that there was no turning back to past lifestyles: younger generations of Indians had to find their place in the civilized world using what had been given them through education; the best they could do to preserve their Native art forms was to apply their talents to "the daily needs and uses of modern life" and "leave [their] artistic mark on what [they] produce." This was, according to DeCora, the only way Indian art would be perpetuated and not lost.[48] Her efforts brought the desired results in that many pupils learned the designs of their respective tribes. While it might seem that DeCora compromised genuineness for marketability, her thinking reflected the awareness that Indigenous art forms could not be frozen in the past but needed to consider contemporary changes in purpose, technology, and patterns of cultural and social interaction.[49]

The last two major exhibits during Estelle Reel's career were set up in 1909 in Denver and Seattle. Because the Indian Office was already represented at the Alaska-Yukon-Pacific Exposition, with a display under the direction of Superintendent H. H. Johnson, the exhibit that accompanied the Department of Indian Education in Denver (July 5–9) was not very large. Articles from the boys' industrial branches and the girls' sewing and dressmaking departments were supplemented by drawings, paintings, and specimens of Indian art such as blankets, beadwork, and pottery, all of which adorned Unity Church, the designated locale of the Indian exhibition. As in the previous year, student demonstrations of Native industries were also featured to show that government schools were not neglecting Indian arts

and crafts but were making serious efforts and progress in their revival and conservation; on this occasion, participants came from the nearby Grand Junction Indian School. Three Navajo girls stationed at Native looms offered weaving demonstrations to the curiosity and delight of many attendees.

This dichotomy of old (traditional weaving) versus new (schoolwork and Anglo crafts), largely employed and admired at international world's fairs, however, was not always appreciated in Denver, or at least did not garner the sympathy for the government's preservation efforts that Reel probably expected. A local newspaper, for example, commented on the apparent anachronism of these craft demonstrations, as the Navajo weavers sat side-by-side with "Indian maidens doing finest embroidery, their straight black hair done in modern coiffures, their feet which, less than a generation ago, were encased in moccasins, covered with patent leathers." Yet the reported concluded that this stark contrast evidenced even more powerfully "the wonderful evolution of the American Indian" and his advancement in the modern world.[50] Another paper also compared the "work characteristic of the Indian in his native, uneducated condition" such as pottery, baskets, and bead work, which were found in abundance, to items such as freehand drawings, watercolor sketches, illustrated essays, and neat dresses, which could "only be the result of hard and careful training by the teachers in the Indian schools."[51] This writer seemed to insinuate that despite their quality, Indigenous art works, which were synonymous with primitive and uncultivated peoples, could not equal the refined advances achieved through formal schooling.

Pupils' demonstrations were a central attraction also in Seattle; both the Congress of Indian Educators, which convened at the Alaska-Yukon-Pacific Exposition, and the exhibit prepared in connection with it, featured students at work according to the practical methods of instruction announced by the new commissioner of Indian Affairs, Robert G. Valentine. Boys and girls from Indian schools in the state of Washington took center stage as they proved their skills at panel discussions; the former showed how they were taught local industries, the latter illustrated their practical training through a miniature model home. The exhibit of academic and industrial work was set up along the auditorium walls and its hallway and consisted of "classroom papers, freehand drawings, paintings, plain and ornamental

"The Comparison with the Work"

needlework, clothing, shoes, harness, farm implements, tools, and many other industrial specimens" as well as "Indian handicraft, native paintings, and silver work."[52] A few pupils daily engaged in "rug, basket and mat weaving, beadwork and blanket making" at the entrance of the auditorium, thus parading that the government, not Indian parents, was responsible for current efforts to salvage Native arts.[53] Their demonstrations were the most attractive features of the Congress. Two full-blood Navajo girls from the Navajo reservation in New Mexico, but attending school at Fort Defiance, Arizona, sat at their Native looms weaving beautiful blankets "with no pattern other than their own fancy"; they impressed the audience for their ability to card, spin, and dye the wool as their ancestors had done before them.[54] Sitting beside the weavers to attract audience attention were members of Northwestern tribes intent in their basket-making endeavors: Klickitat girls made baskets while Kootnas girls wove mats, both items in demand among collectors. Samples of other Native crafts, particularly pottery, were on display in the hall, although no one was demonstrating them.

Figure 50 is a group photograph of Indian employees and students convened in the auditorium of the Seattle exposition; seated in the center left is Estelle Reel, presider of the Indian Congress and organizer of the display. In the foreground of the picture is a long row of tables covered with Navajo blankets and woven mats on which are placed numerous specimens of Native arts grouped according to their geographical region of provenance: from left to right we can see Southwestern pottery (Pueblo and Hopi), California baskets of various shapes and sizes, and Northwest baskets and woven mats. Indian school banners decorate the stage, while the wall in the background is adorned with pictures of Indian life. On the right-hand side of the picture are pupils from the Tulalip Indian School, summoned to demonstrate the practical skills and trades they were learning, including a lesson on fishing; on the left side are female musicians, likely from Chemawa.[55] Between the musicians and the pottery display two women sit facing each other; according to the *Seattle Post International*, "while the exercises were in progress, an elderly Indian woman at the front of the platform was instructing a young Indian girl in the primary branches of basket weaving."[56] Likely, these are the women mentioned in the paper as they hold basket weave in their hands. The goal of this

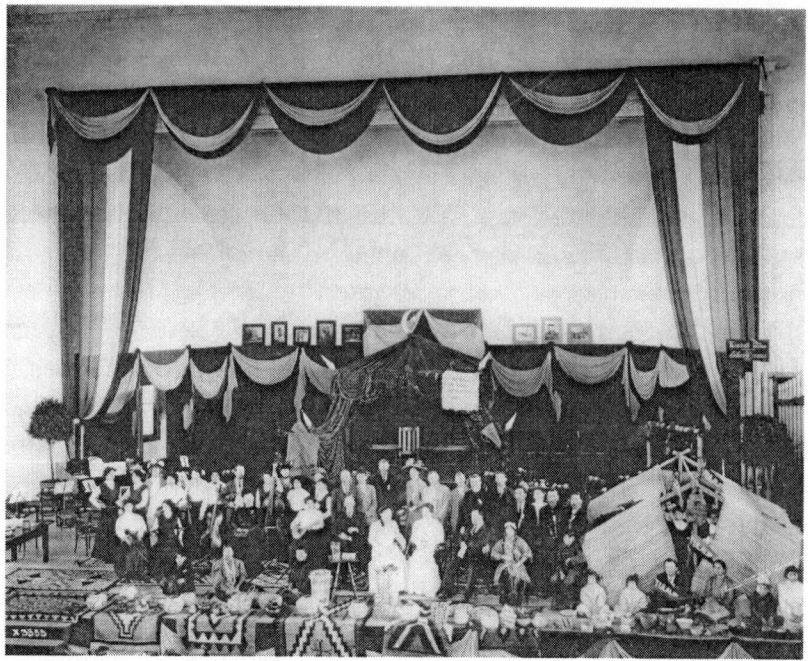

Fig. 50. Alaska-Yukon-Pacific Exposition, Seattle, 1909. Estelle Reel Collection, Northwest Museum of Arts and Culture / Eastern Washington State Historical Society, Spokane, Washington, MONAC no. 18.

exhibit was to illustrate the progress made by Indian youth thanks to the government's practical education, but also to convince the general public that Native arts and crafts were preserved, perpetuated, and encouraged. The presence of a Native elder and artist teaching a student was an assurance of the government's efforts.

Reel expressed her satisfaction with the success of the Congress and the great turnout of Indian-school employees in attendance, but did not offer much feedback on the exhibit or how the public perceived it. However, she informed the commissioner that numerous requests for blankets, baskets, pottery, and bead work had been received, thus creating an "active demand."[57] This was tangible proof to the Indian Office that her policy of salvaging Native industries was effective and that the sale of student-made crafts could eventually become a substantial source of income for many.

This also indicates that the superintendent's concern was not necessarily craft preservation per se, but rather the creation of a stable supply chain for market demands.

The Sale of Indian Crafts

Because Reel wanted students to provide articles desired by American consumers, the sale of Indian crafts was highly encouraged. For many Indian schools this often occurred within the perimeters of their institution; whether made by students or by adult Indians from nearby reservations, handicrafts were available for purchase to guests and tourists as souvenirs of their visit and authentic specimens to add to their collections. Sherman Institute, for example, offered Navajo rugs and Hopi baskets brought to Riverside from the Keams Canyon Trading Post and also sold baskets made by the Hopi women that had arrived at the school with Chief Tawaquaptewa; Carlisle and Chilocco sold blankets, beadwork, pottery, and baskets made by students as well as by reservation Indians; the Oneida School had student-made beadwork, baskets, and lacework, while beaded and birch-bark articles were available for sale at the Bena School (Minnesota).[58]

Indian crafts were also often advertised in school publications for mail order so that patrons and subscribers living in distant areas could buy the desired items from the comfort of their homes; the leading, and maybe only, institutions in this business were Carlisle and Chilocco.[59] Carlisle mail orders started after the institution of the Native Indian Art Department in 1905 under the direction of Angel DeCora; full-page ads for "Handicraft of the American Indian" (fig. 51) and "Navaho Blankets Native & Genuine" publicized authentic crafts of the finest quality made by Indian men and women and enticed readers to buy these reasonably priced items in order to support and help "the Old Indians." Advertisements for "The New Carlisle Rugs" (fig. 52) on the other hand, promoted student-woven rugs that resembled Oriental ones but with Indian designs and symbols. Mailorder Indian crafts were publicized by Chilocco at about the same time; printed ads about goods made by reservation Indians regularly appeared in the *Indian School Journal*, starting in 1905.[60] I came across black-and-white, full- and half-page advertisements for "Navajo Indian Rugs," "Hopi

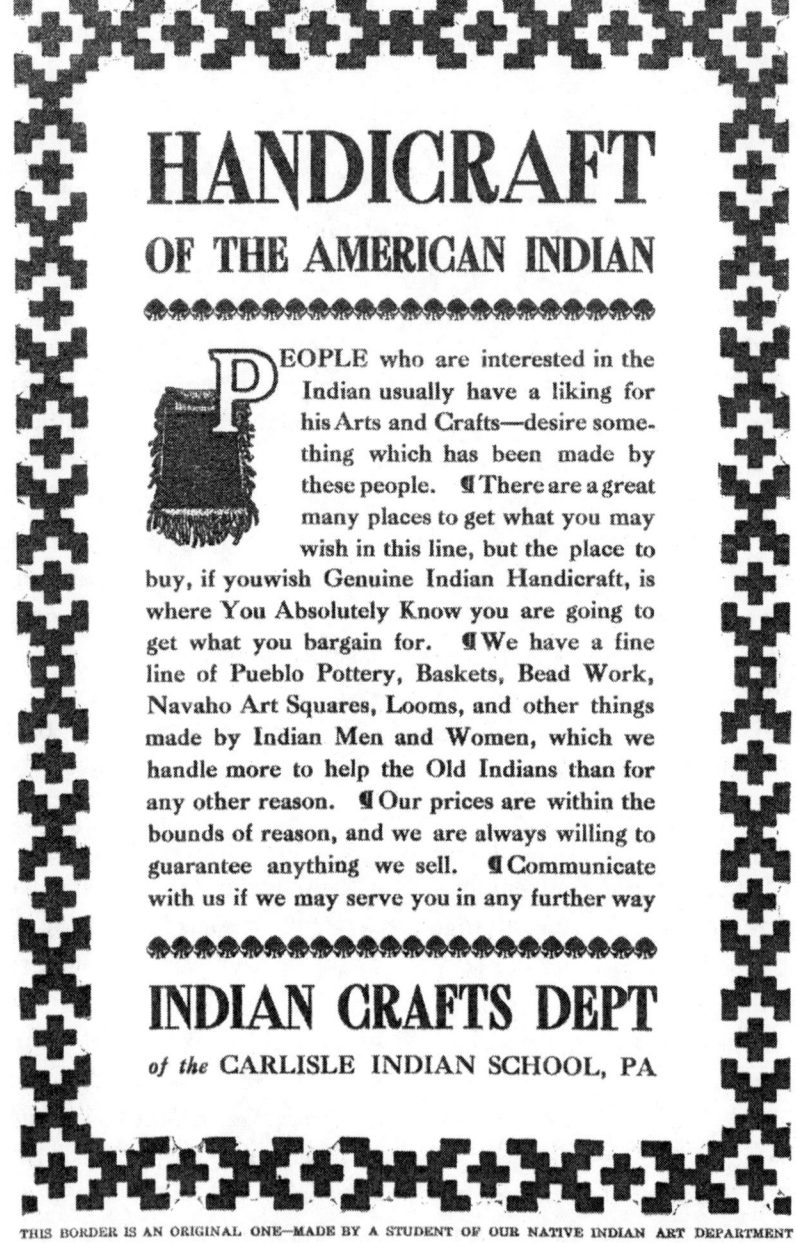

HANDICRAFT
OF THE AMERICAN INDIAN

PEOPLE who are interested in the Indian usually have a liking for his Arts and Crafts—desire something which has been made by these people. ❡ There are a great many places to get what you may wish in this line, but the place to buy, if you wish Genuine Indian Handicraft, is where You Absolutely Know you are going to get what you bargain for. ❡ We have a fine line of Pueblo Pottery, Baskets, Bead Work, Navaho Art Squares, Looms, and other things made by Indian Men and Women, which we handle more to help the Old Indians than for any other reason. ❡ Our prices are within the bounds of reason, and we are always willing to guarantee anything we sell. ❡ Communicate with us if we may serve you in any further way

INDIAN CRAFTS DEPT
of the CARLISLE INDIAN SCHOOL, PA

THIS BORDER IS AN ORIGINAL ONE—MADE BY A STUDENT OF OUR NATIVE INDIAN ART DEPARTMENT

Fig. 51. Advertisement from the *Indian Craftsman*, February 1909. Courtesy of the Carlisle Indian School Digital Resource Center (http://carlisleindian.dickinson.edu/).

Fig. 52. Advertisement from the *Indian Craftsman*, April 1909. Courtesy of the Carlisle Indian School Digital Resource Center (http://carlisleindian.dickinson.edu/).

Pottery," "Tesuque Rain Gods," "Artistic Indian Pottery," and "Beautiful Indian Art" in a 1915 issue; it is quite possible that this practice continued intermittently throughout this decade.[61]

Information on revenues from the sale of Indian handicrafts is scarce, but there are a few observations that can be drawn from primary documents and the few official reports of the superintendent of Indian schools that mention this practice in selected institutions. In the case of student-made crafts, Reel wrote on a few occasions that the Native industries carried out at the Oneida School and Chilocco generated some profits to the Indian girls who practiced them: in 1902, she reported that in Wisconsin "basketry and beadwork have successfully been practiced, producing considerable revenue for the Indians," while in Oklahoma "the bead fan chains made at Chilocco have netted a nice profit to the Indian girls."[62] In 1903, in writing again about Oneida, she stated that "native industries, such as beadwork, basket weaving, and moccasins, have been valuable as a training in skill and neatness, as furnishing a pleasant and profitable way of using time, and incidentally producing a considerable income for many whose resources are necessarily limited."[63] Each of these references indicates that female students received money for the work done in school and sold to visitors.

While these instances are obviously limited to two institutions and cannot be taken as representative of all Indian schools, they reveal a common pattern: students benefited from their work and received some kind of compensation for it. Whether they received all the profits derived from the sale of their crafts or only a part of them, however, is difficult to ascertain at this time. It is possible, though, that schools kept part of the revenues in order to cover the expenses for the raw materials that were purchased with institutional funds.[64] At Sherman, for example, Superintendent Conser believed that profits from the sale of lacework, another "Native" craft, needed to be used to pay for the expenses of that department and the surplus money for whatever else might benefit the school.[65] Other institutions might have done the same and used part of the revenues for further educational purposes.

Proceedings from the sale of handicrafts made by adult men and women went directly to the artists, too. Carlisle and Chilocco stated in their printed advertisements that this was the case. The *Indian Craftsman*

ads, for example, said that the Indian handicrafts were handled "more to help the Old Indians than for any other reason," while the *Indian School Journal* explained that the school's main goal was not to make money but to help the Indians by distributing their work and creating "a lucrative demand for the main products of these worthy people and to advertise the fact that these blankets—or rugs—are exceptional in their values as related to other articles of floor covering of the better kind."[66] Again, it is difficult to determine whether artists received full profits or, consequently, whether the school kept a percentage of the money. It is possible that in cases such as these, where schools simply acted as intermediaries between producers and consumers and thus did not incur any expenses for the purchase of raw materials, revenues actually went entirely to the makers. This was not the case at Sherman, as this institution did not want to be a simple trading venue but an actual souvenir store. Here Navajo rugs, for example, were not purchased directly from weavers but from a trading post in Arizona and were resold to employees or tourists, likely at higher costs so that the administration could profit from the difference. Similarly, I believe the school pocketed money from the sale of Hopi baskets that were made by the women on school premises; although there is no direct evidence that the basket makers kept all the profits, records indicate that raw materials were bought by the administration with institutional funds and it is, therefore, likely that Superintendent Hall claimed a percentage of the sale. These few examples are not representative of all Indian schools or of the habitual sales practices of the institutions mentioned; they illustrate, however, some significant instances of marketing of Indian crafts in these particular environments.

According to some scholars, the sale of student-made crafts was not limited to the confines of Indian schools or to the readership of their publications, but also occurred in the context of events such as world's fairs and NEA annual meetings. I believe this was not the case. As far as world's fairs are concerned, data are extremely limited and the only study that mentions the sale of student-made articles of any kind is Parezo and Fowler's investigation of the 1904 Louisiana Purchase Exposition. Their research reveals that the exhibitions halls of the Indian School Building were set up with tables where visitors could buy items such as baked

goods, embroidery, lacework, and other fancywork made by girls as well as wagons, harness, and small souvenirs produced by boys. There is no indication, however, that student crafts were available for purchase at the fairgrounds. As pupils were put on display to demonstrate their skills in civilized occupations and not in Native industries, it makes sense that McCowan did not want to publicize this minor aspect of their education with which, according to Parezo and Fowler, he was not in complete agreement. Sale of Native crafts made by adult artists from different tribes, on the other hand, occurred on a daily basis; their works were sold in the main hall and the revenues distributed at the conclusion of each day.[67]

The trend of marketing student-made articles likely continued at successive fairs, although it seems that, as in previous years, Native crafts were not among the items sold as specimens of students' work. Two letters from Superintendent and Special Disbursing Agent H. H. Johnson of the Puyallup Consolidated Agency, who was in charge of the Indian exhibit for the 1909 Alaska-Yukon-Pacific Exposition in Seattle, reveal that articles manufactured by pupils in the school shops were sold on the fairgrounds and that whatever remained unsold was returned to its institution of provenance. Indian handicrafts were not among these items and were referred to in the correspondence only as specimens that could be used to decorate the exhibit area in order to create an Indian setting.[68] Once again, the evidence is minimal and more research is needed in order to unveil a broader trend, but it nonetheless suggests that student crafts were not sold at international expositions.

I also believe that the sale of pupils' Native industries did not occur at NEA meetings for two reasons: first, Reel left no records of these sales in her numerous narrative reports and letters; second, there is no mention of this activity in any of the newspapers that reported on the displays prepared for the annual educational conventions. As the organizer of all exhibits in which Native arts played a significant role and as the promoter of these industries because of their economic potential, Reel would have certainly and proudly reported some figures or, in the worst scenario, at least mentioned the sales had they happened. Such evidence, however, is missing from both her official accounts and the numerous primary documents that comprise her collection. This does not exclude the possibility

of its existence but, similarly, it cannot even allow conceding that sales of student crafts actually occurred in the context of NEA exhibits. In her 1909 report to the commissioner of Indian Affairs, Reel wrote that the exhibit generated "many written and oral requests for Indian rugs, baskets, pottery, bead work, etc.," thus suggesting that crafts on display were not for sale on site.[69] Had they been available for purchase, her wording would have undoubtedly been different. Also, if NEA attendees and visitors had had the opportunity to purchase student-made handicrafts, this fact would have been reported and publicized by the many newspapers that discussed the exhibits. The lack of information on this issue suggests that there were no sales going on at these widely attended events.

Once Reel left office, the practice of exhibiting the fruits of Indian education at NEA conventions was discontinued. Schools were encouraged even more to prepare displays for local events and participate in county and state fairs, often alongside reservations, where they could better showcase the products of their industrial training next to those of nearby public institutions, but were no longer asked to submit samples of work for larger-scale exhibits organized by the Indian Office. Furthermore, as more emphasis was placed on the practical side of education, classroom samples, including drawings and paintings, lost their importance and appeal and were considered only marginally important as testimonials of Indian progress. After more than two decades of government-sponsored education at taxpayers' expense, the American people had seen enough pretty pictures and neat handwriting. Now they wanted to see assimilation and its tangible fruits.

Conclusion

The concepts of colonization of consciousness and cultural hegemony, coined respectively by Jean and John Comaroff and Antonio Gramsci, were developed to explicate the act of domination of a class of citizens over another and the consequent subjugation of the weaker to the influence and power of the stronger. For the Comaroffs, this authority was exemplified by nineteenth-century British religious missionaries in South Africa; for Gramsci, it was embodied in the post–World War I national socialistic regimes in Germany and Italy. Separated by almost a century, these two very different kinds of powers shared a common objective: the transformation of subservient groups through culture rather than force. The introduction of art education in the curriculum of Indian schools in the United States precisely served this purpose as well: to reshape the students' values and worldviews through trivial activities such as drawing and Native arts and crafts in order to maintain a political, economic, social, and racial hierarchy. Simple cultural traits were powerfully used by the dominant society in the colonization of a targeted group with the goal of integrating it into a subordinate and controllable social class.

Boarding schools for American Indian children were unique institutions in the educational panorama of the United States; no other racial or ethnic group had to endure such devastating physical, psychological, and moral indoctrination at the hands of the federal government. The assimilation

of the Indigenous population through education, however, was not an isolated case, but was rather part of a broader policy that aimed to destroy all those local cultures that did not contribute to the country's economic interests or threatened the country's notion of itself as a unified or homogenous place of opportunity. Thus, whether for immigrants, lower-class, or African American citizens, public schools intended to erase diversity for the sake of a socially constructed uniformity. From a political perspective, these groups were simply raw materials to be exploited through a utilitarian logic that saw economic interests triumphing over individual and family freedom and that desired the obliteration of exogenous as well as Indigenous cultures to the advantage of the country's wealth and social stability. The good of the individual or his community was subordinated to the dominant capitalist interests of society at large.

Art education was a way in which the totalitarian dominance of this economic rationale was asserted; it was part of an intentional, broad effort to culturally transform American Indians in order to force them into white society on Anglo-American terms, that is, not as equal citizens but as inferior subjects (or servants) to be disposed of as those in positions of power and dominance considered best. Because it sought to change American Indians' ways of seeing and thinking from their core, art education was a textbook example of cultural hegemony. The teachings proposed were not designed for the well-being of the students, for their humanity, or their intellectual growth, but rather to impose ideals and values that actually sought to limit their full human potential and confine it within Anglo-American prescribed boundaries. Commissioner Thomas Morgan believed elementary art would train the head and the hand, thus improving manual skills, instilling a sense of taste, and teaching order and the proper disposition of the mind; Superintendent Estelle Reel, on the other hand, thought that Native crafts would impart values of industriousness, care, domesticity, and self-sufficiency. Overall, art education was a tool to prepare Indian children for their roles as subservient and useful working-class citizens in American society. The narrative presented in these chapters tells us precisely this: art education served to train Indian children to think, act, work, crave, and consume goods like white people in order to make them instruments of the dominant ideology and expand the country's economic

base. America's hegemonic power was once again unjustly imposed in the Indian school classroom through innocent and enjoyable activities such as art and traditional crafts that subtly contributed to destroying what did not immediately contribute to the nation's well-being.

In nineteenth-century public schools across the nation, drawing and handicrafts were not creative exercises but rather instruments of social improvement and control, a means to elevate the masses by instilling morality and the values of the dominant bourgeois elite as well as to impart practical skills that could improve the quality of work. Drawing developed the power of seeing, the connection between brain and hand, and a sense of taste; it was the basis of any industrial art, a talent that needed to be mastered in order for students to become good artisans, mechanics, carpenters, blacksmiths, dressmakers, and the like. Handicrafts, on the other hand, perfected manual skills and provided future factory workers with both useful employment and pleasant activities to relieve them from the burden and routine of mechanized work. Art could teach discipline, "correct manners and morals," refine people's sense of taste, and enable them to become better producers and consumers of manufactured goods.[1]

The same art forms in Indian schools were not out of character, but carefully planned as part of the curriculum for similar reasons. However, here art was also intended to aid the students' progression from a primitive to a civilized state. Drawing would mold character, instill qualities of order, cleanliness, and taste, teach work habits, and proper use of time; according to policymakers and educators, all these concepts were foreign to children raised in Indian communities on reservations and were thus considered critical for their advancement into American civil society. Paradoxically Native crafts, although relying on "archaic" tools and technology, were thought to contribute to Indian self-sufficiency, particularly for young girls, because they could teach productivity and wise employment of one's spare time, while enabling the earning of supplemental income. Additionally, students were trained in art not only to become able makers of handmade objects craved by the American public, but so that they could also develop into steadfast consumers of products and services that would serve the growth of the economy. As students were expected to become civilized, their good taste, developed in Indian schools through art classes, would

have facilitated assimilation and the imitation of an American lifestyle (i.e., living in a nicely decorated home, wearing certain kinds of clothes, etc.) through the consumption of objects that conferred lower- and middle-class status. All in all, art education meant to inculcate a specific set of values in order to prepare American Indian youth for life as subservient citizens; it was a tool for the colonial effort of subordination and subjugation.

In their own different approaches to art, the Albuquerque Indian School and Sherman Institute exemplify this agenda. At both institutions, drawing initially progressed from simple to more complicated exercises that required attention and the development of head-hand coordination and was then used as a supplementary aid in the classroom to teach subjects such as language, math, geography, civics, and nature study. Students drew during their academic hours but time was allotted also outside of these moments. At Sherman, particularly after the publication of Reel's *Course of Study*, Indian themes were often featured to show not only that students were studying reservations and aspects of Indian traditions, but also that the administration did not shy away from the students' heritage. This did not happen at Albuquerque. These two approaches toward the inclusion of Indian content in the classroom were reflected in their divergent attitudes toward crafts. Native industries appeared in the AIS curriculum for a very short time and simply to show that, on paper at least, the school was complying with Reel's mandates. In reality, instruction was offered only to a small group of students and for an insignificant part of their domestic training. Ironically, despite its aversion to this requirement, the AIS tried to do the right thing and offer real Navajo weaving and not a generic type of craft as was done at the Sherman Institute. Native industries at the California school, in fact, had little or no Indigenous character. Contrary to the Albuquerque Indian School, the Sherman administration was quite eager to promote basketry and weaving among its students, but when it came down to it, it emphasized neither traditional Native techniques nor motifs, thus turning these works into bland and unspecific items. While markets were available and demands for Indian baskets and rugs were high, Sherman was instructing its students to produce goods that were indistinguishable from other commercial products, if not for the fact that they had been made by Indians. Because these crafts had the

Conclusion

potential to generate profits though, they were acceptable and welcomed finger skills for Sherman girls.

The two schools examined in this study also show that while Washington bureaucrats crafted centralized curricula in the hope of homogenizing Indian education to a maximum extent, local administrations did not take these prepackaged sets of rules and blindly apply them to the institutions under their care. Directives were bent, exceptions were made, and new procedures created as needed, particularly when it came to Native industries. In fact, while the AIS and Sherman both complied with the Indian Office's policies on drawing, as the majority of Indian schools did, they took very different routes when it came to Indian arts and crafts. Drawing was a safe subject to teach because it did not threaten the overall assimilationist scheme of government boarding schools; on the contrary, with its emphasis on discipline and sensory training, it infused moral values and set the stage for industrial education. Even when occasional Indian themes such a pottery, rug patterns, or Native homes surfaced and were encouraged in the classroom, they were not adequate to carry broader cultural meanings and thus they could not jeopardize assimilation. The Albuquerque Indian School and the Sherman Institute dutifully instructed their students in the basic elements of drawing for specific classroom use as well as for the illustration of daily chores and activities, as requested by Reel. Some administrators might have frowned at drawing because they did not see its immediate practical utility, yet they still complied with the directives, as they conceived it rather harmless overall. Indian arts and crafts were another story.

The close proximity to the local pueblos and to art markets and trading centers made arts and crafts at the Albuquerque Indian School very dangerous. Recent scholarship has suggested that local Pueblo communities were able to negotiate with the school administration and win battles on many fronts, yet the curriculum was not an area of compromise; parents did not have the power to enact changes at this level. The administration's resistance to the teaching of traditional crafts was dictated by a very practical reason: students could easily revert to what were seen as unproductive and wasteful habits. Thus, they were not to leave the Albuquerque Indian School and go back to become artisans and make a living only by the sale of their handiworks. This could have endangered all their years of practical

and useful education, and the school could not accept this kind of failure. Students were to return to their communities and use the industrial skills learned in the shops for the benefit of their people and, more importantly, the improvement of their own conditions. A life of craft making, while possibly profitable, was not seen as a step forward, but rather a return to the past. For this reason, the AIS did not allow its students to engage in traditional artistic endeavors in a substantial manner.

Sherman Institute, on the other hand, not only took to heart the Indian Office's directives; it also took the liberty of expanding them. The California school, in fact, diligently incorporated the teaching of a few selected crafts into its curriculum—although not necessarily Native in character—and created venues for the promotion and marketing of Indian cultures, something quite revolutionary for a government school bent on assimilating its pupils into American society. The appointment of Francis Leupp had made the Indian Office more sympathetic and welcoming toward Native crafts and other aspects of Indian cultures, but nowhere were superintendents directed to endorse the students' cultures at this level. No other school had a group of Indian men and women living on its premises, sponsored traditional dances, and encouraged the production and sale of Indian-themed drawings. From this perspective, Sherman was truly unique. Superintendent Hall knew his environment well—a popular tourist destination—and exploited the curiosity of the local and visiting people for his own purposes: to garner support not just for Indian education, but for *his* progressive work in educating the Indian. Arts and crafts and the display of Native cultures contributed to increasing the school's popularity among local citizens, and thus their financial support for the institution, and the superintendent's own name.

Art education was not a unique feature of American Indian boarding schools, but was part of a larger national trend permeating all public and private institutions across the country. Public exhibitions of students' work at the turn of the twentieth century and until the First World War, whether at international expositions or at educational conventions, sought to connect the classrooms and shops to the outside world in order to show the American public what was being accomplished in U.S. schools and how pupils of every background and social class were learning to contribute to

America's progress. Indian schools' displays were part of this narrative, although they were set up in separate locales and divided from other educational institutions. Yet they were also expected to reveal something more. People no longer wanted to see untutored "savages," but rather subdued, assimilated, and compliant young men and women who had acquired the basic skills of civilized society and could thus depend on the work of their hands and not the government's paternal aid. Schools' participation at world's fairs and expositions, therefore, were meant to provide tangible proof that these goals had been achieved. Displays of classroom samples, among which were well-executed drawings of plants, animals, buildings, and other civilized subjects, were intended to convince the public that formal schooling was bearing fruit and a transformation of the Indian mind and habits was underway. Between 1876 and the early 1900s, millions of visitors admired the progress of Indian children through these exhibitions, yet the fascination with the older Indian lifestyle continued, often eliciting more attention than expected. Paradoxically, while the American public vehemently called for Indian assimilation, it refused to let go of some aspects of the Indians' colorful past.

Displays for educational conventions were envisioned for similar reasons except that now Indian schools were directly compared to public institutions. The challenge for Estelle Reel, the mastermind of these presentations, was to prove not only that Indian children were advancing on the road of civilization, but also that this improvement was successfully achieved in very specific settings, that is, in reservation and off-reservation schools. The exhibition of students' drawings was one of the ways in which Reel showed to the world that Indian schools favorably compared to other institutions around the country. This is why photographic evidence shows rows and rows of poster boards featuring sketches of fruits, vegetables, plants, and other natural elements; through these kinds of artistic endeavors, Native students were learning the same subject matters as their peers in public institutions. There is more to this story, however; these careful illustrations, in fact, also told the audience that pupils had abandoned their "savage" habits for more orderly, disciplined, and intentional ways. To Reel and all those who viewed her exhibits, drawing had succeeded in conquering the students' minds and instilling the ideals of mainstream society.

Conclusion

It is difficult to assess the success of Indian schools in colonizing the students' consciousness, but what we do know is that the policies of the colonizer were not unquestionably accepted and internalized by the colonized. Students often found ingenious ways to resist, adapt, ignore, or undermine the foreign educational practices that characterized their boarding school experience. The evidence provided in this book shows that drawing and Native crafts were central in instilling the desired values and habits of mainstream society, and yet were not passively or negatively welcomed by the students, quite the contrary. Numerous examples have shown how pupils from different tribal backgrounds embraced drawing as both a familiar activity and a pleasant respite from the monotony of a foreign educational system. They took pleasure in the artistic endeavors they were exposed to in the classroom because, albeit different, these reminded them of the pictorial arts practiced in their communities. Similarly, these activities allowed boys and girls a minimal level of freedom and personal expression that other academic subjects or industries did not afford; even when copying from models or reproducing very specific natural objects, students could feel in control of their work and its ultimate outcome.

Historical documents reveal that students were often eager, motivated, and willing to make traditional crafts in and out of the classroom, thus demonstrating that pupils were actively engaged in their educational process and took advantage of these windows of opportunity to make their school experiences more their own. Students seemed to enjoy making crafts even when these activities were stripped of all their Native traits, thus further suggesting that young Indian boys and girls were able to navigate the muddy waters of boarding schools to their advantage and turn what could have seemed like impositions into favorable situations. There is no evidence of students not liking or being bored with drawing or Native crafts; all references are positive and a testimonial to the special role these activities played in the young people's lives in school and in their communities back home. Thus, while government bureaucrats used art education to homogenize students and repress their personal values and traditions, students also used these creative venues to make their school experiences more pleasant and somehow reconnect to their tribal heritage.

Nonetheless, the employment of drawing and other artistic endeavors

for very specific kinds of training—of the mind and of the hand—impacted generations of children in Indian schools by severing them from their Indigenous worldviews, art-making traditions, and social practices, which came to be replaced by Anglo-American utilitarian notions and consumption skills. At the end of the day, these art teachings did not intend to benefit American Indian children in the proper way. As trivial and innocuous as it appeared, art instruction meant to radically transform the students' behaviors, work habits, and individual participation into the nation's market economy so that they would think and live like every other American and eventually become efficient workers, producers, and consumers of goods. From the early 1890s, when it was first introduced into Indian schools, to the mid-1910s, when it lost its significance, art education was a tool for the assertion of America's hegemonic power over its Indigenous population.

After over two decades of unjust pedagogies and practices, new meanings and directions in art education eventually opened up in the late 1920s when the tide of federal Indian policy began to change toward a recognition of Indigenous peoples' rights to sovereignty and self-determination. Thanks to the full-scale government investigation known as the Meriam Report, those in power recognized their previous shortcomings and deleterious policies toward American Indians and worked to improve education (among many other areas of Native life), including the schools' art curricula. However, while more inclusive of Native worldviews and artistic traditions, the new course of study was still very much ethnocentric, written from an Anglo perspective, and mostly taught by non-Native teachers. It would take many more decades to see real changes in the American Indian art classroom. As Angel DeCora said, however, "The Indian in his native dress is a thing of the past, but his art that is inborn shall endure."[2]

APPENDIX A

List of Fairs, Expositions, and Educational Conventions That Featured Indian School Exhibits

Date	Fair/Event	Location
1876	Philadelphia Centennial Exposition	Philadelphia
1884	World's Industrial and Cotton Centennial Exposition	New Orleans
1893	World's Columbian Exposition	Chicago
1895	Cotton States and International Exposition	Atlanta
1897	Tennessee Centennial Exposition	Nashville
1898	Trans-Mississippi International Exposition	Omaha
1899	Paris Exposition	Paris
	Indian School Service Institute	Los Angeles
1900	Pan-American Exposition	Buffalo
1901	National Educational Association (NEA)	Detroit
	Congress of Indian Educators	Buffalo
1902	National Educational Association	Minneapolis
1903	National Educational Association	Boston
1904	Louisiana Purchase Exposition	St. Louis
	Congress of Indian Educators	St. Louis
1905	Lewis and Clark Exposition	Portland
	Department of Indian Education at NEA	Asbury Park NJ

1906	Department of Indian Education at NEA	Tacoma
1907	Jamestown Exposition	Norfolk VA
	Department of Indian Education at NEA	Los Angeles
1908	Department of Indian Education at NEA	Cleveland
1909	Department of Indian Education at NEA	Denver
	Alaska-Yukon-Pacific Exposition	Seattle
	Pacific Coast Institute at AYPE	Seattle
1915	Panama-Pacific International Exposition	San Francisco
	California-Pacific International Exposition	San Diego

APPENDIX B

Day, Reservation, and Non-Reservation Schools
Represented at Major National and International Fairs

World's Industrial and Cotton Centennial Exposition, New Orleans, 1884

State	Name of School	Type
New Mexico	Albuquerque	non-reservation
Oregon	Forest Grove	non-reservation
Pennsylvania	Carlisle	non-reservation

World's Columbian Exposition, Chicago, 1893

State	Name of School	Type
Kansas	Haskell	non-reservation
Nebraska	Genoa	non-reservation
New Mexico	Albuquerque	non-reservation
Oklahoma	Chilocco	non-reservation
	Osage	reservation
Pennsylvania	Carlisle	non-reservation

Cotton States and International Exposition, Atlanta, 1895

State	Name of School	Type
Arizona	Fort Mojave	non-reservation
	Keams Canyon	non-reservation
	Navajo	reservation
	Phoenix	non-reservation
	San Carlos	reservation
California	Perris	non-reservation
Colorado	Grand Junction	non-reservation
Idaho	Fort Lapwai	non-reservation
Kansas	Haskell	non-reservation
Montana	Fort Shaw	non-reservation
Nevada	Carson	non-reservation
New Mexico	Albuquerque	non-reservation
	Santa Fe	non-reservation
North Carolina	Cherokee Training School	non-reservation
North Dakota	Fort Totten	non-reservation
	Standing Rock	reservation
Oklahoma	Chilocco	non-reservation
	Comanche	reservation
	Kiowa	reservation
	Sac & Fox	reservation
	2 mission schools	
Oregon	Chemawa	non-reservation
	Klamath	reservation
Pennsylvania	Carlisle	non-reservation
South Dakota	Pine Ridge	day schools

	Rosebud	day schools
Utah	Ourai	reservation
Washington	Puyallup	reservation

Tennessee Centennial Exposition, Nashville, 1897

State	Name of School	Type
Arizona	Phoenix	non-reservation
California	Hoopa	reservation
	Mission	day schools
Kansas	Lawrence	non-reservation
Montana	Fort Shaw	non-reservation
Nevada	Carson	non-reservation
New Mexico	Albuquerque	non-reservation
	Pueblo	day schools
North Carolina	Eastern Cherokee	reservation
North Dakota	Standing Rock	reservation (2 schools)
Oklahoma	Arapaho	reservation
	Chilocco	non-reservation
	Fort Sill	reservation
	Ponca	reservation
Pennsylvania	Carlisle	non-reservation
South Dakota	Crow Creek	reservation
	Flandreau	non-reservation
	Lower Brule	reservation
	Pine Ridge	day schools
	Rosebud	day schools

Washington	Puyallup	reservation
Wisconsin	Oneida	reservation
Wyoming	Shoshone	reservation

Trans-Mississippi International Exposition, Omaha, 1898

State	Name of School	Type
California	Hoopa Valley	reservation
	Mission Indians	day school
Colorado	Grand Junction	non-reservation
Kansas	Lawrence	non-reservation
Nebraska	Genoa	non-reservation
	Winnebago	reservation
Nevada	Carson	non-reservation
Oklahoma	Seger Colony	reservation
	Riverside	reservation
Pennsylvania	Carlisle	non-reservation
South Dakota	Crow Creek	reservation
	Pine Ridge	day school
	Rosebud	day school
Wisconsin	Oneida	reservation

Pan-American Exposition, Buffalo, 1901

State	Name of School	Type
Arizona	Keams Canyon	non-reservation
	Fort Mojave	non-reservation

	Navajo	reservation
	Phoenix	non-reservation
	San Carlos	reservation
California	Perris	non-reservation
Colorado	Fort Lewis	non-reservation
Idaho	Nez Perce	reservation
Kansas	Haskell	non-reservation
Montana	Blackfeet	reservation
	Fort Shaw	non-reservation
Nebraska	Genoa	non-reservation
Nevada	Carson	non-reservation
New Mexico	Mescalero	reservation
North Carolina	Eastern Cherokee	reservation
Oklahoma	Chilocco	non-reservation
	Seger Colony	reservation
Oregon	Chemawa	non-reservation
Pennsylvania	Carlisle	non-reservation
South Dakota	Cheyenne River	reservation
	Pine Ridge	day schools
	Rosebud	day schools
Virginia	Hampton	non-reservation
Wisconsin	Oneida	reservation

Louisiana Purchase Exposition, St. Louis, 1904

State	Name of School	Type
Arizona	Sacaton	reservation
California	Sherman	non-reservation
Colorado	Grand Junction	non-reservation
	Fort Lewis	non-reservation
Indian Territory	Seneca	reservation
Kansas	Haskell	non-reservation
Minnesota	Leech Lake	reservation
	Morris	non-reservation
Montana	Crow	reservation
	Fort Shaw	non-reservation
	Fort Peck	reservation
	Tongue River	reservation
Nebraska	Genoa	non-reservation
North Dakota	Fort Berthold	reservation
Oklahoma	Cantonment	reservation
	Chilocco	non-reservation
	Fort Sill	reservation
	Rainy Mountain	
	Seneca	
Oregon	Chemawa	non-reservation
South Dakota	Pine Ridge	day schools
	Rosebud	reservation
Wyoming	Shoshone	reservation

Lewis and Clark Exposition, Portland, 1905

State	Name of School	Type
Arizona	Fort Apache	reservation
	Fort Mojave	non-reservation
	Fort Yuma	reservation
	Phoenix	non-reservation
California	Hoopa Valley	reservation
	San Jacinto	reservation
Colorado	Grand Junction	non-reservation
	Southern Ute	reservation
Idaho	Fort Lapwai	non-reservation
Indian Territory	Seneca	reservation
Kansas	Haskell	non-reservation
Minnesota	Morris	non-reservation
Montana	Crow	reservation
	Flathead	reservation
	Fort Belknap	reservation
	Fort Shaw	non-reservation
Nevada	Carson	non-reservation
North Dakota	Fort Berthold	reservation
Oklahoma	Cantonment	reservation
	Kiowa	reservation
	Ponca	reservation
Oregon	Chemawa	non-reservation
	Grande Ronde	reservation
	Siletz	reservation

	Umatilla	reservation
	Warm Springs	reservation
Pennsylvania	Carlisle	non-reservation
South Dakota	Rosebud	reservation
	Sisseton	reservation
Utah	Southern Utah	reservation
Washington	Neah Bay	day school
	Puyallup	reservation
	Spokane	reservation
	Yakima	reservation
Wisconsin	Lac du Flambeau	reservation
	Tomah	non-reservation
	Wittenberg	non-reservation
Wyoming	Shoshone	reservation

Jamestown Tercentennial Exposition, 1907

State	Name of School	Type
Arizona	Navajo	reservation
	Phoenix	non-reservation
California	Mission	reservation
Idaho	Lemhi	reservation
Indian Territory	Seneca	reservation
Kansas	Haskell	non-reservation
	Shawnee	mission
Minnesota	Morris	non-reservation
Montana	Cheyenne	reservation

	Crow	reservation
	Flathead	reservation
	Fort Peck	reservation
	Fort Shaw	non-reservation
Nebraska	Genoa	non-reservation
Nevada	Carson	non-reservation
New Mexico	Santa Fe	non-reservation
New York	Six public schools for Indians	
Oklahoma	Cantonment	reservation
	Chilocco	non-reservation
	Ponca	reservation
	Riverside	reservation
Oregon	Chemawa	non-reservation
	Klamath	reservation
	Siletz	reservation
Pennsylvania	Carlisle	non-reservation
South Dakota	Cheyenne River	reservation
	Crow Creek	reservation
Virginia	Hampton	non-reservation
Washington	Neah Bay	reservation
	Swinomish	reservation
	Quileute	reservation
Wisconsin	Lac du Flambeau	reservation
	Tomah	non-reservation
	Wittenberg	non-reservation

Alaska-Yukon-Pacific Exposition, Seattle 1909

State	Name of School	Type
California	Sherman	non-reservation
Kansas	Haskell	non-reservation
Oklahoma	Chilocco	non-reservation
Oregon	Chemawa	non-reservation
	Colville	day schools
Pennsylvania	Carlisle	non-reservation
Washington	Tulalip	reservation

APPENDIX C

Layouts of Minneapolis and Boston Exhibits

Layout of the 1902 Minneapolis Exhibit as seen in figure 42

Unknown school, South Dakota	Greenville, California	Upper Lake, California	Lac du Flambeau, Wisconsin	Oneida Day School	Chemawa
Unknown school, South Dakota	Greenville, California	Round Valley, California	Lac du Flambeau, Wisconsin	Oneida Indian School	Chemawa
Unknown school, South Dakota	Greenville, California	Round Valley, California	Odanah Day School, Wisconsin	Oneida Indian School	Chemawa
Rosebud (?) Day Schools	Perris, California	Hoopa Valley, California	Odanah Day School, Wisconsin	Oneida Indian School	Chemawa
Rosebud (?) Day Schools	Perris, California	Hoopa Valley, California	St. Mary's, La Pointe, Wisconsin	Oneida Indian School	Chemawa
Rosebud (?) Day Schools	Rugs	Browning School	St. Mary's, La Pointe, Wisconsin	Oneida Indian School	Wild Rice River

Layout of the 1902 Minneapolis Exhibit as seen in figure 43

Haskell Institute	Carlisle	Rosebud	Rapid City	Oto School, Oklahoma
Haskell Institute	Carlisle	Rosebud	Rapid City	Seneca School
Haskell Institute	Carlisle	Rosebud	Fort Shaw	Seneca School
Navajo Boarding School	Carlisle	Rosebud	Fort Shaw	Cheyenne School
Navajo Boarding School	Carlisle	Rosebud	Flathead	Rug
Table with photographs	Carlisle	Rosebud	Pyramid Lake	Basket display on a chair covered with rug

Appendix C

Grand Junction	Grand Junction	Morris, Minnesota	Pine Ridge Boarding	Boarding School Standing Rock Agency	Lower Brule Schools, South Dakota	Pierre
Grand Junction	Grand Junction	Morris, Minnesota	Pine Ridge	Boarding School Standing Rock Agency	Crow Creek	Pierre
Fort Lewis	Painting hanging from wall lamp	Morris, Minnesota	Chamberlain School, South Dakota	Boarding School Standing Rock Agency	Crow Creek	Pierre (?)
Fort Lewis	Eastern Cherokee	Leech Lake	Chamberlain	Boarding School Standing Rock Agency	Grace, South Dakota	Pierre (?)
Fort Lewis	Eastern Cherokee	Leech Lake	Crow Creek	Day Schools, Standing Rock Agency	Lower Brule School, South Dakota	Pierre (?)
Bay Mills, Michigan, Day School	Sauk and Fox	Grand River on the floor	Crow Creek covered by Yakima (?)	Couch covered with rug		

Layout of the 1902 Minneapolis Exhibit as seen in figure 44

Upper Lake	Rug	Rug
Upper Lake		
Upper Lake	Small rug / Small rug	Rug
Upper Lake	Small rug / Small rug	
Rug	Rug	
	Rug	
Couch covered with rug and items from sewing and tailor department		

Day Schools, Pine Ridge, South Dakota		Grande Ronde Boarding, Oregon
Day Schools, Pine Ridge, South Dakota	Embroidered table runner	
Day Schools, Pine Ridge, South Dakota		Warm Springs, Oregon
Day Schools, Pine Ridge, South Dakota	Odanah Day School, Wisconsin	paintings
Day Schools, Pine Ridge, South Dakota	Display table with dolls' clothes	Ukiah Day School, California
		Unknown school

Layout of the 1903 Boston Exhibit as seen in figure 48

Albuquerque Day Schools	Santee	Seger Colony School	Albuquerque Day Schools	Grand Junction	
Albuquerque Day Schools	Santee	Seger Colony School	Crow Creek, South Dakota		
Albuquerque Day Schools	Santee	Round Valley, California	Crow Creek, South Dakota		Indian Service
Albuquerque Day Schools	Santee	Round Valley, California	Santa Fe Day Schools		
Uinta	Fort Apache	Carson Indian School	Santa Fe Day Schools		
Uinta	Fort Apache		Albuquerque Day Schools		

Layout of the 1903 Boston Exhibit, left wall, as seen in figure 48

Phoenix	Phoenix	Phoenix
Phoenix	Phoenix	Phoenix
Phoenix	Rug	Phoenix
Rug	Baskets	Rug
	Phoenix	

		Grand Junction	St. Mary's	Morris, Minnesota	Hayward	Shawnee
			St Mary's	Santa Fe Day Schools	Hayward	Klamath
			Cass Lake	Santa Fe Day Schools	Standing Rock	Klamath
			Cass Lake	Santa Fe Day Schools	Cahuilla	Shawnee
			Yankton Training	Santa Fe Day Schools	Cahuilla	
			Santa Fe, New Mexico			

Layout of the 1903 Boston Exhibit as seen in figure 49

		Leech Lake	Uinta	Round Valley, California	Fort Yuma, California
Wind River	Pierre	Leech Lake	Arapaho	Round Valley, California	
Hoopa Valley	Pierre	Leech Lake	Arapaho	Round Valley, California	Fort Yuma, California
Hoopa Valley	Pierre	Pine Point, Minnesota	Arapaho	Standing Rock, North Dakota	Neah Bay Day School
Hoopa Valley	Pierre	Miniature building	Arapaho	Standing Rock, North Dakota	Neah Bay Day School
Hoopa Valley	Pierre			Standing Rock, North Dakota	

Red Moon	Chilocco	Chilocco photographs	Chilocco	
	Chilocco		Chilocco	Albuquerque
Red Moon			Chilocco	Albuquerque
			Chilocco	Albuquerque
Southern Utah	Pottery	Canned goods from Chilocco	Chilocco	Albuquerque
Fort Yuma, California			Chilocco	Albuquerque

Navajo rugs NW blanket

NOTES

ABBREVIATIONS

CSWR Center for Southwest Research, University of New Mexico, Albuquerque, New Mexico

DASP Dickinson Archives and Special Collections, Dickinson College, Carlisle, Pennsylvania

LAA Museum of Indian Arts & Culture, Laboratory of Anthropology Archives, Santa Fe, New Mexico

NAA National Anthropological Archives, Smithsonian Institution, Suitland, Maryland

NACP National Archives at College Park, Maryland

NARA-PR National Archives and Records Administration–Pacific Region, Riverside, California

NARA-RMR National Archives Records Administration–Rocky Mountain Region, Denver, Colorado

NARA-APR National Archives and Records Administration–Alaska Pacific Region, Seattle, Washington

SRCA New Mexico State Records Center and Archives, Santa Fe, New Mexico

NWMAC Northwest Museum of Arts and Culture/Eastern Washington State Historical Society, Spokane, Washington

SIMA Sherman Indian Museum and Archives, Riverside, California

INTRODUCTION

1. Pratt, *Battlefield and Classroom*, 271.
2. See P. Smith, *History of American Art Education*; Stankiewicz, *Roots of Art Education Practice*; Soucy and Stankiewicz, eds., *Framing the Past*; Wygant, *Art in American Schools*.

3. Comaroff and Comaroff, "Colonization of Consciousness in South Africa," 267. See also "Colonization of Consciousness," in *Ethnography and the Historical Imagination*, 235–63, 289.

4. For a discussion of education by and for Indians, see Lomawaima, "American Indian Education," 422–40.

5. Gramsci, *Selections*, 9; Lomawaima and McCarty, *"To Remain an Indian."*

6. Gramsci, *Selections*; Dominic Mastroianni, *Hegemony in Gramsci*, accessed March 31, 2014, https://scholarblogs.emory.edu/postcolonialstudies/2014/06/20/hegemony-in-gramsci/.

7. Works that examine the sale and marketing of Native arts and crafts include Brody, *Indian Painters and White Patrons*; Hoerig, *Under the Palace Portal*; McNitt, *Indian Traders*; Parezo, "A Multitude of Markets"; Wade, "History of the Southwest Indian Ethnic Market."

8. Research on the Albuquerque Indian School has proven to be particularly problematic since many early official records have been lost or damaged over the years. During its first twenty years of existence the school had a very high rate of personnel turnover, including superintendents, which resulted in inconsistent record keeping. Furthermore, as Indian agencies in the Territory of New Mexico were created, abolished, reinstated, and consolidated, school jurisdiction often passed from one agency to another, thus creating additional bureaucratic turmoil. To complicate things even more, once all early administrative records were finally housed on the school grounds, a fire broke out in the mid-1950s, unfortunately destroying the majority of them. Whatever was spared was left in the damaged buildings which, once the school eventually closed, were abandoned, left to decay, and to the homeless people who appropriated them as their homes and used the loose sheets of paper for their own personal needs. The surviving documents that were recuperated were eventually transferred to the Denver Federal Archives and Records Center (now National Archives and Records Center–Rocky Mountain Region) in 1974.

9. As historian Jacqueline Fear-Segal has written, scholars of Indian education are faced not only with a predominantly oral culture, but also with the reality that Indian people "concealed their activities and clouded or obscured their opinions in ways common to many subordinate and threatened groups." See Fear-Segal, *White Man's Club*, xvii.

10. Trennert, *Phoenix Indian School*; Lomawaima, *They Called It Prairie Light*; Child, *Boarding School Seasons*; Mihesuah, *Cultivating the Rosebuds*; Fear-Segal, *White Man's Club*; Gilbert, *Education Beyond the Mesa*.

11. See Clastres, *Society Against the State*; Fanon, *Wretched of the Earth*; Lefevre, *Critique of Everyday Life*; Memmi, *Colonizer and the Colonized*.

1. Royal Bailey Farnum (1884–1967) was an art educator, administrator, and author of many books on art education. Among his many administrative roles, he served as director of the Normal Department of the Cleveland School of Art, principal of the Massachusetts Normal Art School, and director of art education for the states of Massachusetts and New York.

2. Friedrich Froebel was the leading advocate of the German kindergarten movement and author of volumes on education and pedagogy such as *Education of Man, Education by Development, and Friedrich Froebel's Pedagogics of the Kindergarten, or, His Ideas Concerning the Play and Playthings of the Child*. He was a disciple of Heinrich Pestalozzi and was largely influenced by the writings of his master and his philosophy of training the heart, the head, and the hand through schooling experiences that could prepare for life. For a discussion of Froebel's educational pedagogy, see Efland, "Changing Conceptions of Human Development"; Marzio, *Art Crusade*.

3. The examination of the development of art education provided here does not pretend to be exhaustive and all-encompassing. For more comprehensive histories and analysis, see Dalton, *Gendering of Art Education*; Efland, *History of Art Education*; Eisner and Day, eds., *Handbook of Research and Policy in Art Education*; P. Smith, *History of American Art Education*; Stankiewicz, *Roots of Art Education Practice*; Soucy and Stankiewicz, eds., *Framing the Past*; Wygant, *Art in American Schools*.

4. Stankiewicz, "'The Eye Is a Nobler Organ,'" 57.

5. Stankiewicz, "'The Eye Is a Nobler Organ,'" 58; Perkins, *Art Education in America*, 17.

6. Other influential figures of the time were Bronson Alcott and Elizabeth Peabody, both from Massachusetts; Alcott was one of the first educators to advocate freedom of expression in the classroom, while Peabody was responsible for establishing the first English-speaking kindergarten in Boston in 1860. Both worked tirelessly to convince the American people of the usefulness of art in education. See Logan, *Growth of Art in American Schools*; Stankiewicz, "Mary Dana Hicks Prang"; Stankiewicz, Amburgy, and Bolin, "Questioning the Past."

7. Marzio, *Art Crusade*, 9–18.

8. John Gadsby Chapman, as quoted in Marzio, *Art Crusade*, 9.

9. See Downs, *Heinrich Pestalozzi*; Reese, "The Origin of Progressive Education."

10. Downs, *Heinrich Pestalozzi*, 59–61. For a discussion of Pestalozzi's educational theories applied to drawing, see also Efland, "Changing Conceptions of Human Development"; Marzio, *Art Crusade*; Tarr, "Pestalozzian and Froebelian Influences."

11. Marzio, *Art Crusade*, 5.

12. Marzio, *Art Crusade*, 31–32.

13. Mann, quoted in Saunders, "Selections from Historical Writings," 28.

14. Saunders, "Selections from Historical Writings," 29.

15. Saunders, "Selections from Historical Writings." For a discussion of Mann's ideas, see also, Efland, *History of Art Education*, and P. Smith, *History of American Art Education*.

16. Efland, "Art and Education for Women," 136.

17. It is important to remember that public education arose from the need for controlling the lower classes and indoctrinating them into being obedient citizens who would neither challenge nor destabilize the political and social authorities of the time. The public school curriculum reflected the ideology of the dominant class and the needs of the new industrial capitalistic society. See Bowles, "Unequal Education." See also Boyer, *Urban Masses and Moral Order*.

18. Massachusetts was also the first state to open a school for the preparation of art teachers; the Massachusetts Normal Art School was approved by the state legislature in the spring of 1872 and became operational in November of the following year under the direction of Walter Smith. See Green, "Walter Smith"; Korzenik, "Art Education of Working Women"; P. Smith, *History of American Art Education*; Stankiewicz, Amburgy, and Bolin, "Questioning the Past."

19. Massachusetts Drawing Act of 1870, quoted in Marzio, *Art Crusade*, 63.

20. Bolin, "Massachusetts Drawing Act of 1870," 64.

21. Clarke, *Art and Industry*, 1:127.

22. Such a distinction had existed in European art since the Middle Ages; in more recent years it had been exemplified at the international expositions of London (1851), Paris, and Philadelphia where fine and industrial arts were exhibited in clearly differentiated spaces. During the 1870s and for the first time in the United States, however, this separation engendered official educational policies and the establishment of specific institutions for the teaching of one or the other type of art. See Efland, "Art and Education for Women"; Saunders, "Art, Industrial Art, and the 200 Years War."

23. Clarke, *Art and Industry*, 1:8.

24. L. Thompson, "Some Reasons Why Drawing Should Be Taught," 42–43.

25. A professional sculptor and educator, Walter Smith graduated from the South Kensington Training School of Art. In early 1871, he was recruited by John D. Philbrick, superintendent of schools for the city of Boston, for the position of supervisor of drawing. After some initial difficulties in the negotiation of his salary, he was hired as director of drawing in the Boston public schools and state director of art education for Massachusetts. He moved to the United

States in October of 1871. For more thorough examinations of Smith's career, see Green, "Walter Smith," and Stankiewicz, "Drawing Book Wars," 59–72.

26. Green, "Walter Smith," 5.

27. The reasons for the dismissal of Smith's ideas go far beyond his art pedagogy; friction between Smith, the Normal School administration, and state school authorities, teachers' antagonism to his methods, public opposition to drawing, and competition from other drawing book authors were among the causes that led to his rebuttal. See Green, "Walter Smith," and Stankiewicz, "Drawing Book Wars."

28. Aesthetic education was not considered relevant until the 1880s because it had not yet gained the support of the industrial and manufacturing world; in 1870, teaching industrial drawing could bring immediate economic benefits that could not be obtained by any discourse on beauty and style. For a discussion of the industrial/economic rationale versus the aesthetic rationale, see Stankiewicz, "From the Aesthetic Movement to the Arts and Crafts Movement," 165–73.

29. Woodward, *Educational Value of Manual Training*, 3, 12.

30. For studies on the evolution of the American public school curriculum, see Cremin, *Transformation of the School*; Kliebard, *Struggle for the American Curriculum* and *Schooled to Work*; Reese, "Origin of Progressive Education."

31. Among these reformers were Jane Addams and Ellen Gates Starr who founded Hull House in Chicago in 1889 to improve the lives of lower-class citizens through art classes, exhibits, reading groups, and arts and crafts. See Amburgy, "Culture for the Masses," and "Arts and Crafts Education in Chicago," 384–88; Stankiewicz, "Art at Hull House," 35–39.

32. Kaplan, "Lamp of British Precedent," 54.

33. Eaton wrote a brief introduction for the special report on art and industries written by Isaac Edwards Clarke of the Bureau of Education to the secretary of the interior. See Clarke, *Art and Industry*, 1:5.

34. Clarke, *Art and Industry*, 1:74.

35. Macalister, "Art Education in the Public Schools," 461.

36. Clarke, *Art and Industry*, 1:77.

37. It is around this time that we see the growth of art museums, clubs, and societies, all of which, according to Clarke, meant to "instruct and develop in the public a correct taste based upon a knowledge and appreciation of the manifold applications of art to industry." See Clarke, *Art and Industry*, 1:5. For studies on the development of art museums and arts and crafts societies, see Alexander, "Early American Museums," 337–51; Burt, *Palaces for the People*; Kaplan, "Art That Is Life"; Zeller, "Historical and Philosophical Foundations."

38. Perkins, *Art Education in America*, 12.

39. Stankiewicz, "From the Aesthetic Movement," 167.

40. Amburgy, "Culture for the Masses," 108.

41. Developmental psychology was greatly influenced by Darwin's theory of evolution. In fact, psychologists borrowed Darwin's theory of recapitulation—the idea of a progression from a lower to a higher evolutionary stage—from the field of biology and simply applied it to the human mind and individual behavior. See Belden, "History of the Child Study Movement in the United States"; Cremin, *Transformation of the School*; Davidson and Benjamin Jr., "History of the Child Study Movement in America," 41–60.

42. Mary Dana Hicks, quoted in Stankiewicz, "Mary Dana Hicks Prang," 36.

43. Stankiewicz, "Drawing Book Wars," 66–67.

44. Cushman, "Aesthetic Development," 500.

45. Cushman, "Aesthetic Development," 499.

46. Amburgy, "Arts and Crafts Education in Chicago," 387.

47. Kaplan, "Lamp of British Precedent," 58.

48. Stankiewicz, "'The Eye is a Noble Organ,'" 61. See also Dalton, *Gendering of Art Education*, 50.

49. Amburgy, "Arts and Crafts Education in Chicago," 387.

50. Duncan, Mitchell, and Hollister, "Applied Arts," 274–86.

51. I. H. Clark, "Hand-Work in the Elementary School," 166. See also, Whitehead, "Application of Art to Hand-Work," 92–96.

52. Mrs. John O'Connor, 1910, quoted in Boris, "Dream of Brotherhood and Beauty," 220.

53. Technological changes were an additional factor that influenced art education. According to Stankiewicz, the mechanical reproduction of works of art through chromolithographs and other printed solutions had a strong impact in that it made art more accessible to the masses. See Stankiewicz, "Picture Age," 86–92.

54. Dow, quoted in Key, "New System of Art Education," 260–61.

55. Key, "New System of Art Education," 259.

56. Haney, "Art Education in the Public Schools of the United States," 9–10.

57. Bailey, "Arts and Crafts in the Public Schools," 72.

58. One of the most significant events that contributed to the institutionalization of art appreciation in schools was an art survey class at Harvard University offered by Professor Charles Elliott Norton in 1898. According to art history professor Ronald Jones, the course was designed "not only to elevate art to an academic subject, but more importantly to cultivate an attitude toward art as being of historical importance." This set a precedent for many other institutions of higher education, which soon began to follow Harvard's example in

order to expand their offerings of elective courses, but also for primary and secondary schools, which did not want to be left behind. See, Jones, "Aesthetic Education," 12–16.

59. Stankiewicz, "'The Eye Is a Nobler Organ,'" 61, and "Picture Age," 91.

60. The book was coauthored with Severance Burrage, a professor of sanitary engineering at Purdue University and member of the American Public Health Association. Bailey and Burrage, *School Sanitation and Decoration*, 100–104.

61. Stankiewicz, "Picture Age," 86.

62. Margolis, "Class Pictures," 10.

2. "AN INDISPENSABLE ADJUNCT TO ALL TRAINING"

1. For a discussion of American Indian policy and its relation to education, see Adams, *Education for Extinction*; Hoxie, *Final Promise*; and Prucha, *Great Father*.

2. Jacqueline Fear-Segal suggests that Pratt's views on Indian education were inherently contradicting because young students at Carlisle were not trained to enter white society on equal terms; among her many examples is her analysis of the school spatial layout, which discloses an agenda that centered on a clear racial distinction between white power and Indian submission. See *White Man's Club*, 184–205.

3. On education for subservience see for example Fear-Segal, *White Man's Club*; Hoxie, *Final Promise*; Littlefield, "Learning to Labor," 43–59; Littlefield and Knack, eds., *Native Americans and Wage Labor*; Lomawaima, "Estelle Reel," 5–31. Alice Littlefield in particular suggests that "proletarization" rather than assimilation better describes the goals of the federal government toward its wards. In her view, government-run educational institutions did not really intend to train American Indian students to fit into white Anglo society but prepared them for "menial and unskilled work" in the lower social strata.

4. Disciplinary methods and the types of punishments for disobedient students are discussed by numerous scholars, including Adams, *Education for Extinction*; Lomawaima, *They Called It Prairie Light*; Trennert, *Phoenix Indian School* and "Corporal Punishment," 595–617. The use of ridicule, however, has not been thoroughly considered by many. In *White Man's Club*, Fear-Segal shows how at Carlisle this kind of humiliation was perpetrated publicly through the pages of the school publication, *Indian Helper*, in the commentaries by its imaginary editor, Man-on-the-Bandstand, who took every possible opportunity to point out and complain about the children's constant infractions of the school rules.

5. *Annual Report of the Commissioner of Indian Affairs to the Secretary of the Interior* (hereafter cited as ARCIA) 1885, xiv.

6. The sand table, as the words say, was a table covered in sand used for learning

writing and arithmetic. A photograph titled "Method of Teaching English by Use of Sand Table, No. 27 Day School, Pine Ridge" can be found in ARCIA 1903, facing 374. This image has been reproduced by Reyhner and Eder in their book *American Indian Education*, 100.

7. On the history of the Forest Grove Training School, later renamed Chemawa Indian School, see Collins, "Through the Lens of Assimilation," 390–425 and "Oregon's Carlisle," 6–10.

8. An interesting study of teachers' struggles in the Indian Service is provided by Carter, "'Completely Discouraged,'" 53–86.

9. Morgan was vice president of the NEA from 1887 to 1889. Information on Morgan's education and career as an educator can be found in Prucha, *American Indian Policy in Crisis*, 294–96.

10. February 8, the date the Dawes Act was signed, was to take its place among celebrations such as Independence Day, Thanksgiving, Christmas, New Year's Day, George Washington's birthday, and Arbor Day.

11. "Supplemental Report on Indian Education, December 1, 1889" in ARCIA 1889, 96–97. Morgan also unveiled his plan for Indian education during a public presentation at the 1889 Lake Mohonk Conference. See also Prucha, *American Indian Policy in Crisis*.

12. Office of Indian Affairs, *Rules for Indian Schools*, 3.

13. Office of Indian Affairs, *Rules for Indian Schools*, 35–43.

14. A similar picture of a kindergarten class playing with blocks can be found in Archuleta, Child, and Lomawaima, *Away From Home*, 29.

15. Office of Indian Affairs, *Rules for Indian Schools*, 35.

16. Fay, "Kinds of Schools to Be Introduced," 206; L. Thompson, "Some Reasons Why Drawing Should Be Taught," 44.

17. Littlefield, "Learning to Labor," 43.

18. Hyde, "Organization of American Education," 222.

19. Haney, "Art Education in the Public Schools of the United States," 9–10.

20. Saville-Troike, "Navajo Art and Education,"47.

21. On Arizona Swayney, see Carney, *Eastern Band Cherokee Women*, and Hill, *Weaving New Worlds*. On Angel DeCora, see McAnulty, "Angel de Cora," 178–86; Gere, "Art of Survivance," 649–84; Holm, *Great Confusion in Indian Affairs*; Hutchinson, "Modern Native American Art," 740–56 and *Indian Craze*; Waggoner, *Firelight*.

22. DeCora quoted in Curtis, "American Indian Artist," 65.

23. For a discussion of "windows of opportunities," breakthrough moments that suddenly opened at particular times in the lives of Native people and that allowed them to intelligently incorporate aspects of modernity and non-Native

cultural traits into their lives, see Deloria, *Indians in Unexpected Places*, and Lomawaima and McCarty "*To Remain an Indian.*"

24. An educator and administrator, Hailmann served as superintendent of public schools in Laporte, Indiana, before his appointment to the Indian Service. He was one of the leading proponents of kindergarten and object teaching and a prolific writer in the field of education. Among his many works were *Kindergarten Culture* (1873), *Primary Methods* (1887), and *Law of Childhood* (1889). He was superintendent of Indian schools from 1894 to 1898.

25. *Report of the Superintendent of Indian Schools to the Commissioner of Indian Affairs* (hereafter cited as *RSIS*) in *ARCIA* 1894, 351–52.

26. *RSIS* 1895, 14–15.

27. *RSIS* 1896, 6–7.

28. Hailmann, "Discussion," in *ARCIA* 1897, 97.

29. F. A. Thackrey, "The Organic Connection between the Industrial and the Academic Training in Indian Schools," in *RSIS* 1897, 88.

30. *ARCIA* 1899, 472.

31. *RSIS* 1898, 49.

32. This and the image "Art Department" (fig. 8) were part of a series of photographs commissioned by the school administration to Phoenix bookkeeper turned photographer Alfred Fenton Messinger, or Messinger Viewist, as he liked to be credited. Taken in June of 1900 at the completion of the campus facilities, they included views of the school grounds, buildings, dormitories, and various school activities, as well as students posing in classrooms. For more information on Messinger, see Margolis and Rowe. "Images of Assimilation," 207–8.

33. Margolis and Rowe, "Images of Assimilation," 207.

34. Reel, *Course of Study*, 20, NWMAC, Estelle Reel Papers MS120, box 1, folder 1–8. Reel discusses the use of drawing in connection with "nature study and language work, as, indeed, with any subject whose ideas are susceptible of graphic representation." On Reel's political career, see Lomawaima, "Estelle Reel."

35. The content page of the *Course of Study* indicates classroom subjects as being the following: arithmetic, geography, history, music, reading, language, and subprimary work, spelling, and writing. Drawing does not appear. See Reel, *Course of Study*.

36. Reel, *Course of Study*, 264.

37. *ARCIA* 1901, 69.

38. Reel, *Course of Study*, 215–16.

39. Reel, *Course of Study*, 223.

40. Hutchinson, *Indian Craze*. The photograph described can be seen on page 72.

41. Reel, *Course of Study*, 138, 169, 171.

42. Reel, *Course of Study*, 138. A few examples of these types of drawings from Haskell, the Round Valley School, and the Albuquerque Day Schools can be identified in the photographs of the Indian school exhibits at Minneapolis (fig. 43) and Boston (fig. 48) which are discussed in chapter 7.

43. Reel, *Course of Study*, 227.

44. For a discussion on domesticity and American Indian education, see Lomawaima, "Domesticity in the Federal Indian Schools," 227–40.

45. Estelle Reel resigned from her position as superintendent of Indian schools in 1910, and there is no evidence that her successor continued her trend of exhibiting Indian schools' work at NEA meetings.

46. The Prang system was one of the books recommended by Professor Simons at the 1898 summer institute and was among the manuals adopted by the Indian Office in the mid-1890s as per the pamphlet *Estimate of School Books and Supplies for the fiscal year 1894–1895*, issued by Commissioner Browning.

47. Lists of Indian Service employees were normally appended to the *Annual Reports of the Commissioner of Indian Affairs to the Secretary of the Interior*, although not included yearly. Another source of information is the Official Register of the United States Employees.

48. *Indian Helper* 9, no. 16 (Friday, January 12, 1894): 3.

49. "Employees in the Indian School Service," in ARCIA 1897, 536. That this position existed only at Carlisle is indicative of the unique nature of this institution under Pratt's leadership; in his view, in fact, Indians needed to be educated in order to compete with white Americans and enter into mainstream society on an equal footing. Following this conception of education, art instruction was seen as more than an auxiliary; it served to develop the Indians' aesthetic sense so that they could become artists, not simply artisans. Indian educators and bureaucrats followed the Carlisle model, but did not conform to it in its entirety as the example of art indicates. Drawing was a good forming activity, but in the eyes of many, Pratt seemed to have pushed it a little too far. An excellent examination of Pratt's educational creed for American Indians can be found in Fear-Segal, *White Man's Club*. See also Adams, *Education for Extinction*.

50. ARCIA 1897, 372.

51. See "Application for Appointment in the U.S. Indian School Service" contained in *Rules for Indian Schools*, ARCIA 1890, 163.

52. Professor Frederick Simons' class on "Art and Art Education in Their Relation to the Social Welfare of the People" at the 1898 summer institute was the only one of this kind ever offered to teachers in the Indian Service although it was not mandatory.

53. Office of Indian Affairs, *Tentative Course of Study*, 100. The committee on the course of study included the following superintendents: H. B. Peairs, supervisor of Indian schools; W. W. Coon, assistant supervisor of Indian schools; O. H. Lipps, superintendent of Carlisle; E. A. Allen, superintendent of Chilocco; F. M. Conser, superintendent of Sherman Institute; Chas M. Buchanan, superintendent of the Tulalip School in Washington; Evan W. Estep, superintendent of the Crow Agency Indian School in Montana; Peyton Carter, superintendent of the Wahpeton School in North Dakota; and F. F. Avery, day school inspector from Colville, Washington.

54. For a discussion of prewar changes in the American curriculum, see Kliebard, *Struggle for the American Curriculum* and *Schooled to Work*.

3. "SHOW HIM THE NEEDS OF CIVILIZATION"

1. Pratt quoted in Fear-Segal, *White Man's Club*, 161.

2. See, for example, Holm, *Great Confusion in Indian Affairs*; Hutchinson, *Indian Craze*; Lomawaima and McCarty, "*To Remain an Indian*"; Schrader, *Indian Arts and Crafts Board*.

3. Education Circular no. 43, Jones to Superintendents, September 19, 1900. SIMA, Records of Sherman Institute, box: circulars 1894–98.

4. RSIS 1898, 6.

5. Hoxie, *Final Promise*, 85.

6. Armstrong, quoted in Fear-Segal, "Nineteenth-Century Indian Education," 335.

7. For studies on reform movements for the preservation and promotion of Native crafts, see Herzog, "Aesthetics and Meanings"; Jacobs, "Shaping a New Way," and *Engendered Encounters*; Mullin, *Culture in the Marketplace*; Trump, "'Idea of Help.'" For Indian reform movements in general, see Bannan, "Ideal of Civilization"; Burgess, *Mohonk, Its People and Spirit*; Mardock, *Reformers and the American Indian*; Mathes, "Nineteenth-Century Women and Reform"; Wanken, "'Woman's Sphere' and Indian Reform."

8. Lears, *No Place of Grace*, 93.

9. For a discussion of Southwestern art markets, see Batkin, "Tourism Is Overrated"; Berlo, *Early Years of Native American Art History*; Hutchinson, *Indian Craze*; Mullin, *Culture in the Marketplace*; Wade, "History of the Southwest Indian Ethnic Market" and "Ethnic Art Market."

10. ARCIA 1894, 348.

11. Quoted in Holm, *Great Confusion in Indian Affairs*, 89.

12. RSIS 1894–97.

13. Untitled document, NWMAC, Estelle Reel Papers MS120, box 1, folder 1–5. Reel maintained her close ties with the National Educational Association throughout

her tenure in the Indian Office as evidenced by her choice of holding the annual Indian Institutes in connection with the association meetings. For a discussion of Reel's career see Lomawaima, "Estelle Reel," 5–31.

14. *RSIS* 1901, 23.
15. Reel, *Course of Study*, 55.
16. Reel, *Course of Study*, 131.
17. *RSIS* 1902, 20.
18. *RSIS* 1904, 22.
19. *RSIS* 1902, 21.
20. For a discussion of safe versus dangerous cultural differences, see Lomawaima and McCarty, *"To Remain an Indian."*
21. *ARCIA* 1898, 335.
22. *ARCIA* 1898, 342.
23. Reel, *Course of Study*, 58; *RSIS* 1902, 21.
24. *RSIS* 1902, 21.
25. *RSIS* 1903, 33.
26. *RSIS* 1904, 22.
27. *RSIS* 1901, 13.
28. Reel, *Course of Study*, 56–57.
29. Reel, *Course of Study*, 231.
30. Reel, *Course of Study*, 59.
31. Reel, *Course of Study*.
32. *ARCIA* 1901, 415.
33. On the exceptionality and uniqueness of Carlisle see in particular Waggoner, *Firelight*.
34. "Reports of Superintendent of Independent Schools" in *ARCIA* 1902, 165.
35. "Reports of Superintendent of Independent Schools" in *ARCIA* 1903, 435.
36. "Reports of Superintendent of Independent Schools" in *ARCIA* 1904, 458, and *ARCIA* 1903, 421.
37. "Reports of Superintendent of Independent Schools" in *ARCIA* 1903, 418; Child, *Boarding School Seasons*, 80.
38. Lomawaima and McCarty, *"To Remain an Indian,"* 60.
39. Lomawaima and McCarty, *"To Remain an Indian,"* 61.
40. The Reel Papers contain another photograph of the Crow school depicting a group of students posing outdoors with their works. Elizabeth Hutchinson describes the "coarsely woven wicker baskets" as having "little 'Native' character." See *Indian Craze*, 61–62.
41. "Reports of Superintendent of Independent Schools" in *ARCIA* 1904, 456.
42. *RSIS* 1905, 16.

43. For a discussion on the use of photography in displaying the progress toward assimilation in Indian schools, see Adams, *Education for Extinction*; Fear-Segal, *White Man's Club*; Malmsheimer, "'Imitation Whiteman'"; Margolis, "Looking at Discipline, Looking at Labour"; and Margolis and Rowe, "Images of Assimilation."

44. Sociologists Eric Margolis and Jeremy Rowe analyze a similar photograph from 1908 they found in a private collection; printed on a colored postcard likely used to advertise the Phoenix School, this image is extremely fascinating in that it depicts two Navajo boys engaged in blanket weaving, something rarely seen in historical photographs of Native industries in Indian schools. Like the two girls in Reel's report, the boys are working on looms made out of a bed frame, but contrary to the other picture, are captured in a more natural and less fabricated classroom environment. See Margolis and Rowe, "Manufacturing Assimilation," available at http://www.public.asu.edu/~jeremy/indianschool /paper.htm. The article "Images of Assimilation," a revised version of this article, did not include this photograph.

45. Lomawaima and McCarty, *"To Remain an Indian,"* 60–61; Hutchinson, *Indian Craze*, 80–81.

46. *ARCIA* 1904, 404.

47. *ARCIA* 1905, 385

48. *RSIS* 1905, 17.

49. *ARCIA* 1905, 7, 12.

50. *ARCIA* 1905, 12.

51. *RSIS* 1905, 28.

52. *ARCIA* 1906, 71–72.

53. Waggoner provides extensive analysis and visual documentation of DeCora's career as an illustrator as well as of her participation at BIA exhibits. See *Firelight*, 83–105.

54. *ARCIA* 1906, 72.

55. DeCora, quoted in Curtis, "American Indian Artist," 65.

56. DeCora, "Native Indian Art (1907)," 1007. Similar speeches with the same title were delivered at the twenty-sixth meeting of the Lake Mohonk Conference in 1908 and at the first meeting of the Society of American Indians held in Columbus, Ohio, in 1911.

57. Simonsen, *Making Home Work*, 201.

58. DeCora, "Native Indian Art" (1908), 16.

59. After her first year at Carlisle, DeCora wrote an account of the progress made in teaching Indian art upon request of the commissioner; a portion of this narrative is included in Leupp's 1906 annual report. See *ARCIA* 1906, 72.

60. DeCora, "Native Indian Art" (1911), 85. Additional examples of DeCora's designs were included in *The Indians' Book*, by Natalie Curtis, which collected stories and songs from different geographical areas and organized them according to their regional provenance. DeCora designed a lettered motif for each tribe listed under the main regions identified by Curtis, which were Eastern, Lake, Plains, Northwestern, Southwestern, and Pueblo.

61. *ARCIA* 1906, 72.

62. The volume was found among the photographic collections of the Bureau of Indian Affairs at the National Archives in College Park, Maryland, and belongs to a series of similar bound volumes with reproductions of original exhibit prints. The volume that contains the rug designs is labeled "Unidentified" as the schools of provenance are unknown. While it is very likely that these designs were produced by DeCora's students around 1909, there is no evidence to confirm that this was the case.

63. DeCora, "Native Indian Art" (1907), 1007.

64. DeCora, quoted in Curtis, "American Indian Artist," 65.

65. "Carlisle's Commencement Exercises," *Indian Craftsman* 1, no. 4 (May 1909): 50.

66. The school permanently closed in 1918 after an official investigation requested by the students. For a discussion of the problems that engulfed Carlisle in the 1910s—mismanagement and incompetency, harsh corporal punishments, scandals related to the football team, and an overall moral decline—and that eventually led also to the elimination of the Native art program see Adams, *Education for Extinction*, and Waggoner, *Firelight*.

67. Lomawaima and McCarty, *"To Remain an Indian,"* 56.

68. DeCora, "Native Indian Art" (1907), 1006.

69. Lomawaima presents abundant evidence that students at Chilocco created a school culture of their own by ingeniously using the opportunities that presented themselves, thus reinforcing the very Indian identities that the school tried to erase. See Lomawaima, *They Called It Prairie Light*, particularly chapter 6.

70. Agents on reservations also often did what they considered best in dealing with Indians under their charge. In a 1913 article published in *Outlook*, Natalie Curtis lamented that the while the "old oppressive educational system was at least nominally revoked at Washington," it continued on the reservations where "the old prejudice still prevails; for it will take some time to banish from the minds of isolated Government employees in remote outposts (themselves denied all intercourse with a larger world of thought) the old, deep-rooted conviction that they are there to make the Indian over into a white man as speedily as possible, and that to this end all things Indian must be vigorously stamped out." See "Perpetuating of Indian Art," 624.

71. Simonsen, *Making Home Work*, 201–2.

72. On the education of Indian girls, see in particular Devens, "'If We Get the Girls, We Get the Race'"; Lomawaima, "Domesticity in the Federal Indian Schools"; and Trennert, "Educating Indian Girls."

73. Office of Indian Affairs, *Rules for the Indian School Service*. Commissioner Sells indicated agriculture, stock raising, and home building as the main trades for the boys, and housekeeping, sewing, and nursing for girls.

74. Office of Indian Affairs, *Tentative Course of Study*, 3.

75. Office of Indian Affairs, *Tentative Course of Study*, 5–6.

76. Office of Indian Affairs, *Tentative Course of Study*, 15.

77. This can also be seen in the grade-by-grade outline of the course of study; there is no mention of Native industries anywhere in either the primary, prevocational, or vocational divisions. See Office of Indian Affairs, *Tentative Course of Study*, 16–24.

78. See for example, Adams, *Education for Extinction*; Child, *Boarding School Seasons*; Ellis, "We Had a Lot of Fun"; Lomawaima, *They Called It Prairie Light*; Trennert, *The Phoenix Indian School*.

4. "THE ADMINISTRATION HAS NO SYMPATHY"

1. Biebel, "Cultural Change on the Southwest Frontier," 215.

2. A Methodist school, the Albuquerque College, opened in 1887 but did not survive the passage of the 1891 public law, either, and closed soon after.

3. Thomas to Marble, February 7, 1881, NARA-RMR, RG 75, Pueblo/Pueblo and Jicarilla Agencies, Press Copies of Letters Sent, entry 1, box 4, volume 7.

4. Reverend Jackson, a founding member of the Woman's Board of Home Missions of the Presbyterian Church, was the first missionary to establish schools in Alaska for the education of Alaska Natives. Accounts of his work can be found in *Alaska and Missions on the North Pacific Coast* and his *Annual Reports on Education in Alaska*.

5. Thomas to Price, November 28, 1881, NARA-RMR, RG 75, Pueblo/Pueblo and Jicarilla Agencies, Press Copies of Letters Sent, entry 1, box 4, volume 7.

6. *Annual Report (First Eight Months of the Pueblo Industrial Boarding school Located at Albuquerque, New Mexico)*, August 31, 1881, NARA-RMR, RG 75, Pueblo/Pueblo and Jicarilla Agencies, Copies of Monthly and Annual Narrative Reports, 1875–1885, entry 20, box 1.

7. Thornton, *Report of the Governor of New Mexico to the Secretary of Interior, 1895*, SRCA, Territorial Archives of New Mexico–Governor Papers, roll 125, frame 1113. The Territory of New Mexico became the state of New Mexico in 1912. Unfortunately, there is no evidence to reveal the parents' perspective on the school. While

numerous scholars have documented Indians' acceptance and even encouragement of the white man's education for their children, one has to ponder the truthfulness of Shearer's observation that parents saw teachers as their "truest friends."

8. Thomas to Marble, February 7, 1881, NARA-RMR, RG 75, 2.

9. Jojola, "Come the Red Men, Hear Them Marching." Similar lobbying efforts are documented by historian Robert Trennert in his work on the Phoenix Indian School. Trennert writes that the need to bolster the local economy was the main reason behind the establishment of the school in the early 1890s. As the city was quickly expanding, a school could have brought the seat of the capital (moved from Prescott), real estate development and increases in land value, building contracts, and extra dollars for the local administration. Additionally, it could have also benefited local businesses and families as the first looked for cheap labor and the second for domestic aids. The school Indian population could have supplied both needs. Set in such an ideal environment, near an urban area but close to farmland, Phoenix offered plenty of training opportunities for Indian children, thus meeting the goals set by educators and policymakers. See Trennert, *Phoenix Indian School*.

10. In-depth examinations of Presbyterian missionaries' education of American Indians are provided by Michael Coleman. See "No Race, but Grace"; *Presbyterian Missionary Attitudes*; and "Response of American Indian Children."

11. Coleman, "No Race, but Grace." For a discussion of Pratt's racial theories, see Fear-Segal, *White Man's Club*.

12. Coleman, "Response of American Indian Children," 475.

13. McKinney, "History of the Albuquerque Indian School (to 1934) I," 116.

14. They were John Lane, U.S. Indian agent, April 1, 1894, to June 15, 1894; F. F. Avery, superintendent, June 16, 1894, to August 7, 1894; W. M. Moss, supervisor, August 8, 1894, to September 30, 1894; J. J. McKoin, superintendent, October 1, 1894, to April 9, 1896; M. B. Shelby, Special U.S. Indian agent, April 10, 1896, to April 26, 1896; S. M. McCowan, superintendent, April 27, 1896, to June 5, 1897.

15. ARCIA 1897, 360.

16. They were Edgar A. Allen, superintendent, June 6, 1897, to March 31, 1900; M. F. Holland, supervisor, April 1, 1900, to May 26, 1900; Ralph P. Collins, superintendent, May 27, 1900, to March 17, 1903; A. O. Wright, supervisor, March 18, 1903, to June 30, 1903; James K. Allen, superintendent, July 1, 1903, to May 27, 1906; Charles H. Dickson, supervisor, June 1906, to July 5, 1906; Burton B. Custer, superintendent, July 6, 1906, to February 17, 1908; Reuben Perry, superintendent, February 18, 1908, to 1932.

17. "Historical Sketch of the United States Indian School, Albuquerque, New

Mex.," *Albuquerque School for Indians, U.S. Indian School,* CSWR, Richard W. D. Bryan Family Papers, MSS I BC, box 2, folder 3.

18. *Calendar for Indian Training School, 1914–1915,* CSWR, Richard W. D. Bryan Family Papers, MSS I BC, box 2, folder 3, 5.

19. "Historical sketch—United States Indian Training School, Albuquerque, New Mexico," *Albuquerque Indian School Calendar, 1925–1926,* 5–6.

20. *Annual Report, August 31, 1881,* p. 1.

21. "The Savage at the School," *Albuquerque Journal,* September 1883.

22. "Our Young Savages," *Albuquerque Evening Democrat,* January 22, 1885.

23. "The Albuquerque Indian School," *New Year's Journal* [?], date unknown, CSWR, Richard W. D. Bryan Family Papers, MSS I BC, box 2, folder 4.

24. Michael Coleman does not mention drawing as one of the curriculum subjects in his many studies of Presbyterian-run schools for American Indians, so a comparison with other institutions affiliated with this religious denomination is not possible.

25. *Report Form,* CSWR, Richard W. D. Bryan Family Papers, MSS I BC, box I, folder I.

26. A graduate of Lafayette College in Pennsylvania, Bryan worked at the Naval Observatory in Washington and participated in the Polaris expedition in search of the North Pole. When he was appointed to the Albuquerque School, he had no previous experience in Indian education. CSWR, Richard W. D. Bryan Family Papers, MSS I.

27. "Albuquerque Indian School, September 15, 1884," CSWR, Richard W. D. Bryan Family Papers, MSS I BC, box I, folder I, p. 2.

28. Newspaper and date unknown, CSWR, Richard W. D. Bryan papers, MSS I BC, box 2, folder 4.

29. "Civilizing the Indian. A Better and Cheaper Plan than Killing Them. School-work in the Southwest," May 16, 1886, CSWR, Richard W. Bryan Papers, box 2, folder 4.

30. *The History of the Women's Exhibit from the Territory of New Mexico to the World's Columbian Exposition,* CSWR, L. B. Prince Papers, box 14029, folder 6, p. 3.

31. For a critical discussion of school photographs, see Malmsheimer, "'Imitation Whiteman'"; Margolis, "Class Pictures" and "Looking at Discipline."

32. Otero, *Report of the Governor of New Mexico,* 1902, SRCA, Territorial Archives of New Mexico, Governor Papers, roll 149, frame 2, p. 71; "Exhibition Hall. Few More Facts about the Exhibits in the Hall," *Albuquerque Daily Citizen,* October 14, 1903, 5.

33. See figures 48 and 49 for images of the Boston Exhibit.

34. McKinney, "History of the Albuquerque Indian School," 130. Collins was in charge of the school from May 27, 1900, to March 17, 1903.

35. "Kindergarten and Primary," *Albuquerque Indian* 1, no. 2 (July 1905): 8.

36. "School Exhibit Incomplete, Men Work on Sunday," *Albuquerque Morning Journal*, November 22, 1915, 5.

37. The overall Indian policy of the time reflected this belief: without aid from the government, Indians were unable to progress because impaired by nature. As historian Frederick Hoxie writes, the gap between the races was too wide. Policymakers, therefore, no longer conceived Indian education as the means to improve the quality of life of American Indian children, and assimilation into American society was no longer the desired goal, although still a government responsibility. See Hoxie, *Final Promise*.

38. Thomas to Price, December 22, 1881, NARA-RMR, RG 75, Pueblo/Pueblo Jicarilla Agencies, Copies of Monthly and Annual Narrative Reports, 1875–1885, entry 20, box, 1.

39. The Alvarado Indian Department hired Native craftspeople and put them "on display" while they worked at their crafts so that tourists who passed through the building could admire and more importantly purchase their work. The display areas were strategically placed at the entrance of the hotel, so that tourists coming from the tracks and walking to the lobby had to pass through them. For studies on the Fred Harvey Company, see Howard and Pardue, *Inventing the Southwest*; Weigle and Babcock, *Great Southwest of the Fred Harvey Company*.

40. RSIS 1902, 10, 26.

41. McKinney, "History of the Albuquerque Indian School," 134–35.

42. RSIS 1904, 22.

43. In the *Course of Study*, Reel recommended Mary White's *How to Make Baskets* "for helpful ideas." See *Course of Study*, 58. Other very popular books were George Wharton James's *Indian Basketry* (1903) and later *Indian Blankets and their Makers*, and Otis Mason's *American Indian Basketry* (1904).

44. Reel, *Course of Study*, 58.

45. Among the famous artists working at the Alvarado was Navajo weaver Elle of Ganado. See Howard and Pardue, *Inventing the Southwest*; L. J. Moore, "Elle Meets the President," 21–44; Weigle and Babcock, *Great Southwest of the Fred Harvey Company*.

46. Parezo and Fowler, *Anthropology Goes to the Fair*, 143.

47. McCowan to School Superintendents, August 22, 1903, SIMA, Records of Sherman Institute, Circulars 1901–1903.

48. RSIS 1905, 15.

49. Printing was one of the subjects outlined in the *Course of Study*, but did not exist at Albuquerque prior to 1905. It is possible that the publication of the *Albuquerque Indian* was envisioned in the aftermath of the St. Louis Fair and

the success of the *Indian School Journal*, which brought money to the school that published it. See Parezo and Fowler, *Anthropology Goes to the Fair*, 149.

50. "Future of Our School," *Albuquerque Indian* 1, no. 1 (June 1905): 13.

51. "Future of Our School," *Albuquerque Indian* 1, no. 1 (June 1905): 13.

52. "Our Young Savages," *Albuquerque Evening Democrat*, January 22, 1885.

53. In addition to her popular novel *Ramona*, which was set in Southern California and filled with scenes of mission lifestyle, Helen Hunt Jackson wrote *Glimpses of California and the Missions*, an illustrated collection of essays on the old churches. Charles Lummis, on the other hand, popularized the missions through the pages of the *Los Angeles Times* for which he was a reporter. For a study of the mission style, see Baca, *Romance of the Mission*.

54. Rodel and Binzen, *Arts and Crafts Furniture*.

55. Parezo and Fowler, *Anthropology Goes to the Fair*, 433n44.

56. "Future of Our School," *Albuquerque Indian* 1, no. 1 (June 1905): 13.

57. "Big Fair Parade Best Ever Witnessed in Albuquerque," *Albuquerque Weekly Citizen*, October 12, 1907, 1; "Warmly Commends School Exhibit," *Albuquerque Morning Journal*, October 2, 1908, 6; "Industrial Trades Display Parade Feature of Fair Program Thursday," *Albuquerque Morning Journal*, October 13, 1909, 6.

58. McKinney, "History of the Albuquerque Indian School II," 210.

59. "Prizes Awarded in Agricultural Exhibit," *Albuquerque Morning Journal*, October 7, 1910, 3.

60. McKinney, "History of the Albuquerque Indian School II," 212–13.

61. Woodman, "Value of Manual Arts," 31–32.

62. *Annual Report of the Albuquerque Indian School*, 1910, 8.

63. "Program of NM Educational Convention, Nov. 24–28," *Santa Fe New Mexican*, November 23, 1917, 5.

64. McKinney, "History of the Albuquerque Indian School (to 1934 conclusion)," 313.

65. *Tentative Course of Study for Arts and Crafts, Albuquerque Indian School*, Albuquerque, New Mexico, circa 1930, LAA, Kenneth M. Chapman Collection, 89KC0.016.

66. Gram, *Education at the Edge of Empire*, 6.

5. "DRAWING AND ALL THE NATURAL ARTISTIC TALENTS"

1. *Sherman Institute, U.S. Indian School, Riverside, California*, 1908, SIMA, Records of Sherman Institute.

2. Mission Indians included La Jolla, Manzanita, Morongo, Pala, San Manuel, and Santa Rosa. Other Southern California tribes included Chumash, Cahuilla, Luiseño, Serrano, Diegueno, Mohave, and Yuma.

3. "Perris School for Indians," *Los Angeles Times*, April 2, 1900, 19. For a picture of the Perris school building, see Gonzales, "Riverside, Tourism, and the Indian," 203.

4. Hall was not the first to voice his concerns; some of the problems of the school had already been reported by previous superintendents. In 1894 William Bray lamented the scarcity of irrigation water and the lack of school facilities able to accommodate all the children that sought admission. The following year, Edgar Allen described the land of the Indian school as the "poorest in the locality," with "no natural drainage" and a soil that is "an adobe that bakes hard after being wet, and seems exceedingly poor in plant food." He also noted the scarcity of water and the difficulties of irrigation. See ARCIA 1894, 372–73 and ARCIA 1895, 362.

5. "New Indian School," *Los Angeles Times*, January 15, 1898, 2.

6. Reel to the Commissioner of Indian Affairs, June 3, 1899, NWMAC, Estelle Reel Collection MS 120, box 2, folder 2.15; Hall to the Commissioner of Indian Affairs, July 26, 1899, NARA-PR, Sherman Institute, Records of the Superintendent, Letters sent to the Commissioner of Indian Affairs, box 42. According to Clyde Ellis, the Rainy Mountain Boarding School in Oklahoma was another institution with insufficient water supply; in this case, however, the Indian Service neither intervened nor cared. For Perris, there is evidence that Riverside businessmen, particularly Frank A. Miller, strongly lobbied their congressman and the commissioner of Indian Affairs to ensure that the school was moved to a more prosperous location such as Riverside. See, Ellis, *To Change Them Forever*; Gonzales, "Riverside, Tourism, and the Indian."

7. Quoted in Gonzales, "Riverside, Tourism, and the Indian," 198, 211.

8. Economic advantages for the local community were the rationales also for the establishment of two "neighboring" institutions built around the same time: the Albuquerque Indian School, discussed in the previous chapter, and the Phoenix Indian School. For more on this institution, see Trennert, *Phoenix Indian School*.

9. See Gonzales, "Riverside, Tourism, and the Indian," 194–208; "Perris Protests," *Los Angeles Times*, January 28, 1898, 15; "The Perris Indian School," *Los Angeles Times*, March 10, 1900, 18; "Scheming Push," *Los Angeles Times*, March 25, 1900, 16; "The Perris School," *Los Angeles Times*, March 27, 1900, 18; "Perris School for Indians," *Los Angeles Times*, April 2, 1900, 19.

10. "The Perris Indian School," *Los Angeles Times*, March 10, 1900, 18; "Ways of Riverside 'Push,'" *Los Angeles Times*, June 23, 1900, 18.

11. "Corner-stone of Sherman Institute Laid Yesterday with Appropriate Ceremony," *Los Angeles Times*, July 19, 1901, A1. Interestingly enough, as Gonzales

points out, a formal opening ceremony "was not held, however, until February 10, 1903, nineteen days after Miller's New Glenwood Mission Inn opened to guests." For the next thirty years, Frank Miller continued to be involved in "promoting" the Indian school in ways that would ensure profitable returns for himself and his businesses. For example, he was the mastermind behind the construction of the Chemawa Park and Zoo next to the school grounds (his savvy plan would take his hotel costumers to the park by way of a ride on the streetcar and a visit to the school), frequently organized and sponsored school band concerts in the park, commissioned student plays, and hired students to work as domestics in his hotel, just to name a few. See Gonzales, "Riverside, Tourism, and the Indian."

12. Reel to the Commissioner of Indian Affairs, June 3, 1899, NWMAC, Estelle Reel Collection, MS 120, box 2, folder 2.15, 3–4.

13. For a discussion of Sherman's marketing technique through the promotion of music and sports, see Medina, "Selling Indians at Sherman Institute, 1902–1922."

14. Hall to the Commissioner of Indian Affairs, April 23, 1902, SIMA, Records of Sherman Institute, Letters to the Commissioner of Indian Affairs.

15. Hall to the Commissioner of Indian Affairs, March 31, 1902, SIMA, Records of Sherman Institute, Letters to the Commissioner of Indian Affairs.

16. *Sherman Institute*, 10–11.

17. "Our Purpose," *Sherman Bulletin* 1, no. 1 (March 6, 1907): 1, SIMA, Records of Sherman Institute.

18. *Estimate of School Books and Supplies for the Fiscal Year 1894–1895*, SIMA, Records of Sherman Institute, box unmarked [employees].

19. *Report of the Board of Management, United States Government Exhibit, Cotton States and International Exposition*, 70.

20. "The Riverside Show," *Los Angeles Times*, April 18, 1900.

21. ARCIA 1900, 483.

22. Hall to Anna M. Lukens, July 2, 1902, SIMA, Records of Sherman Institute, Letters, September 1901 to July 1902.

23. One such letter came from Miss Anna Noble in March of 1907. See Hall to Miss Anna Noble, March 29, 1907, NARA-PR, Sherman Institute, Records of the Superintendent, Letters Sent, 1909–1948, box 58.

24. Hall to the Commissioner of Indian Affairs, November 20, 1902, NARA-PR, Sherman Institute, Letters Sent to the Commissioner of Indian Affairs, box 42.

25. "Our Purpose," *Sherman Bulletin* 1, no. 1 (March 6, 1907): 11.

26. These journals were published respectively by Carlisle, Chilocco, and Haskell. Chemawa and Phoenix also had their own magazines. An in-depth study of

Indian school publications has yet to be done. Jacqueline Fear-Segal has used the pages of Carlisle's *Indian Helper* as her principal source for learning about the personal experiences of those students who did not leave behind any written account. A thorough examination of the commentaries of the journal's imaginary editor, Man-on-the-Bandstand, and more particularly the "constant complaints and lists of infractions" he refers to, has provided invaluable insights into the lives of Indian children. According to the author, these subtle admonitions and reproaches for the students' misconduct not only reveal the many instances in which pupils purposefully disobeyed the rules as an act of resistance, but can also disclose their personal views and responses to school policies. As Fear-Segal has demonstrated, the lack of individual written accounts of these small "accomplishments" does not signify their nonexistence. See Fear-Segal, *White Man's Club*, 223.

27. "General News," *Sherman Bulletin* 3, no. 22 (June 2, 1909): 3.
28. "General Items," *Sherman Bulletin* 1, no. 4 (March 27, 1907): 3.
29. "School Room Notes," *Sherman Bulletin* 1, no. 9 (May 1, 1907): 3.
30. "Local Items," *Sherman Bulletin* 1, no. 12 (May 22, 1907): 4.
31. "School Room Notes," *Sherman Bulletin* 1, no. 13 (May 29, 1907): 3.
32. The issue of forced education of Hopi children in government schools had caused divisions among many villages, particularly at Oraibi. Here, the diatribes between the "Friendly," who favored education, and the "Hostile," who strongly rejected it, came to a dramatic battle that ended in what is commonly referred to as the Oraibi split in September of 1906. Chief Tawaquaptewa, leader of the Friendly faction, forced the Hostiles to leave the village, but was eventually mandated by government officials to either go to prison or attend an off-reservation school. He chose the latter and decided to attend Sherman Institute with a group of about seventy Hopi. For a more detailed account of his experience at Sherman, see Gilbert, *Education Beyond the Mesa*.
33. Natalie Curtis began her work with the Hopis with Loolomai, Tawaquaptewa's predecessor, before he died in 1904. She continued her preservation efforts with Chief Tawaquaptewa and often visited him at Sherman. See Gilbert, *Education Beyond the Mesas*.
34. "Commencement Week," *Sherman Bulletin* 1, no. 11 (May 16, 1907): 1.
35. Medina, "Selling Indians at Sherman Institute," 2, 109.
36. Gilbert, *Education Beyond the Mesas*, 80.
37. Manuscript 4492, NAA.
38. Anne Israel to Dr. D. S. Lamb, November 16, 1908, Manuscript 4492, NAA.
39. For more information on Dr. Israel and her work at Sherman, see Keller, *Empty Beds*, and "Healing Touch," 81–106.
40. "General Items," *Sherman Bulletin* 1, no. 14 (June 5, 1907): 4. According to

Sherman's student records, there was no one with the name of Clarence at the school at this time, so even the identity of the artist named Clarence remains unknown. Pierce Kewyantewa, on the other hand, was a sixteen-year-old boy from Oraibi who entered Sherman in the fall of 1906 or spring of 1907.

41. Kabotie and Belknap, *Fred Kabotie*, 8.
42. Brody, *Pueblo Indian Painting*, 24.
43. For a discussion of art in New Mexico schools, see Brody, *Pueblo Indian Painting* and also *Indian Painters and White Patrons*.
44. Fewkes, *Hopi Katcinas*, 13–14.
45. "School Room Notes," *Sherman Bulletin* 1, no. 8 (April 24, 1907): 3; "School Room Notes," *Sherman Bulletin* 1, no. 9 (May 1, 1907): 3; "General News," *Sherman Bulletin* 1, no. 12 (May 22, 1907): 3; "General Items," *Sherman Bulletin* 1, no. 14 (June 5, 1907): 4; "Personal Items," *Sherman Bulletin* 1, no. 26 (October 30, 1907): 4.
46. "A Glimpse into the Classrooms," *Sherman Bulletin* 1, no. 22 (October 2, 1907): 1. The school's intention to cultivate drawing is also demonstrated by the fact that teachers who, like Harriet Harvey, wanted to study art and improve their own skills in order to provide better instruction for the children, were supported by the administration. See, for example, "Personal Items," *Sherman Bulletin* 1, no. 24 (October 16, 1907): 3, and "Personal Notes," *Sherman Bulletin* 2, no. 27 (September 9, 1908): 3.
47. "Local Items," *Sherman Bulletin* 1, no. 6 (April 10, 1907): 4.
48. "General News," *Sherman Bulletin* 3, no. 9 (March 3, 1909): 3.
49. "Pupils' Notes," *Sherman Bulletin* 3, no. 14 (April 7, 1909): 4, and "Pupils' Notes," *Sherman Bulletin* 3, no. 18 (May 5, 1909): 4.
50. "Indian Teachers Illustrate Work," *Los Angeles Herald*, July 4, 1907, 5.
51. "Asks Citizenship for the Indian," *Los Angeles Herald*, July 6, 1907, 7; "Indians Given Broad Training," *Los Angeles Herald*, July 10, 1907.
52. "General News," *Sherman Bulletin* 1, no. 7 (April 17, 1907): 2.
53. "Indian Art in the Schoolroom," *Sherman Bulletin* 1, no. 24 (October 16, 1907): 1.
54. "General News," *Sherman Bulletin* 3, no. 9 (March 3, 1909): 3.
55. For example, in 1919 Sherman attended the Sacramento State Fair with a school display of maps, samples of penmanship, drawings, examination papers, and written work, but it is only through internal correspondence between Conser and the superintendent in charge of the Indian exhibit that we learn that "Sherman took the prize of $20 for Best General Exhibit by Indian Boarding School, and Homer Cacy took prize for Best Drawing." Conser did not publicize this success in any way. See Frank A. Virtue to Conser, September 12, 1919, NARA-PR, Sherman Institute, Central Classified Files, box 4, folder 047.

56. "General News," *Sherman Bulletin* 2, no. 31 (October 7, 1908): 2.

57. Hall to Mr. Frank Sorenson, September 7, 1908, NARA-PR, Sherman Institute, Records of the Superintendent, Letters Sent, 1909–1948, box 59. These included ambro protractor, triangle ambro protractor, ruling pen, spring divider, and compass. The Eugene Dietzgen Co. Manufacturers of Drawing Materials and Surveying Instruments was a nationwide renowned supplier of drawing paper and drawing supplies. Its factory and headquarters were in Chicago, but branch offices were also in New York, Pittsburgh, New Orleans, San Francisco, and Los Angeles. http://www.sphere.bc.ca/test/dietzgen.html (accessed October 14, 2014).

58. Conser to Mr. John Charles, June 11, 1909, NARA-PR, Sherman Institute, Records of the Superintendent, Letters Sent, 1909–1948, box 59.

59. Conser to Mr. H. B. Peairs, June 24, 1909, NARA-PR, Sherman Institute, Records of the Superintendent, Letters Sent, 1909–1948, box 59; Conser to Mr. Reuben Perry, July 14, 1909, NARA-PR, Sherman Institute, Records of the Superintendent, Letters Sent, 1909–1948, box 59.

60. Vocational Courses, NARA-PR, Sherman Institute, box 114, folder: Vocational Course Outlines 1911–1912.

61. M. A. Collins to Conser, December 2 [1914] and Conser to CIA, December 8, 1914, NARA-PR, Sherman Institute, Records of the Superintendent, Letters Sent to the Commissioner of Indian Affairs, box 44. The book by Linus Faunce was *Mechanical Drawing: Prepared for the Use of the Students of the Massachusetts Institute of Technology*, originally published in 1887.

62. Hall to Clara Sanford, March 27, 1900, SIMA, Records of Sherman Institute, Letters, April 1898 to May 1900.

63. Hall to the Commissioner of Indian Affairs, July 18, 1900 (a), NARA-PR, Sherman Institute, Records of the Superintendent, Letters Sent to the Commissioner of Indian Affairs, box 42.

64. Hall to the Commissioner of Indian Affairs, July 18, 1900 (b), NARA-PR, Sherman Institute, Records of the Superintendent, Letters Sent to the Commissioner of Indian Affairs, box 42.

65. Hall to the Commissioner of Indian Affairs, June 3, 1901, SIMA, Records of Sherman Institute, Letters to the Commissioner of Indian Affairs; and Hall to Mrs. Elizabeth M. Jones, January 16, 1902, SIMA, Records of Sherman Institute, Letters, September 1901 to July 1902.

66. Assistant Commissioner Tonner to Hall, February 15, 1902, SIMA, Records of Sherman Institute, Circulars 1901–1903.

67. Hall to the Commissioner of Indian Affairs, March 31, 1902, SIMA, Records of Sherman Institute, Letters Sent to the Commissioner of Indian Affairs.

68. Hall to Commissioner of Indian Affairs, April 23, 1902, SIMA, Records of Sherman Institute, Letters to the Commissioner of Indian Affairs.

69. Reel to Hall, January 7, 1903, SIMA, Records of Sherman Institute, box unmarked [employees].

70. In his second annual message to the nation on December 2, 1902, President Theodore Roosevelt said that "every effort should be made to develop the Indian along the lines of natural aptitude, and to encourage the existing native industries peculiar to certain tribes, such as the various kinds of basket weaving, canoe building, smith work, and blanket work." See *The American Presidency Project*, "Theodore Roosevelt. Second Annual Message, December 2, 1902." http://www.presidency.ucsb.edu/ws/index.php?pid=29543.

71. Reel to Miss Olive Ford, October 30, 1906, NARA-PR, Sherman Institute, Records of the Superintendent, Central Classified Files, 1907–1939, box 4, folder 047.

72. "Indian Art in the Schoolroom," *Sherman Bulletin* 1, no. 24 (October 16, 1907): 1.

73. "A Glimpse into Ramona Home," *Sherman Bulletin* 1, no. 2 (March 13, 1907): 1; "General News," *Sherman Bulletin* 1, no. 4 (March 27, 1907): 2; "General News," *Sherman Bulletin* 1, no. 8 (April 24, 1907): 2; "Industrial Notes," *Sherman Bulletin* 1, no. 26 (October 30, 1907): 3; "General News," *Sherman Bulletin* 1, no. 32 (December 11, 1907): 2; "Ranch Notes," *Sherman Bulletin* 2, no. 2 (January 8, 1908): 3; "General News," *Sherman Bulletin* 2, no. 6 (February 5, 1908): 2.

74. "General News," *Sherman Bulletin* 1, no. 8 (April 24, 1907): 2; "Pupils' Notes," *Sherman Bulletin* 2, no. 4 (January 22, 1908): 2; "General News," *Sherman Bulletin* 2, no. 5 (January 29, 1908): 2.

75. "Industrial Notes," *Sherman Bulletin* 1, no. 26 (October 30, 1907): 3. This seems to contradict Hall's claim that rug weaving was to "make the pupils self supporting at once" (Hall to Commissioner of Indian Affairs, April 23, 1902, Sherman Museum, Letters to the Commissioner of Indian Affairs), but as I have previously explained, the rug-making skills learned at Sherman would have allowed female students to become more economically independent only after they left school.

76. Hall to Mr. C. C. Manning, December 3, 1904, NARA-PR, Sherman Institute, Records of the Superintendent, Letters Sent, box 57; and April 26, 1906, NARA-PR, Sherman Institute, Records of the Superintendent, Letters Sent, box 58. Hall also bought Navajo blankets from another supplier in Fort Defiance, the Ilfeld Indian Trading Co.

77. *Sherman Bulletin* 1, no. 32 (December 11, 1907): 3; "General News," *Sherman Bulletin* 3, no. 5 (February 3, 1909): 2; "General News," *Sherman Bulletin* 3, no. 13 (March 31, 1909): 2; "General News," *Sherman Bulletin* 3, no. 21 (May 26, 1909): 2.

78. It is important to remember that 1909 also marked the end of Francis Leupp's tenure as commissioner of Indian Affairs.

79. Conser to Esther Fowler, November 14, 1913, NARA-PR, Sherman Institute, Records of the Superintendent, Central Classified Files, box 38, folder 1000.

80. "Dressmaking," "Intermediate Sewing," Vocational Courses, NARA-PR, Sherman Institute, box 114, folder Vocational Course Outlines 1911–1912.

81. Reel, *Course of Study*, 232–33.

82. See, for example, Gibbs, *Household Textiles*; M. P. Todd, *Hand-Loom Weaving*; Woolman and McGowan, *Textiles*.

83. Conser to the Commissioner of Indian Affairs, August 23, 1912, NARA-PR, Sherman Institute, Records of the Superintendent, Letters Sent to the Commissioner of Indian Affairs, box 44.

84. Conser to Reed Manufacturing Company, February 28, 1913, and Conser to the Newcomb Loom Company, February 28, 1913, NARA-PR, Sherman Institute, Records of the Superintendent, Letters Sent, 1909–1948, box 63. The Reed Loom Company, owned by F. C. Reed, began the manufacture of looms in the late 1800s and sold, according to its catalogue, "the most practical line of carpet and rug weaving machinery on the market." Its main products included the "Weaver's Friend," the "Ideal Loom," and the "Cambridge," which was recommended as "particularly adapted for teaching weaving in schools and colleges." Each loom came with its own "Manual on Weaving." The Newcomb Company, on the other hand, was started in the early 1880s by contractor and wheel-maker Charles Newcomb of Omaha, Nebraska, who originally made the "Newcomb shuttle" and sold it throughout in Nebraska, Kansas, and western Iowa. In 1889 he moved to Davenport, enlarged his factory, and modified his original loom thus creating the "Weaver's Friend," "Little Daisy," and "Weaver's Delight." See *Loom Weaving Supplies* (Reed Loom Company, Springfield, Ohio), available at On-Line Digital Archive of Documents on Weaving and Related, http://www.cs.arizona.edu/patterns/weaving/index.html; *The Weaver's Friend*, http://www.weaversfriend.com/page1/page1.html.

85. In later correspondence with the commissioner of Indian Affairs, Conser lamented the inadequacy of the expenditure funds allotted to Sherman to cover these expenses. See Conser to the Commissioner of Indian Affairs, February 24, 1914, NARA-PR, Sherman Institute, Records of the Superintendent, Letters Sent to the Commissioner of Indian Affairs, box 44.

86. These and other photographs of students working on upright looms can be found in Reel's reports. See, for example, "Blanket Weaving in the Class Room as Suggested by the Course of Study, Fort Lewis, Colorado," in *RSIS* 1902, facing 20; "Teaching Blanket Weaving, Phoenix Indian School, Arizona," in *RSIS*

1903, facing 20; "Weaving Room at Navajo Boarding School, Fort Defiance, Arizona," in RSIS 1905, 17. See also Archuleta, Child, and Lomawaima, *Away From Home*, 90, for a picture of Carlisle.

87. Conser to the Commissioner of Indian Affairs, July 29, 1915, and March 6, 1916,NARA-PR, Sherman Institute, Records of the Superintendent, Letters Sent to the Commissioner of Indian Affairs, box 45.

88. Hall to Commissioner of Indian Affairs, April 23, 1902, SIMA, Records of Sherman Institute, Letters to the Commissioner of Indian Affairs.

89. Reel to Hall, January 7, 1903, SIMA, Records of Sherman Institute, box unmarked [employees].

90. Hall to Mr. Joe Kinsman, March 21, 1906, NARA-PR, Sherman Institute, Records of the Superintendent, Letters Sent, 1909–1948, box 58.

91. Hall to Reverend L. M. Ewing, March 30, 1906, NARA-PR, Sherman Institute, Records of the Superintendent, Letters Sent, 1909–1948, box 58.

92. Reel was not particularly impressed by Sherman and found that various industrial areas needed to be improved or emphasized; she did not make any comments on the state of Native industries other than saying that the school needed "better equipment in the cooking and sewing departments." See RSIS 1906, 7.

93. Hall to Miltona M. Keith, November 27, 1906, NARA-PR, Sherman Institute, Records of the Superintendent, Letters Sent, 1909–1948, box 58.

94. Hall to Leupp, February 4, 1907, NARA-PR, Sherman Institute, Records of the Superintendent, Letters Sent, 1909–1948, box 58.

95. Hall to Miltona M. Staufer, May 11, 1908, NARA-PR, Sherman Institute, Records of the Superintendent, Letters Sent, 1909–1948, box 58, and "General News," *Sherman Bulletin* 2, no. 20 (May 13, 1908): 2.

96. Hall to Miltona M. Keith, November 27, 1906, NARA-PR, Sherman Institute.

97. Hall to Leupp, February 4, 1907, NARA-PR, Sherman Institute; "General News," *Sherman Bulletin* 1, no. 1 (March 6, 1907): 2.

98. Hall to Miltona M. Keith, December 24, 1906,NARA-PR, Sherman Institute, Records of the Superintendent, Letters Sent, 1909–1948, box 58.

99. "General News," *Sherman Bulletin*, 4, no. 4 (January 26, 1910): 2.

100. "Sewing Department," *Sherman Bulletin* 1, no. 4 (March 27, 1907): 1; "Local Items," *Sherman Bulletin* 1, no. 8 (April 24, 1907): 3; "Local Items," *Sherman Bulletin* 1, no. 9 (May 1, 1907): 4; "General News," *Sherman Bulletin* 1, no. 13 (May 29, 1907): 2.

101. "Sewing Department," *Sherman Bulletin* 1, no. 4 (March 27, 1907): 1.

102. "General News," *Sherman Bulletin* 1, no. 22 (October 2, 1907): 2; "Industrial Notes," *Sherman Bulletin* 1, no. 26 (October 30, 1907): 3.

103. At least six letters dealing with the purchase of baskets were found at NARA-PR,

Sherman Institute, Records of the Superintendent, Letters Sent, 1909–1948, boxes 57–59.

104. This could be either a Snow Maiden or a Butterfly Maiden Kachina.

105. Hall to Horton H. Miller, November 27, 1907, NARA-PR, Sherman Institute, Records of the Superintendent, Letters Sent, 1909–1948, box 58.

106. "Pupils' Notes," *Sherman Bulletin* 2, no. 22 (May 27, 1908): 3.

107. Conser to the Commissioner of Indian Affairs, September 12, 1912, NARA-PR, Sherman Institute, Letters Sent to the Commissioner of Indian Affairs, box 44. For a full text of this letter, see Lentis, "Art Education in American Indian Boarding Schools," 386.

108. Conser to the Commissioner of Indian Affairs, May 8, 1916, NARA-PR, Sherman Institute, Records of the Superintendent, Letters Sent to the Commissioner of Indian Affairs, box 45.

109. "Indians Weave Rugs and Baskets at State Fair," *Sacramento Bee*, September 8, 1920; "Work of School Children Reveals Much Originality," *Sacramento Union*, September 8, 1920; Conser to the Commissioner of Indian Affairs, February 28, 1921, NARA-PR, Sherman Institute, Central Classified Files, box 4, folder 047.

110. *Sherman Purple & Gold*, 1934, 36, 72, SIMA, Records of Sherman Institute.

6. "SUSIE CHASE-THE-ENEMY AND HER FRIENDS"

1. For general studies on the representation of American Indians at world's fairs, see Benedict, "International Exhibitions and National Identity"; Hinsley, "World as a Marketplace"; Rydell, *All the World's a Fair*; Rydell, Findling, and Pelle, *Fair America*.

2. Hinsley, "World as a Marketplace," 344.

3. It is important to remember that the first government-run boarding school, Carlisle Indian Industrial School, was founded in 1879. Prior to that, other institutions for the education of Indian children were in existence, for example Forest Grove, in Oregon, and Albuquerque, in New Mexico, but were run by the Board of Home Missions of the Presbyterian Church.

4. See Hutchinson, *Indian Craze*.

5. McCabe, *Illustrated History of the Centennial Exhibition*, 555.

6. "The Centennial," *New York Times*, March 29, 1876; McCabe, *Illustrated History of the Centennial Exhibition*, 555. For more in-depth discussions of the Indian exhibit at the Centennial Exposition, see Huhndorf, *Going Native*, particularly chapter 1, "Imagining America: Race, Nation, and Imperialism at the Turn of the Century"; Trennert, "Grand Failure," and "Indian Role in the 1876 Centennial Celebration."

7. Frank H. Norton, *Frank Leslie's Illustrated Historical Register of the Centennial Exposition*, quoted in Huhndorf, *Going Native*, 32.

8. Rydell, Findling, and Pelle, *Fair America*, 26.

9. "For the New Orleans Exposition," *Washington Post*, November 28, 1884, 1.

10. *Special Report by the Bureau of Education, Educational Exhibits and Conventions*, 41.

11. It is important to remember that drawing was an integral part of Pratt's experiment at Fort Marion. Prisoners were allowed, actually encouraged, to sketch scenes of Indian life according to their pictorial tradition. For more on ledger art, see Earenfight, *Kiowa's Odyssey* and Szabo, *Art from Fort Marion*.

12. ARCIA 1885, 220.

13. *Report of the U.S. National Museum under the Direction of the Smithsonian Institution*, 130. As Gail Bederman has written, this exhibition ultimately wanted to show that the "talents of civilized women" like the Lady Managers—the organizers—"were important for civilization's further advancement." See *Manliness and Civilization*, 38.

14. Fogelson, "Red Man in the White City," 81–84.

15. ARCIA 1892, 61.

16. ARCIA 1891, 79–80.

17. ARCIA 1893, 20.

18. "Our Indian Schools: Exhibit of Industrial Education at the Fair," *Colorado Transcript*, September 13, 1893, 2.

19. ARCIA 1893, 21–22.

20. "Our Indian Schools," *Colorado Transcript*, September 13, 1893, 2.

21. "Work of Indian Children," *New York Times*, November 12, 1893, 18.

22. "Indian Girls' Work," *Chicago Daily Tribune*, April 26, 1893, 9.

23. A very detailed description of what each platoon was bearing was included in Pratt's 1893 report to the superintendent of Indian schools. See ARCIA 1893, 452–53.

24. ARCIA 1893. Press extracts covering the New York parade were from the *New York Sun* (October 11), *New York Tribune, New York World, Boston News, New York Mail and Express, New York Evening Post, Natchez (MS) Democrat, Boston Advertiser*, and *New York Recorder* (October 11). Press extracts on the Chicago parade were from the *Chicago Tribune* (October 21), *Chicago Inter-Ocean, Chicago Journal, New York Herald, Jamestown (NY) Journal* (November 1), and *Chicago News Record*.

25. ARCIA 1893, 21.

26. Trennert, "Selling Indian Education," 210–11. A discussion of Wild West Shows at world's fairs can be found in Moses, *Wild West Shows*, particularly chapter 7, "Indians on the Midway: Fairs and Expositions, 1893–1903."

27. ARCIA 1895, 17.

28. Perdue, *Race and the Atlanta Cotton States Exposition*.

29. *ARCIA* 1896, 21.

30. Commissioner Browning to Edgar A. Allen, March 14, 1895, SIMA, Records of Sherman Institute, box: purchase orders 1895–1905.

31. *ARCIA* 1896, 21–22.

32. *ARCIA* 1896, 21–22.

33. Sloyd, a Swedish word that means "physical force, sagacity, and skill," was a Swedish manual training system traditionally used among peasant families for making utilitarian household objects and farm implements. After the industrial revolution, educator Otto Salomon instituted a sloyd school so that children of working parents could continue learning practical skills, good habits, and taste. Solomon's ideas, strongly influenced by Friedrich Froebel, entered America's public schools thanks to one of his students, Gustaf Larsson, who in 1880 started the Sloyd Training School of Boston for training teachers. Larsson adapted Solomon's curriculum to make it consistent with the public schools' course of study and proposed sloyd particularly in connection with woodwork. Sloyd work consisted of projects that increased in difficulty as a child's skills improved. For studies on sloyd, see Efland, *History of Art Education*; Eyestone, "Influence of Swedish Sloyd"; Logan, *Growth of Art in American Schools*; Wygant, *Art in American Schools*. A photograph of a sloyd class in an Indian school (Carlisle) can be found in *RSIS* 1903, facing 6.

34. *Report of the United States Government Exhibit*, 75.

35. *ARCIA* 1897, 20.

36. "History of the Indian," *Omaha Daily Bee*, August 16, 1897, 8.

37. *ARCIA* 1898, 27.

38. Contrary to organizers' plans, particularly Rosewater and ethnologist James Mooney, the Indian Congress did not turn out as expected for various reasons. Firstly, the planning of the exhibit was assigned to the Bureau of Indian Affairs instead of the Bureau of Ethnology, as originally thought. Secondly, the commissioner of Indian Affairs did not follow Rosewater's and Mooney's original design for the ethnological exposition, but allowed Captain Mercer to stage battles and other events; thirdly, Native participants were crucial in determining the course of the Indian Congress, particularly in the choice of activities they took part in, thus demonstrating that Indian people were resilient in their ways of life and traditions and far from being on the verge of extinction. For more in-depth studies of the Omaha Indian Congress, see Clough "'Vanishing' Indians?" and Etzel, "'A Serious Ethnological Exhibition,'" available at http://digitalcommons .cedarville.edu/library_publications/43 (accessed August 20, 2014).

39. "Report of the Representative of the Department of the Interior," in Wakefield, *A*

History of the TransMississippi & International Exposition. Available at http://omaha
publiclibrary.org/transmiss/secretary/table.html (accessed August 20, 2014).

40. *ARCIA* 1898, 30–31.
41. "Uncle Sam's Big Exhibit," *Omaha Daily Bee*, June 5, 1898, 5. A portrait of an
 Indian girl can be found in Waggoner, *Firelight*, 72. It is possible that this is
 the painting mentioned in the newspaper.
42. *ARCIA* 1898, 31.
43. Fletcher, "Indian at the Trans-Mississippi Exposition," 217.
44. "Commissioner Jones Is Pleased," *Omaha Daily Bee*, September 22, 1898, 5;
 "Report of the Representative of the Department of the Interior."
45. W. V. Cox, "The Indian Congress," in Wakefield, *A History of the TransMississippi*.
46. Fletcher, "Indian at the Trans-Mississippi Exposition," 217.
47. *Pan-American Exposition, Buffalo*, 4.
48. *ARCIA* 1901, 47.
49. *ARCIA* 1901, 47.
50. More information on the government exhibit can be found in *The Rand-McNally
 Hand-Book to the Pan-American Exposition*, available at http://panam1901.org/
 usgov/randmcnallygov.html (accessed August 26, 2014).
51. *ARCIA* 1901, 48.
52. "Department of the Interior at the Pan-American," *Holley (NY) Standard*, August
 8, 1901.
53. "Department of the Interior at the Pan-American," *Holley Standard*. For a
 reproduction of the painting *Fire Light*, see Waggoner, *Firelight*, 102–3.
54. *ARCIA* 1901, 48.
55. *ARCIA* 1901, 49.
56. "Noted Indian Chiefs," *Washington Post*, June 2, 1901, 24.
57. For an in-depth study of the St. Louis world fair, see Parezo and Fowler, *Anthro-
 pology Goes to the Fair*. See also *ARCIA* 1904, 54–55.
58. Parezo and Fowler, *Anthropology Goes to the Fair*, 138, 435.
59. Parezo and Fowler, *Anthropology Goes to the Fair*, 138–48. For a list of Native
 participants, see appendix 2, 405–7.
60. *ARCIA* 1904, 53.
61. *ARCIA* 1904, 52.
62. Buel, ed., *Louisiana and the Fair*, 3077.
63. Bennitt and Stockbridge, eds. *History of the Louisiana Purchase Exposition*, 336.
64. Buel, ed., *Louisiana and the Fair*, 3077.
65. *ARCIA* 1904, 53.
66. *Report of the Superintendent of Indian Schools* 1904, 25.

67. *Report of the Superintendent of Indian Schools* 1904, 38–39.

68. "Feathered Indians as Exhibit Better Attraction Than His Educated Brothers," *St. Louis Republic*, Sunday, August 21, 1904, 8.

69. Blee, "Completing Lewis and Clark's Westward March," 238.

70. *ARCIA* 1905, 57.

71. *ARCIA* 1905.

72. "To Show Indian Work," *Washington Post*, January 30, 1905, 5.

73. Bound volumes of the poster boards with the photographs of Indian school life exhibited here in the wall frames can be found at NACP, Still Pictures Division.

74. *See! See! See! Guide to Jamestown Exposition*, 33. See also, Gleach, "Pocahontas at the Fair," 419–21.

75. *The Exhibits of the Smithsonian Institution*, 14; Norfolk Public Library, "The Jamestown Exposition 1907," http://www.npl.lib.va.us (accessed June 1, 2011).

76. *ARCIA* 1907, 51.

77. *ARCIA* 1907, 51–52.

78. While the weaving technique was not Native, but Persian, DeCora believed that what made a handicraft "Indian" was the Indian designs created by the students and inspired by their own tribal artistic traditions.

79. Edward Curtis, from the foreword to volume 1, *The North American Indian*, 1907, quoted in Graybill and Boesen, *Edward S. Curtis*, 1.

80. Hoxie, *Final Promise*, 93.

81. "A Great Exposition," *Outlook* 92, no. 7 (June 12, 1909): 344.

82. Johnson to U.S. Indian Agent or Superintendent, December 7, 1908, NARA-APR, RG 75, Colville Indian Agency, General Subject "M" Files FY 1909, Series 40–59, box 108a, folder 56.

83. *Official Daily Program no. 12, Saturday, June 12, 1909*, 4.

84. *The End of the Trail* depicts a storm-beaten Indian man and his exhausted horse having "reached the end of their resources" and both "ready to give up the task they are not equal to meet." This work was juxtaposed to the "American Pioneer," a similar-size sculpture by Solon Borglum located in front of the Court of Flowers and representing a strong, confident man who courageously and expectantly faces the future and thus the challenges ahead of him. Interestingly enough, another statue at the exposition conveyed this image of the Indian race at the end of their existence, *The Alaskan*, by Frederick George Richard Roth, part of the ensemble *Nations of the West*, located in the Court of the Universe: burdened by the weight of his culture, represented by a bundle of totem poles wrapped around a blanket, an Alaskan man is trudging in his march forward. See Neuhaus, *Art of the Exposition*, 31–32; S. Moore, *Empire on Display*, 120–25; and Perry, *The Sculpture & Murals of the Panama-Pacific International Exposition*.

85. *Panama-Pacific International Exposition*, 5.

86. At the so-called 101 Ranch, a small group of Indians, cowboys and cowgirls with stagecoach, and a cowboy band from Oklahoma provided daily Wild West reenactments and parades. Apparently, despite the corporation's willingness to stage these kinds of entertainment, the ranch and its people lacked public patronage, even when performances were run at no cost to visitors, and caused a substantial loss of money to the exposition. Ultimately, the deal was canceled and the area remained vacant. Additionally, a contingent of Plains Indians (Oglala Sioux, Blackfeet, and Winnebago) participated in the Pageant of Peace that took place on June 5, in war bonnets, and regularly performed dances on the Esplanade. See F. M. Todd, *Story of the Exposition*, 2:363–64 and 5:12.

87. ARCIA 1915, 59.

88. Cato Sells to Superintendents, Circular No. 824, February 3, 1914, NARA-PR, RG 75, Sherman Institute, Records of the Superintendent, Central Classified Files, 1907–1939, box 4, folder 047.

89. Cato Sells to Superintendents, February 3, 1914.

90. Cato Sells to Superintendents, April 4, 1914, NARA-PR, RG 75, Sherman Institute, Records of the Superintendent, Central Classified Files, 1907–1939, box 4, folder 047.

91. ARCIA 1915, 59.

92. ARCIA 1915.

93. Collins to Conser, February 19, 1914, NARA-PR, RG 75, Sherman Institute, Records of the Superintendent, Central Classified Files, 1907–1939, box 4, folder 047.

94. E. B. Hutchison to Conser, July 27, 1915, NARA-PR, RG 75, Sherman Institute, Records of the Superintendent, Central Classified Files, 1907–1939, box 4, folder 047.

95. Collins to Conser, August 3, 1915; Conser to Hutchison, August 4, 1915, NARA-PR, RG 75, Sherman Institute, Records of the Superintendent, Central Classified Files, 1907–1939, box 4, folder 047.

96. ARCIA 1915, 58–59.

97. President of the Exposition David C. Collier, quoted in Rydell, *All the World's a Fair*, 220.

98. Amero, "Panama-California Exposition: A History of the Exposition," available at http://www.sandiegohistory.org/pancal/sdexpo99.htm#people (accessed September 10, 2014).

99. Amero, "Panama-California Exposition."

100. Rosaldo, "Imperialist Nostalgia," 107–8.

1. Indian School Service Institutes, or summer schools, were generally held during the summer months; they were the most important annual gathering of educators and employees in the Indian Service. When under Reel the institutes began to be organized in conjunction with the NEA meeting, they came to be known as Department of Indian Education. Various Indian Institutes, however, continued to be organized at a more regional level every year.

2. According to the *Sherman Bulletin*, the first Indian fair was on the Crow Reservation in the fall of 1905; ten years later, one hundred fairs were held throughout the country. Indian Fairs in Shiprock, New Mexico (Navajo Fair), and Cherokee, North Carolina (Cherokee Fair), were two examples. Starting from the 1920s, one of the best-known Indian fairs was the Southwest Indian Fair in Santa Fe, organized by Edgard L. Hewett as part of the Santa Fe Fiesta. This eventually became the Santa Fe Indian Market, an annual event that still takes place every August. See "Indian Fairs," *Sherman Bulletin* 9, no. 32 (November 17, 1915): 1; Meyer, "Saving the Pueblos." For historical backgrounds of the Santa Fe Indian Market, see Bernstein, "Marketing of Culture," "Indian Fair to Indian Market," and "Booth Sitters of Santa Fe's Indian Market." See also Hoerig, *Under the Palace Portal*, and Mullin, *Culture in the Marketplace*, particularly chapter 4, "The Patronage of Difference," 91–127.

3. Lawn, "Sites of the Future," 18.

4. DeCora, "Native Indian Art" (1911), 84.

5. "Their Mission the Uplifting of the Indian," *San Francisco Call*, July 11, 1899, 3.

6. ARCIA 1899, 446.

7. ARCIA 446, 28.

8. "Indian Institute," *Los Angeles Times*, July 11, 1899, 13; "Indian Educators," *Los Angeles Times*, July 18, 1899, 8; "Make them Citizens," *Los Angeles Times*, July 19, 1899, 8.

9. ARCIA 1900, 434.

10. ARCIA 1900, 45.

11. ARCIA 1900, 45.

12. "Industrial Training of Indians," *Detroit Journal*, June 21, 1900.

13. "Exhibit of Indian Work," Washington DC newspaper, July 20, 1900.

14. "Bright Little Indians," *Washington Post*, July 19, 1900, 9.

15. "Bright Little Indians," *Washington Post*. Work was also sent by the following schools: Supai, Keams Canyon, Fort Apache, Kingsman, Hackberry, Moqui, Navajo (Arizona); Mission Tule, Round Valley, Hoopa Valley (California); Fort Hall (Idaho); Quapaw (Indian Territory); Morris (Minnesota); Fort Belknap (Montana); St. Mary's, Winnebago, Santee (Nebraska); Carson, Pyramid Lake (Nevada);

Santa Fe (New Mexico); Pawnee, Seger, Sac and Fox, Otoe, Ponca, Riverside, (Oklahoma); Yainax, Siletz, Klamath, Grande Ronde, and Chemawa (Oregon); Chamberlain, Rosebud, Pine Ridge, Cheyenne River, and Hope (South Dakota); White Rock's, Shebit's Day Schools (Utah); Tomah, Wittenberg, and Menominee (Wisconsin); Puyallup, Lumni, Tulalip, Yakima, and Fort Simcoe (Washington).

16. "Education of the Indian-Exhibit Being Collected Which Shows Their Progress," *Texas News*, June 16, 1901.

17. "Exhibit of Indian Work," *Detroit Free Press*, June 4, 1901; "Interesting Exhibit," *Washington DC Pioneer Press*, June 7, 1901; "Exhibit of Indian Work," *Genoa News*, June 15, 1901; "Education of the Indian-Exhibit Being Collected."

18. "Interesting Exhibition of Indian Children's Work," *Detroit Free Press*, July 9, 1901, 2.

19. "Baskets Made by Indians—Remarkable Collection of Art Work Gathered by Miss Reel," *Texas Statesman*, June 18, 1901; "Interesting Exhibition of Indian Children's Work," *Detroit Free Press*, July 9, 1901, 2.

20. Circular No. 16, March 20, 1902, SIMA, Records of Sherman Institute, Circulars 1901–1903.

21. *RSIS* 1902, 23.

22. "Indian Welfare Their Purpose," *San Francisco Call*, June 22, 1902, 24.

23. "From Indian Hands," *Minneapolis Journal*, July 9, 1902, 8. Charles Albert Bender from Brainer, Minnesota (White Earth Reservation), run away from home in 1896 at the age of thirteen in order to attend Carlisle. He was enrolled in the fourth grade and graduated in 1902 upon completion of the tenth grade. He played on the Carlisle baseball team as a pitcher for one year, 1901–2. After leaving Carlisle, he worked as a watchmaker and jeweler in Philadelphia before being recruited by the Philadelphia Athletics as a pitcher, where he remained until 1911. He was nicknamed Chief Bender. Charles Albert Bender Student File, DASP, Carlisle Indian School Digital Resource Center.

24. "The Indian Exhibit," *Minneapolis Journal Junior*, July 12, 1902, 4.

25. *RSIS* 1902, 23.

26. "From Indian Hands," *Minneapolis Journal Junior*, July 9, 1902, 8.

27. "The Indian Exhibit," *Minneapolis Journal Junior*, July 12, 1902, 4.

28. *RSIS* 1902, 23.

29. "From Indian Hands," *Minneapolis Journal Junior*, July 9, 1902, 8; "The Indian Exhibit," *Minneapolis Journal Junior*, July 12, 1902, 4.

30. "Progress of the Indian," *Washington Post*, August 3, 1902, 14.

31. "Indian's Friends to Meet," *Washington Post*, December 9, 1902, 9; "Indian Association," *Washington DC Evening Star*, December 11, 1902.

32. "Indian's Friends to Meet," *Washington Post*, December 9, 1902, 9.

33. "Art News and Gossip of the Past Week," *Washington Times*, Sunday, January 18, 1903, 12.
34. "The Fine Arts," *Boston Transcript*, January 7, 1903.
35. "Indian Boys and Girls Exhibit Handiwork to Boston," *Boston Sunday Post*, January 23, 1903, 25.
36. "Indian Boys and Girls Exhibit Handiwork to Boston," *Boston Sunday Post*.
37. Ruth Bear, a Ponca from the Santee Agency in South Dakota, arrived at Carlisle in October 1898 and remained until July 1901. She entered the second grade and completed the fourth grade before being discharged for unknown reasons (according to her file, the cause of discharge is "bad"). Ruth Bear Student File, DASP, Carlisle Indian School Digital Resource Center.
38. Reel to Agents and Superintendents, Circular No. 57, April 1, 1903, SIMA, Records of Sherman Institute, Circulars, 1901–1903.
39. *RSIS* 1903, 17.
40. *ARCIA* 1907, 51.
41. "Indians Coming: Teachers and Aborigines Will Have Part in Big Convention Here Next Month," *Los Angeles Times*, June 21, 1907, 17; "Indian Chorus to Visit Los Angeles," *Los Angeles Herald*, June 22, 1907, 12.
42. In her presentation on "Native Indian Art" delivered at the 1907 Department of Indian Education in Los Angeles, DeCora lamented that exhibits of Indian-school work do not have any trace of the Indian except in the tribal names of the students. A similar talk was delivered years later at the first meeting of the Society of American Indians held in 1911 in Columbus, Ohio. See "Native Indian Art" (1907), 1005–7 and "Native Indian Art" (1911), 82–87.
43. "Indian Teachers' Institute" *Sherman Bulletin* 2, no. 14 (April 1, 1908): 4.
44. *RSIS* 1908, 29, 39.
45. *Cleveland Plain Dealer*, July 2, 1908, 3.
46. *RSIS* in *ARCIA* 1909, 134.
47. Curtis, "An American Indian Artist," 65.
48. DeCora, "Native Indian Art" (1907), 1007.
49. For discussions on the changes in craft production subsequent to the development of Indian art markets, see, in particular, Batkin, "Tourism Is Overrated," 282–86; Brody, *Indian Painters and White Patrons*, 59–83; Parezo, Hays, and Slivac, "Mind's Road," 151–58; Wade, "History of the Southwest Indian Ethnic Market," 50–87, and "Ethnic Art Market in the American Southwest," 167–76.
50. "Indian Pupils Surprise N.E.A. by Proficiency," *Denver Post*, July 5, 1909.
51. "Indian Exhibit at Unity is of Exceptional Merit," unknown Denver newspaper, 1909.
52. "Shows Stages of Indians' Progress," *Seattle Post International*, August 23, 1909; "Indians Visit Council of Whites," *Seattle Post International*, August 23, 1909.

53. "Would Save Indian Art to the World," *Seattle Post International*, August 20, 1909.

54. "Indians Visit Council of Whites," *Seattle Post International*, August 23, 1909.

55. The Chemawa Indian School orchestra was composed of twelve girls who provided musical entertainment during the opening sessions of the convention. They made the news not only for their musical skills but also for their cooking abilities; after their performance, in fact, the girls put down their instruments, grabbed cooking utensils and prepared a delicious lunch in honor of Mrs. Ballinger, wife of the secretary of the interior, and the Indian Service employees. For a study of the Chemawa music program, see Parkhurst, *To Win the Indian Heart*.

56. "Indians Visit Council of Whites," *Seattle Post International*, August 23, 1909.

57. *RSIS* 1909, 14.

58. *RSIS* 1902, 22; *RSIS* 1903, 33; *Indian Craftsman* 1, no. 1, February 1909 (formerly the *Arrow* from August 25, 1904, to June 19, 1908, then the *Carlisle Arrow*, from September 1908 to February 1909); *Indian School Journal*, June 1915.

59. On the origin of mail-order trade of Indian arts see, Batkin, "Tourism Is Overrated," 291–97, and "Mail-order Catalogs," 40–49, 76.

60. Batkin, "Tourism Is Overrated," 296–97; Hutchinson, *Indian Craze*, 74.

61. *Indian School Journal*, June 1915.

62. *ARCIA* 1902, 410; *RSIS* 1902, 22.

63. *RSIS* 1903, 33.

64. Records from both the Albuquerque School and Sherman Institute show that superintendents were able to obtain basket weave, wool, and natural dyes used for the making of baskets and rugs only upon receipt of purchase approvals from the commissioner of Indian Affairs, thus indicating that these materials were procured at government expense.

65. Conser to Mrs. Bayard Cutting, March 17, 1910, NARA-PR, Perris, RG 75, Sherman Institute, Records of the Superintendent, Letters Sent, 1909–1948, box 60.

66. *Indian Craftsman* 1, no. 1, February 1909; *Indian School Journal*, June 1915.

67. Parezo and Fowler, *Anthropology Goes to the Fair*, 140–48.

68. H. H. Johnson to U.S. Indian Agent or Superintendent, December 7, 1908, and H. H. Johnson to Webster, November 15, 1909, NARA-PAR, Seattle, RG 75, Colville Indian Agency, General Subject M Files FY 1909, Series 40–59, box 108a.

69. *RSIS* 1909, 14.

CONCLUSION

1. Stankiewicz, "'The Eye Is a Nobler Organ,'" 57.

2. DeCora, "Native Indian Art" (1911), 87.

BIBLIOGRAPHY

ARCHIVES AND MANUSCRIPT MATERIALS

Center for Southwest Research, University of New Mexico, Albuquerque, New Mexico
 Albuquerque Indian
 Albuquerque Photograph Collection
 Cobb Memorial Photograph Collection
 Richard W. D. Bryan Family Papers
 Richard W. D. Bryan Photograph Collection
Dickinson Archives and Special Collections, Dickinson College, Pennsylvania
 Carlisle Indian School Digital Resource Center
Fray Angelico Chavez History Library, Santa Fe, New Mexico
 Benjamin Morris Thomas Collection
 Indian Schools
Laboratory of Anthropology Archives, Santa Fe, New Mexico
 Kenneth M. Chapman Collection
Library of Congress, Washington DC
 Prints and Photographic Division
 Frances Benjamin Johnston Collection
National Anthropological Archives, Smithsonian Institution, Suitland, Maryland
 Bureau of American Ethnology–File Prints–Schools
 Photographs of American Indians and Other Subjects 1840s–1960s
 SPC Miscellaneous Indian Schools
 Manuscript 4492, Drawings of Kachinas by Hopi Indian students at Sherman Institute
National Archives Building, Washington DC
 Record Group 75–Records of the Bureau of Indian Affairs
 Central Classified Files, 1907–39, Albuquerque

Central Classified Files, 1907–39, Sherman Institute

General Records, Circulars Issued by the Superintendent of Indian Schools, 1899–1908

Letters Sent Concerning Textbooks, 1907–9

Office File of Harvey B. Peairs, Chief Supervisor of Education and General

Superintendent, 1910–27

Records of the Employees Section, Rosters of School Employees, 1884–1909

National Archives at College Park, Maryland

Record Group 48–Records of the Office of the Secretary of the Interior, 1826–2009

Photographs Relating to the Interior Exhibit at the Louisiana Purchase Exposition, 1904

Record Group 56–Records of the Department of the Treasury

Cyanotypes of the Pan American Exposition, Buffalo, New York, 1901

Cyanotypes of the Cotton States & International Exposition, Atlanta, Georgia, 1895–96

Photographs of the Centennial Exposition, Nashville, Tennessee, 1897

Photographs of the Louis and Clark Exposition, Portland, Oregon, 1905

Prints: black and white prints of the Jamestown Tercentennial Exposition, 1907

Record Group 75–Records of the Bureau of Indian Affairs

Exhibit Prints

Department of the Interior, Indian Service, Industrial School, Genoa, Nebraska

Life in an American Indian School, ca. 1914

Panoramic views of Indian Schools, Bureau Personnel, and U.S. Public Health Service Facilities, ca. 1904–31

Photographs of Indians, Indian agencies, and schools, 1876–96

Prints related to various jurisdictions, tribes, Indian schools and activities, 1904–36

National Archives and Records Administration–Pacific Region, Riverside, California

Record Group 75–Records of the Bureau of Indian Affairs

Sherman Institute

National Archives and Records Administration–Rocky Mountain Region, Denver, Colorado

Record Group 75–Records of the Bureau of Indian Affairs

Albuquerque Indian School

Northern Pueblo Agency

Pueblo/Pueblo and Jicarilla Agencies

Southern Pueblo Agency

United Pueblo Agency

National Archives and Records Administration–Alaska Pacific Region, Seattle, Washington

Record Group 75–Records of the Bureau of Indian Affairs

Chemawa Indian School

Colville Indian Agency

Puyallup Indian Agency, Tacoma, Washington

New Mexico State Records Center and Archives, Santa Fe, New Mexico

Governor George Curry Papers

Department of Education Records

Herbert J. Hagerman Collection

William McDonald Papers

E. H. Plummer Papers

L. Bradford Prince Papers

Territorial Archives of New Mexico (TANM)–Governor Papers

Northwest Museum of Arts and Culture/Eastern Washington State Historical Society, Spokane, Washington

Estelle Reel Papers

Sherman Indian Museum and Archives, Riverside, California

Records of Sherman Institute

University of Washington, Allan Library Special Collections

Alaska-Yukon-Pacific Exposition Scrapbooks, circa 1906–9

Catalogue of Educational Exhibits in the Washington Educational Building, Alaska-Yukon-Pacific Exposition

Official Daily Program

Official Guide of the Alaska-Yukon-Pacific Exposition, Seattle, Washington, June 1 to October 16, 1909

Records of the Alaska-Yukon-Pacific Exposition, 1907–09

PUBLISHED WORKS

Abbott, Carl. *The Great Extravaganza: Portland and the Lewis and Clark Exposition.* Portland: Oregon Historical Society, 1981.

Adams, David W. *Education for Extinction: American Indians and the Boarding School Experience, 1875–1928.* Lawrence: University Press of Kansas, 1995.

Addicott, James E. "Art as Related to Manual Training." *Elementary School Teacher* 7, no. 2 (1906): 91–99.

Albuquerque Indian. Albuquerque: U.S. Indian School, 1905–1906.

Albuquerque Indian School, New Mexico, 1925–1926 Calendar. Albuquerque, New Mexico, 1925.

Albuquerque School for Indians, U.S. Indian School, Albuquerque, N. Mex. Chilocco OK: United States Indian Training School.

Alexander, Edward P. "Early American Museums from Collections of Curiosities to Popular Education." *International Journal of Museum Management and Curatorship* 6 (1987): 337–51.

Amburgy, Patricia M. "Arts and Crafts Education in Chicago, 1890–1920." In *History of Art Education: Proceedings of the Third Penn State International Symposium, October 12–15, 1995*, edited by Albert A. Anderson Jr. and Paul E. Bolin, 384–88. University Park: Penn State University, 1997.

———. "Culture for the Masses: Art Education and Progressive Reforms, 1880–1917." In *Framing the Past: Essays on Art Education*, edited by Donald Soucy and Mary Ann Stankiewicz, 103–16. Reston VA: National Art Education Association, 1990.

The American Presidency Project. "Theodore Roosevelt: Second Annual Message, December 2, 1902." http://www.presidency.ucsb.edu/ws/index.php?pid=29543.

Amero, Richard. "Panama-California Exposition, San Diego, 1915–1916: A History of the Exposition." http://www.sandiegohistory.org/pancal/sdexpo99.htm#people.

———. "The Southwest on Display at the Panama-California Exposition, 1915." *Journal of San Diego History* 36, no. 4 (Fall 1990).

Anderson, James D. "Art and the Problem of Vocationalism in American Education." In *History of Art Education: Proceedings of the Second Penn State Conference, 1989*, edited by Paul E. Bolin, 12–15. Reston VA: National Art Education Association, 1992.

Annual Report of the Commissioner of Indian Affairs to the Secretary of the Interior. Washington DC: Government Printing Office, 1881–1917.

Annual Report of the Superintendent of Public Instruction to the Governor of New Mexico. Santa Fe: New Mexican Printing Company, 1890–1913.

Annual Report on Education in Alaska. Washington DC: Government Printing Office, 1881–1900.

Archuleta, Margaret L., Brenda J. Child, and K. Tsianina Lomawaima. *Away From Home: American Indian Boarding School Experiences, 1879–2000.* Phoenix: Heard Museum, 2000.

Asad, Talal. *Anthropology and the Colonial Encounter.* Amherst NY: Humanity Books, 1973.

Baca, Elmo. *Romance of the Mission: Decorating in the Mission Style.* Salt Lake City: Gibbs Smith Publisher, 1996.

Bailey, Henry Turner. "The Arts and Crafts in the Public Schools." In *Sixty-Sixth*

Annual Meeting of the American Institute of Instruction, New Haven, Connecticut, 80–92. Boston: American Institute of Instruction, 1906.

Bailey, Henry Turner, and Severance Burrage. *School Sanitation and Decoration*, Boston: D.C. Heath, 1899.

Bannan, Helen M. "The Ideal of Civilization and the American Indian Policy Reformers of the 1880s." *Journal of American Culture* 1, no. 4 (Winter 1978): 787–99.

Batkin, Jonathan. "Mail-order Catalogs as Artifacts of the Early Native American Curio Trade." *American Indian Art Magazine* 29, no. 2 (2004): 40–49, 76.

———. *The Native America Curio Trade in New Mexico*. Santa Fe: Wheelwright Museum of the American Indian, 2008.

———. "Some Early Curio Dealers of New Mexico." *American Indian Art Magazine* 23, no. 3 (1998): 68–81.

———. "Tourism Is Overrated: Pueblo Pottery and the Early Curio Trade, 1880–1910." In *Unpacking Culture: Art and Commodity in Colonial and Postcolonial Worlds*, edited by Ruth Phillips and Christopher Steiner, 282–300. Berkeley: University of California Press, 1999.

Bederman, Gail. *Manliness and Civilization: A Cultural History of Gender and Race in the United States, 1880–1917*. Chicago: University of Chicago Press, 2008.

Belden, Ernest. "A History of the Child Study Movement in the United States, 1870–1920, with Special Reference to Its Scientific and Educational Background." PhD diss., University of California–Berkeley, 1965.

Benedict, Burton. *The Anthropology of World's Fairs*. London and Berkeley: Scolar Press, 1983.

———. "International Exhibitions and National Identity." *Anthropology Today* 7, no. 3 (1991): 5–9.

Benjamin, Walter. "The Work of Art in the Age of Mechanical Reproduction." In *Illuminations: Essays and Reflections*, 217–54. New York: Schocken Books, 1968.

Bennett, Tony. *The Birth of the Museum: History, Theory, Politics*. London: Routledge, 1995.

Bennitt, Mark, and Frank P. Stockbridge, eds. *History of the Louisiana Purchase Exposition: Comprising the History of the Louisiana Territory, the Story of the Louisiana Purchase and a Full Account of the Great Exposition, Embracing the Participation of the States and Nations of the World, and Other Events of the St. Louis World's Fair of 1904*. St. Louis: Universal Exposition Publishing Company, 1905.

Berg, S. Carol. "Memories of an Indian Boarding School: White Earth, Minnesota, 1909–1945." *Midwest Review* 11 (1989): 27–36.

Berlo, Janet, ed. *The Early Years of Native American Art History: The Politics of Scholarship and Collecting*. Seattle: University of Washington Press, 1992.

Berlo, Janet, and Ruth B. Phillips. *Native North American Art*. New York: Oxford University Press, 1998.

Bermingham, Ann. *Learning to Draw: Studies in the Cultural History of a Polite and Useful Art.* New Haven: Yale University Press, 2000.

Bernstein, Bruce. "The Booth Sitters of Santa Fe's Indian Market: Making and Maintaining Authenticity." *American Indian Culture and Research Journal* 31, no. 3 (2007): 49–79.

———. "Indian Fair to Indian Market." *El Palacio* 98 (Summer 1993): 14–20, 47–54.

———. "The Marketing of Culture: Pottery and Santa Fe's Indian Market." PhD diss., University of New Mexico, 1993.

Bernstein, Bruce, and W. Jackson Rushing. *Modern by Tradition: American Indian Painting in the Studio Style.* Santa Fe: Museum of New Mexico Press, 1995.

Biebel, Charles D. "Cultural Change on the Southwest Frontier: Albuquerque Schooling, 1870–1895." *New Mexico Historical Review* 55, no. 3 (1980): 209–30.

Bigart, Robert, and Clarence Woodcock. "The Trans-Mississippi and International Exposition and the Flathead Delegation." *Montana, the Magazine of Western History* 29 (Autumn 1979): 14–23.

Blee, Lisa. "Completing Lewis and Clark's Westward March: Exhibiting a History of Empire at the 1905 Portland World's Fair." *Oregon Historical Quarterly* 106, no. 2 (summer 2005): 232–53.

Bokovoy, Matthew F. *The San Diego World's Fairs and Southwestern Memory, 1880–1940.* Albuquerque: University of New Mexico Press, 2005.

Boles, Joann F. "The Navajo Rug at the Hubbell Trading Post, 1880–1920." *American Indian Culture and Research Journal* 5, no. 1 (1981): 47–63.

Bolin, Paul. E. "Bordering the Familiar: Drawing Education Legislation in the Northeastern United States, 1871–1876." *Studies in Art Education* 45, no. 2 (2004): 101–16.

———. "The Massachusetts Drawing Act of 1870: Industrial Mandate or Democratic Maneuver?" In *Framing the Past: Essays on Art Education,* edited by Donald Soucy and Mary Ann Stankiewicz, 59–70. Reston VA: National Art Education Association, 1990.

Boris, Eileen. *Art and Labor: Ruskin, Morris, and the Craftsman Ideal in America.* Philadelphia: Temple University Press, 1986.

———. "Crossing Boundaries: The Gendered Meaning of Arts and Crafts." In *The Ideal Home: The History of Twentieth-Century American Craft,* edited by Janet Kardon, 32–44. New York: American Craft Museum, 1993.

———. "'Dream of Brotherhood and Beauty': The Social Ideas of the Arts and Crafts Movement." In *"The Art That Is Life": The Arts and Crafts Movement in America, 1875–1920,* edited by Wendy Kaplan, 208–22. Boston: Little, Brown for Museum of Fine Arts, 1987.

Bowles, Samuel. "Unequal Education and the Reproduction of the Social Division

of Labor." In *Schooling in a Corporate Society: The Political Economy of Education in America*, edited by Martin Carnoy, 36–46. New York: D. McKay, 1975.

Boyer, Paul. *Urban Masses and Moral Order in America, 1820–1920*. Cambridge: Harvard University Press, 1978.

Brody, J. J. *Indian Painters and White Patrons*. Albuquerque: University of New Mexico Press, 1971.

———. *Pueblo Indian Painting: Tradition and Modernism in New Mexico, 1900–1930*. Santa Fe: School of American Research Press, 1997.

Bronner, Simon, ed. *Consuming Visions: Accumulation and Display of Goods in America, 1880–1920*. New York: Norton, 1989.

Brown, Julie K. *Contesting Images: Photography and the World's Columbian Exposition*. Tucson: University of Arizona Press, 1994.

Bryant, Billy Joe. "Issues of Art Education for American Indians in the Bureau of Indian Affairs' Schools." EdD diss., Pennsylvania State University, 1974.

Buel, J. W., ed. *Louisiana and the Fair: An Exposition of the World, Its People and Their Achievements*. Vol. 8. St. Louis: World's Progress Publishing, 1905.

Bureau of Education. *Report of the Commissioner of Education*. Washington DC: Government Printing Office, 1887–99.

Burgess, Larry E. *Mohonk, Its People and Spirit: A History of One Hundred Years of Growth and Service*. New Paltz NJ: Smiley Brothers, 1980.

Burt, Nathaniel. *Palaces for the People: A Social History of American Art Museums*. Boston: Little, Brown, 1977.

Cahill, Cathleen D. "Only the Home Can Found a State: Gender, Labor, and the United States Indian Service, 1869–1928." PhD diss., University of Chicago, 2004.

Calendar for Indian Training School, Albuquerque, New Mexico, for the Year 1914–1915. Albuquerque: U.S. Indian School, 1914.

Carney, Virginia Moore. *Eastern Band Cherokee Women: Cultural Persistence in Their Letters and Speeches*. Knoxville: University of Tennessee Press, 2005.

Carnoy, Martin, ed. *Schooling in a Corporate Society: The Political Economy of Education in America*. New York: D. McKay, 1975.

Carter, Patricia A. "'Completely Discouraged': Women Teachers' Resistance in the Bureau of Indian Affairs Schools, 1900–1910." *Frontiers: A Journal of Women Studies* 15, no. 3 (1995): 53–86.

Catalogue, United States Indian School, Carlisle, Pennsylvania, 1910. Carlisle: U.S. Indian School, 1910.

Chalmers, F. Greame. "Art Education in 'Indian' Residential Schools in British Columbia." *Canadian Review of Art Education* 27, no. 1 (2000): 21–35.

Chase, Katherine. *Indian Painters of the Southwest: The Deep Remembering*. Santa Fe: School of American Research Press, 2002.

Child, Brenda J. *Boarding School Seasons: American Indian Families, 1900–1940.* Lincoln: University of Nebraska Press, 1998.

———. "Runaway Boys, Resistant Girls: Rebellion at Flandreau and Haskell, 1900–1940." *Journal of American Indian Education* 35, no. 3 (1996): 49–57.

Clark, Ida Hood. "Hand-Work in the Elementary School." *Elementary School Teacher* 5, no. 3 (1904): 164–68.

Clark, Robert Judson. *The Arts and Crafts Movement in America, 1876–1916.* Princeton NJ: Princeton University Press, 1972.

Clarke, Isaac Edwards. *Art and Industry: Education in the Industrial and Fine Arts in the United States.* Part 1: *Drawing in Public Schools.* Washington DC: Government Printing Office, 1885.

———. *Art and Industry: Education in the Industrial and Fine Arts in the United States.* Part 2: *Industrial and Manual Training in Public Schools.* Washington DC: Government Printing Office, 1892.

———. *Drawing in Public Schools: The Present Relation of Art to Education in the United States.* Issues 1–3. Washington DC: U.S. Government Printing Office, 1874.

Clastres, Pierre. *Society Against the State.* New York: Zone Books, 1989.

Clifford, James. *The Predicament of Culture: Twentieth-Century Ethnography, Literature, and Art.* Cambridge MA: Harvard University Press, 1988.

Clough, Josh. "'Vanishing' Indians? Cultural Persistence on Display at the Omaha World's Fair of 1898." *Great Plains Quarterly* 25, no. 2 (Spring 2005): 67–86.

Coleman, Michael. *American Indian Children at School, 1850–1930.* Jackson: University of Mississippi Press, 1993.

———. "No Race, but Grace: Presbyterian Missionaries and American Indians, 1857–1893." *Journal of American History* 67, no. 1 (1980): 41–60.

———. *Presbyterian Missionary Attitudes toward American Indians, 1837–1893.* Jackson: University Press of Mississippi, 1985.

———. "The Response of American Indian Children to Presbyterian Schools in the Nineteenth Century: An Analysis through Missionary Sources." *History of Education Quarterly* 27, no. 4 (1987): 473–97.

———. "The Symbiotic Embrace: American Indians, White Educators, and the School." *History of Education* 25, no. 1 (1996): 7–12.

Collins, Cary C. "Oregon's Carlisle: Teaching 'American' at Chemawa Indian School." *Columbia: The Magazine of Northwest History* (Summer 1998): 6–10.

———. "Through the Lens of Assimilation: Edwin L. Chalcraft and Chemawa Indian School." *Oregon Historical Quarterly* 98, no. 14 (1997–98): 390–425.

Comaroff, Jean, and John L. Comaroff. "The Colonization of Consciousness in South Africa." *Economy and Society* 18, no. 3 (1989): 267–96.

———. "Colonization of Consciousness." In *Ethnography and the Historical Imagination*. Boulder CO: Westview Press, 1992.

Conway, Jill K. "Perspectives on the History of Women's Education in the United States." *History of Education Quarterly* 14, no. 1 (1974): 1–12.

Cornell, Stephen. *The Return of the Native: American Indian Political Resurgence*. New York: Oxford University Press, 1988.

Covington, Annette. "Drawing and Painting in Connection with Nature-Study." *Elementary School Teacher* 4, no. 10 (1904): 701–4.

Cremin, Lawrence A. *The Transformation of the School: Progressivism in American Education, 1876–1957*. New York: Vintage Books, 1964.

Curti, Merle. "America at the World's Fairs, 1851–1893." *American Historical Review* 55 (1950): 833–56.

Curtis, Natalie. "An American Indian Artist." *Outlook* (January 14, 1920): 64–66.

———. "The Perpetuating of Indian Art." *Outlook* (November 22, 1913): 623–31.

Cushman, Lillian. "Aesthetic Development: The Problem of the Future." *Elementary School Teacher* 4, no. 7 (March 1904): 485–500.

Dalton, Pen. *The Gendering of Art Education: Modernism, Identity, and Critical Feminism*. Philadelphia: Open University Press, 2001.

Davidson, Emily S., and Ludy T. Benjamin Jr. "A History of the Child Study Movement in America." In *Historical Foundations of Educational Psychology*, edited by John A. Glover and Royce R. Ronning, 41–60. New York: Plenum Press, 1987.

Davies, Cynthia. "Frontier Merchants and Native Craftsmen: The Fred Harvey Company Collects Indian Art." *Journal of the West* 21, no.1 (1982): 120–25.

De Certeau, Michel. *The Practice of Everyday Life*. Berkeley: University of California Press, 1984.

DeCora, Angel. "An Effort to Encourage Indian Art." In *Congres International Des Americanistes XVe Session tenue à Québec en 1906*, 205–9. Quebec: Dessault and Proulx, 1907.

———. "Native Indian Art." In *Journal of Proceeding and Addresses of the Forty-Fifth Annual Meeting Held at Los Angeles, California, July 8–12, 1907*, 1005–7. Winona MN: National Educational Association, 1907.

———. "Native Indian Art." In *Report of the Twenty-Sixth Annual Meeting of the Lake Mohonk Conference of Friends of the Indian and Other Dependent Peoples*, 16–18. Mohonk Lake NY: The Conference, 1908.

———. "Native Indian Art." In *Report of the Executive on the Proceedings of the First Annual Conference of the Society of American Indians Held at the University of Ohio, Columbus, Ohio, October 12–17, 1911*, 82–87. Washington DC: Society of American Indians, 1911.

Deloria, Philip J. *Indians in Unexpected Places*. Lawrence: University Press of Kansas, 2004.

Denker, Bert, ed. *The Substance of Style: Perspectives on the American Arts and Crafts Movement*. Hanover NH: University Press of New England, 1996.

Devens, Carol. "'If We Get the Girls, We Get the Race': Missionary Education of Native American Girls." *Journal of World History* 3, no. 2 (Fall 1992): 219–37.

Dewey, John. *The Child and the Curriculum and the School and Society*. Chicago: University of Chicago Press, 1956.

Dilworth, Leah. *Imagining Indians in the Southwest: Persistent Visions of a Primitive Past*. Washington DC: Smithsonian Institution, 1996.

Dombkowski, Kristen. "Kindergarten Teacher Training in England and the United States, 1850–1918." *History of Education* 31, no. 5 (2000): 475–89.

Dopp, Katharine E. "A Report of the First Annual Meeting of the National Society for the Promotion of Industrial Education." *Elementary School Teacher* 8, no. 7 (1908): 393–99.

Downs, Robert B. *Heinrich Pestalozzi: Father of Modern Pedagogy*. Boston: Twayne Publishers, 1975.

Dubin, Margaret. *Native America Collected: The Culture of an Art World*. Albuquerque: University of New Mexico Press, 2001.

Duncan, John. "Art." *Elementary School Teacher and Course of Study* 2, no. 8 (1902): 581–85.

Duncan, John, Clara Isabel Mitchell, and Antoinette B. Hollister. "Applied Arts." *Elementary School Teacher and Course of Study* 2, no. 4 (1901): 274–86.

Duncan, Kate. "American Indian Lace Making." *American Indian Art Magazine* 5 (May 1980): 28–35, 80.

Dutton, Bertha P. *American Indians of the Southwest*. Albuquerque: University of New Mexico Press, 1983.

Earenfight, Phillip. *A Kiowa's Odyssey: A Sketchbook from Fort Marion*. Seattle: University of Washington Press, 2007.

——. *Visualizing a Mission: Artifacts and Imagery of the Carlisle Indian School, 1879–1918*. Carlisle PA: Trout Gallery, Dickinson College, 2004.

Eastman, Charles A. "'My People': The Indian's Contribution to the Art of America." *The Red Man (Indian Craftsman)* 7, no. 4 (December 1914): 133–40.

Efland, Arthur D. "Art and Education for Women in 19th Century Boston." *Studies in Art Education* 26, no. 3 (1986): 133–40.

——. "Changing Conceptions of Human Development and Its Role in Teaching the Visual Arts." *Visual Arts Research* 11, no. 1 (Spring 1985): 105–19.

——. *A History of Art Education: Intellectual and Social Currents in Teaching the Visual Arts*. New York: Teachers College Press, 1990.

———. "A Persistent Interpretation: Art Education Historiography and the Legacy of Isaac Edwards Clark." *History of Education Quarterly* 31, no. 4 (1991): 489–511.

———. "School Art and its Social Origins." *Studies in Art Education* 24, no. 3 (1983): 149–57.

Eisner, Elliot W., and Michael D. Day, eds. *Handbook of Research and Policy in Art Education*. Mahwah NJ: National Art Education Association, 2004.

Eldridge, Laurie. "Dorothy Dunn and the Art Education of Native Americans." *Studies in Art Education* 42, no. 4 (2001): 318–32.

Ellis, Clyde. *To Change Them Forever: Indian Education at the Rainy Mountain Boarding School, 1893–1920*. Norman: University of Oklahoma Press, 1996.

———. "We Had a Lot of Fun, but of Course, That Wasn't the School Part." In *Boarding School Blues: Revisiting American Indian Educational Experience*, edited by Clifford E. Trafzer, Jean A. Keller, and Lorene Sisquoc, 65–98. Lincoln: University of Nebraska Press, 2006.

Engs, Robert F. *Educating the Disfranchised and Disinherited: Samuel Chapman Armstrong and Hampton Institute, 1839–1893*. Knoxville: University of Tennessee Press, 1999.

Estimate of School Books and Supplies for the Fiscal Year 1894–1895. Washington DC: Government Printing Office, 1894.

Etzel, J. Brent. "'A Serious Ethnological Exhibition': The Indian Congress of the Trans-Mississippi & International Exposition of 1898." *Library Faculty Publications*. Paper 43 (2006). http://digitalcommons.cedarville.edu/library_publications/43.

The Exhibits of the Smithsonian Institution and United States National Museum at the Jamestown Tercentennial Exposition, Norfolk, Virginia, 1907. Washington DC: Judd and Dettweiler, 1907.

Eyestone, June E. "The Influence of Swedish Sloyd and Its Interpreters on American Art Education." *Studies in Art Education* 34, no. 1 (Autumn 1992): 28–38.

Fanon, Franz. *The Wretched of the Earth*. New York: Grove Press, 1966.

Fay, L. A. "Kinds of Schools to be Introduced, and Practical Methods of Instruction." In *Journal of Proceedings and Addresses of the National Educational Association, Session of the Year 1887, held at Chicago*, 206–11. Salem MA: Observer Book and Job Print, 1888.

Fear-Segal, Jacqueline. "Nineteenth-Century Indian Education: Universalism versus Evolutionism." *Journal of American Studies* 33, no. 2 (1999): 323–41.

———. *White Man's Club: School, Race, and the Struggle of Indian Acculturation*. Lincoln: University of Nebraska Press, 2007.

Fewkes, Jesse Walter. *Hopi Katcinas*. New York: Dover, 1985.

Fletcher, Alice C. "The Indian at the Trans-Mississippi Exposition." *Southern Workman*, no. 27 (November 1898): 216–17.

Fogelson, Raymond D. "The Red Man in the White City." In *Columbian Consequences.* Vol. 3, edited by David Hurst Thomas, 73–90. Washington DC: Smithsonian Institution Press, 1991.

Ford, Richard. "Inter-Indian Exchange in the Southwest." In *Handbook of North American Indians.* Vol. 10, edited by Alfonso Ortiz, 711–22. William C. Sturtevant, General Editor. Washington DC: Smithsonian Institution Press, 1983.

Forman, Bernard I. "Early Antecedents of American Art Education: A Critical Evaluation of Pioneer Influences." *Studies in Art Education* 9, no. 2 (Winter 1968): 38–51.

Frissel, Hollis B. "Thirty-Fourth Annual Report of the Principal of Hampton Institute." *Southern Workman* 31, no. 5 (May 1902): 271–89.

Froebel, Friedrich. *Education by Development: The Second Part of the Pedagogics of the Kindergarten.* Translated by Josephine Jarvis. New York: D. Appleton, 1902.

——. *The Education of Man.* New York: Lovell, 1885.

——. *Friedrich Froebel's Pedagogics of the Kindergarten, or, His Ideas Concerning the Play and Playthings of the Child.* Translated by Josephine Jarvis. New York: D. Appleton, 1912.

Frye, Melinda Young, ed. *Natives and Settlers: Indian and Yankee Culture in Early California: The Collection of Charles P. Wilcomb.* Oakland CA: Oakland Museum, 1979.

Fuchs, Estelle, and Robert J. Havighurst. *To Live on This Earth: American Indian Education.* New York: Anchor Books, 1973.

Garmhausen, Winona. *History of Indian Arts Education in Santa Fe: The Institute of American Indian Arts with Historical Background 1890 to 1962.* Santa Fe: Sunstone Press, 1988.

Gere, Anne Ruggles. "An Art of Survivance: Angel DeCora at Carlisle." *American Indian Quarterly* 28, no. 3/4 (2004): 649–84.

——. "Indian Heart/White Man's Head: Native American Teachers in Indian Schools, 1880–1930." *History of Education Quarterly* 45, no. 1 (2005): 38–65.

Gibbs, Charlotte M. *Household Textiles.* Boston: Whitcomb and Barrows, 1913.

Gilbert, Matthew T. Sakiestewa. *Education beyond the Mesa: Hopi Students at Sherman Institute, 1902–1929.* Lincoln: University of Nebraska Press, 2010.

——. "'The Hopi Followers': Chief Tawaquaptewa and Hopi Student Advancement at Sherman Institute, 1906–1909." *Journal of American Indian Education* 44, no. 2 (2005): 1–23.

Gleach, Frederic W. "Pocahontas at the Fair: Crafting Identities at the 1907 Jamestown Exposition." *Ethnohistory* 5, no. 3 (Summer 2003): 419–45.

Gonzales, Nathan. "Riverside, Tourism, and the Indian: Frank A. Miller and the Creation of Sherman Institute." *Southern California Quarterly* 84, no. 3/4 (2002): 193–222.

———. "Visit Yesterday, Today: Ethno-tourism and Southern California, 1884–1955." PhD diss., University of California–Riverside, 2006.

Graburn, Nelson H., ed. *Ethnic and Tourist Arts: Cultural Expressions from the Fourth World*. Berkeley: University of California Press, 1976.

Gram, John R. *Education at the Edge of Empire: Negotiating Pueblo Identity in New Mexico's Indian Boarding Schools*. Seattle: University of Washington Press, 2015.

Gramsci, Antonio. *Selections from the Prison Notebooks*. New York: International Publishers, 2003.

Graybill, Florence Curtis, and Victor Boesen. *Edward S. Curtis: Visions of a Vanishing Race*. Albuquerque: University of New Mexico Press, 1976.

Green, Harry. "Walter Smith: The Forgotten Man." *Art Education* 19, no. 1 (January 1966): 3–9.

Gritton, Joy. *The Institute of American Indian Arts: Modernism and U.S. Indian Policy*. Albuquerque: University of New Mexico Press, 2000.

Haber, Samuel. *Efficiency and Uplift: Scientific Management in the Progressive Era, 1890–1920*. Chicago, University of Chicago Press, 1964.

Hailmann, William N. *Kindergarten Culture*. New York: Wilson, Hinkle, 1873.

———. *Law of Childhood, and Other Papers*. Chicago: Alice B. Stockham, 1889.

———. *Primary Methods*. Chicago: A. S. Barnes, 1887.

Halttunen, Karen. "From Parlor to Living Room: Domestic Space, Interior Decoration, and the Culture of Personality." In *Consuming Visions: Accumulation and Display of Goods in America, 1880–1920*, edited by Simon J. Bronner, 157–89. New York: Norton, 1989.

Haney, James Parton. "Art Education in the Public Schools of the United States." *American Art Annual* 6 (1907–1908): 9–12.

Hendrick, Irving G. "Federal Policy Affecting the Education of Indians in California, 1849–1934." *History of Education Quarterly* 16, no. 2 (1976): 163–85.

Harmer, Althea. "Basketry." *Elementary School Teacher* 4, no. 2 (1903): 116–19.

Herbst, Jurgen. *And Sadly Teach: Teacher Education and Professionalization in American Culture*. Madison: University of Wisconsin Press, 1989.

Herzog, Melanie. "Aesthetics and Meanings: The Arts and Crafts Movement and the Revival of American Indian Basketry." In *The Substance of Style: Perspectives on the American Arts and Crafts Movement*, edited by Bert Denker, 69–92. Hanover NH: University Press of New England, 1996.

Hicks, John H. "The United States Centennial Exhibition of 1876." PhD diss., University of Georgia, 1972.

Hill, Sarah H. *Weaving New Worlds: Southeastern Cherokee Women and their Baskets*. Chapel Hill: University of North Carolina Press, 1997.

Hinsley, Curtis M. "The World as a Marketplace: Commodification of the Exotic at

the World's Columbian Exposition, Chicago, 1893." In *Exhibiting Cultures: The Poetics and Politics of Museum Display*, edited by Ivan Karp and Steven Lavine, 344–65. Washington DC: Smithsonian Institution Press, 1991.

Hoerig, Karl A. *Under the Palace Portal: Native American Artists in Santa Fe*. Albuquerque: University of New Mexico Press, 2003.

Hoffa, Harlan E. "The Roots of Art Education in the United States." *Art Education* 37, no. 1 (1984): 24–26.

Holm, Tom. "The Discovery of Indian Art: Awareness or Choices?" In *Sharing a Heritage: Contemporary American Indian Issues Series*, no. 5, 67–74. Los Angeles: American Indian Studies Center, 1984.

———. *The Great Confusion in Indian Affairs*. Austin: University of Texas Press, 2005.

Howard, Kathleen L. "Weaving a Legend: Elle of Ganado Promotes the Indian Southwest." *New Mexico Historical Review* 74, no. 2 (1999): 127–53.

Howard, Kathleen, and Diana L. Pardue. *Inventing the Southwest: The Fred Harvey Company and Native American Art*. Flagstaff AZ: Northland Publishing, Heard Museum, 1996.

Hoxie, Frederick E. *A Final Promise: The Campaign to Assimilate the Indians, 1880–1920*. Cambridge: Cambridge University Press, 1984.

Hultgren, Mary Lou. *To Lead and to Serve: American Indian Education At Hampton Institute, 1878–1923*. Charlottesville: Virginia Foundation for the Humanities and Public Policy, in cooperation with Hampton University, 1989.

Huhndorf, Shari M. *Going Native: American Indians in the American Cultural Imagination*. Ithaca: Cornell University Press, 2001.

Hutchinson, Elizabeth. *The Indian Craze: Primitivism, Modernism, and Transculturation in American Art*. Durham NC: Duke University Press, 2009.

———. "Modern Native American Art: Angel DeCora's Transcultural Aesthetics." *Art Bulletin* 83, no. 4 (December 2001): 740–56.

Hyde, William Dewitt. "The Organization of American Education." In *Journal of Proceedings and Addresses of the National Educational Association, Session of the Year 1892 Held at Saratoga Springs, New York*, 217–29. New York: National Educational Association, 1893.

Hyer, Sally. *One House, One Voice, One Heart: Native American Education at the Santa Fe Indian School*. Santa Fe: Museum of New Mexico Press, 1990.

Illustrated Souvenir: Jamestown Ter-Centennial Exposition. Norfolk VA: Seaboard, 1907.

The Indian Craftsman. Carlisle PA: U.S. Indian Industrial School, 1909–13.

Ives, Halsey. "Art Education: An Important Factor in Industrial Development." *American Art Annual* 6 (1907–1908): 13–16.

Jacobs, Margaret D. *Engendered Encounters: Feminism and Pueblo Cultures 1879–1934*. Lincoln: University of Nebraska Press, 1999.

———. "Shaping a New Way: White Women and the Movement to Promote Pueblo Indian Arts and Crafts, 1900–1935." *Journal of the Southwest* 40, no. 2 (1998): 187–215.

Jackson, Sheldon. *Alaska and Missions on the North Pacific Coast.* New York: Dodd, Mead, 1880.

James, George Wharton. *Indian Basketry.* New York: Dover, 1972.

———. *Indian Blankets and Their Makers.* Chicago: A. C. McClurg, 1914.

Johnston, Basil. *Indian School Days.* Norman: University of Oklahoma Press, 1989.

Jojola, Ted. "Come the Red Men, Hear them Marching: The Legacy of the Albuquerque Indian School." Public Presentation at the Center for Regional Studies, University of New Mexico, February 2002.

Jones, Ronald L. "Aesthetic Education: Its Historical Precedents." *Art Education* 27, no. 9 (December 1974): 12–16.

Journal and Proceedings of the Twenty-Second Annual Meeting of the New Mexico Education Association, Santa Fe NM, December 26–28, 1907. Albuquerque: New Mexico Journal of Education, 1907.

Kabotie, Fred, and Bill Belknap. *Fred Kabotie: Hopi Indian Artist.* Flagstaff: Museum of Northern Arizona with Northland Press, 1977.

Kaplan, Wendy, ed. *"The Art That Is Life": The Arts and Crafts Movement in America, 1875–1920.* Boston: Little, Brown for Museum of Fine Arts, 1987.

———. "The Lamp of British Precedent: An Introduction to the Arts and Crafts Movement." In *"The Art That Is Life": The Arts and Crafts Movement in America, 1875–1920,* edited by Wendy Kaplan, 52–62. Boston: Little, Brown for Museum of Fine Arts, 1987.

———. "Spreading the Crafts: The Role of the Schools." In *"The Art That Is Life": The Arts and Crafts Movement in America, 1875–1920,* edited by Wendy Kaplan, 298–319. Boston: Little, Brown and Company for Museum of Fine Arts, 1987.

Keller, Jean A. *Empty Beds: Indian Student Health at Sherman Institute, 1902–1922.* East Lansing: Michigan State University Press, 2002.

———. "Healing Touch: The Nursing Program of Sherman Institute." In *The Indian School on Magnolia Avenue: Voices and Images from Sherman Institute,* edited by Clifford E. Trafzer, Matthew Sakiestewa Gilbert, and Lorene Sisquoc, 81–106. Corvallis: Oregon State University Press, 2012.

Kent, Kate Peck. *Navajo Weaving: Three Centuries of Change.* Santa Fe: School of American Research Press, 2002.

Key, Mabel. "A New System of Art Education: Arranged and Directed by Arthur W. Dow." *Brush and Pencil* 4, no. 5 (1899): 258–71.

Kimmel, Michael S. "Out of the Guilds and into the Streets: The Ideology and Organization of the Arts and Crafts Movement in England and the United

States." In *Art, Ideology, and Politics*, edited by Judith H. Balfe and Margaret Jane Wyszomirski, 45–168. New York: Praeger, 1985.

Kliebard, Herbert M. *Schooled to Work: Vocationalism and the American Curriculum, 1876–1946*. New York: Teachers College Press, 1999.

———. *The Struggle for the American Curriculum, 1893–1958*. Boston: Routledge and Kegan Paul, 1986.

Kline, Cindra. *Navajo Spoons: Indian Artistry and the Souvenir Trade, 1880s-1940s*. Santa Fe: Museum of New Mexico, 2001.

Kohlstedt, Sally Gregory. "'A Better Crop of Boys and Girls': The School Gardening Movement, 1890–1920." *History of Education Quarterly* 48, no. 1 (February 2008): 58–60.

Korzenik, Diana. "The Art Education of Working Women, 1873–1903." In *Pilgrims and Pioneers: New England Women in the Arts*, edited by Alicia Faxon and Sylvia Moore, 32–41. New York: Midmarch Arts, 1987.

Krech, Shepard, and Barbara Hail. *Collecting Native America, 1870–1960*. Washington DC: Smithsonian Institution Press, 1999.

Kvasnicka, Robert M., and Herman J. Viola, eds. *The Commissioners of Indian Affairs 1824–1977*. Lincoln: University of Nebraska Press, 1979.

LaFlesche, Francis. *The Middle Five: Indian Schoolboys of the Omaha Tribe*. Lincoln: University of Nebraska Press, 1963.

Landis, Barbara. "Carlisle Indian Industrial School 1879–1918." http://home.epix .net/~landis/.

Lawn, Martin. "Sites of the Future: Comparing and Ordering New Educational Actualities." In *Modelling the Future: Exhibitions and the Materiality of Education*, edited by Martin Lawn, 15–30. Oxford: Symposium Books, 2009.

Lears, T. J. Jackson. *No Place of Grace: Antimodernism and the Transformation of American Culture, 1880–1920*. New York: Pantheon, 1981.

Lefevre, Henri. *Critique of Everyday Life*. London: Verso, 2002.

Lentis, Marinella. "Art Education in American Indian Boarding Schools: Tool of Assimilation, Tool of Resistance." PhD diss., University of Arizona, 2011.

———. "Art for Assimilation's Sake: Indian-School Drawings in the Estelle Reel Papers." *American Indian Art Magazine* 38, no. 5 (Winter 2013): 44–51.

Littlefield, Alice. "Learning to Labor: Native American Education in the United States, 1880–1930." In *The Political Economy of North American Indians*, edited by John H. Moore, 43–59. Norman: University of Oklahoma Press, 1993.

Littlefield, Alice, and Martha C. Knack, eds. *Native Americans and Wage Labor: Ethnohistorical Perspectives*. Norman: University of Oklahoma Press, 1996.

Logan, Frederick. M. *Growth of Art in American Schools*. New York: Harper and Brothers, 1955.

Lomawaima, K. Tsianina. "American Indian Education: *By* Indians versus *for* Indians." In *A Companion to American Indian History,* edited by Philip J. Deloria and Neal Salisbury, 422–40. Malden MA: Blackwell, 2002.

———. "Domesticity in the Federal Indian Schools: The Power of Authority over Mind and Body." *American Ethnologist* 20, no. 2 (1993): 227–240.

———. "Estelle Reel, Superintendent of Indian Schools, 1898–1910: Politics, Curriculum and Land." *Journal of American Indian Education* 35, no. 3 (1996): 5–31.

———. *They Called It Prairie Light: The Story of Chilocco Indian Agricultural School.* Lincoln: University of Nebraska Press, 1994.

Lomawaima, K. Tsianina, and Theresa L. McCarty. *"To Remain an Indian": Lessons in Democracy from a Century of Native American Education.* New York: Teachers College Press, 2006.

Louisiana Purchase Exposition Commission. *Final Report of the Louisiana Purchase Exposition Commission.* Washington DC: Government Printing Office, 1906.

Macalister, James. "Art Education in the Public Schools." In *Journal of Proceedings and Addresses of the National Educational Association,* 456–66. New York: National Educational Association, 1891.

Malmsheimer, Lonna M. "'Imitation Whiteman': Images of Transformation at the Carlisle Indian School." *Studies in Visual Communications* 11 (1985): 54–75.

———. "Photographic Analysis as Ethnohistory: Interpretive Strategies." *Visual Anthropology* 1, no. 1 (1987): 21–36.

Mardock, Robert Winston. *The Reformers and the American Indian.* Columbia: University of Mississippi Press, 1971.

Margolis, Eric. "Class Pictures: Representations of Race, Gender and Ability in a Century of School Photography." *Visual Studies* 14, no. 1 (1999): 7–38.

———. "Looking at Discipline, Looking at Labour: Photographic Representations of Indian Boarding Schools." *Visual Studies* 19, no. 1 (2004): 72–96.

———. "Mining Photographs: Unearthing the Meaning of Historical Photos." *Radical History Review* 40 (1988): 32–48.

Margolis, Eric, and Jeremy Rowe. "Images of Assimilation: Photographs of Indian Schools in Arizona." *History of Education* 33, no. 2 (2004): 199–230.

———. "Manufacturing Assimilation: Photographs of Indian Schools in Arizona." http://www.public.asu.edu/~jeremy/indianschool/paper.htm.

Marzio, Peter. *The Art Crusade: An Analysis of American Drawing Manuals, 1820–1860.* Washington DC: Smithsonian Institution Press, 1976.

Mason, Otis. *American Indian Basketry.* New York: Doubleday, 1904.

Mathes, Valerie Sherer. "Nineteenth-Century Women and Reform: The Women's National Indian Association." *American Indian Quarterly* 14, no. 1 (Winter 1990): 1–18.

McAnulty, Sarah. "Angel de Cora: American Indian Artist and Educator." *Nebraska History* 57, no. 2 (1976): 178–86.

McCabe, James D. *The Illustrated History of the Centennial Exhibition, Held in Commemoration with the One Hundredth Anniversary of American Independence.* Philadelphia: National, 1876.

M'Closkey, Kathy. "Marketing Multiple Myths: The Hidden History of Navajo Weaving." *Journal of the Southwest* 36, no. 3 (1994): 185–220.

———. *Swept Under the Rug: A Hidden History of Navajo Weaving.* Albuquerque: University of New Mexico Press, 2002.

McGeough, Michelle. *Through Their Eyes: Paintings from the Santa Fe Indian School.* Santa Fe: Wheelwright Museum of the American Indian, 2009.

McKinney, Lillie. "History of the Albuquerque Indian School (to 1934) I." *New Mexico Historical Review* 20, no. 2 (1945): 109–38.

———. "History of the Albuquerque Indian School II." *New Mexico Historical Review* 20, no. 3 (1945): 207–26.

———. "History of the Albuquerque Indian School" (to 1934 conclusion)." *New Mexico Historical Review* 20, no. 4 (1945): 310–35.

McLendon, Sally. "Collecting Pomoan Baskets, 1889–1939." *Museum Anthropology* 17, no. 2 (1993): 49–60.

McLuhan, T. C. *Dream Tracks: The Railroad and the American Indian, 1890–1930.* New York: Harry N. Abrams, 1985.

McNitt, Frank. *The Indian Traders.* Norman: University of Oklahoma Press, 1962.

McPherson, Robert S. "Naalyehe Ba Hooghan–'House of Merchandise': The Navajo Trading Post as an Institution of Cultural Exchange, 1900–1930." *American Indian Culture and Research Journal* 16, no. 1 (1992): 23–44.

Medina, William O. "Selling Indians at Sherman Institute, 1902–1922." PhD diss., University of California–Riverside, 2005.

Memmi, Albert. *The Colonizer and the Colonized.* Boston: Beacon Press, 1991.

Merry, Sally Engle. "Hegemony and Culture in Historical Anthropology: A Review Essay on Jean and John L. Comaroff's 'Of Revelation and Revolution.'" *American Historical Review* 108, no. 2 (April 2003): 460–70.

Meyer, Carter Jones. "Saving the Pueblos: Commercialism and Indian Reform in the 1920s." In *Selling the Indian: Commercializing and Appropriating American Indian Cultures,* edited by Carter Jones Meyer and Diana Royer, 190–211. Tucson: University of Arizona Press, 2001.

Mihesuah, Devon A. *Cultivating the Rosebuds: The Education of Women at the Cherokee Female Seminary, 1851–1909.* Urbana: University of Illinois Press, 1993.

Mitchell, Clara Isabel. "Textiles." *Elementary School Teacher and Course of Study* 3, no. 1 (1902): 43–45.

Moore, Laura Jane. "Elle Meets the President: Weaving Navajo Culture and Commerce in the Southwestern Tourist Industry." *Frontiers: A Journal of Women Studies* 22, no. 1 (2001): 21–44.

Moore, Sarah J. *Empire on Display: San Francisco's Panama-Pacific International Exposition of 1915.* Norman: University of Oklahoma Press, 2013.

Morgan, Lewis Henry. *Ancient Society.* Tucson: University of Arizona Press, 1985.

Moses, L. G. *Wild West Shows and the Images of American Indians, 1883–1933.* Albuquerque: University of New Mexico Press, 1996.

Mullin, Molly. *Culture in the Marketplace: Gender, Art, and Value in the American Southwest.* Durham NC: Duke University Press, 2001.

Mullis, Sharon M. "Extravaganza of the New South: The Cotton States and International Exposition, 1895." *Atlanta Historical Bulletin* 20 (Fall 1976): 17–36.

National Education Association. *Journal of Proceedings and Addresses of the National Education Association of the United States.* Winona MN: National Education Association, 1882–1911.

Neuhaus, Eugen. *The Art of the Exposition: Personal Impressions of the Architecture, Sculpture, Mural Decorations, Color Scheme & Other Aesthetic Aspects of the Panama-Pacific International Exposition.* San Francisco: Paul Elder, 1915.

New, Lloyd H. "The Role of Art in the Education of the American Indian." *Arts in Society* 9 (1972): 411–18.

Office of Indian Affairs. *General Course of Work and Text-Books Adopted for Indian Schools.* Washington DC: Government Printing Office, n.d.

———. *Rules for Indian Schools, with Course of Study, List of Text-Books, and Civil Service Rules.* Washington DC: Government Printing Office, 1892.

———. *Rules for the Indian School Service.* Washington DC: Government Printing Office, 1913.

———. *Tentative Course of Study for United States Indian Schools.* Washington DC: Government Printing Office, 1915.

Official Catalogue of the Alaska-Yukon-Pacific Exposition. Seattle: A-Y-P Exposition Publishing Company, 1909.

Official Daily Programs, Alaska-Yukon-Pacific Exposition. Seattle: AYPE Official Programme Co., 1909.

Official Guide of the Panama-Pacific International Exposition. San Francisco: Wahlgreen, 1915.

The Official Guidebook of the Panama California Exposition, San Diego 1915. San Diego: National Views Company, 1915.

Official Register of U.S. Employees. Washington DC: Government Printing Office, 1900–1910.

Otero, Miguel. *Report of the Governor of New Mexico to the Secretary of Interior*. Washington DC: Government Printing Office, 1902.

Pan-American Exposition, Buffalo, May 1 to November 1 1901, Its Purpose and Its Plan with Illustrations. Buffalo: Pan-American Exposition Company, 1901.

Panama-Pacific International Exposition: Department Manufactures. San Francisco: Wahlgreen, 1915.

Parezo, Nancy J. "The Challenge of Native American Art and Material Culture." *Museum Anthropology* 14, no. 4 (1990): 12–29.

———. "A Multitude of Markets." *Journal of the Southwest* 32, no. 4 (1991): 563–75.

———. "Southwestern Art Worlds." *Journal of the Southwest* 38, no. 4 (1996): 499–512.

Parezo, Nancy, and Don Fowler. *Anthropology Goes to the Fair: The 1904 Louisiana Purchase Exposition*. Lincoln: University of Nebraska Press, 2009.

Parezo, Nancy J., Kelley A. Hays, and Barbara F. Slivac. "The Mind's Road: Southwestern and Indian Women's Art." In *The Desert Is No Lady: Southwestern Landscapes in Women's Writing and Art*, edited by Vera Norwood and Janice Monk, 146–73. New Haven: Yale University Press, 1987.

Parker, Dorothy A. *Phoenix Indian School: The Second Half-Century*. Tucson: University of Arizona Press, 1996.

Parkhurst, Melissa D. *To Win the Indian Heart: Music at Chemawa Indian School*. Corvallis: Oregon State University Press, 2014.

Parry, Linda, and David Cathers. *Arts and Crafts Rugs for Craftsman Interiors: The Crab Tree Farm Collection*. New York: W. W. Norton, 2010.

Penney, David W. *North American Indian Art*. New York: Thames and Hudson, 2004.

Perdue, Theda. *Race and the Atlanta Cotton States Exposition of 1895*. Athens: University of Georgia Press, 2010.

Perkins, Charles C. *Art Education in America: Read before the American Social Science Association at the Lowell Institute, Boston, February 22, 1870*. Cambridge MA: Riverside Press, 1870.

Perry, Stella G. S. *The Sculpture & Murals of the Panama-Pacific International Exposition*. San Francisco: Wahlgreen, 1915.

Phillips, Ruth. *Trading Identities: The Souvenir in Native North American Art from the Northeast, 1700–1900*. Seattle: University of Washington Press, 1999.

Pratt, Mary Louise. *Imperial Eyes: Travel Writing and Transculturation*. London: Routledge, 1992.

Pratt, Richard H. *Battlefield and Classroom: Four Decades with the American Indian*, edited by Robert Utley. New Haven: Yale University Press, 1964.

Price, Sally. *Primitive Art in Civilized Places*. Chicago: University of Chicago Press, 1989.

Prucha, Francis P. *American Indian Policy in Crisis: Christian Reformers and the Indian, 1865–1900*. Norman: University of Oklahoma Press, 1976.

———. *Americanizing the American Indians*. Cambridge MA: Harvard University Press, 1973.

———. *The Churches and the Indian Schools, 1888–1912*. Lincoln: University of Nebraska Press, 1979.

———. *The Great Father: The United States Government and the American Indians*. Lincoln: University of Nebraska Press, 1984.

Qoyawayma, Polingaysi (Elizabeth White). *No Turning Back*. Albuquerque: University of New Mexico Press, 1964.

Rand-McNally Hand-Book to the Pan-American Exposition, Buffalo and Niagara Falls. Chicago and New York: Rand McNally, 1901.

Reel, Estelle. *Course of Study for the Indian Schools of the United States, Industrial and Literary*. Washington DC: Government Printing Office, 1901.

———. *Outline Course of Study for the Wyoming Public Schools*. Laramie: Republican Book and Job Print, 1897.

Reese, William J. "The Origin of Progressive Education." *History of Education Quarterly* 41, no. 1 (Spring 2001): 1–24.

Report of the Board of Management, United States Government Exhibit, Cotton States and International Exposition, Atlanta, Georgia, 1895. Washington DC, 1895.

Report of the Executive on the Proceedings of the First Annual Conference of the Society of American Indians, October 12–17, 1911. Washington DC: Society of American Indians, 1912.

Report of the Secretary of the Interior for the Fiscal Year Ended June 30, 1904. Washington DC: Government Printing Office, 1904.

Report of the Superintendent of Indian Schools to the Commissioner of Indian Affairs. Washington DC: Government Printing Office, 1894–1910.

Report of the U.S. National Museum under the Direction of the Smithsonian Institution, for the Year Ending in June 30, 1893. Washington DC: Government Printing Office, 1893.

*Report of the United States Government Exhibit at the Tennessee Centennial Exposition, Nashville, 1897.*Washington DC: Government Printing Office, 1901.

Reyhner, Jon Allan, and Jeanne Eder. *American Indian Education: A History*. Norman: University of Oklahoma Press, 2004.

Riding In, James. "The Contracting of Albuquerque Indian School." *Indian Historian* 11, no. 4 (1978): 20–27.

Rodel, Kevin P., and Jonathan Binzen. *Arts and Crafts Furniture: From Classic to Contemporary*. Newton CT: Taunton Press, 2003.

Rodríguez, Sylvia. "Art, Tourism, and Race Relations in Taos: Toward a Sociology of the Art Colony." *Journal of Anthropological Research* 45, no. 1 (1989): 77–99.

Rosaldo, Renato. "Imperialist Nostalgia." *Representations* no. 26 (Spring 1989): 107–22.

Rushing, W. Jackson, ed. *Native American Art in the Twentieth Century.* New York: Routledge, 1999.

Rydell, Robert W. *All the World's a Fair: Visions of Empire at American International Expositions, 1876–1916.* Chicago: University of Chicago Press, 1984.

———. "The Trans-Mississippi and International Exposition: To Work Out the Problem of Universal Civilization." *American Quarterly* 33, no. 5 (1981): 587–607.

———. *World of Fairs: The Century of Progress Expositions.* Chicago: University of Chicago, 1993.

Rydell, Robert W., John E. Findling, and Kimberly D. Pelle. *Fair America: World's Fairs in the United States.* Washington DC: Smithsonian Institution Press, 2000.

Sargent, Walter. "Fine and Industrial Art in Elementary Schools." *Elementary School Teacher* 10, no. 2 (1909): 49–57.

———. "Fine and Industrial Art in Elementary Schools: Grade I." *Elementary School Teacher* 10, no. 3 (1909): 110–20.

———. "Fine and Industrial Art in Elementary Schools: Grade VI." *Elementary School Teacher* 10, no. 7 (1910): 334–46.

Sargent, Walter, Elizabeth E. Miller, and Margaret Gordon. "Course of Study in Drawing in the Elementary School, School of Education, the University of Chicago." *Elementary School Journal* 16, no. 8 (1916): 412–23.

Saunders, Robert J. "Art, Industrial Art, and the 200 Years War." *Art Education* 29, no. 1 (1976): 5–8.

———. "Selections from Historical Writings on Art Education." *Art Education* 19, no. 1 (1966): 25–29.

Saville-Troike, Muriel. "Navajo Art and Education." *Journal of Aesthetic Education* 18, no. 2 (Summer 1984): 41–50.

Schrader, Robert Fay. *The Indian Arts and Crafts Board: An Aspect of New Deal Indian Policy.* Albuquerque: University of New Mexico Press, 1983.

See! See! See! Guide to Jamestown Exposition, Historic Virginia and Washington. Washington DC: Byron S. Adams, 1907.

Sekaquaptewa, Helen. *Me and Mine: The Life Story of Helen Sekaquaptewa.* Tucson: University of Arizona Press, 1985.

Sherman Bulletin. Riverside CA: Sherman Institute, 1907–17.

Sherman Institute, U.S. Indian School, Riverside, California. Riverside CA: Sherman Indian School, 1908.

Sherman Purple and Gold. Riverside CA: Sherman Institute, 1934.

Simonsen, Jane E. *Making Home Work: Domesticity and Native American Assimilation*

in the American West, 1860–1919. Chapel Hill: University of North Carolina Press, 2006.

Simmons, Leo. *Sun Chief: The Autobiography of a Hopi Indian*. New Haven: Yale University Press, 1970.

Simmons, Marc. *Albuquerque: A Narrative History*. Albuquerque: University of New Mexico Press, 1982.

Smith, Peter. *The History of American Art Education: Learning about Art in American Schools*. Westport CT: Greenwood Press, 1996.

———. "The Unexplored: Art Education Historians' Failure to Consider the Southwest." *Studies in Art Education* 40, no. 2 (1999): 114–27.

Smith, Valene L., ed. *Hosts and Guests: The Anthropology of Tourism*. Philadelphia: University of Pennsylvania Press, 1989.

Smith-Ferri, Sherrie. "Basket Weavers, Basket Collectors, and the Market: A Case Study of Joseppa Dick." *Museum Anthropology* 17, no. 2 (1993): 61–66.

———. "'Canastromania': The Development of the Commercial Market for Pomo Indians." *Expedition* 40, no. 1 (1998): 15–22.

Special Report by the Bureau of Education, Educational Exhibits and Conventions at the World's Industrial and Cotton Centennial Exposition, New Orleans, 1884–1885, Part I: Catalogue of Exhibits. Washington DC: Government Printing Office, 1886.

Soucy, Donald, and Mary Ann Stankiewicz, eds. *Framing the Past: Essays on Art Education*. Reston VA: National Art Education Association, 1990.

Southern Workman. Hampton VA: Hampton Institute, 1901–3.

Standing Bear, Luther. *My Indian Boyhood*. Lincoln: University of Nebraska Press, 1988.

Stanczak, Gregory C., ed. *Visual Research Methods: Image, Society, Representation*. London: Sage, 2007.

Stankiewicz, Mary Ann. "Art at Hull House, 1889–1901: Jane Addams and Ellen Gates Starr." *Woman's Art Journal* 10, no. 1 (Spring/Summer 1989): 35–39.

———. "Beauty in Design and Pictures: Idealism and Aesthetic Education." *Journal of Aesthetic Education* 21, no. 4 (1997): 63–76.

———. "Chromo-Civilization and the Genteel Tradition (An Essay on the Social Value of Art Education)." *Studies in Art Education* 40, no. 2 (Winter 1999): 101–13.

———. "Discipline and the Future of Art Education." *Studies in Art Education* 41, no. 4 (Summer 2000): 301–13.

———. "Drawing Book Wars." *Visual Arts Research* 12, no. 2 (Fall 1986): 59–72.

———. "'The Eye Is a Nobler Organ': Ruskin and American Art Education." *Journal of Aesthetic Education* 18, no. 2 (1984): 51–64.

———. "Form, Truth, and Emotion: Transatlantic Influences on Formalist Aesthetics." *Journal of Art and Design Education* 7 (1988): 81–95.

———. "From the Aesthetic Movement to the Arts and Crafts Movement." *Studies in Art Education* 33, no.3 (1992): 165–73.

———. "Mary Dana Hicks Prang: Portrait of a Dynamic Art Educator." In *Women Art Educators II*, edited by Mary Ann Stankiewicz and Enid Zimmerman, 22–38. Bloomington IN: Mary Rouse Memorial Fund and the Women's Caucus of the National Art Education Association, 1985.

———. "A Picture Age: Reproductions in Picture Study." *Studies in Art Education* 26, no. 2 (Winter 1985): 86–92.

———. "Middle Class Desire: Ornament, Industry, and Emulation in 19th Century Art Education." *Studies in Art Education* 43, no. 4 (Summer 2002): 324–38.

———. *Roots of Art Education Practice.* Worcester MA: Davis, 2001.

Stankiewicz, Mary Ann, Patricia Amburgy, and Paul Bolin. "Questioning the Past: Contexts, Functions, and Stakeholders in 19th Century Art Education." In *Handbook of Research and Policy in Art Education*, edited by Elliott W. Eisner and Michael D. Day, 33–53. Mahwah NJ: National Art Education Association, 2004.

Summers, L. D. "The Correlation of Drawing and Manual Training." *Elementary School Teacher* 4, no. 2 (1903): 107–15.

Sullivan, Sean Patrick. "Education through Sport: Athletics in American Indian Boarding Schools of New Mexico, 1885–1940." PhD diss., University of New Mexico, 2004.

Superintendents' Annual Narrative and Statistical Reports from Field Jurisdiction of the Bureau of Indian Affairs. Washington DC: Government Printing Office, 1907–1938.

Szabo, Joyce. *Art from Fort Marion: The Silberman Collection.* Norman: University of Oklahoma Press, 2008.

Szasz, Margaret Connell. *Education and the American Indian: The Road to Self-Determination.* Albuquerque: New Mexico, 1974.

———. *Indian Education in the American Colonies, 1607–1783.* Albuquerque: University of New Mexico Press, 1988.

———. "'Poor Richard' Meets the Native American: Schooling for Young Indian Women in Eighteenth-Century Connecticut." *Pacific Historical Review* 49, no. 2 (1980): 215–35.

Tarr, Patricia. "Pestalozzian and Froebelian Influences on Contemporary Elementary School Art." *Studies in Art Education* 30, no. 2 (Winter 1989): 115–21.

Taylor, Robert T. "The Jamestown Tercentennial Exposition of 1907." *Virginia Magazine of History and Biography* 65, no. 2 (April 1957): 169–208.

Thompson, Langdon S. "Some Reasons Why Drawing Should Be Taught in Our Common Schools." *Journal of Proceedings of the National Educational Association in Louisville, Kentucky*, 40–52. Salem OH: National Educational Association, 1877.

Thompson, Mark. *American Character: The Curious Life of Charles Fletcher Lummis and the Rediscovery of the Southwest.* New York: Arcade, 2001.

Thornton, William T. *Report of the Governor of New Mexico to the Secretary of Interior, 1895.* Washington DC: Government Printing Office, 1895.

Tinkler, Penny. *Using Photographs in Social and Historical Research.* London: Sage, 2013.

Tisdale, Shelby. "Railroads, Tourism, and Native Americans in the Greater Southwest." *Journal of the Southwest* 38, no. 4 (1996): 433–63.

———. "Southwestern Indian Arts and Crafts as Commodities: Introduction." *Journal of the Southwest* 38, no. 4 (1996): 387–94.

Todd, Frank Morton. *The Story of the Exposition, Being the Official History of the International Celebration Held at San Francisco 1915 to Commemorate the Discovery of the Pacific Ocean and the Construction of the Panama Canal.* 5 vols. New York: G. P. Putnam's Sons, Knickerbocker Press, 1921.

Todd, Mattie Phipps. *Hand-Loom Weaving: A Manual for School and Home.* New York: Rand McNally, 1902.

Trafzer, Clifford E., Matthew Sakiestewa Gilbert, and Lorene Sisquoc, eds. *The Indian School on Magnolia Avenue: Voices and Images from Sherman Institute.* Corvallis: Oregon State University Press, 2012.

Trafzer, Clifford E., Jean A. Keller, and Lorene Sisquoc. *Boarding School Blues: Revisiting American Indian Educational Experiences.* Lincoln: University of Nebraska Press, 2006.

Trennert, Robert A. "Corporal Punishment and the Politics of Indian Reform." *History of Education Quarterly* 29, no. 4 (Winter 1989): 595–617.

———. "Educating Indian Girls at Non-reservation Boarding Schools, 1878–1920." *Western Historical Quarterly* 13, no. 3 (1982): 271–90.

———. "Fairs, Expositions, and the Changing Images of Southwestern Indians, 1876–1904." *New Mexico Historical Review* 62, no. 2 (1987): 127–50.

———. "From Carlisle to Phoenix: The Rise and Fall of the Indian Outing System, 1878–1930." *Pacific Historical Review* 59 (1983): 267–91.

———. "A Grand Failure: The Centennial Indian Exhibition of 1876." *Prologue* 6 (1974): 118–29.

———. "The Indian Role in the 1876 Centennial Celebration." *American Indian Culture and Research Journal* 1, no. 4 (1976): 7–13.

———. *The Phoenix Indian School: Forced Assimilation in Arizona, 1891–1935.* Norman: University of Oklahoma Press, 1988.

———. "Selling Indian Education at World's Fairs and Expositions, 1893–1904." *American Indian Quarterly* 11, no. 3 (Summer 1987): 203–20.

Trump, Erik. "'The Idea of Help': White Women Reformers and the Commercialization of Native American Women's Arts." In *Selling the Indian: Commercializing*

and Appropriating American Indian Cultures, edited by Carter Jones Meyer and Diana Royer, 159–89. Tucson: University of Arizona Press, 2001.

Ulrich, Laurel Thatcher. *The Age of Homespun*. New York: Knopf, 2001.

Vuckovic, Myriam. *Voices from Haskell: Indian Students between Two Worlds, 1884–1928*. Lawrence: University Press of Kansas, 2008.

Wade, Edwin, ed. *The Arts of the North American Indian: Native Traditions in Evolution*. New York: Hudson Hills Press, 1986.

———. "The Ethnic Art Market in the American Southwest, 1880–1980." In *Objects and Others: Essays on Museums and Material Culture, History of Anthropology*, edited by George W. W. Stocking, 167–91. Madison: University of Wisconsin Press, 1985.

———. "The History of the Southwest Indian Ethnic Market." PhD diss., University of Washington, 1976.

Waggoner, Linda L. *Firelight: The Life of Angel DeCora, Winnebago Artist*. Norman: University of Oklahoma Press, 2008.

Wakefield, John. *A History of the TransMississippi & International Exposition*. Omaha: Omaha Public Library, 1992. First published 1903.

Wanken, Helen. "'Woman's Sphere' and Indian Reform: The Women's National Indian Association, 1879–1901." PhD diss., Marquette University, 1981.

Washburn, Dorothy. "Dealers and Collectors of Indian Basketry at the Turn of the Century in California." *Empirical Studies of the Arts* 2, no. 1 (1984): 51–74.

Webster, Laurie D. "Reproducing the Past: Revival and Revision in Navajo Weaving." *Journal of the Southwest* 38, no. 4 (1996): 415–31.

Weigle, Marta. "Exposition and Mediation: Mary Colter, Erna Fergusson, and the Santa Fe/Harvey Popularization of the Native Southwest, 1902–1940." *Frontiers: A Journal of Women Studies* 12, no. 3 (1992): 116–50.

Weigle, Marta, and Barbara A. Babcock, eds. *The Great Southwest of the Fred Harvey Company and the Santa Fe Railway*. Phoenix: Heard Museum, 1996.

Weiler, Kathleen. "Women's History and the History of Women Teachers." In *Country Schoolwomen: Teaching in Rural California, 1850–1950*, 8–34. Stanford: Stanford University Press, 1998.

Wenger, Gina. "Angel DeCora: Native American Art Educator, 1871–1919." In *Women Art Educators V: Conversations Across Time*, edited by Kit Grauer, Rita Irwin, and Enid Zimmerman, 42–49. Reston VA: National Art Education Association, 2003.

Whitehead, Ralph R. "The Application of Art to Hand-Work." *Elementary School Teacher* 5, no. 2 (1904): 92–96.

Whitford, W. G. "Brief History of Art Education in the United States." *Elementary School Journal* 24, no. 2 (1923): 109–15.

Witmer, Linda F. *The Indian Industrial School, Carlisle, Pennsylvania, 1879–1918.* Cumberland County Historical Society, 1999.

Woodman, Emma. "The Value of Manual Arts." In *Journal and Proceedings of the Twenty-Second Annual Meeting*, 31–32. Santa Fe: New Mexico Education Association, 1907.

Woodward, Calvin M. *The Educational Value of Manual Training.* Boston: D. C. Heath, 1890.

Woolman, Mary Schenck, and Ellen Beers McGowan. *Textiles: A Handbook for the Student and the Consumer.* New York: Macmillan, 1913.

Wyckoff, Lydia, ed. *Visions and Voices: Native American Painting from the Philbrook Museum of Art.* Tulsa OK: Philbrook Museum of Art, 1996.

Wygant, Foster. *Art in American Schools in the Nineteenth Century.* Cincinnati: Interwood Press, 1983.

Zeller, Terry. "The Historical and Philosophical Foundations of Art Museum Education in America." In *Museum Education: History, Theory, and Practice*, edited by Nancy Berry and Susan Mayer, 10–40. Reston VA: National Art Education Association, 1989.

Zitkala-Ša. *American Indian Stories.* Lincoln: University of Nebraska Press, 1986.

INDEX

Cantonment Indian School (OK), 94, 244, 326, 327, 329

Carlisle Indian Industrial School (PA), xviii, 28, 33–36, 46, 55, 61, 66, 131, 149, 165, 166, 172, 194, 321, 322, 323, 324, 325, 329, 330, 354n66, 361n26; at Atlanta Cotton Exposition, 232; Boston display, 288; Cleveland display, 296–97; at Columbian Exposition, 228–30; curriculum, 72–73; display at Cotton Exposition, 222–24; drawings, 61–64; goals, 72; at Jamestown, 252; at Lewis and Clark Exposition, 248; Los Angeles display, 295–96; Minneapolis display, 275, 277, 283, 332; Native Indian Art Department, 92, 108–14, 115, 116; sale of Native crafts, 301–5; at St. Louis Exposition, 242; at Trans-Mississippi Exposition, 234; Washington DC display, 271–72

Carson Indian School (NV), 92, 234, 248, 291, 322, 323, 324, 325, 327, 329, 336, 374n15

Carter, Charles D., 113

Carter, Sybil, 235, 243

Cassidy, Gerald, 261

Cass Lake Indian School (MN), 293, 337

Catawba Indians, 252

Chalcraft, Edwin L., 247

Chamberlain Indian School (SD), 283, 333, 374n15

Chapman, John Gadsby, 3–4, 6

Charles, John, 186

Chautauqua Institute, 75

Chemawa Indian School (OR), 239, 247, 275, 277, 299, 322, 325, 326, 327, 329, 330, 332, 374n15, 377n55

Chemehuevi Indians, 192. *See also* Mission Indians

Cherokee Indians, 231, 252

Cherokee students, 91

Cherokee Training School (NC), 91, 94, 272, 276, 288, 322, 323, 325, 333

Cheyenne Indians, 242

Cheyenne River Agency, 289

Cheyenne River Indian School (SD), 94, 96, 97, 288, 325, 329, 332, 374n15

Cheyenne students, 286–88

Chicago Women's Club, 23

Child Study Movement, 18, 26, 48

Chilocco Indian Agricultural School (OK), 81, 88, 94, 96, 97, 98, 144, 226, 228, 229, 238, 244, 284, 293, 294, 301, 304, 321, 322, 323, 325, 326, 329, 330, 339

Chippewa students, 113, 277

Chitimacha Indians, 242, 244

Chumash Indians, 192. *See also* Mission Indians

Clapp, Moses E., 113

Clarence, 175–78, 180, 362n40

Clark, John B., 18

Clarke, Isaac Edwards, 10, 16

Coe, Benjamin, 3–4, 6

Coffin, W. V., 224

Collins, M. A., 186–88, 259–60

Collins, Ralph P., 134–35, 136

colonization of consciousness, xviii, xxi–xxii, xxiii, 61, 91, 227, 309, 315–16

Columbia Teachers College, 25

Colville Indian School (OR), 330

Comanche Indians, 242

Comanche Indian School (OK), 322

Comes-to-Drink, John, 271

creative activity, 1–2, 13, 18, 23–24; as influence on learning, 7, 11; as nature study, 27–28; opposition to its instruction, 7–8; pedagogy, 5–6, 12–13, 18–19, 24–27; as picture study, 25–27; in public schools, 43–44; rationale, xix–xx; subject matter, 2, 12

Drawing Act of 1870, 9–10

drawing in Indian schools, 37–38; in connection with other subjects, 46, 48, 57–58; as creative activity, 47–48, 67–68; drawing/art teachers, 46, 66, 128, 166–67; drawings of farming, 60–61, 172, 282, 290; drawings of fauna, 52, 61, 133–34, 182–83, 258, 269, 275, 276, 277, 286, 288, 290, 291, 315; drawings of flora, 52, 61, 136, 172, 183, 228, 258, 269, 275, 276, 277, 282, 290, 315; drawings of fruits and vegetables, 58, 60–63, 172, 184, 258, 269, 275, 276, 280, 281, 290, 291, 315; drawings of geometrical shapes, 228, 267, 269, 275, 276, 290, 291; drawings of Indian subject matters, 58–59, 111, 223, 224, 258, 269, 272, 276, 286, 288, 289–90, 291, 296, 312; drawings of landscapes, 56, 63, 133, 258, 288, 301; drawings of maps, 134, 165, 183, 227, 232, 233, 258, 273, 276, 282, 290; drawings of people, 258, 269, 275, 276, 277; drawings of pottery, 223, 269, 276, 291; drawings of school life/chores, 59, 61–62, 172, 276, 280–81, 290, 291; drawings of still lifes, 63, 172, 286; drawings of utilitarian objects, 39, 58, 59, 60, 65, 129, 258, 269, 276, 286, 288; as foundation for manual

trades, 43–44; freehand, 37, 48, 52, 165, 232, 237, 244, 258; mechanical drawings, 237, 258; as nature study, 39, 53–54, 56, 58, 59, 61, 134; pedagogy, 37–38, 43–44, 48, 50–51, 57, 59, 67–69; as picture study and object drawing, 52, 55; purpose, 41, 43–45, 46–48, 49, 50, 56, 59, 65–67, 68–69; subject matter, 37, 49, 57–59, 60–61, 64–65, 265

drawing manuals, 4, 6–7, 11

drawnwork, 205, 206, 232, 235, 243, 244, 245, 248, 270, 271, 273, 275, 283, 289

Drexel Institute of Art, Science, and Industry, 16, 109

Eaglehawk, Alice, 271

Eastern Cherokee Indians, 231

Eastern Cherokee School. *See* Cherokee Training School

Eastern High School (Washington DC), 26

Eaton, John, 15

Elle of Ganado, 148, 257

Elliott, Hazel, 195

Engavo, Willie, 41

Eskimos, 225, 255

Eugene Dietzgen Company, 186, 364n57

Eve, Caroline, 185

Ewing, Rev. L. M., 201

exhibition of Native people, 217, 225, 230–31, 234, 241–42, 247, 250, 255, 257, 261–62

expositions: purpose of, 217

fancywork, 28, 75, 98, 162, 202, 206, 209, 223, 233, 235, 243, 244, 251,

Hailmann, William N., 46–50, 56, 65, 69, 71, 76–77, 105, 136, 139, 158, 165, 349n24
Hall, G. Stanley, 18
Hall, Harwood, 157–58, 160, 165–66, 186, 305, 314; on basketry, 200–213; career, 161; on choice of Riverside, 158–60; differences from Conser 212–13, 214–15; on drawing teacher, 166–68; personal basket collection, 208; on promotion of Indian culture, 172–74; on sale of baskets, 210; on sale of rugs, 190, 196–97; on weaving and basketry, 189–97, 200
Hampton Normal and Agricultural Institute (VA), 34–35, 46, 53–55, 74, 95, 96, 97, 115, 131, 235, 238, 244, 247, 271, 325, 329
handicrafts. See arts and crafts
Hart, Lucy, 88
Haskell Indian Institute (KS), 38–39, 55, 92, 93, 144, 186, 226, 229, 234, 239, 242–43, 244, 248, 276, 284, 321, 322, 325, 326, 327, 329, 330, 322, 323, 324, 325, 326, 327, 328, 330, 332
Hayward Indian Training School (WI), 93, 97, 337
Hernandez, Margaret, 195
Hewett, Edgar L., 260–61, 374n2
Hicks, Mary Dana, 18–19
high arts, xx
Holmes, W. H., 225
Hoopa Valley School (CA), 93, 97, 234, 291, 323, 324, 327, 332, 338, 374n15
Hopi Eagle Dance, 172–73
Hopi Indians, 173–74, 202–6, 209–10, 362n32
Hopi students, 114, 170–72, 173–82

Hoppin, James Mason, 3
Hora, Wyo, 41
Howe, Charles S., 121
Hoyt, Esther B., 181
Hrdlička, Aleš, 261
Hubbel, Lorenzo, 149
Hugo, Willie, 41
Hutchison, E. B., 260

Indian Arts and Crafts Board, 154
Indian Congress (at Omaha), 233–34, 236, 370n38
Indian corner, 188, 206, 219, 235, 249, 265, 273–74, 294
Indian fairs, 374n2
Indian Industries League, 74, 76, 77
Indian Office. See Office of Indian Affairs
Indian Rights Association, 107
Indian Rights Fund, 74
Indian schools: curriculum, 31–37; industrial training, 69, 73; purpose and goals, xvii–xviii, xix, 31–32, 36–37, 72–73, 117
Indian schools displays at international fairs and expositions, xix, xxvi, 109; in Atlanta, 231–32; in Buffalo, 237–40; in Chicago, 219, 224–31; content, 218–20; in Jamestown, 251–52; model Indian school in St. Louis, 240–42, 245–46; in Nashville, 232–33; Native arts and crafts displays, 219; in New Orleans, 219, 222–24; in Omaha, 234–36; in Philadelphia, 219, 221–22; in Portland, 247–49; purpose, 218, 314–16; in San Francisco, 257–60; static display in in Seattle, 254–55; St. Louis, 242–45

Mojave students, 165
Mono students, 195
Montano, Augustine, 182
Montoya, Francisco, 289
Moqui Indians. *See* Hopi Indians
Moqui Training School (AZ), 210, 374n15
Morgan, Thomas J., xviii, xix, xxv, 13,
 31, 33, 35–38, 41–44, 47–50, 65, 126,
 128, 132, 134, 136, 165, 226, 310
Morris, William, 15, 24
Morris Indian School (MN), 93, 248,
 276, 293, 326, 327, 328, 333, 337,
 374n15
Mount Pleasant Indian School (MI), 94

Nashingayumtewa, Myron, 183
National Art Training School of South
 Kensington, 12
National Education Association (NEA),
 xxvi, 11, 14, 35, 43, 59, 61, 77, 109,
 134, 140, 172, 184, 193, 255, 263,
 265, 267, 270, 274, 275, 282, 283,
 289, 294, 296, 304, 305, 307, 319
National Indian Association (NIA),
 283–84, 285
Native arts and crafts, 77–78; civilizing
 effect, 87–89, 90–91, 98–99, 119;
 disappearance of, 114–20; display
 of, 132, 140–41; displays of basketry,
 225, 226, 235, 237, 241, 242, 248,
 252, 273, 275, 282, 284, 289, 293,
 294, 295, 296, 297, 299; displays
 of beadwork, 225, 235, 241, 242,
 248, 252, 258, 259, 273, 279, 282,
 284, 285, 289, 292, 293, 295, 296,
 297, 299; displays of leatherwork,
 295, 296; displays of pottery, 225,
 226, 232, 235, 237, 241, 242, 252,
 261, 262, 284, 294, 295, 296, 297,

299; displays of rugs/weaving,
 225, 226, 232, 235, 237, 241, 242,
 248, 252, 258, 259, 261, 262, 273,
 275, 282, 284, 289, 290, 292, 293,
 295, 296, 297, 299; displays of
 silverwork, 242, 258, 262, 299;
 marketability, 77–83, 100–101;
 pedagogy, 90–91; preservation of,
 73–75, 83–87; rationale, xix–xx, xxii–
 xxiii, xxvi, 34, 71–91, 98–99, 105–6;
 reevaluation of, 74–74; sale of, 139–
 40, 148, 152, 301–7
Native Indian Art Department. *See*
 Carlisle Indian Industrial School
Native industries. *See* Native arts and
 crafts
Native teachers, 89, 92, 106, 108–15,
 117–18, 120, 141, 142, 148–49, 153
natural selection, 261
nature study, 18, 25, 27–28, 36, 39, 47,
 50, 52–54, 56, 58, 59–61, 104, 134,
 258, 281
Navajo Indians, 242, 225, 226
Navajo Indian School (AZ), 95, 97, 101–
 102, 145, 322, 325, 328, 332, 374n15
Navajo students, 45, 194, 200, 241,
 298, 299
Neah Bay Indian School (WA), 293,
 328, 329, 338
Needham, Milton J., 92
needlework, xx, 16, 19, 22, 28, 75, 93,
 98, 133, 151, 162, 165, 202, 203,
 205–6, 208, 235, 251, 259, 265, 267,
 270, 274, 275, 289, 295, 299
Newcomb Loom Company, 198–99,
 366n84
New Mexico Education Association, 152
New Mexico State Teachers' Associa-
 tion, 153

CPSIA information can be obtained
at www.ICGtesting.com
Printed in the USA
LVOW12*0733130418

573368LV00003B/18/P